PIT BULL
FLOWER POWER

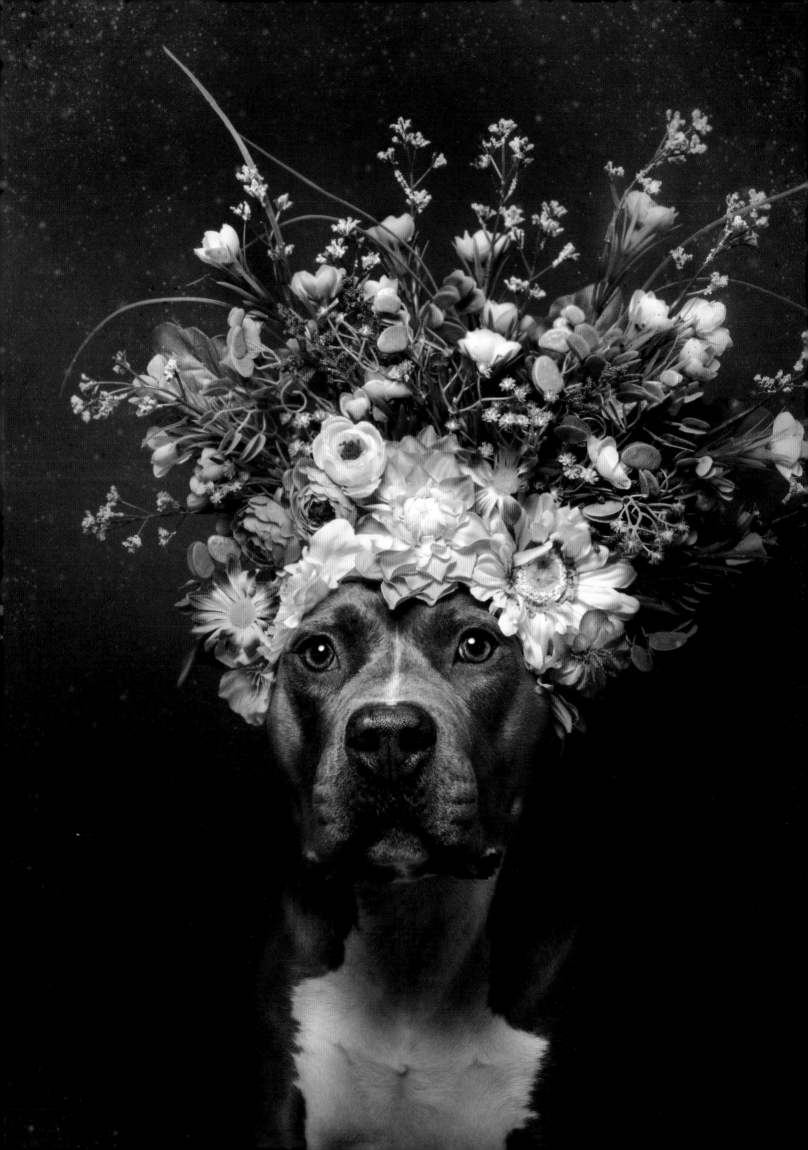

PIT BULL FLOWER POWER

SOPHIE GAMAND

LANTERN BOOKS • NEW YORK

2018
Lantern Books
128 Second Place
Brooklyn, NY 11231
www.lanternbooks.com

Printed in the United States of America.

Library of Congress Cataloging-in-Publication Data

Names: Gamand, Sophie, author.
Title: Pit bull flower power / Sophie Gamand.
Description: New York : Lantern Books, 2018. | Includes index.
Identifiers: LCCN 2018038353 | ISBN 9781590565827 (hardcover : alk. paper)
Subjects: LCSH: Pit bull terriers—Pictorial works. | Photography of dogs.
Classification: LCC SF429.P58 G36 2018 | DDC 636.755/90222—dc23
LC record available at https://lccn.loc.gov/2018038353

Title page:

Moose, 2017
Adopted
Hounds in Pounds, New Jersey

"You become responsible, forever,
for what you have tamed."

—Antoine de Saint-Exupéry, *The Little Prince*

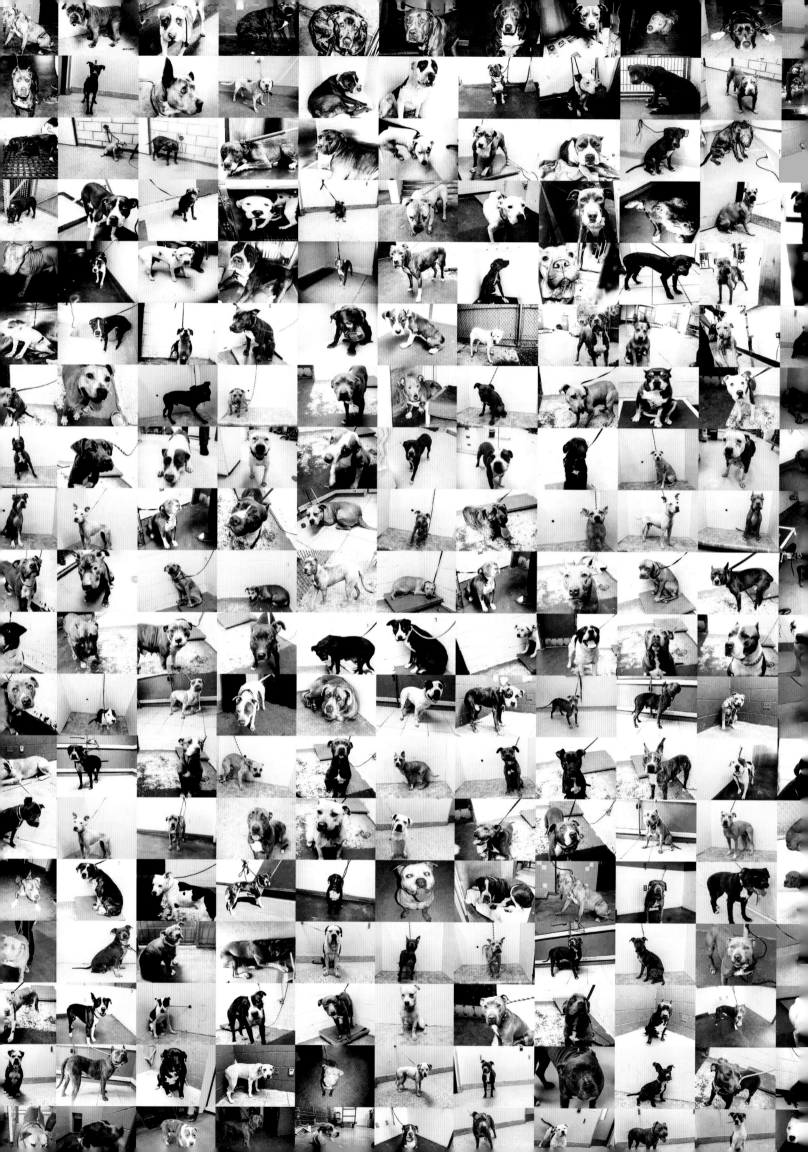

INTRODUCTION

I rang the doorbell. Behind the large wooden gate, the dog went nuts.

I was about thirteen years old, and a couple of times a week a schoolmate's parents drove me to school. They were usually late, and their Briard (a sizable, shaggy herding dog) would grow increasingly aggravated by my presence. "Do not open the gate!" the mother shouted from inside the house to her daughter, who'd come out to greet me. The dog was barking angrily, throwing himself against the gate, trying to get to me from underneath it. I was terrified. It was clear to me the adults weren't in control of what I saw as a beast; they even encouraged his guarding behavior.

After a few minutes, which seemed an eternity for the both of us kids, with the furious dog between us, the girl unlatched the gate and propped it open slightly to say *hi* and apologize for her parents' lateness. I recall vividly the moment the dog forced his muzzle through the opening and jumped on top of me. He looked like a bear standing on his back paws, looming over me. I fell under the full weight of his wrath.

Instinctively, I rolled into the tightest ball I could, my arms firmly protecting my neck, and braced myself for the assault. The owners ran outside and managed to pull their dog off. In the end, I was left with puncture wounds on my butt cheek, saved by the thick pockets of my jeans. My injuries could have been much worse. Not until the Briard killed another dog and mauled their own son's leg did the owners have him euthanized.

I only knew at that age a fraction of what I've learned since about animals. But I held then, and continue to hold, the adults responsible for what happened—not the dog. Nonetheless, when I started volunteering with animal rescues years later, I still felt one thing deep down: I should stay away from large, jumpy dogs.

In particular, I was afraid of pit bulls.

In France, where I grew up, pit bulls were banned. Although I had no idea what pit bulls looked like, my negative encounter with a powerful, angry dog, combined with pit bulls' reputation as vicious, made me think they probably shouldn't be allowed in our communities. Why take the risk?

Fear fueled my desire to start *Pit Bull Flower Power*. I couldn't reconcile the horrors I'd read about pit bulls in the press with how loving the ones I met at the shelter were. It felt hypocritical to want to help homeless dogs, yet be afraid of pit bulls. I decided to overcome my apprehension and try to understand them. The best way I knew how was to create an intimate series of portraits. Nothing had prepared me for the journey that ensued.

Soon, the idea of using flowers emerged. Inspired by Baroque aesthetics, I wanted to portray pit bulls in a way we'd never seen before—challenging our perceptions and shortening the emotional distance between them and the viewer. I wondered if art could be a tool powerful enough to change the fate of these dogs and help some of them get adopted by depicting them as fragile and soulful, rather than the bloodthirsty monsters we were accustomed to. What started as creative experimentation soon evolved into a passion project, especially when I realized that every year hundreds of thousands of pit bulls are euthanized in the United States alone. The flowers took on another meaning: they became a symbol of the ephemeral quality of existence and a reminder that all lives are precious and demand our protection—pit bulls' as well.

"Pit bulls have become the most feared, hated, and abused of all companion animals."

The moment my first *Pit Bull Flower Power* photographs were released to the public in the summer of 2014, I was reluctantly pulled into the fiery controversy surrounding pit bulls. Propelled into the role of an advocate, I was proclaimed these dogs' new champion. Soon, my images reached nine million views on social media and requests for interviews flooded in. Everyone expected me to answer two burning questions: *What is a pit bull?* and, *Are pit bulls more dangerous than other dogs?*[1]

It seemed to me that nobody, myself included, knew how to define what a pit bull was, and the few people who appeared to have answers couldn't agree with one another. I was quickly made aware of the scale of the controversy—particularly when hate mail appeared in my inbox, accusing me of having the blood of innocent children on my hands because I was portraying these dogs as harmless. I even received an angry phone call from a breed enthusiast who urged me to reconsider my work. "These are not pit bulls," the man explained, and I would "get in trouble" if I continued.

Four years later, the agitation surrounding *Pit Bull Flower Power* hasn't ceased. The series has been incredibly successful at rebranding shelter pit bulls around the world, getting many of the models adopted, and transforming pit bull advocacy. My work has been mocked and praised; the photos have been received enthusiastically by pit bull lovers and criticized virulently by their haters. Through it all, I've tried to steer a straight course and, in my own way, help disentangle the complex controversy surrounding pit bulls.

So, to answer that first question, what *is* a pit bull? Technically, there's a breed called the American Pit Bull Terrier; to breed purists, a pit bull is just that: an APBT and nothing else. However, to the general public,

the government, law enforcement—and maybe most importantly to shelter staff, volunteers, and adopters—pit bulls have become an ill-defined cluster of breeds: the bully breeds and some terriers, and their mixes. These usually include American Pit Bull Terriers, American Staffordshire Terriers, Staffordshire Bull Terriers, English Bull Terriers, sometimes American Bullies and American Bulldogs, and any dog sharing physical characteristics with these breeds: short hair, stocky muscular bodies, blocky heads, and large smiles. These are dogs who existed long before breeds were institutionalized. To put it briefly, the term *pit bull* as understood today does not describe a specific breed, but rather a look and a type of dog that has been popular for centuries.

Most people wouldn't know how to pick a pit bull from a lineup. I've heard that statement many times in my years working with these dogs. One day at the dog park I experienced it personally, when a woman grabbed her puppy, clenched my arm, pointed feverishly at a French Bulldog, and gasped, "Is that a pit bull?!" Not only was the Frenchie not a pit bull, but unbeknownst to her the woman's puppy had been playing with a pit bull for half an hour.

One look at a cross-section of my portraits for *Pit Bull Flower Power* reveals how difficult—even meaningless—visual breed identification is. I let shelter staff determine which dogs should take part in my photo shoots. I simply request, "Bring me your pit bulls." More often than not, the staff doesn't know where to draw the pit bull line, and the result is a wide range of types of dogs being represented in the series.

Unfortunately for a shelter dog, receiving a *pit bull* label is often a near-certain death sentence. Without knowing exactly how to identify pit bulls, the term has become a synonym for *dangerous* and we've been conditioned to fear them. Because of this, pit bulls are the last to be adopted from shelters, and the most euthanized. Around the world, governing entities continue to design and implement laws (called Breed Specific Legislation or BSL) that ban or regulate pit bulls and other dogs, based solely on breed labels and visual identification,

1. The history of and controversy surrounding the pit bull are multilayered, extremely complex subjects, which have been covered by many talented authors. I won't delve into them in this book, but I highly recommend, among other titles, *Pit Bull: The Battle over an American Icon* by Bronwen Dickey (Knopf, 2016). It's one of the most thoroughly researched, well-documented, and balanced books I've read on the subject.

and regardless of the dogs' temperaments. These laws provide a false sense of security to communities, while punishing good dogs and their owners, and they are responsible for the senseless deaths of many innocent dogs.

Our obsession with looks has led us to place breed labels above dogs' individual personalities, which is absurd. For too long, we've been led to believe that breed implies behavior, but a closer look at dogs' genetics teaches us that the reality is far more complex. "Breedism" is superficial and often tied to economic interests that contravene the animals' best interests. And when it comes to pit bulls, it has led to the abuse of millions of dogs.

There's another issue that our relationship with pit bulls brings up—one tied to that second question I'm often asked: *Are pit bulls more dangerous than other dogs?* The short answer is *no*. What is most dangerous is our arrogance towards animals.

Thousands of years ago, we tamed our fear of predators and brought dogs into our homes. With implicit trust, we let them play with our children, sleep in our beds, and share our resources. Over the centuries, we've developed an incredible bond, a codependent relationship. However, we've also designed a tiny behavioral box for these animals, and have demanded that they stay within the limits of what we deem acceptable, or be destroyed. Dogs are to be playful yet obedient, kind with children yet protective and safe at the same time. Dogs are to learn skills that fulfill our needs and advance our interests, but they must remain at the end of a leash.

We have demanded dogs' behavior be predictable— to us—at all times, yet we've expended little effort, until now, to really learn their language. We've placed enormous demands on these animals without fully understanding them. As their creators and guardians, we're profoundly responsible for dogs' actions and wellbeing; however, we assign all the obligations for that behavior to the animals themselves. How can we expect dogs to always make appropriate decisions when navigating the complicated human world?

Decades ago, pit bulls disrupted our carefully constructed box. The media brought the crime of dogfighting into the spotlight and the public relished the gruesome details of this horrific practice. The idea that pit bulls couldn't feel pain and that they enjoyed fighting spread like wildfire. What should have been viewed as the ultimate betrayal of dogs by humans who forced them to fight for their entertainment became the main argument for pit bulls' detractors, who demanded they be destroyed. Most people were afraid of these dogs who'd stepped outside the limits of the acceptable, traitors who'd broken the truce and seemed to enjoy it. Some thought these dogs were splendid animals and revered their determination; others considered them victims or simply misunderstood.

The controversy was born—one that would become the longest-standing dog disagreement in the history of the human–dog bond and would lead to the massacre of millions of presumed pit bulls, who became the most feared, hated, and abused of all companion animals. The "dispute" is complex, with both sides making outlandish claims and setting up the pit bull as a kind of mythological creature—at once a fairy-tale monster or hero.

Wouldn't it be more realistic to consider pit bulls neither beasts nor "nanny dogs," as they are so often referred to; or to accept that the way you raise a dog isn't always the way the dog will turn out? Haven't we witnessed enough how puppies brought up together from the same litter can turn out so differently, and how dogs can learn or unlearn behaviors and change throughout their lives? Pit bulls are just dogs, and dogs, just like us, are individuals. We're all the beautifully multifaceted sums of many intricate factors such as genetics, upbringing, and environment. Pit bulls' individuality should be celebrated. Each of these dogs should be considered for the unique, soulful characters they are and not judged as a group. This is something I wish to achieve with *Pit Bull Flower Power.*

Thankfully, things are looking better for the dogs we call pit bulls and for shelter dogs in general. There's been an admirable pit bull advocacy effort for the past ten years, which has made a huge difference for these dogs. More

recently, a groundbreaking (and wise) movement has encouraged removing breed labels in animal shelters, and it's proven successful in re-homing dogs who might have otherwise been overlooked due to their type. The adoption profiles focus on the dogs' personalities and temperaments, as they should. After all, if dogs are truly our best friends, their personalities should be more important than their looks.

Today we must demand more not from dogs but from ourselves. As we move toward becoming a more humane society, we must accept that dogs cannot always fit that box we've created for them, and that it is up to us to understand their limitations and address their needs. We must improve our treatment of dogs who don't fit our expectations. Our shelters are full of such dogs who present no danger, who are perfectly manageable, but whose looks, age, personality quirks, or particular needs disrupt our dog fantasy and make us uncomfortable. For all these dogs, meaningless destruction should no longer be the expected outcome.

Maybe dogs, in part by way of the pit bull controversy, are challenging us to see past physical appearances, to confront our irrational fears and mystical imaginings, and to shed ourselves of our human presumptuousness.

Fear doesn't have to be a negative force. It can be transcended and become a creative tool to inspire positive change. And if instead of seeking to annihilate others we make the effort to comprehend them—even those who scare us the most—we might finally foster a world safe for us all.

Sophie Gamand
Brooklyn, 2018

THE DOGS

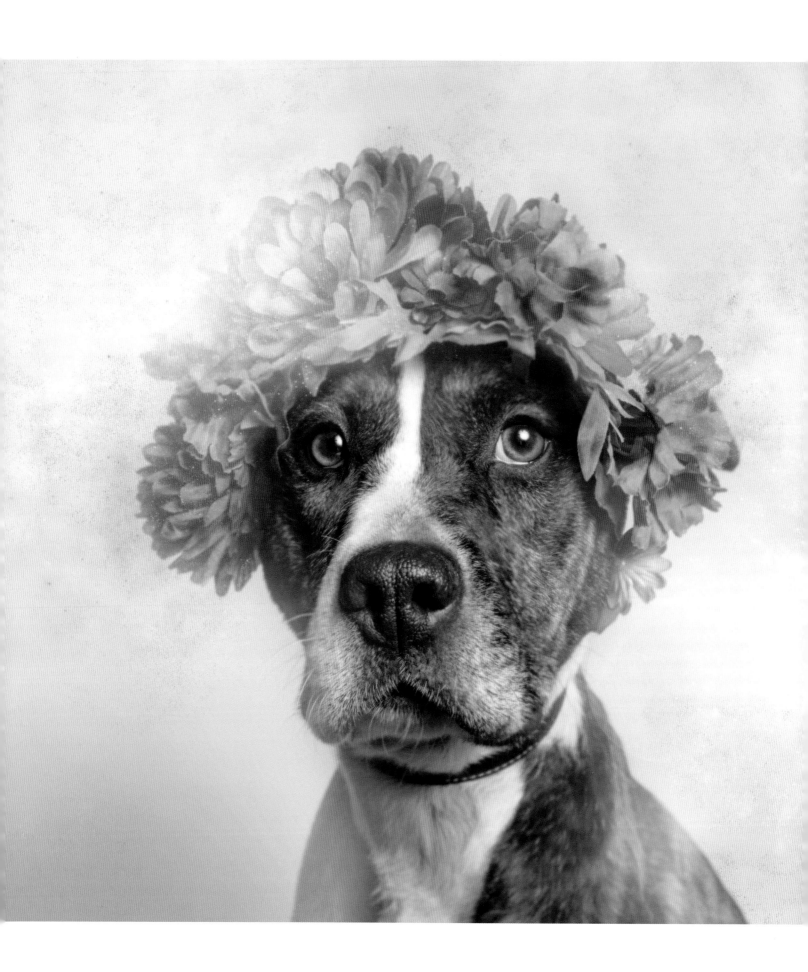

BABY

2014, *Adopted*
Sean Casey Animal Rescue, New York

Pit Bull Flower Power was born with Baby. My very first flower model, she gave me the most incredible gift: she allowed me to crown her. Until I wrapped my hands around her face to tie the very first crown, *Pit Bull Flower Power* was only an abstract, slightly crazy idea. My flower crowns were just flimsy, gimmicky props. After Baby, everything changed. Her dignity, her pride, and her patience with the process showed me that not only was this project doable and exciting, it was also indispensable for these dogs. Baby was kind, worried yet trusting. She was a queen who had been invisible at the shelter for months.

What we know of Baby's story begins in the Rockaways in 2010. On this sandbar near New York City, Baby was found in a dumpster. Later brought to Sean Casey Animal Rescue, she waited about a year before getting adopted in 2011. Everyone believed she had found her forever family. Sadly, in June 2014, Baby ended up at the New York City shelter. Thanks to her microchip, which was still registered with the rescue, she returned to Sean Casey's dedicated team. Nobody knows what happened to her between 2011 and 2014, and by then Rockaway Baby, as the rescue nicknamed her, was estimated to be about seven years old, making her a senior in the world of rescue. Senior, dark-colored pit bulls tend to languish in shelters longer than other dogs, but considering her stunning looks and easy temperament, the Sean Casey team imagined she would swiftly find a home. Unfortunately, even in a smaller shelter, Baby was constantly overlooked because of her age, color, and type.

While Baby was readjusting to life in a shelter, I was preparing for my first-ever *Pit Bull Flower Power* photo shoot. My friend Samantha volunteered at Sean Casey Animal Rescue. She mentioned the shelter might be open to a shoot and got the ball rolling. I didn't know how to make a flower crown, and had never even used a glue gun before. I put together a few humble crowns and on July 17, 2014, packed them in a suitcase and headed to the shelter. When I arrived, I was quite unsure. Was this the place? I found myself on a deserted street, facing a garage with the metal curtain rolled up. A couple of people were hanging out in front, so I asked them, "Is this Sean Casey's rescue?" Ally, a firecracker of a girl with a stunning smile who looked like she knew how to get things done, greeted me. "Where do you want to set up?" she asked. We proceeded to organize a makeshift photo studio, pushing around towers of boxes containing a variety of dog food, toys, and leashes. It was tight, but we made it work.

Ally gathered a couple of guys who were working that day, announcing we would be doing a photo shoot. I unzipped my suitcase to reveal my flower crowns. *Ta-da!* I tried to sound more confident than I felt when I declared, "I would like to put these on your pit bulls." The tough-looking, scoffing guys stared at me in disbelief. They clearly had no time for or interest in the shenanigans of a girl and her flower crowns. Ally asked, "Who do you want us to bring out first?" There is always an excitement at the beginning of a shoot, but on that day I was also nervous. Were the crowns even going to work out? There was only one way to know. "Why don't you bring out the easiest dog you have?" Ally said she had the perfect candidate. She opened the door leading to the dark kennels and it shut behind her. Silence. A couple of minutes later, the door opened on an unbearable cacophony: a mixture of excited, angry, pleading, frustrated barks, and whines. Ally brought Baby to the light.

I imagined Baby's experience, being pulled out of the dark, loud, uncomfortable kennel onto a set, all the gear pointed at her. *Now, sit.* In that moment, both Baby and I were absolutely unsure. I grabbed a crown, which I thought would complement her eye color nicely, and crawled toward her. She looked around suspiciously. As I approached her, whispering words of encouragement (were they for her or for myself?), my heart started beating out of my chest. My hands began to sweat profusely, and my throat tightened. I know some of that response was the delight of creation. We were about to dare something exciting. But more than that, I was scared of Baby. I thought to myself, *Well, this is the dumbest idea you have ever had. You are about to lose your face or hands, right about now.* I can't imagine what Baby was thinking, seeing me clumsily approach with a weird thing in my hands, probably sensing my apprehension.

Yet she let me crown her. I wrapped the crown around her head, scooched back, and clutched my camera. I looked back at Baby, fully expecting to find the crown on the ground and Baby snacking on the flowers. To my surprise, I was met by a sight the memory of which gives me goose bumps to this day. Baby was sitting still, her crown in position on her head. She was dignified and glorious. There was a hint of nervousness in her face, but she was trying to be brave, just like me. I clicked my camera and within five shots I had the portrait that would kick-start the *Pit Bull Flower Power* series.

We spent the following hours photographing twenty-seven dogs, a few with flower crowns. Samantha and Ally were incredible assets in this endeavor, helping me achieve my vision. This wasn't a small feat. On a shelter shoot, the dogs come with their own personalities and idiosyncrasies. The rambunctious ones are physically exhausting and the worried ones are psychologically draining. Add a flower crown to that combination and you're in for a challenging photo shoot.

After the shoot, we released the photos online and pure frenzy ensued. The shelter reported people coming in just to meet "the flower dogs." Millions of people saw Baby's portrait on social media. But she had to wait a few more months until another shelter-dog advocate, my friend Erin of Susie's Senior Dogs, featured her. Erin has created a very successful platform for senior dogs in shelters, and she is helping countless seniors get adopted throughout the country. As soon as Erin featured Baby, she caught the eye of Laura and Jordan. They immediately went to Sean Casey's shelter. Laura wrote to me: "Baby was curled up in a ball on her cot, in her little cell, and looked sadly at us, almost as if saying, *These folks will pass me up, too.* We walked seven dogs that day over four hours. The shelter was about to close and we were preparing to leave when they asked if there was anyone else we wanted to see. I said that we'd come to see Baby, but she was sleeping and didn't come to the gate. 'No problem!' they said, and out popped Baby. She stretched and rubbed her backside against Jordan's leg and that was that.

"Beebe is now a spoiled brat who will spit out hard biscuits, will sigh loudly when she wants to go to sleep on your side of the bed, and will drag you down the block upon seeing cats or squirrels. If she accidentally nips your finger or paws your face during wrestling, she'll lick your face to make you feel better. I do see the looks from others when they see her (*Oh no! Cross the street: a pit bull!*), but unless you're a walking chicken with a beef roll in your pocket, she wants nothing to do with you."

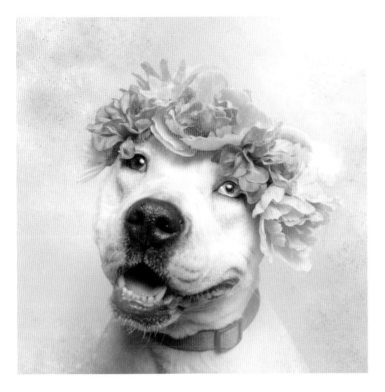

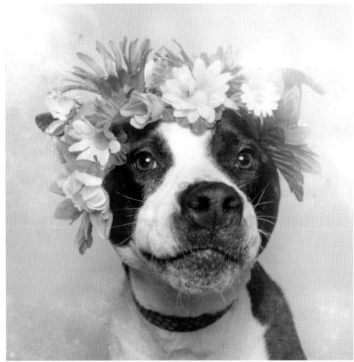

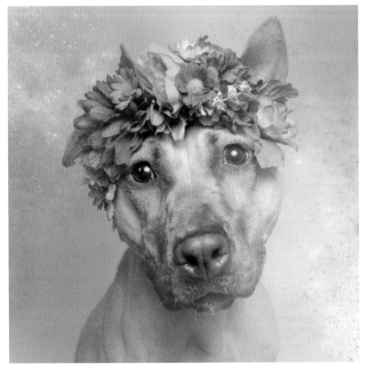

Cali, 2014
Adopted
Sean Casey Animal Rescue, New York

Regina, 2014
Adopted
Sean Casey Animal Rescue, New York

JellyBean, 2014
Adopted
Sean Casey Animal Rescue, New York

Erica, 2014
Adopted
Sean Casey Animal Rescue, New York

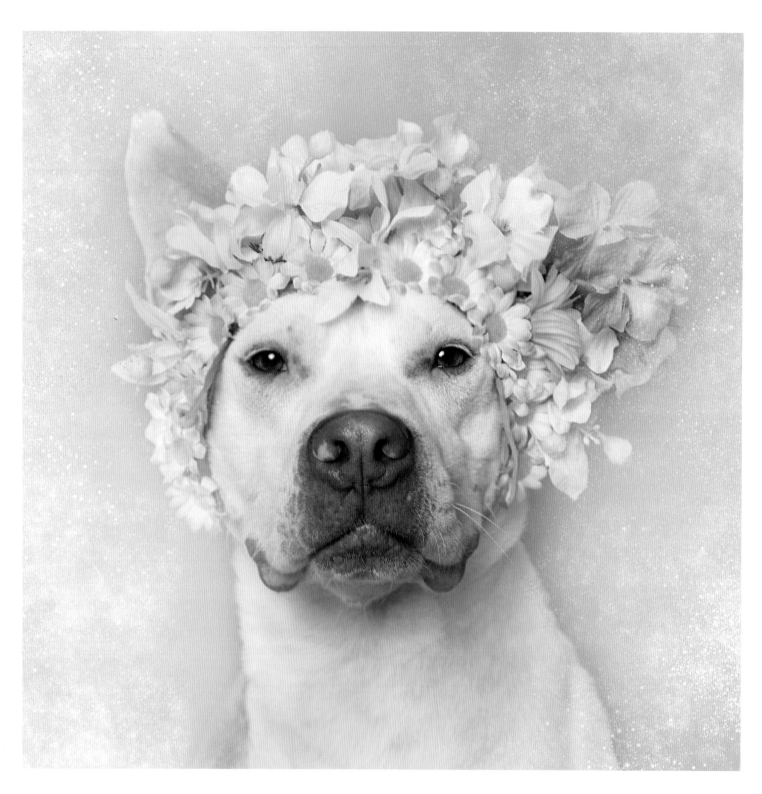

Brewster, 2014
Adopted
Town of Brookhaven Animal Shelter, New York

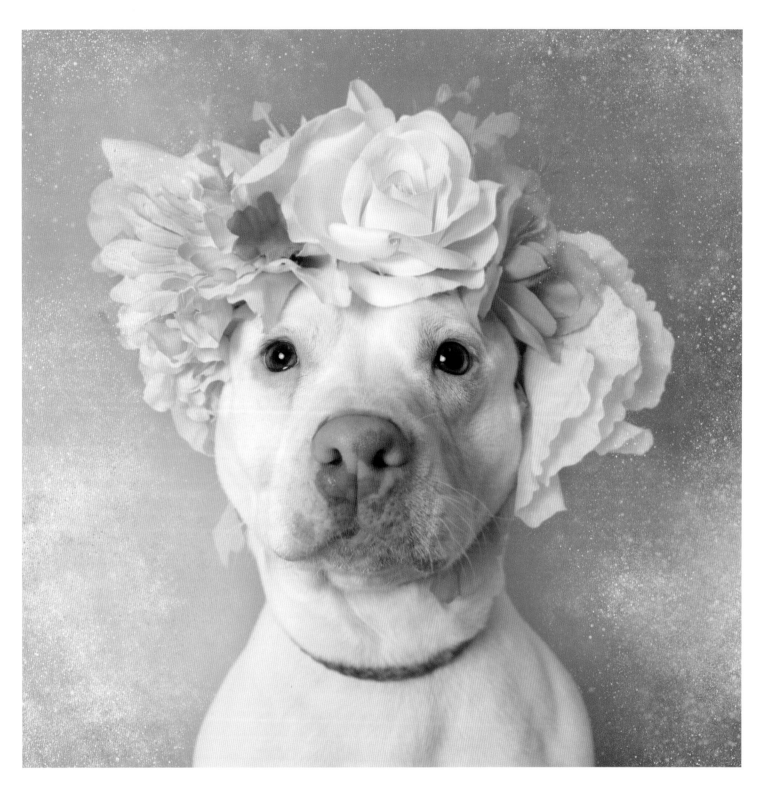

Mami, 2014
Adopted
Town of Brookhaven Animal Shelter, New York

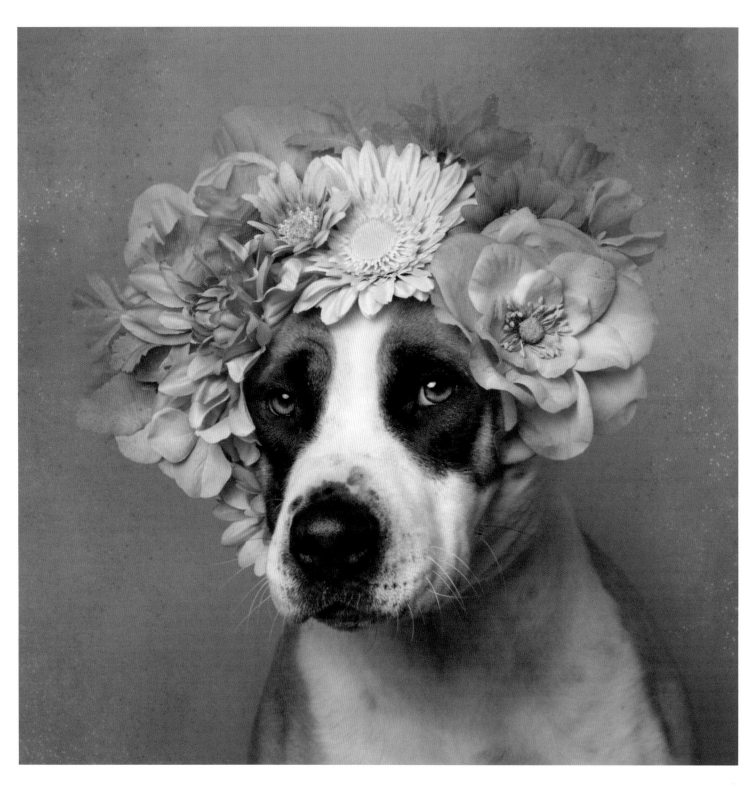

Adrienne, 2015
Adopted
Town of Hempstead Animal Shelter, New York

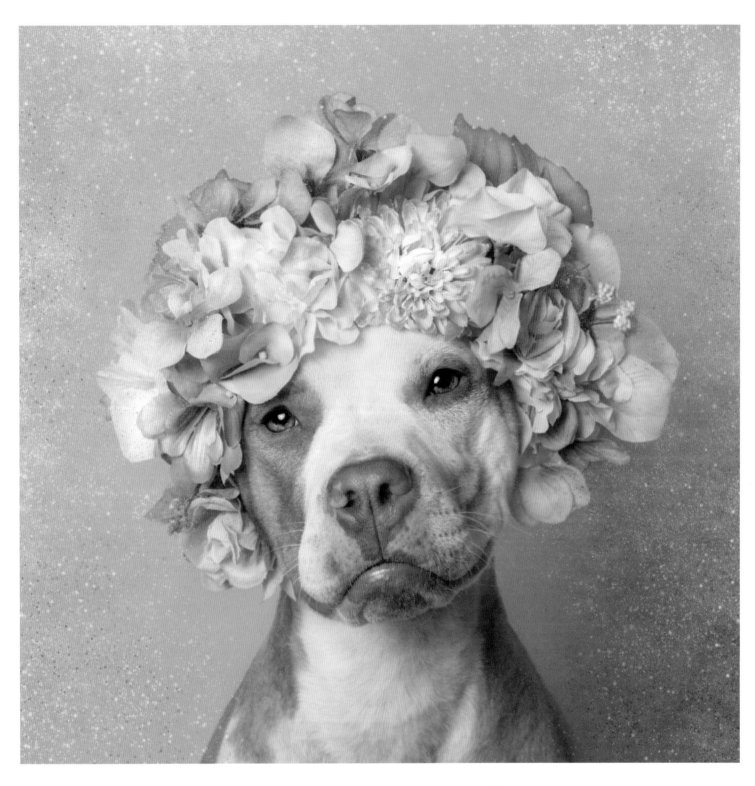

Lola, 2015
Adopted
Rebound Hounds, New York

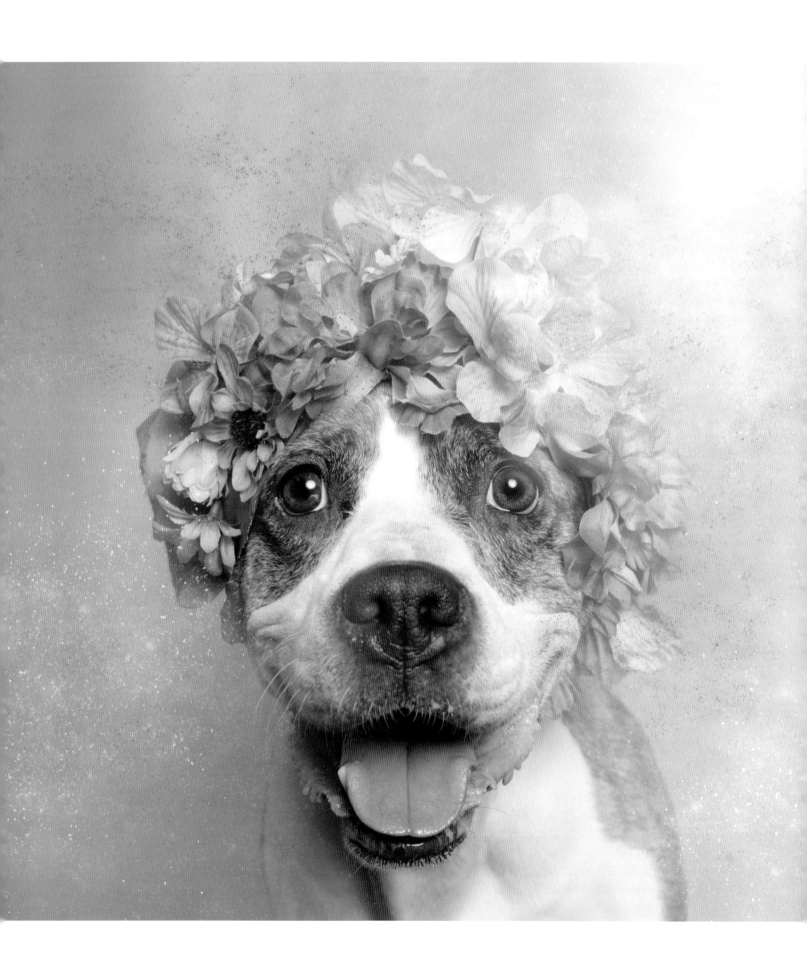

LUCY

2014, *Adopted*
Animal Haven, New York

Animal Haven is a shelter in the SoHo neighborhood of Manhattan. I often refer to it as my second home. In 2013, after I'd been volunteering with rescues for a couple of years, I decided to start setting up my studio in physical shelters rather than working with foster homes, one dog at a time. At a shelter I'd be able to work with more dogs in one sitting, which felt like a more efficient way to help.

After a few rejections by local shelters, I reached out to Animal Haven in October 2013. The executive director, Tiffany, expressed interest and we set up our first date. I was terrified. I'd just started doing studio photography and barely knew how to use a studio light. In all my previous photography projects involving dogs, I'd worked like a fly on the wall, capturing what was happening around me without interfering. This was very different. I would need to get dogs to cooperate. The truth was, I had never walked a dog on a leash in my life, and I certainly didn't know how to make them sit.

I packed my camera and a portable flash and headed to Animal Haven. I dragged the heavy equipment in a suitcase through the deafening subways into the busy, smelly streets of Chinatown, dodging aggressive cabdrivers and cyclists, and arrived, sweaty, at the shelter. I was led upstairs via a tight staircase into a spacious training room. Mantat, director of operations, was tasked with helping me.

Mantat has a quiet strength and is spectacular with pretty much any type of dog, especially the most rambunctious ones. He is a witty, guinea pig–fearing (he worries he might crush their tiny bones), wonderful partner in crime. He's been an incredible asset in my *Pit Bull Flower Power* adventures, alongside the many other staff and volunteers from Animal Haven who've

helped me crown their dogs. Mantat often finds a way to make even the most reluctant dogs cooperate with the crowns, and he takes this project as seriously as I do.

After our very first shoot at Animal Haven and months before I started the *Pit Bull Flower Power* series, I received an encouraging note from Tiffany. The photos had been a hit with Animal Haven's staff and followers, and I had an open invitation to come back. This was the start of a long-lasting relationship that means the world to me. I've watched Animal Haven grow and expand, and thanks to the staff and volunteers and their openness to my process I've been able to explore and mature as well, finding my focus as a shelter photographer and developing my visual language. Over the years, I've conducted about thirty photo shoots at Animal Haven.

Lucy was among my very first *Pit Bull Flower Power* models, in the summer of 2014. She'd arrived at Animal Haven with ambulatory paraparesis of her hind legs after having been abandoned at a medical center. When I photographed Lucy, she couldn't walk without the support of a sling, but thankfully, after surgery she started walking on her own again. When I heard that Mantat had adopted her months later, I was very excited. Mantat had been working at the shelter for about ten years, and I figured there must have been quite a powerful connection between the man and the dog for him to settle on her. What transpired in Lucy and Mantat's story reminded me that sometimes it's not about whom you fall in love with, but rather whom you are meant to be there for.

Mantat has witnessed firsthand, many times over, perfect pit bulls being overlooked by adopters who preferred puppies or purebreds. "It tore me up inside

that the pit bulls that I took care of as if they were my family were being overlooked," he wrote to me. "It made me want to adopt one even more." With years of experience handling larger, energetic dogs, and a particular talent for it, Mantat was ready to take on pretty much any type of pit bull as long as the dog got along with his then two-year-old daughter and his wife.

The whole family came to Animal Haven to meet a few dogs to see which resident might be a good fit, including a couple of pit bull moms whose puppies had all been adopted, and who'd been waiting a while, but who didn't seem interested in the family. And there was Lucy, a six- to ten-year-old dog who, Mantat recalls, "lunged at other dogs, made some unholy messes in her kennel, and apparently had a bite history with one of our volunteers. So here was Lucy meeting my family. Sure enough, she checked the room around and paid attention to us. She was gentle, licked my daughter, and got my wife to pet her. They fell in love with her, which surprised me, as she was the oldest of the three dogs we'd met. My wife and I decided to rename her Libby." Libby went home with her new family and it took less than a day for her to adjust and to learn the rules. Even though sometimes Libby had trouble distinguishing her toys from Mantat's daughter's toys, it was never a big issue, and the toddler knew how to interact safely with dogs. "Occasionally, I'd walk by and see her hugging Libby, or feeding her table scraps, or letting Libby lick her in her mouth. In. Her. Mouth. So gross."

Unfortunately, a few months later, Libby started coughing and despite treatment it escalated. Mantat suspected she was having seizures, and after a series of exams and X-rays, the vet found a tumor the size of Libby's heart pressed up against her lungs. "I felt devastated, defeated," he said. "One day, she was having so many seizures I had to rush her in [to the vet]. On our way there, she had two more seizures in the car. They took her in and stabilized her, which felt like it took forever. They told me she could come in for weekly treatments but then said it wouldn't be unreasonable to consider euthanasia. At the vet's there were dogs everywhere. She hated other dogs. She hated car rides. I didn't think I could subject her to all that.

"We'd just had Thanksgiving and my wife had slipped her some turkey, even though she wasn't supposed to. She'd played with my daughter and friends of ours who had come over. Those were the kind of memories I wanted her to have if she were to go, not of being agitated by everything around her. I opted for euthanasia right there and then. My wife and daughter didn't get to say goodbye. It was just me. I thought that was what was best for her."

I asked Mantat what Libby was like and what she liked most: "It's hard to say because she seemed pretty content most of the time. She liked to lie on the right side of the couch. I've spent many nights going over work emails with her next to me. Sometimes she'd fart in her sleep and wake herself up, but she'd just go back to sleep. She liked to follow me around if she wasn't napping. I took her camping once, figured she'd enjoy nature, eat some campfire goods. I was wrong! She hated camping, wanted to stay in the tent all day. We did go on a short hike. I am not sure she enjoyed that, but she sure enjoyed lying on the grass afterwards."

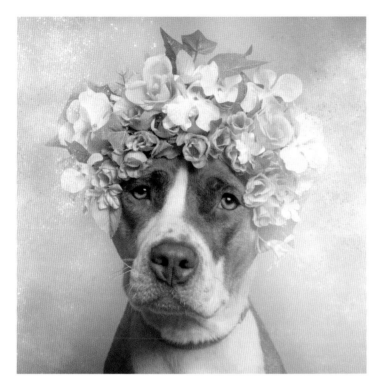

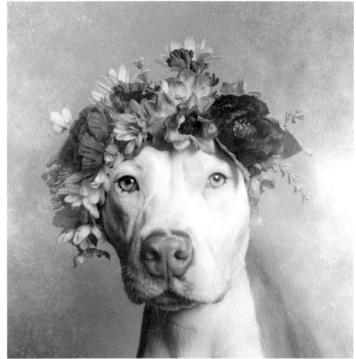

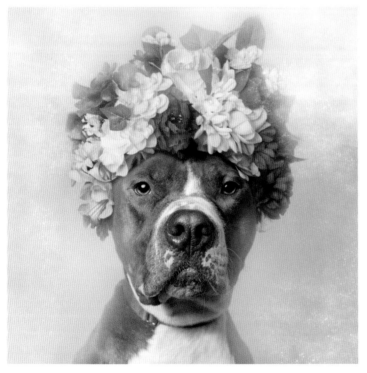

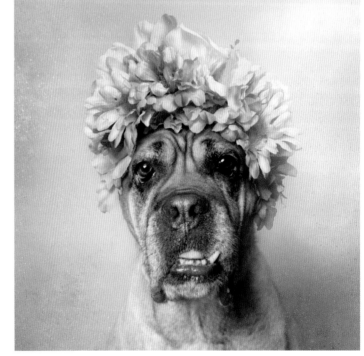

Europa, 2014
Adopted
Animal Haven, New York

Mr. Fantastic, 2014
Adopted
Animal Haven, New York

Dharma, 2014
Adopted
Animal Haven, New York

Zena, 2014
Adopted, deceased
Animal Haven, New York

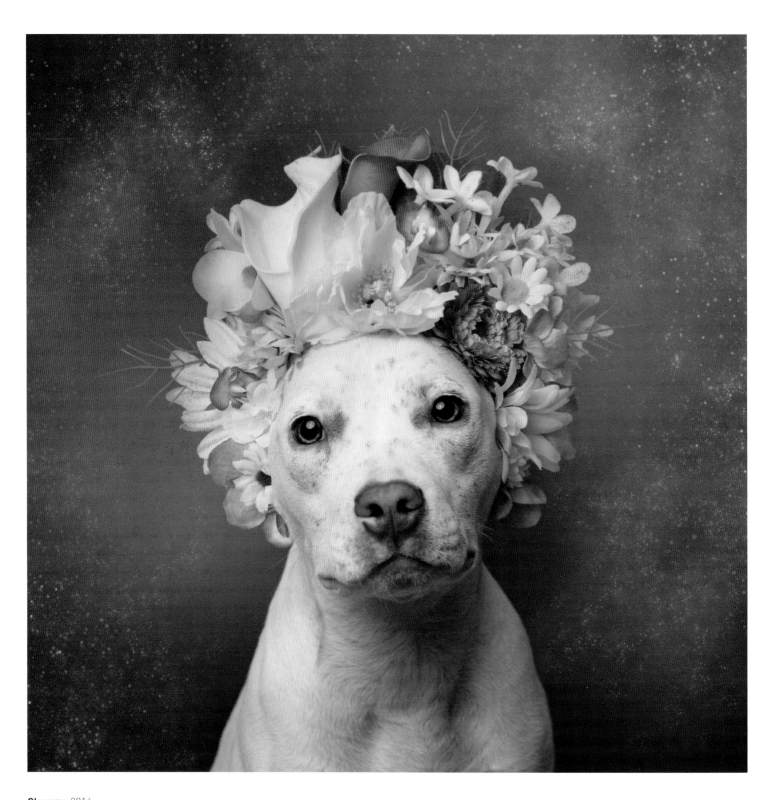

Clooney, 2016
Adopted
Mr. Bones & Co., New York

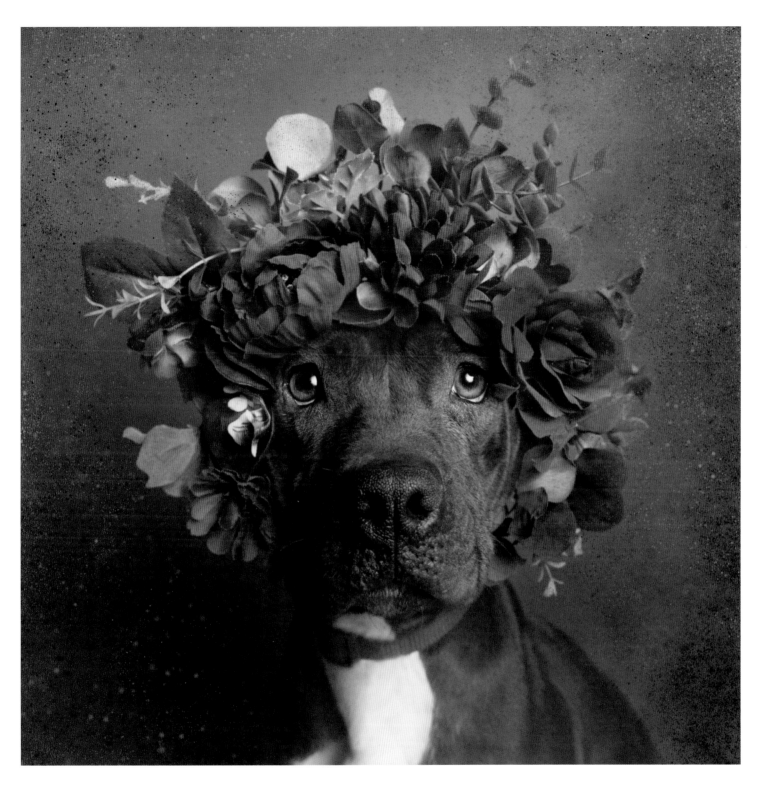

Aria, 2015
Adopted
Sean Casey Animal Rescue, New York

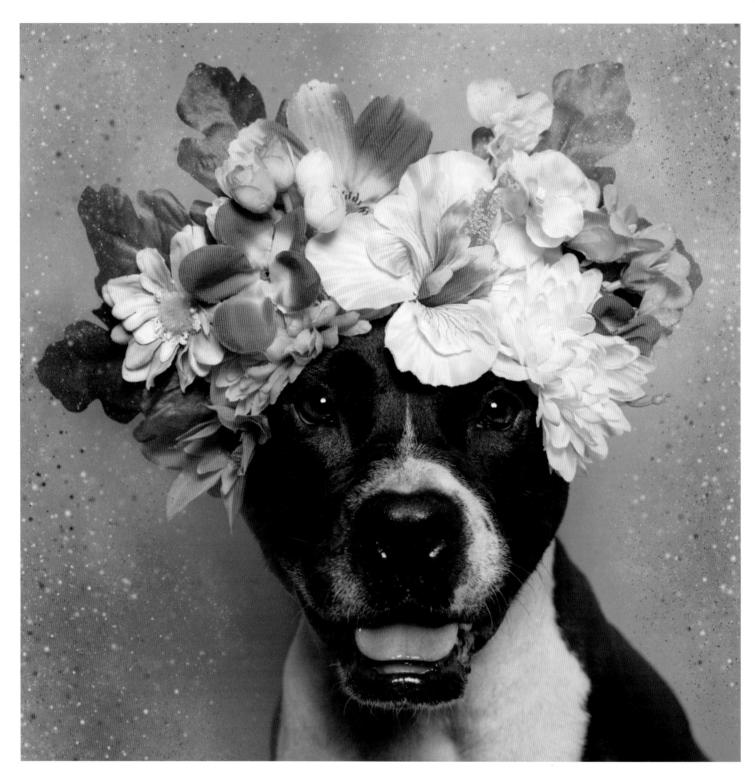

Kato, 2015
Adopted
Animal Haven, New York

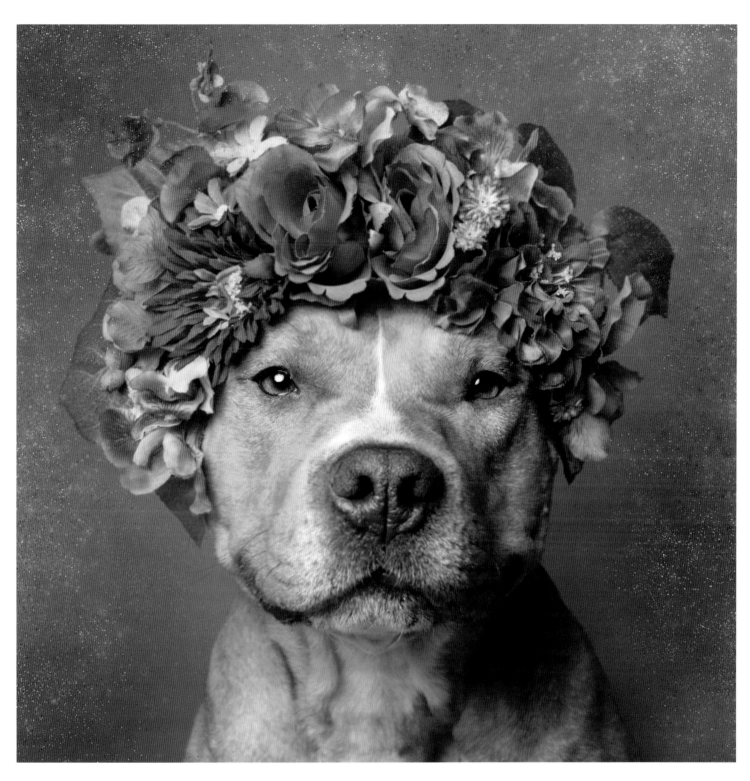

Jimmy Dean, 2015
Adopted
Motley Mutts Pet Rescue, New York

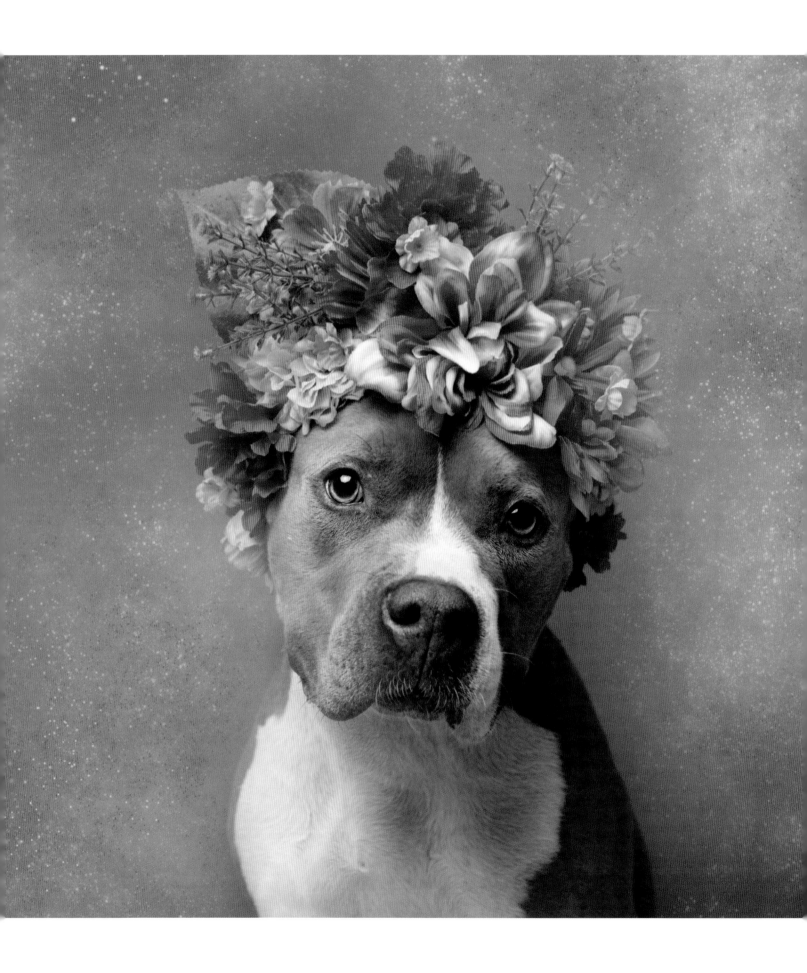

ALIZE

2016, *Adopted*
Monmouth County SPCA, New Jersey

After losing her beloved Labrador Retriever, retired parole officer Sandy started volunteering at the shelter. At first, she was afraid of pit bulls and it's no surprise. In her previous job, all encounters with pit bulls and their owners had been negative, if not downright scary. But soon, Sandy had warmed up to the gentle nature of these dogs, and it took one walk with Stanford, a dogfighting rescue, to win her over entirely. "He was unbelievably sweet," she remembers. "Now I just adore them. They are funny, loving, so engaging, and so misunderstood."

There was one pit bull at the shelter whom Sandy hadn't walked yet and was apprehensive about: Alize. Alize had arrived some months prior, emaciated and covered in sores. The staff imagined she'd been living outside for a while. She was terribly reactive to other dogs, which made her stay at the shelter excruciating and a foster home impossible to find. She would have meltdowns, bark, whine, and drool. The staff moved her around the building, trying to find a space for her to remain happy and calm, but her contentedness would only last a few weeks at a time. Despite being so challenging, Alize became the office dog and a favorite at the shelter. During their "Kiss-a-Pit" challenge, everyone, from staff to volunteers to animal control officers, submitted a photo of themselves kissing Alize.

Alize and Sandy's story merged three years later. Sandy was taking some of the shelter residents (her "dog friends," as she calls them) for overnight stays at her place to give them a reprieve from bustling shelter life. She figured Alize could use the special treatment, and took her for a walk. Sandy worried Alize would be too much to handle because she couldn't be near other dogs, but after a couple more walks, Alize started recognizing Sandy and would become excited when she approached her gate. "She would give me kisses and was so sweet," Sandy remembers. "That started the love affair with her." Sandy took Alize home for the first time just for an afternoon. Once outside of the shelter, Alize transformed and proved to be a perfect guest: polite, housetrained, quiet, and affectionate—nothing like how she had been at the shelter. "She crawled on the sofa and fell asleep immediately. And she remained sound asleep for about three-and-a-half hours. It made me realize how stressed she was at the shelter, and how sweet she really was. Later, I took her home for a weekend and she was beautifully behaved."

By the summer of that year, which is when I visited the shelter and crowned her with flowers, Alize had been waiting for a family for over four years, but had become a regular at Sandy's house. Alize had fallen madly in love with Sandy's husband. It became more and more painful to bring her back to the shelter. She hated that place, but at Sandy's, she was an angel. The couple decided to foster her full time.

They knew it would be hard to find Alize a home, and they'd grown very attached to her. Six months later, they officially adopted her. "Alize is obsessed with my husband," Sandy writes. "Normally, she sleeps next to him with her head on his pillow, the two of them nose to nose. But earlier this week I had surgery and I have to sleep in an armchair in the living room and she has not left my side. She stays with me all night until I get up in the morning. Isn't that amazing? She is an incredible dog and we just love her."

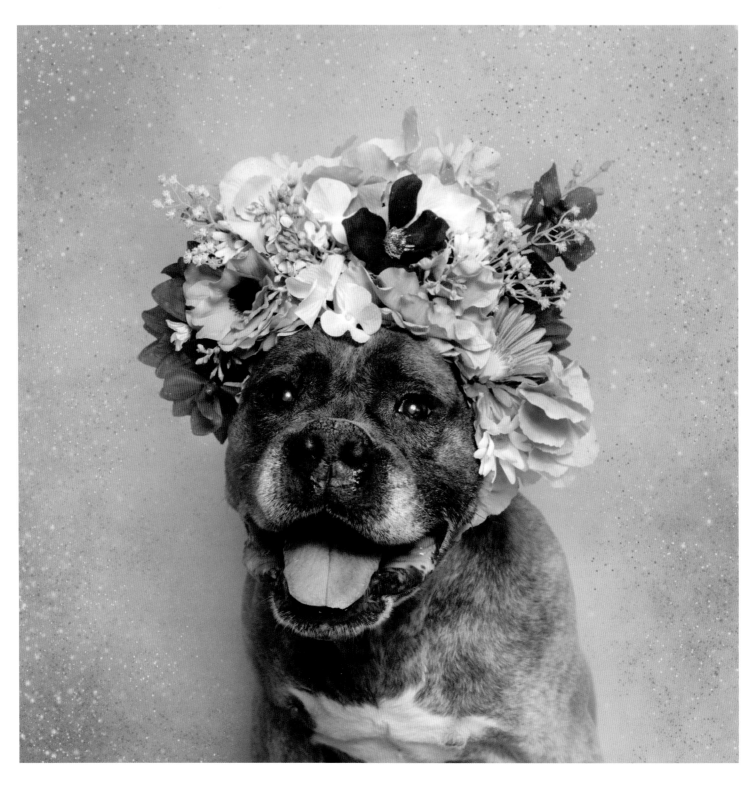

Rumple, 2017
Still waiting
Animal Haven, New York

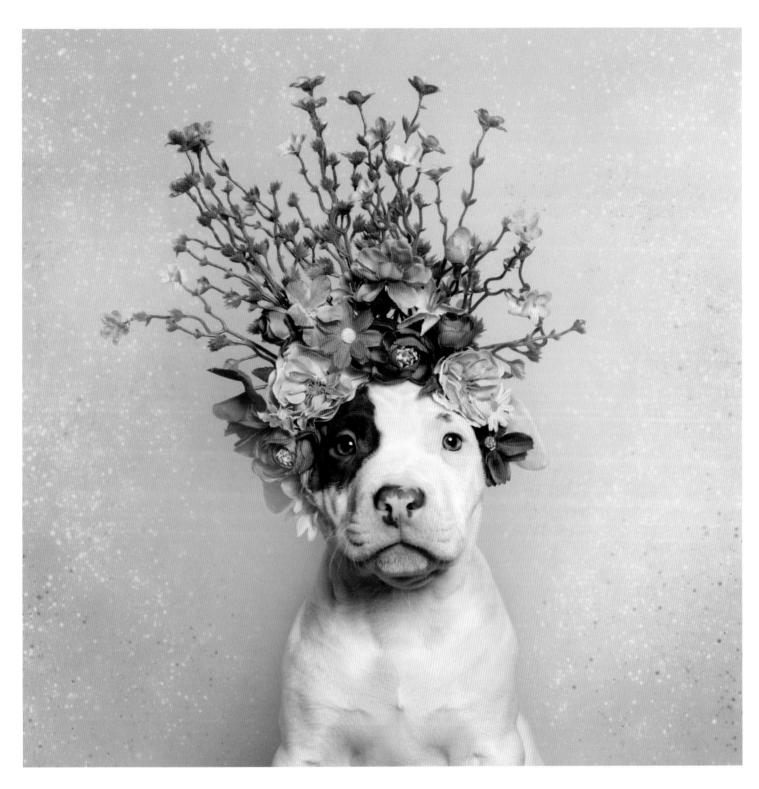

Rum, 2017
Adopted
Luvable Dog Rescue, Oregon

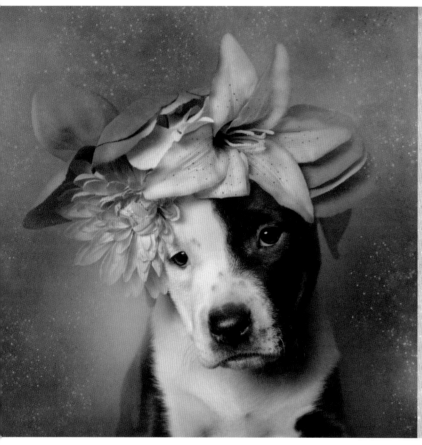

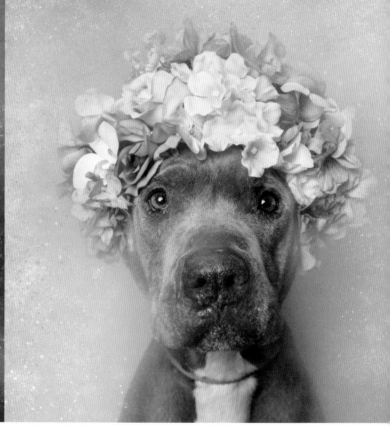

Henry, 2015
Adopted
Redemption Rescues, New York

King, 2015
Adopted, deceased
Animal Haven, New York

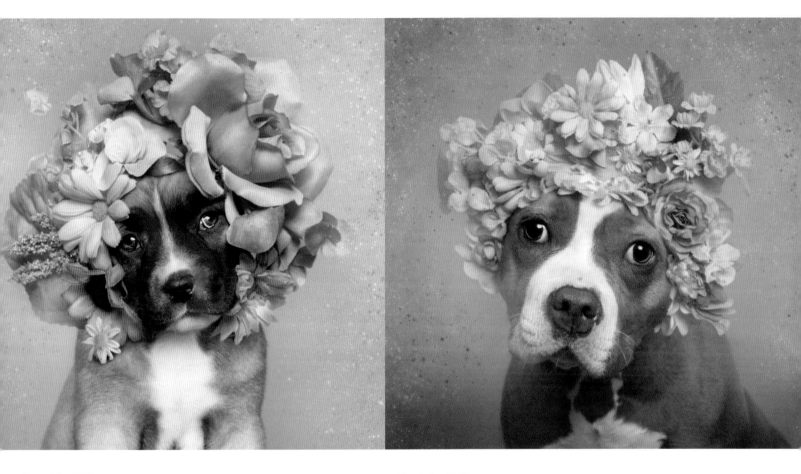

Peatricia, 2015
Adopted
Animal Haven, New York

Charlotte, 2015
Adopted
Town of Hempstead Animal Shelter, New York

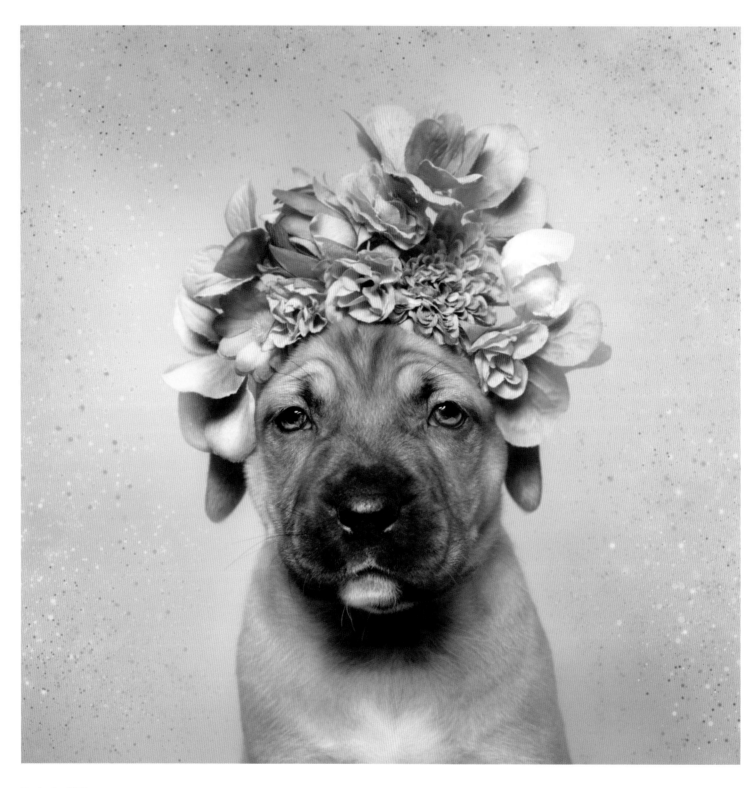

Peab**ody**, 2015
Adopted
Animal Haven, New York

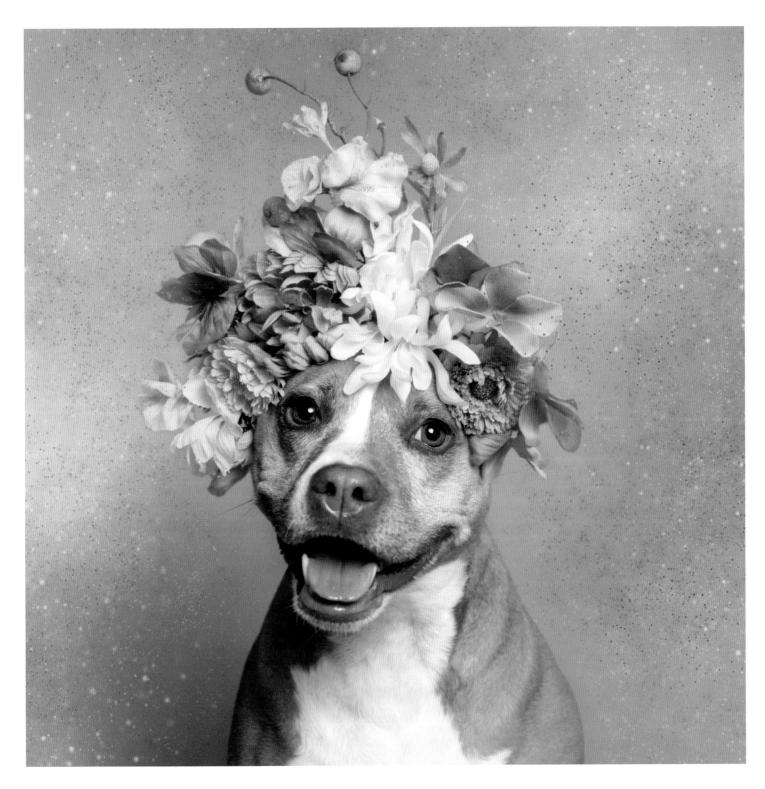

Pearl, 2016
Adopted, deceased
Warwick Valley Humane Society, New York

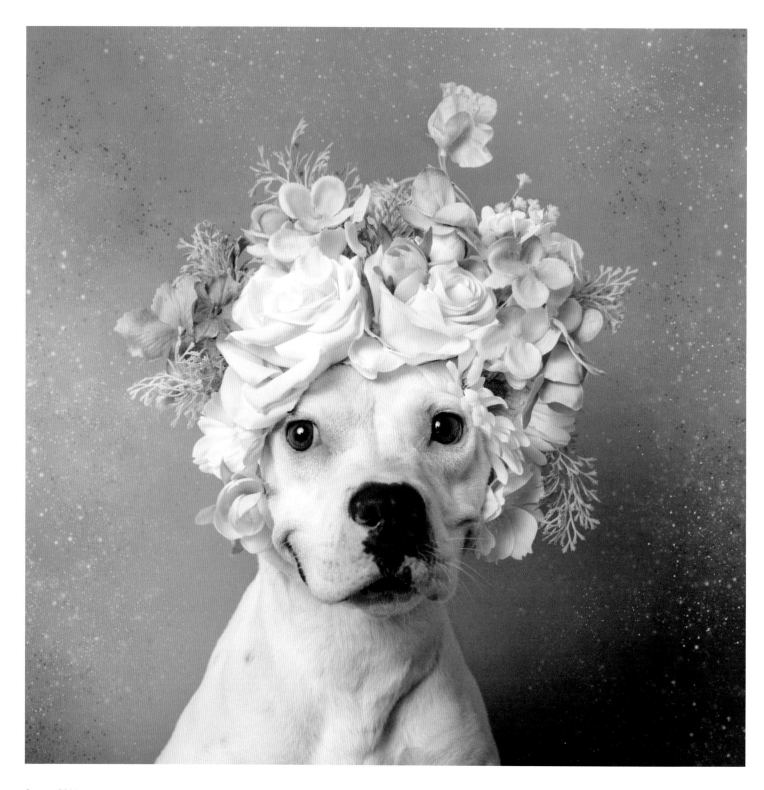

Sassy, 2016
Still waiting
Calhoun County Humane Society, Alabama

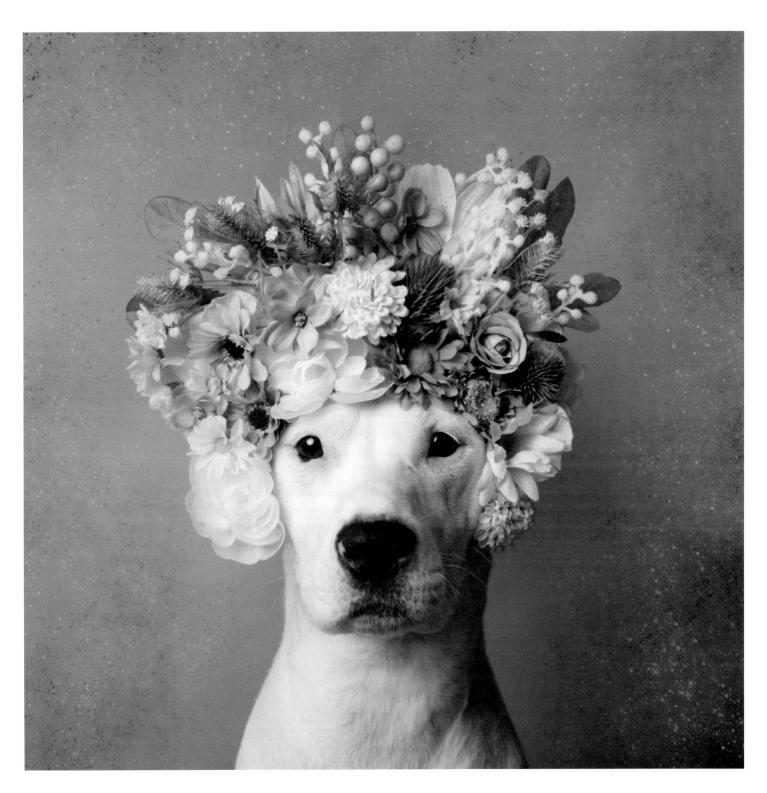

Wiggles, 2016
Adopted
Animal Haven, New York

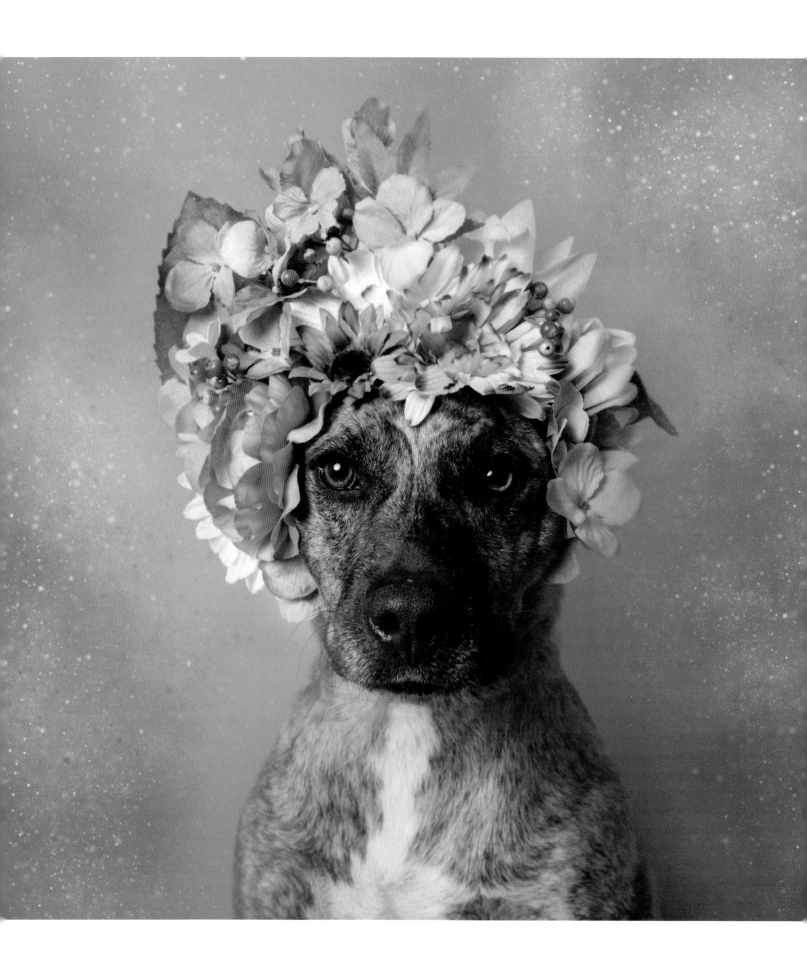

BECKER

2016, *Adopted*
Calhoun County Humane Society, Alabama
Animal Haven, New York

In the summer of 2016 I traveled to Alabama with my friend Erin of Susie's Senior Dogs. Erin had featured dogs from the Calhoun County Humane Society before and thought they could use some good photos and added exposure. It was my first time in Alabama, and although I mainly saw the airport, the hotel, the shelter, and the view from our car, it left a lasting impression on me.

I remember our drive through a plethora of abandoned, derelict houses—remnants of forsaken dreams and the many ghosts driven away by changed economic times. Seeing these beautiful homes falling apart broke my heart and left a deep pit in my stomach. Finally, at the end of a road, protected by a large fence and surrounded by thick flora, was the Calhoun County Humane Society.

This rural shelter is located in Anniston, which is considered one of the most violent cities in the United States, based on FBI statistics. Add to that a widespread culture of dogfighting in the region and you have a pretty good idea of what the shelter is up against. Several local shelters have reported break-ins, stolen dogs, particularly pit bulls, and even fights organized within their property at night. These shelters are reluctant to promote some of their pit bulls for fear the wrong people will adopt them.

A small but valiant team of volunteers runs the Calhoun shelter. It is often on the verge of bankruptcy, but no one there will turn their back on a pet in need. The shelter operates on a shoestring budget in an outdated facility that can't even house half of the shelter's population. Many dogs live outside the main building in outdoor runs covered in tarps. What started as a temporary setup to accommodate the overflow of dogs has become a permanent fixture, a way to save as many lives as possible. The shelter director refuses to euthanize for space.

If you think running a shelter is a difficult and challenging task, you've seen nothing until you spend time at an isolated, rural shelter. Saving animals is a Sisyphean task, but at least in high-turnover shelters your reward is to see animals rescued or adopted out. In isolated shelters like Calhoun, where there are few to no adopters in sight, your animals can wait for two, five, seven years, even a lifetime. How do you possibly push forward when there is no goalpost in sight? How do you continue this heartbreaking, stressful mission when you feel invisible and left behind?

I don't think Erin and I had realized what our visit truly meant for the shelter team. There wasn't a dry eye in the room when we gathered at the end of the shoot and received the staff members' gratitude. "Thank you for seeing us," they said.

The photos and exposure would mean nothing, though, if the shelter wasn't prepared to make the best of the effort. And ready it was. Through the years, the staff realized that welcoming out-of-state adoptions or sending dogs away was often their best chance. The shelter has since developed great partnerships—some as far away as Canada. Adopters sometimes take long, strenuous drives to meet the shelter's animals based on a few profile photos and extensive phone conversations with the staff.

I knew my portraits could be instrumental in translating the personality and charisma of the dogs. Two years after our visit to the shelter, thirty-seven of the dogs we photographed, including many longtimers, have found homes.

One of these lucky dogs was Becker. A gorgeous, light brindle boy with big, round orange eyes and a quirky smile, Becker had been waiting at the shelter since March 2013. At four years old, he'd spent nearly his entire life in a kennel. Erin reached out to Animal Haven in New York City to see if the facility might partner with the Calhoun shelter and take some of its longtime residents. Animal Haven immediately agreed. Becker traveled to the Big Apple in April 2017. At that point he'd spent four years at the Alabama shelter, and everyone hoped his chances would increase in Gotham.

Becker arrived in New York the morning of April 14, and by four o'clock the same day he'd been adopted. Animal Haven shared an adorable photo of him resting in a soft bed, a toy next to him: the first comfortable sleep he'd probably had in his whole life. Mitali, his adopter, recalls she'd been trying to adopt for a while, and had put in about sixteen applications in various shelters, which kept being passed up. After a rough day at work, she decided to go meet dogs at Animal Haven. Becker had just arrived.

"From the moment he entered the playroom I couldn't stop smiling," she wrote to me. "I fell in love with him. I asked him if he'd like to come home with me, and he just flashed the biggest Becker smile. There was no way I could leave him behind." Becker, now named Bruno, is an incredible ball of energy. His tail has not stopped wagging since that day—to the point where he even wags his tail while getting his vaccines at the vet. But he's also very gentle with Mitali's five-month-old niece and instantly befriends people. "Bruno is a blessing to my life and puts a smile on the face of anyone he meets," Mitali continued. "He is also a very silly boy and loves to 'drive-by kiss' people—even when we're on runs. People often ask us how old he is and are surprised to know he's about six, since we're pretty sure he thinks he's about one. He is so vibrant, so loving and trusting, and so full of life, it's hard to believe he spent all those years in a shelter."

Back in Alabama, Shelly, the director of the shelter, explained that since our visit she had started incorporating more enrichment into the dogs' daily care and doing even more rescue outreach. The staff recognized that many of their dogs had been mislabeled when it came to their personality and relationship to other animals. Shelly also noted, "Your and Erin's visit made us realize we were not the only ones who loved our pitties. Our shelter is finally becoming a better place for our dogs and it started with your visit."

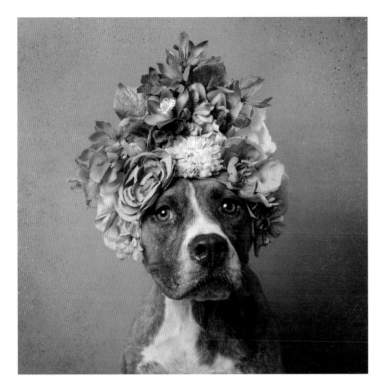
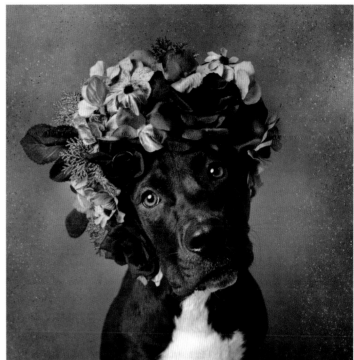
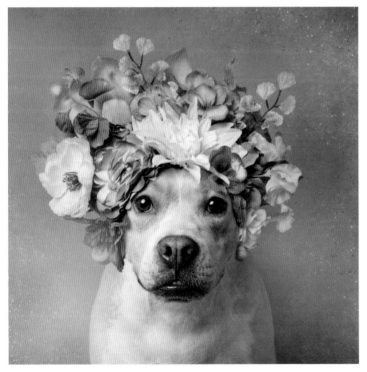
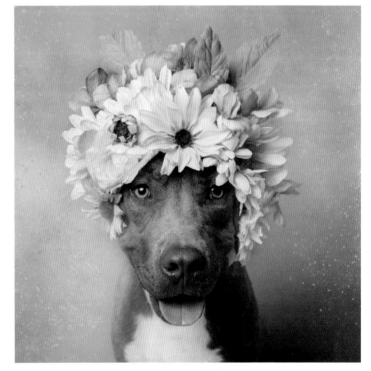

Tibble, 2016
Still waiting
Calhoun County Humane Society, Alabama
Animal Haven, New York

Sweet Pea, 2016
Still waiting
Calhoun County Humane Society, Alabama

Selena, 2016
Adopted
Calhoun County Humane Society, Alabama

Omar, 2016
Still waiting
Calhoun County Humane Society, Alabama

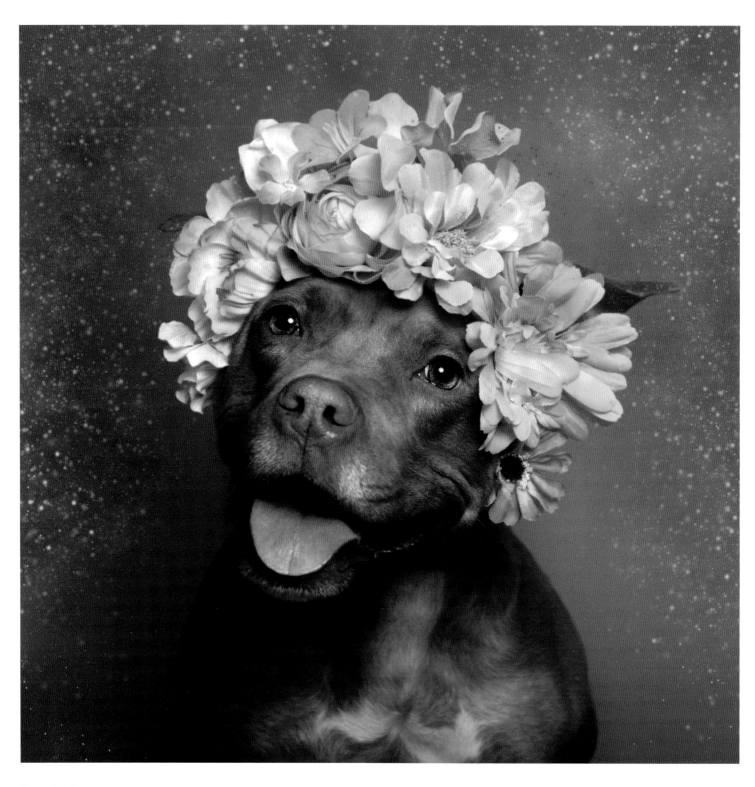

Topaz, 2015
Adopted
Town of Hempstead Animal Shelter, New York

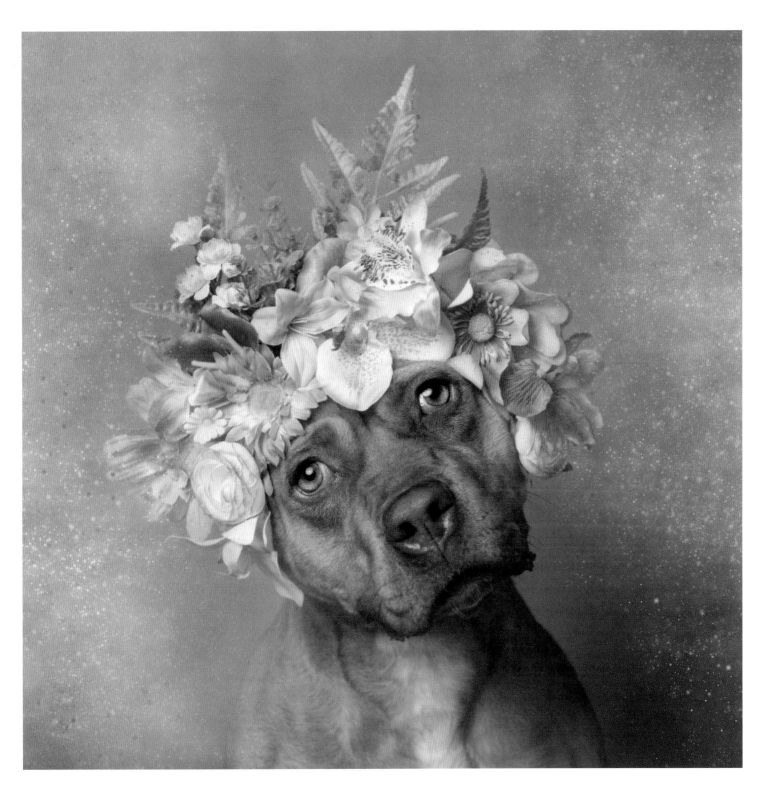

Thelma, 2015
Adopted
Town of Hempstead Animal Shelter, New York

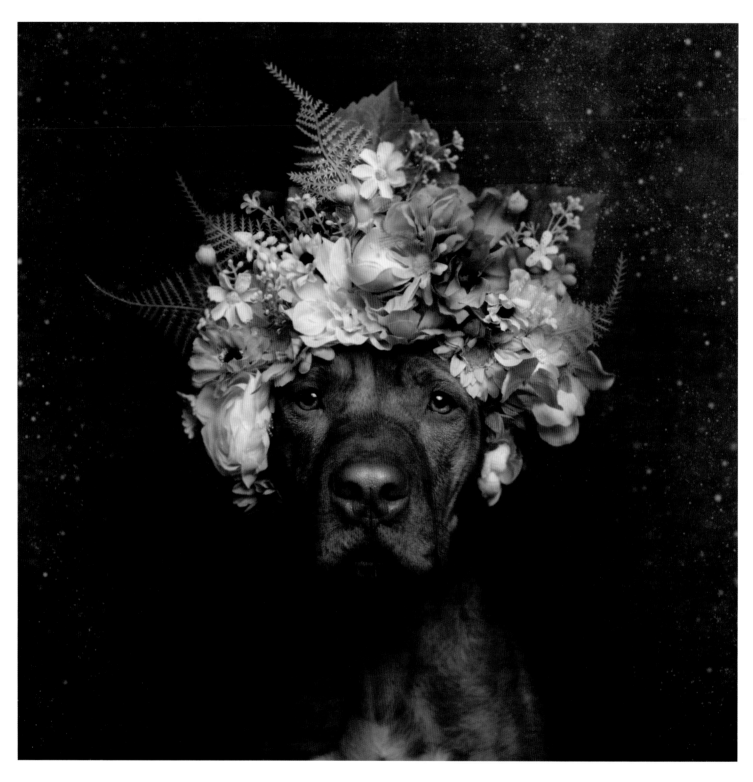

Rodger, 2016
Adopted
Almost Home Animal Shelter, New Jersey

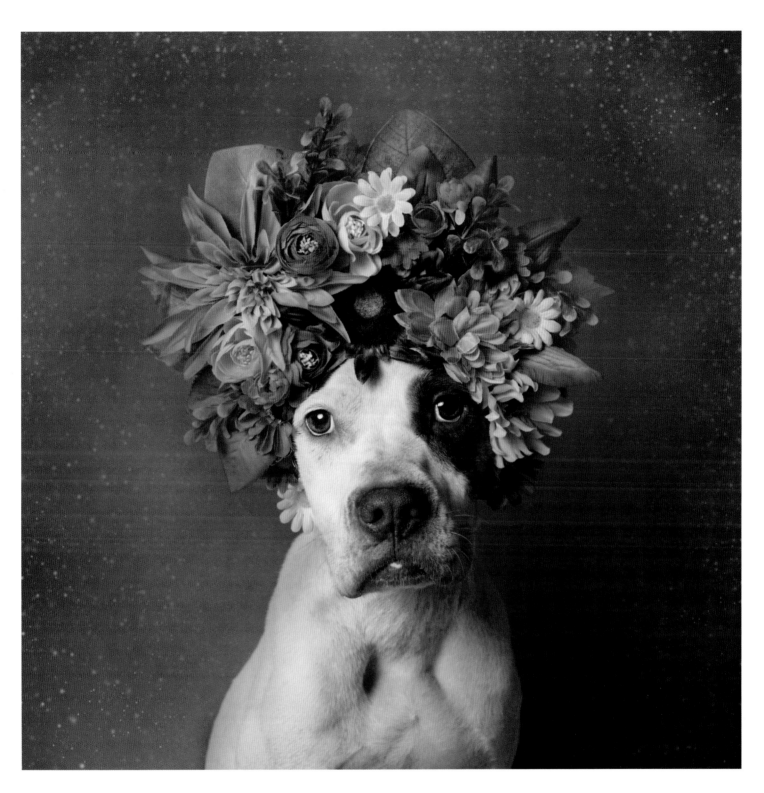

Jolie, 2016
Adopted
Austin Pets Alive, Texas

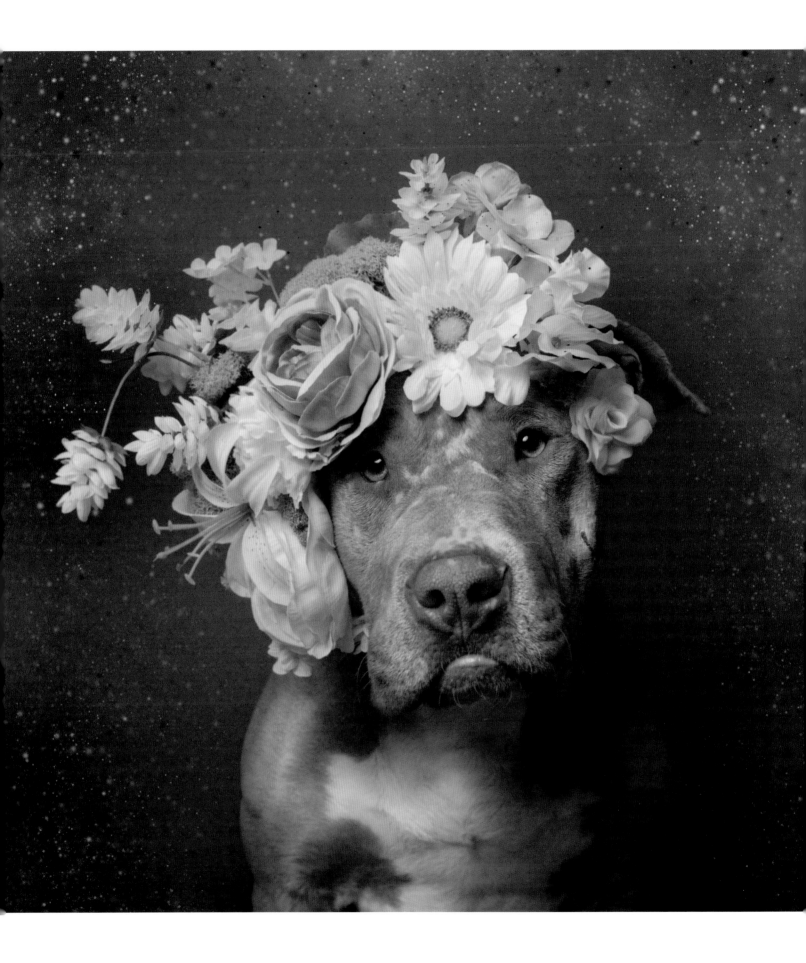

PRINCESS GRACE

2016, *Adopted*
Mr. Bones & Co., New York

In the early hours of a cold day, somewhere in Brooklyn, a couple noticed a dog tied to their fence. The dog's face was covered in severely infected wounds, and her jowl was hanging as if someone had tried to cut it off. They could smell death on her. Though many passersby had ignored the dog, the couple decided to take her into their care. They named her Princess and gave her water, food, warmth, and a safe place to rest while they contacted their dog network for help. Soon her story reached Mr. Bones & Co., a local rescue. They took Princess into their program and drove her to their medical partner. The vet suspected that all of her wounds were dog bites, including the spectacular injury to her jaw, which was infected with necrotic tissues. The vet immediately performed life-saving surgery on Princess, and stitched her mouth back together. Through it all, Princess displayed an incredibly gentle and positive nature, kissing and greeting everyone she met.

The police opened an animal-cruelty case and released footage captured by a nearby surveillance camera, in the hopes of catching the people involved. Unfortunately, nothing came of the effort. The video consists of three quiet, grainy, black-and-white minutes that changed the life of this dog forever. I have watched those three minutes again and again, in the hope of seeing a sign that these men actually cared, or a clue to understanding such despicable behavior.

The time stamp indicates 11:41 p.m. when a black SUV pulls over on the quiet street. Two people jump out of the vehicle with Princess on a leash and bring her over to a fence. They tie her once, change their mind, walk back a bit, then tie her again and walk away. They show no hesitation, no remorse, no emotion. Through it all, Princess remains obedient and calm. As they walk away, she tries to follow them and seems puzzled when she realizes she's tethered. She seems to wag her tail politely at them, as if to say, *Hey, you forgot me!* She stares at the men who disappear outside the frame. For the next eight hours, Princess sat in the cold. It was 38°F (3°C) in Brooklyn that night.

A couple of weeks prior, the same medical facility that was treating Princess (now Princess Grace) had witnessed the heartbreaking goodbye between Tanya and her best friend of nearly ten years, a senior pit bull named Elsie. Tanya had brought Elsie over in her red doggy stroller, and as she left the facility, she'd asked the medical center to hold on to the empty carrier for a while. While she mourned the loss of Elsie, Tanya noticed on social media a video of Princess that the rescue had captured upon her intake at the vet's office. Although her face was devastated by necrotic wounds, which must have been terribly painful, Princess seemed relaxed as she wagged her tail, sat on command, and gently took treats from her rescuer's hand.

And so within two videos, her fate was sealed. Tanya asked if she could meet Princess Grace, since she had to go pick up the red stroller anyway. She worried it might be a bit too early to adopt, but there was something about Princess Grace. "Elsie was my everything for just shy of ten years," Tanya wrote. "My tiny apartment was empty without her. She was everywhere, yet nowhere. Meeting Gracie was definitely a bright light in a dark void, but I didn't know if I was ready for another dog so soon. Elsie was irreplaceable. And Gracie deserved a fresh start. In the week after meeting Gracie, I was asking myself over and over, *How will I feel if she gets adopted and I see her all over social media living her life?* The answer was that I'd feel like I missed out on a really great dog."

Their next date was scheduled. On that second date, Tanya and Gracie kissed. Tanya asked Elli at Mr. Bones & Co. if she would consider her when Gracie was ready to be adopted. Elli said, "Oh, she's going with you. . . . I was just waiting for you to ask." And just like that, Elsie's ending led to Princess Grace and Tanya's new beginning.

Today, Gracie is a beautiful, healthy, loving dog. Despite her past, she even has some dog friends she walks with regularly. She's become a pit bull ambassador, and she and her mom Tanya have taken on the challenge of having Gracie kiss a person from every American state, and every country on the planet, too. Together, they have tackled learning many fun tricks. Gracie is the queen of begging—sitting up straight, with her adorable pouting lower lip—and she also knows how to wrap herself in a comfy blanket.

We'll never know what happened to Princess Grace before the episode with the SUV people and the fence. In a way, we don't really need to know any more, because what's more important about her story is how her past never defined her or how she interacts with people and with the world.

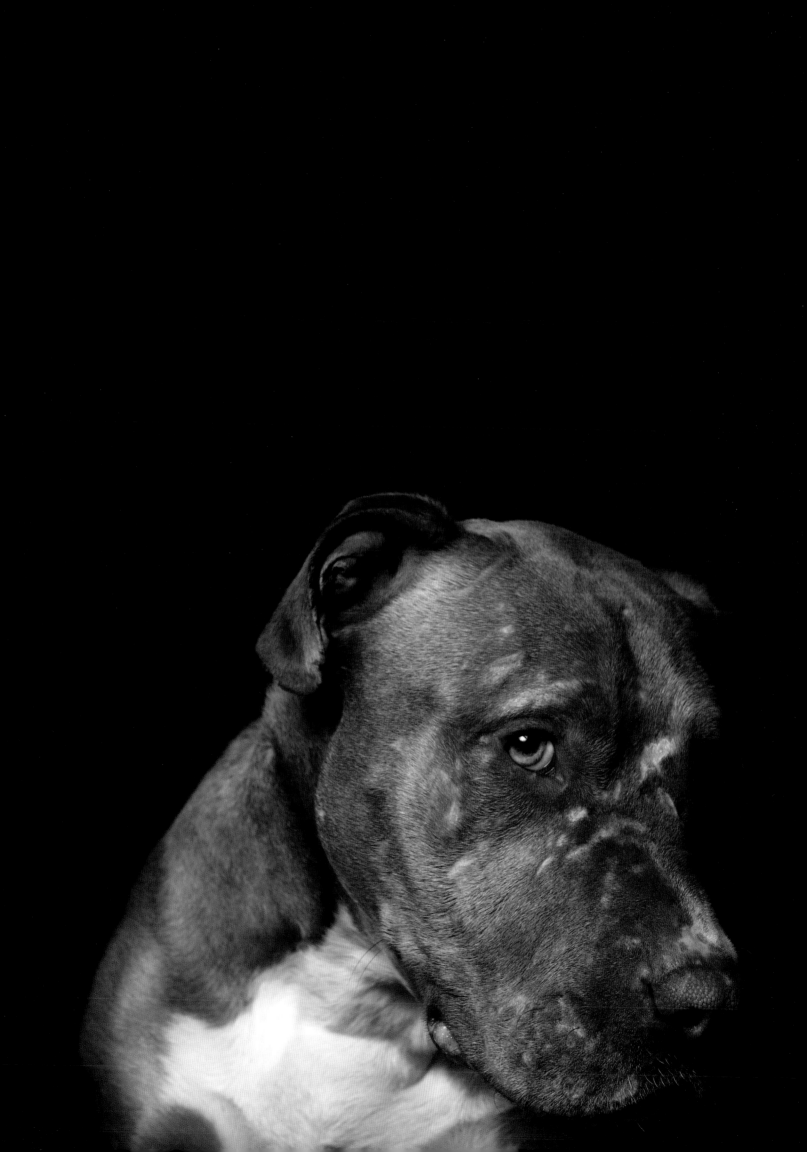

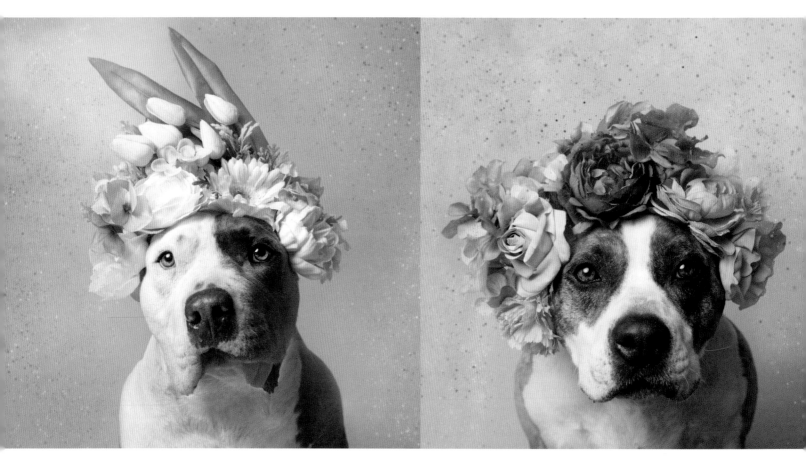

Buddha, 2016
Adopted
Luvable Dog Rescue, Oregon

Asia, 2015
Still waiting
AZK9, Arizona

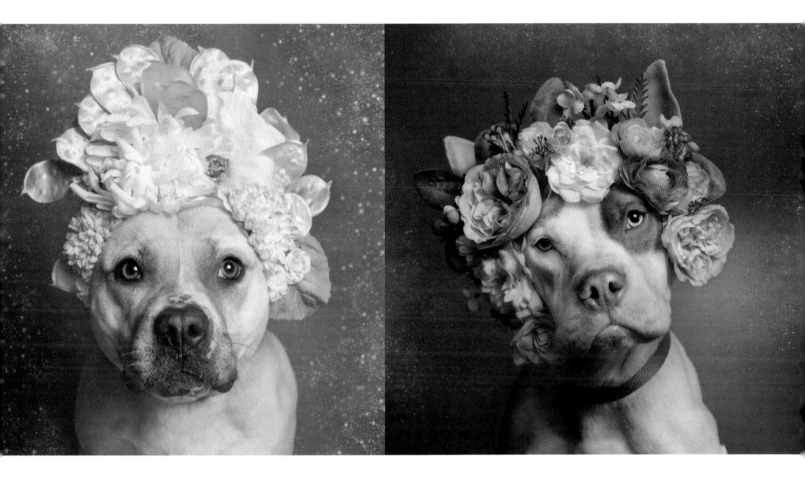

Aphrodite, 2015
Adopted
Sean Casey Animal Rescue, New York

Acadia, 2016
Adopted
Animal Haven, New York

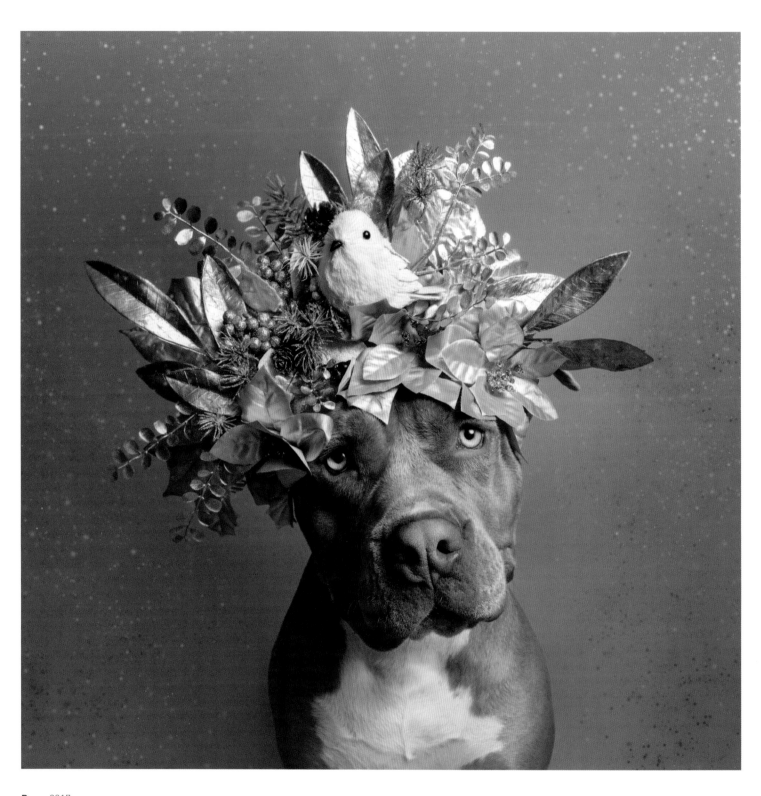

Boss, 2017
Adopted
Central Missouri Humane Society, Missouri

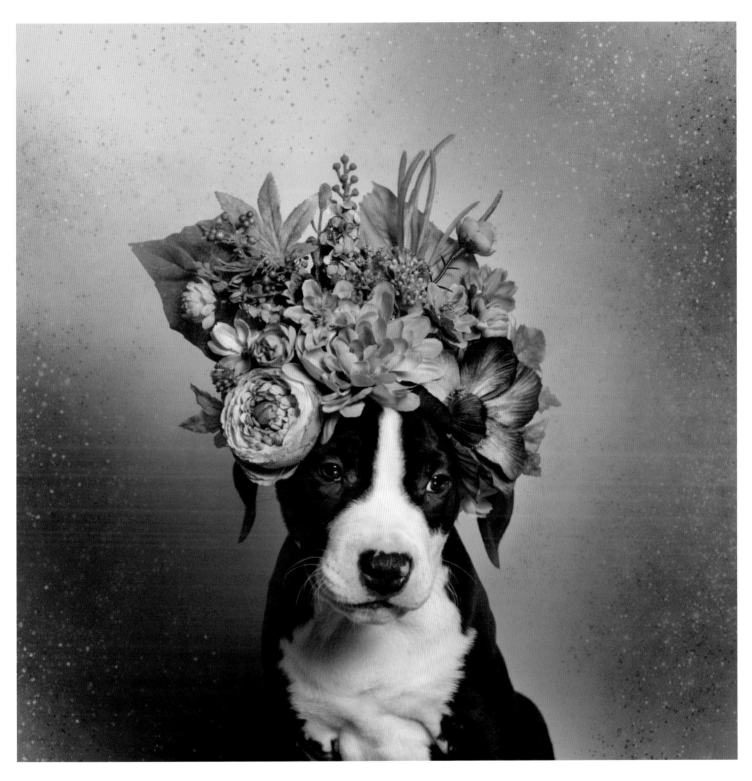

Black Beard, 2017
Adopted
Luvable Dog Rescue, Oregon

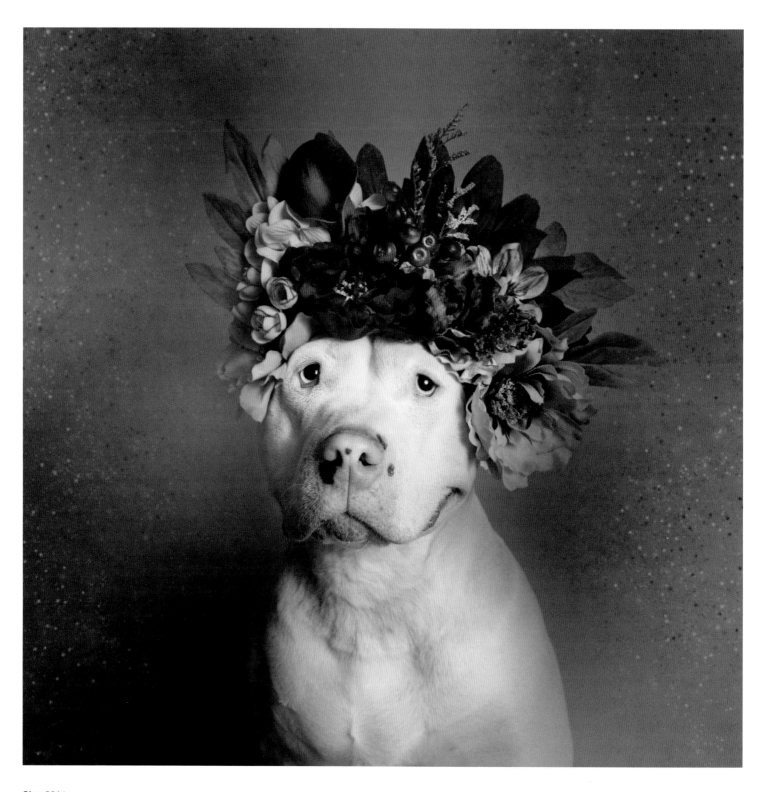

Sky, 2016
Still waiting
Luvable Dog Rescue, Oregon

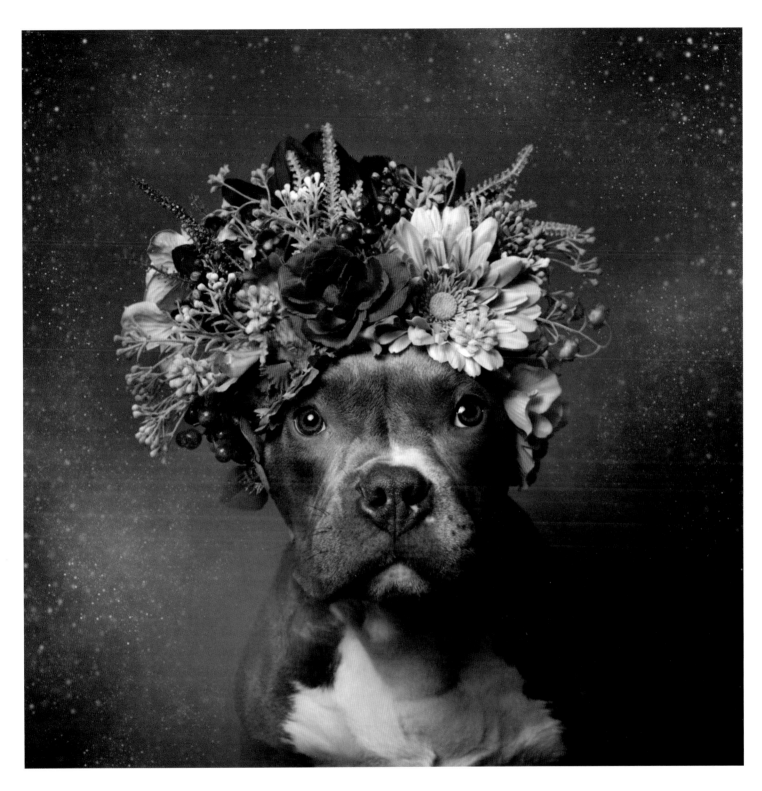

Tater Tot, 2017
Adopted
Mr. Bones & Co., New York

BLOSSOM

2014, Adopted
Town of Brookhaven Animal Shelter, New York

Blossom was first discovered in 2013 roaming around a shopping center. She waited a few months at the shelter and was adopted, only to be returned shortly after, when the resident dog didn't approve. Blossom's second stay at the shelter lasted about a year, partly because after the first adoption mishap she was listed as needing to be the only pet at home.

Few shelters have the resources to properly assess and socialize their dogs. As a consequence, at the first sign of trouble, dogs are quickly labeled as an only pet in an attempt to avoid failed adoptions. At the same time, that label creates huge hurdles for these animals. Many languish for months or years, when they could actually be paired with the right animals, or simply need slower introductions. This proved true for Blossom.

In 2015, Blossom finally found the home of her dreams. She lived happily with her new family, which included children—from a newborn to a fifteen-year-old—and two cats. Everything was going great until the husband was deployed overseas and the whole family had to relocate to Germany, a country that as a rule bans the importation of pit bulls. Blossom's family tried to place her with relatives or friends, and, when all failed, they brought her back to the shelter.

Blossom was quickly adopted again, by a family expecting a baby, and was returned within days when the mother-to-be changed her mind. This was now Blossom's fourth stay at the shelter. Around that time, Patricia and her family decided to adopt a dog. They presented the shelter with their list of criteria, including the common *maybe a lab mix or something, anything but a pit bull really*. Members of the staff explained that most of their dogs matching these criteria were pit bulls. They sent Patricia the profiles of a few select candidates, including Blossom.

"I showed her flower portrait to my husband because it was so cute," Patricia relates, "and at first he said, 'Are you insane? Not a pit bull!' But in her pictures Blossom looked so harmless. We went to the shelter the next day. We walked through the kennels and all the dogs were going bonkers, barking and jumping. I was intimidated. As we approached Blossom's cage, we found her lying down silently. She was the only quiet dog of the whole place. After meeting her and seeing her wonderful disposition, we decided she was the one. We renamed her Gypsy because she had been bounced around so much. She is home now, though. My baby isn't going anywhere."

In early 2018, Patricia and her family added Tyson to the mix, a high-energy pit bull from the same shelter who'd been bounced around, too. Gypsy and Tyson get along wonderfully, even though Tyson is a handful. Patricia had a plethora of delightful anecdotes to share with me. "Recently," she said, "I was having one of those horrible days when everything goes wrong. It was raining—pouring down. I let Gypsy out into the backyard and she disappeared. Later, she came back covered in mud. She was all black, from her nose to the tip of her tail. You could only see her eyes. I was trying to quickly grab a towel when she rushed inside the house, dragging mud everywhere. I started laughing deliriously for a good ten minutes. My dogs make me crazy. But that's what dogs are for, right?"

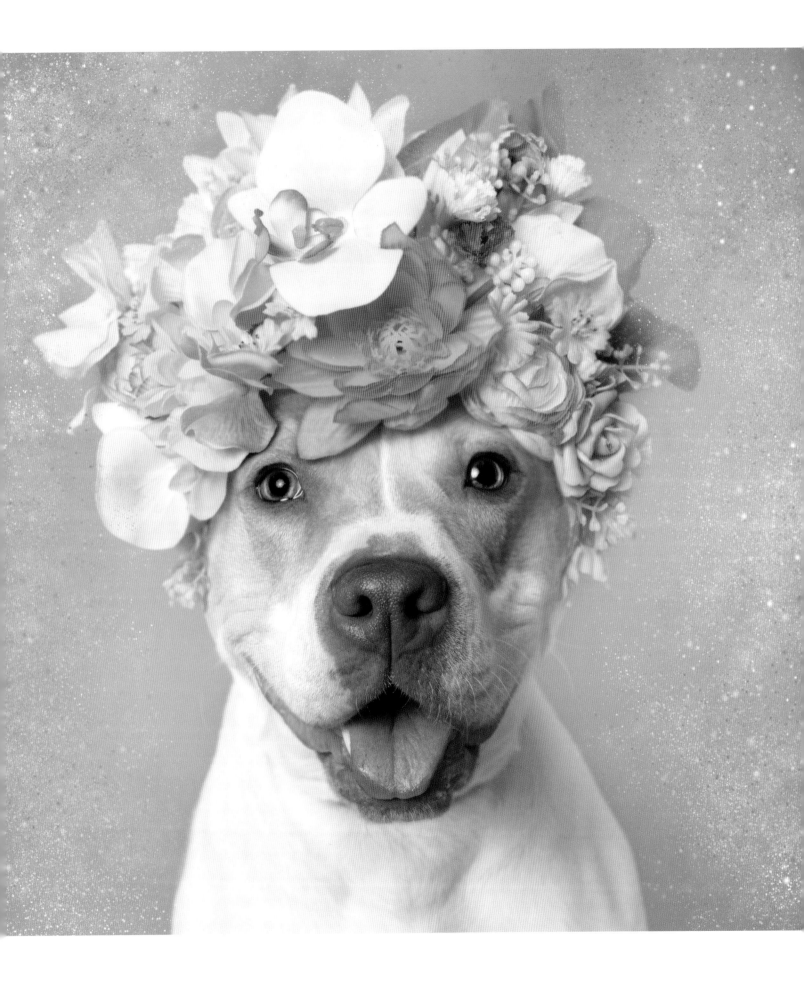

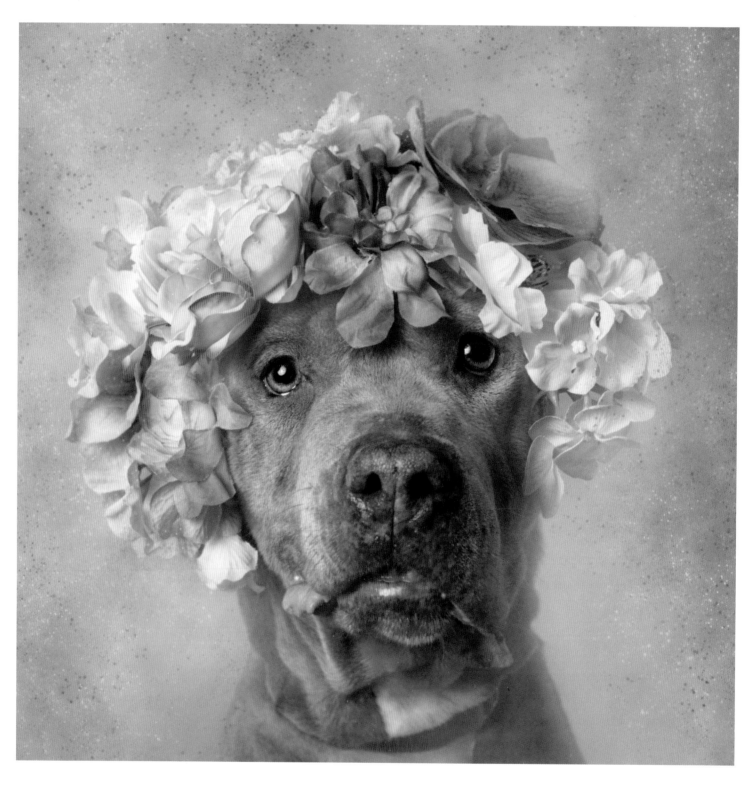

Gladys, 2015
Adopted, deceased
Town of Hempstead Animal Shelter, New York

"I wasn't planning on adopting a senior dog, but this portrait came up online and melted my heart. Gladys had been found, tied, in a parking lot. She'd been bred excessively and seemed to have had a horrific past. I messaged the shelter and, long story short, she was mine. A group of transport volunteers drove her closer to me and I picked her up. It was love at first sight. Gladys was sassy, funny, and loyal like nobody I've ever known. She loved balloons and would bounce them back to me. Her nickname was Big Booty Judy because she was heavy in the back end. She was absolutely amazing and taught me so much. Sadly, I recently had to put her down. Cancer had taken her over, and I always told myself she had suffered enough before and she would never suffer with me. I miss her and my heart is still broken, but I'm glad I got to have almost three years with Sassy Glady." —Kelsey

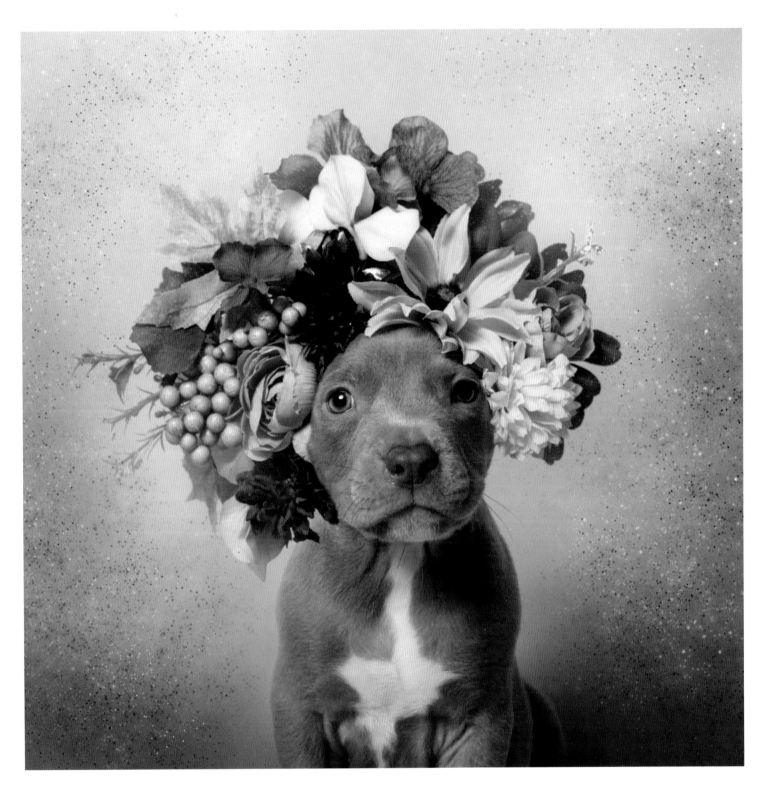

Cheeto, 2017
Adopted
Luvable Dog Rescue, Oregon

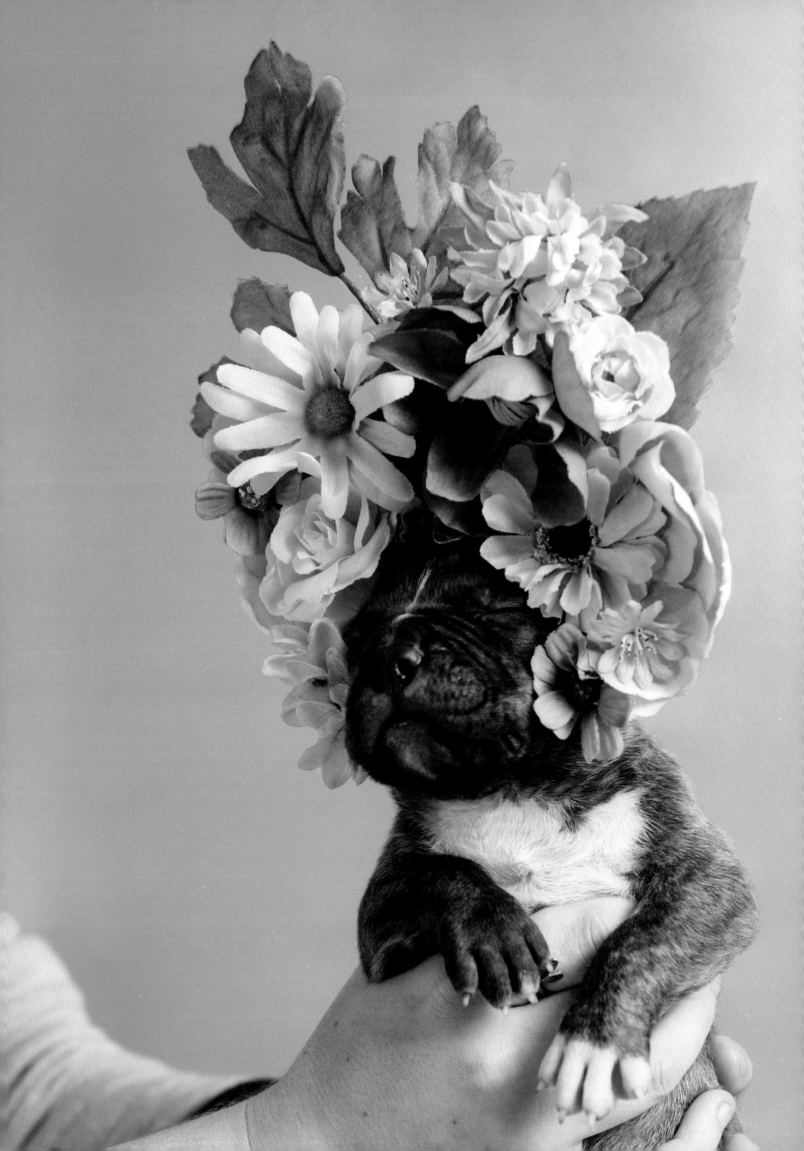

Galavant, 2016
Adopted
Luvable Dog Rescue, Oregon

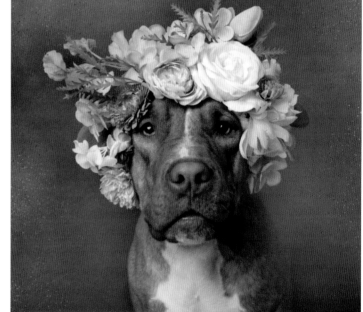

Fancy, 2014
Adopted
Second Chance Rescue, New York

Ravioli, 2015
Adopted
Animal Care Centers of NYC, New York

Zahra, 2014
Adopted
Animal Haven, New York

Harper, 2016
Adopted
Monmouth County SPCA, New Jersey

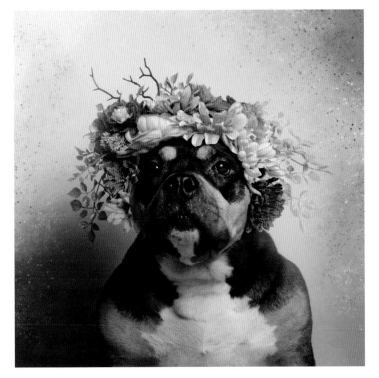
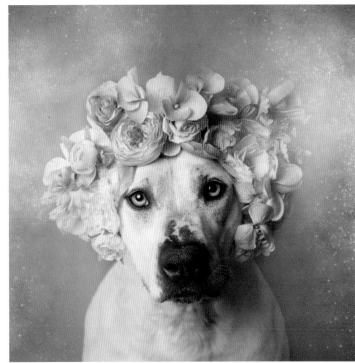
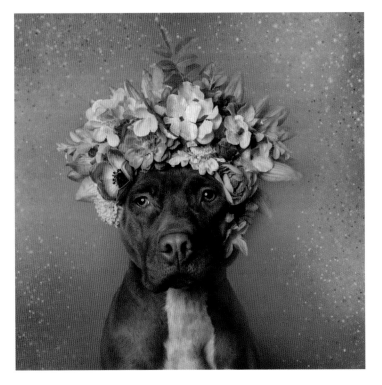
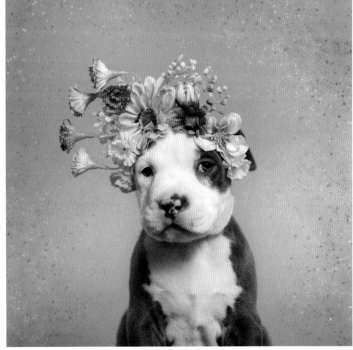

Raven, 2017
Adopted
Luvable Dog Rescue, Oregon

Hashbrown, 2016
Adopted
BARC Houston, Texas

Jessica, 2015
Adopted
Second Chance Rescue, New York

Corpus Christi, 2017
Adopted
Animal Haven, New York

CECILIA & ANNABELLE

Cecilia, 2016, *Adopted*
Annabelle, 2016, *Euthanized*
Centro de Control y Albergue Capitán Correa, Puerto Rico

In the fall of 2016, I headed to Puerto Rico to visit a local open-admission shelter and help a rescue, The Sato Project, pull a few dogs into their program. I hadn't been on the island in a while, but I was very familiar with the situation for homeless animals, having volunteered there for two years in the past.

With an estimated 250,000 stray dogs and a culture resistant to spaying and neutering, the tiny island is faced with an impossible situation. Local open-admission shelters are overwhelmed with the number of animals they take in every day as well as the deadly, highly communicable diseases and parasites they have to deal with. My friend Chrissy and I knew our trip would be heartbreaking, but we weren't fully prepared for what we'd witness there.

The staff at the Centro de Control y Albergue Capitán Correa was indeed overwhelmed, but they agreed to let me photograph the facility so we could raise much-needed funds to help them improve the conditions for their animals. With only about ten adoptions a month, the center's euthanasia rate was through the roof—over ninety percent.

As soon as I entered the scorching intake building, which is closed to the public and where animals are processed upon arrival, I was met with loud cries and a wave of unbearable scents. I saw the animals' broken spirits and their hoping, pleading eyes. Some had retreated to the back of their cages, waiting for the deliverance that would only come in the form of a lethal injection. I would never be the same person again after walking through that shelter's intake floor and hearing the desperate cries. This was hell. In that moment, there was nothing I could do to help but bear witness.

In one of the cages lay a small puppy, completely defeated, awaiting death. "We are going to euthanize him soon," the shelter staff said. When I asked the reason, they told me he was brindle, a coat color that isn't particularly sought after by their adopters. To them, brindle was the color of vermin. But there was something familiar in this little puppy, and when our eyes met, it felt like I was seeing an old friend. That day, the rescue pulled around ten dogs from the shelter, including the brindle puppy. They'd be vetted, rehabilitated, and flown to New York for adoption.

In the adjacent building, open to the public, a few dogs had been cleared for adoption and were waiting patiently in a cleaner, quieter, more inviting space. A group of volunteers was walking the dogs. I noticed an adorable, freckled four-month-old puppy named Cecilia. She was cute as a button and full of life. The staff had high hopes of finding her a home. There was also a black pit bull with soulful eyes and an endearing pout named Annabelle. I crowned them both with flowers, knowing there was little reason to hope my pictures would make a difference for them.

At the end of the day, we left the place with heavy hearts, a few lucky dogs, and the promise we'd raise funds to help the shelter. We held dogs in our arms, their hearts and ours pounding out of their chests, knowing we were pulling them into safety. We whispered comforting words into their ears while we walked away, leaving behind countless more dogs who were crying for our help, too. My heart has never left that moment in that shelter. On our way out, I saw a family surrendering a dog. The dad claimed they had found him, but the little boy told me the dog was theirs. I wondered if they had even the slightest idea of what they were doing to their pet companion who trusted

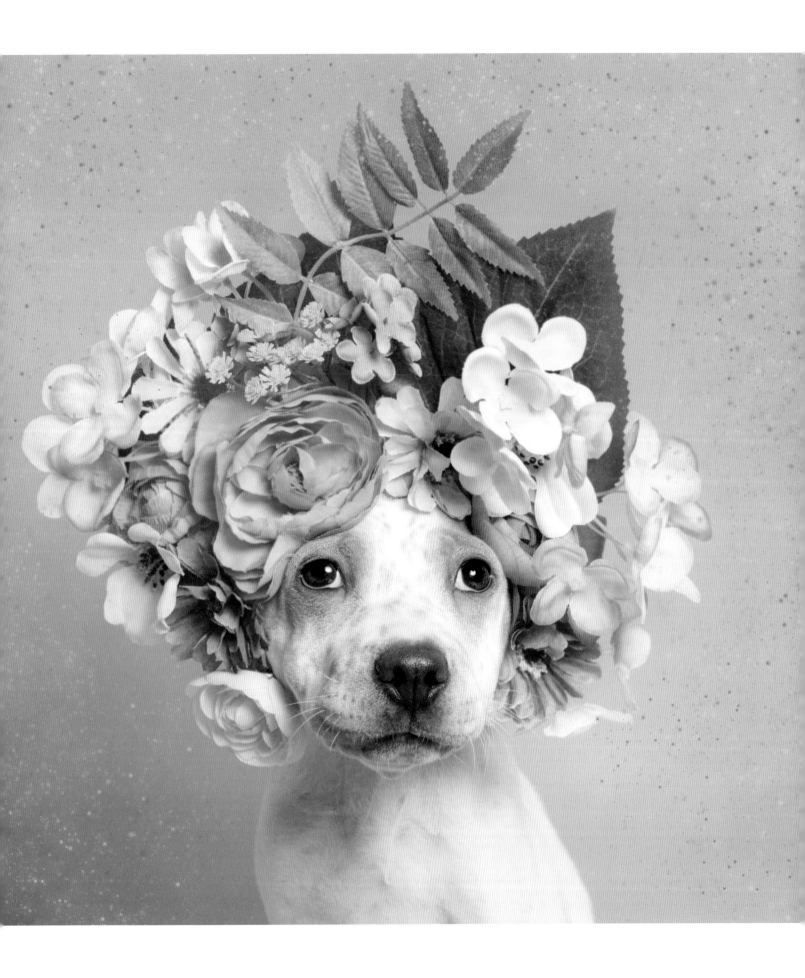

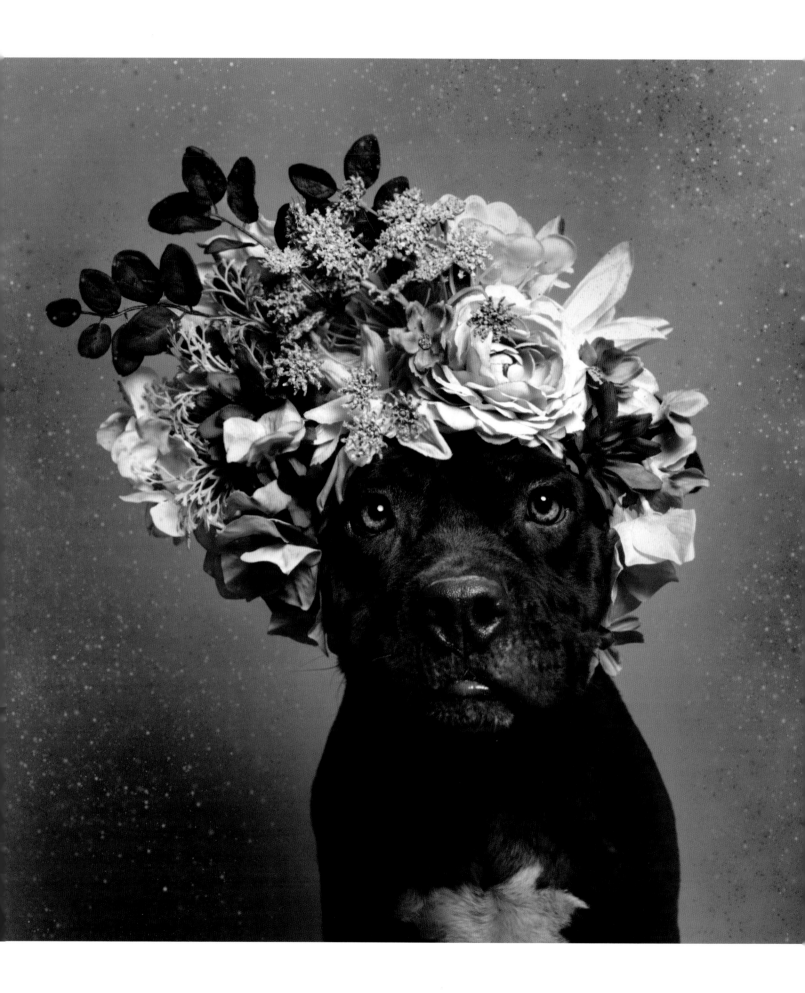

them. The shelter staff took the dog and disappeared into the intake building. The family drove away.

I know many people would judge a place like this harshly; it's easy to judge, I suppose, if you've never spent a day in the shoes of the people who work there. Imagine being exposed to such horror daily and not having any of the resources to even begin to fix the problem! Every day, truckloads of animals pour in. Every day, you have to euthanize these soulful creatures because there's nowhere for them to go and all you can hope to do is prevent more suffering. I feel for those who work in places like these, because they are stuck cleaning up after entire communities, operating on shoestring budgets, and doing it all while self-righteous people shout hateful words at them.

After our first visit, the rescue and I raised funds to improve the shelter's facility, and we went back a few weeks later to check on construction and deliver new equipment. Cages had been repaired, fences secured, and a new, safer puppy ward had been built. These small improvements wouldn't solve the problem of overpopulation, but at least they would make the animals' stay safer and a bit more comfortable.

Annabelle had been euthanized since our last visit. A black pit bull had little to no chance of being taken by the handful of adopters visiting every month. After a year of trying, the shelter decided to give her spot to another dog.

Cecilia herself was now six months old and still waited in the adoption center. She was as perky and endearing as I remembered her, but her days were numbered. Once fully grown, her chances at adoption would drop considerably. I posted her flower portrait again and pleaded. My post reached Laura, who fell in love with the freckled face. She asked a local friend to go adopt Cecilia for her, and later the dog traveled to New York, where she now lives.

"I never thought I would adopt a dog I'd never even met before, but your portrait melted my heart," Laura

shared with me. "The decision to adopt Cece was instantaneous. I had no idea she was covered with all these amazing spots until she came out of the kennel at the airport. She is the friendliest, most enthusiastic, sweet little girl. She is a perfect little sister to our other dog, Z. She is so pesky and mischievous and keeps him on his toes all day.

"She loves to play rough, and her best friend is a giant German Shepherd who fits her whole head in his mouth. Cece is wicked smart and has the fastest 'sit' this side of the Mississippi. We got a genetic test done and it came back as mostly Shar-Pei, with some Chow, Cocker Spaniel, Great Dane, and the rest undetermined island-dog mix. She's the best and we can't imagine life without her."

In early June 2018, the Humane Society of the United States led a coalition of organizations to spay and neuter as many animals as possible in Puerto Rico. Named the Spayathon, this historic, unprecedented event offered free sterilization for owned pets for an entire week. The cost of this surgery is prohibitive for the more than forty percent of Puerto Rico's population who live below the poverty line. It was heartwarming to see the huge lines of local residents bringing their animals in for the procedure, especially at a time when the island was still suffering tremendously, months after the devastation caused by Hurricane Maria.

The Spayathon's success reminded the animal welfare community that given the tools and resources to do so, people want to be a part of the solution. Over 5,000 animals were sterilized that week all over the island, and the Spayathon will have three more rounds over the coming months. This massive campaign offers hopeful prospects for Puerto Rico at last.

As for the brindle puppy from the Capitán Correa shelter, my husband and I named him MacLovin and he officially joined our family soon after. There isn't a day we walk on the streets of Brooklyn without someone commenting on his unique looks—in particular his beautiful brindle coat.

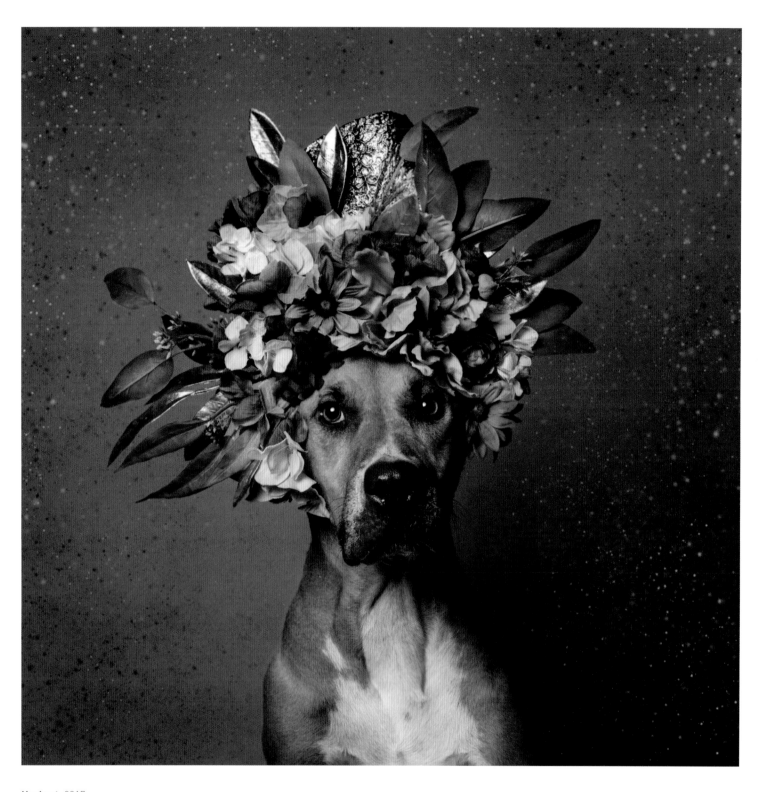

Herbert, 2017
Still waiting
Hallie Hill Animal Sanctuary, South Carolina

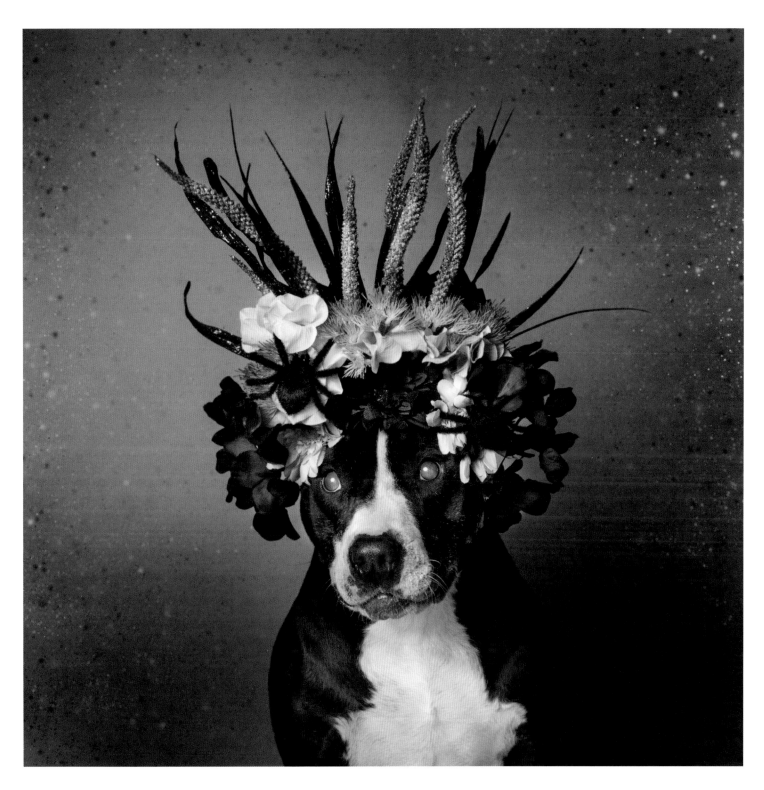

Darla, 2017
Still waiting
Luvable Dog Rescue, Oregon

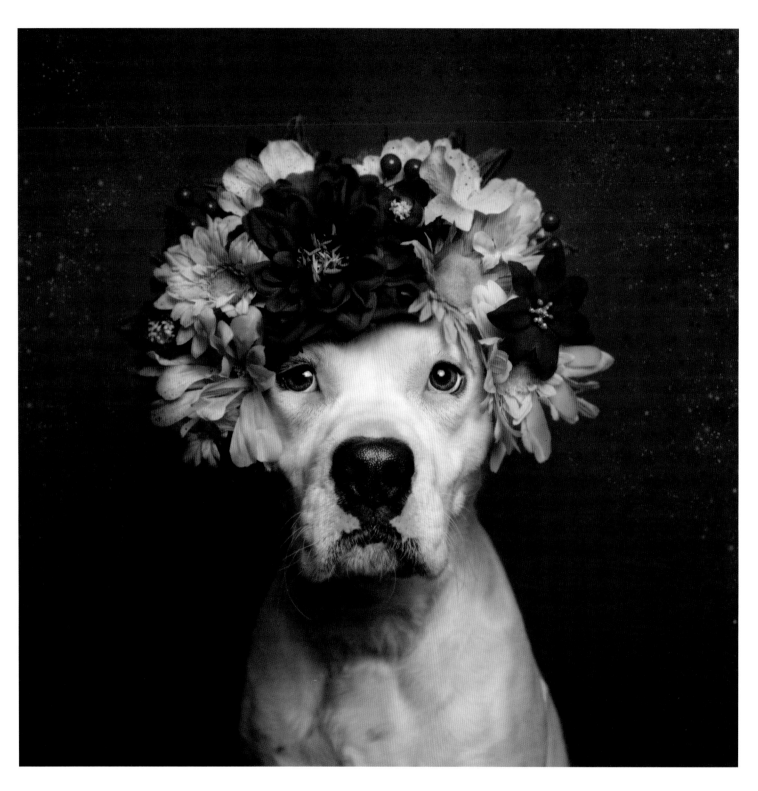

Lizzy, 2016
Adopted
Almost Home Animal Shelter, New Jersey

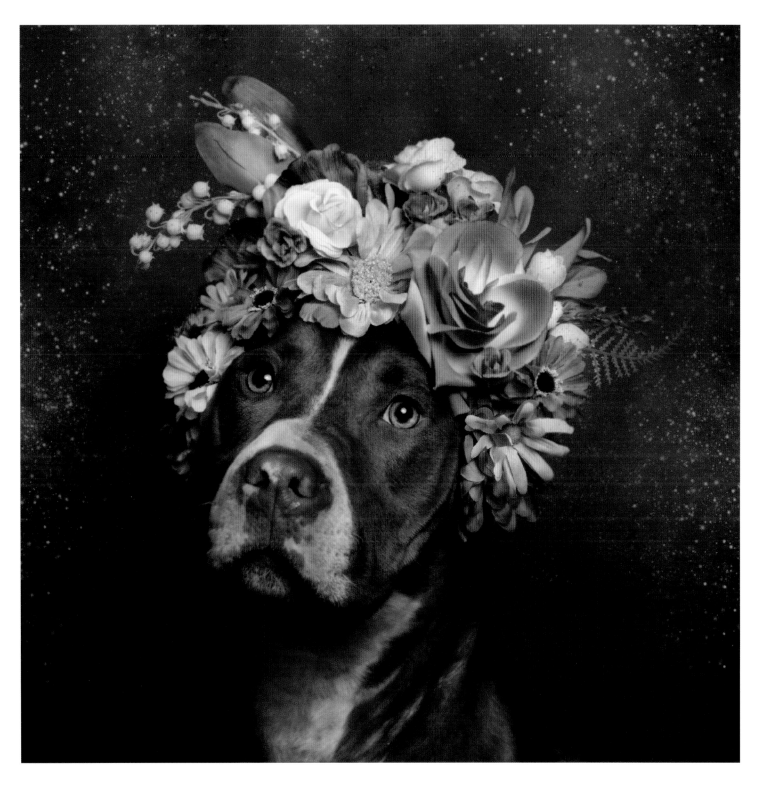

Melo, 2016
Adopted
Almost Home Animal Shelter, New Jersey

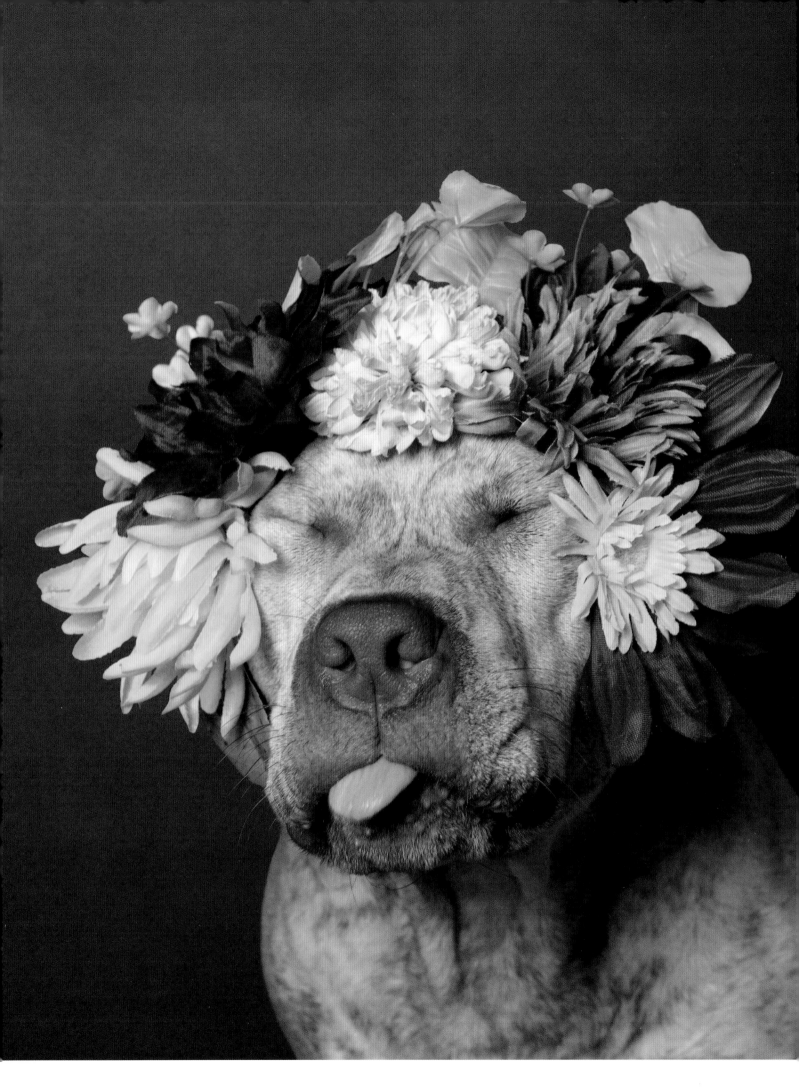

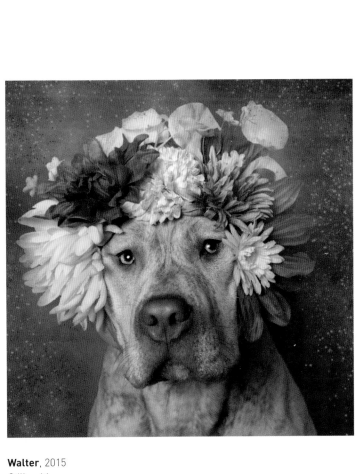

Walter, 2015
Still waiting
Redemption Rescues, New York

INDIE & CHOCO

2016, Adopted
Luvable Dog Rescue, Oregon

When Indie and Choco's owner was deployed overseas he couldn't take his dogs with him so he surrendered them to a shelter in California. This situation happens more often than it should because pit bulls, as was the case with Blossom (see page 50), are usually banned from military housing, their importation from abroad is often forbidden, and more and more airlines refuse to transport them, too. As an unfortunate consequence, many service members have few options when their careers require them to move, often on short notice. A couple of organizations help military personnel rehome their animals or offer fostering services until they come back, but they cannot help everyone.

At eleven years old, Indie and Choco lost everything they'd ever known, and found themselves on a dark, cold, scary slab of concrete behind bars. Pit bulls, seniors, cropped ears, a bonded pair. The two ticked all the boxes that get you a death sentence in such a high-intake shelter. Fortunately, the staff fell in love with the touching pair and reached out to their rescue network. As soon as Luvable Dog Rescue heard about Indie and Choco, the team jumped into action and the two dogs made their way to Oregon via a transport partner.

Indie and Choco were said to be siblings and were so obviously bonded that Luvable decided to try to adopt them together. The rescue knew this wouldn't be a small feat. When I met the dogs in Oregon, they'd settled into the peaceful and green life at Luvable. They had their own individual cottage and had shown themselves to be nondestructive, quiet, mellow, perfect house companions. All they needed was that special someone who'd want to take on two large, senior couch potatoes at once.

We set up our photo shoot in a trailer. A brief staircase led up to the room. I soon heard shuffling sounds and grunts. Indie and Choco laboriously climbed the stairs, entered the trailer, and immediately flopped down on their bellies. They were petrified and also clearly one of the most bonded pairs I'd ever met. The only way we could photograph them was by sitting them together, their shoulders touching. They were absorbing what little courage they had from one another and needed that physical contact.

We tried to make the shoot as comfortable and brief as possible. The two dogs loved to snuggle and enjoyed burying their heads in our laps. Their eyes were mesmerizing, and they were so adorable that I knew the photos could really make a difference by showing the incredible bond they had and their fun side. In some of the pictures, the dogs looked like a couple of gossiping old ladies. Would laughter be the key to getting them into a home? For them, I broke my *Pit Bull Flower Power* format. For the first time, I created a double portrait, the only one of the whole series.

It took less than a year for Indie and Choco to find a home together. Given the challenge presented, this was miraculous. Niq, their adopter, had recently and suddenly lost his dear Pnut, which left him devastated. After seeing some *Pit Bull Flower Power* portraits online, Niq started looking at adoption profiles and saw Choco and Indie. "I thought we could help each other," he said. "I could provide the home and love they needed and they could help me heal. After a lot of thought and a few sleepless nights, I decided to fill out an adoption application." Niq visited the dogs at the shelter, fell in love with them, and took them home immediately. Both dogs have settled nicely into their new lives, gaining more confidence and independence, even though they are still extremely bonded. "These two just truly love each other."

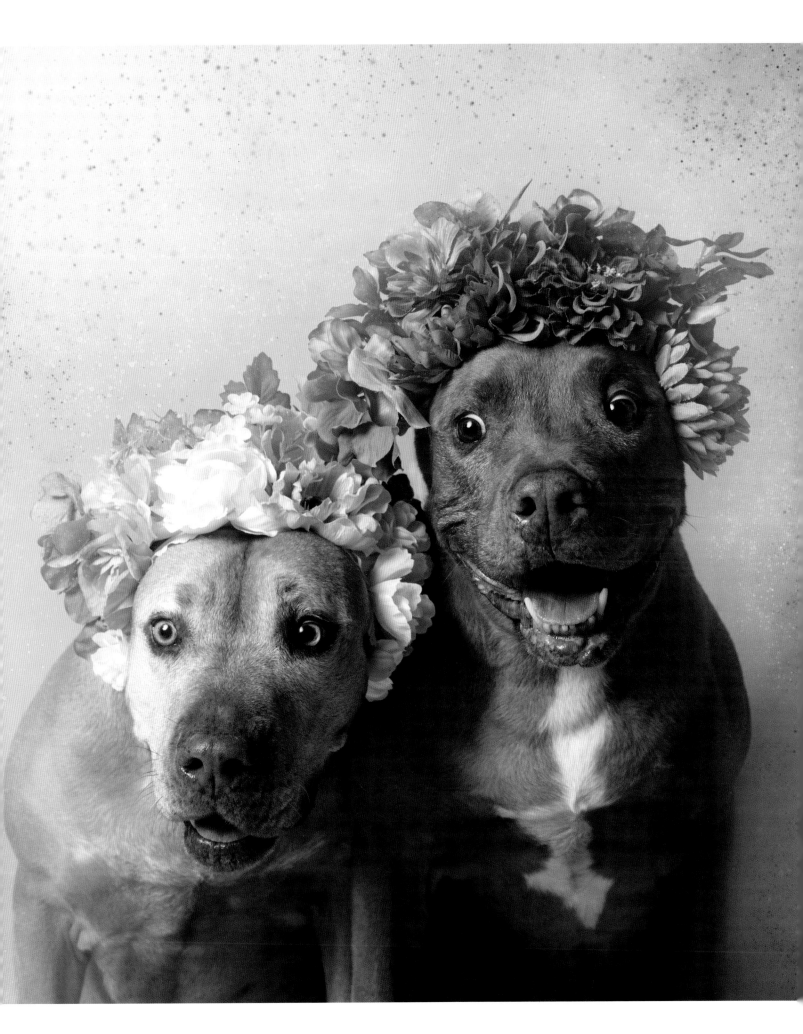

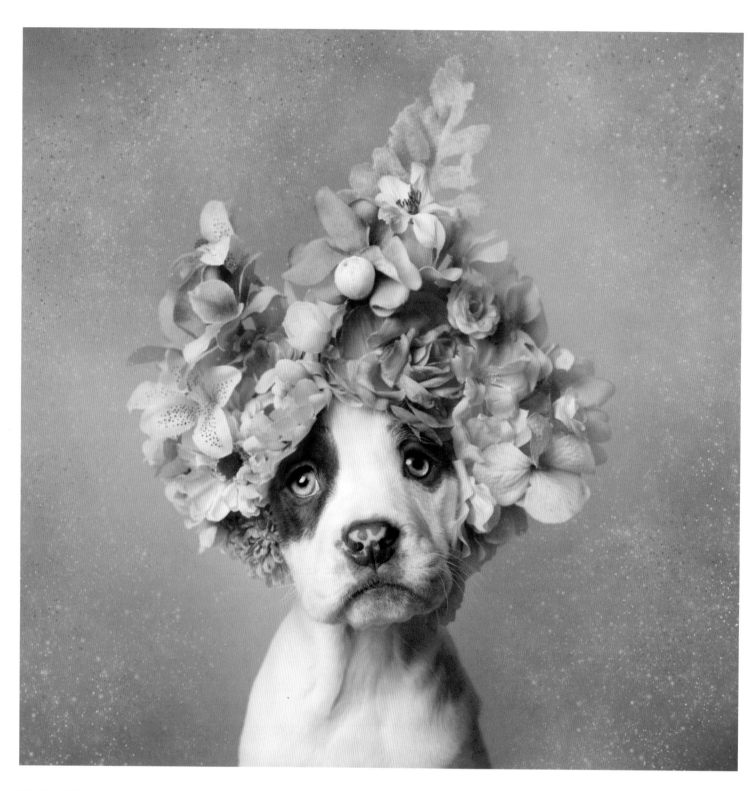

Phoebe, 2016
Adopted
Mr. Bones & Co., New York

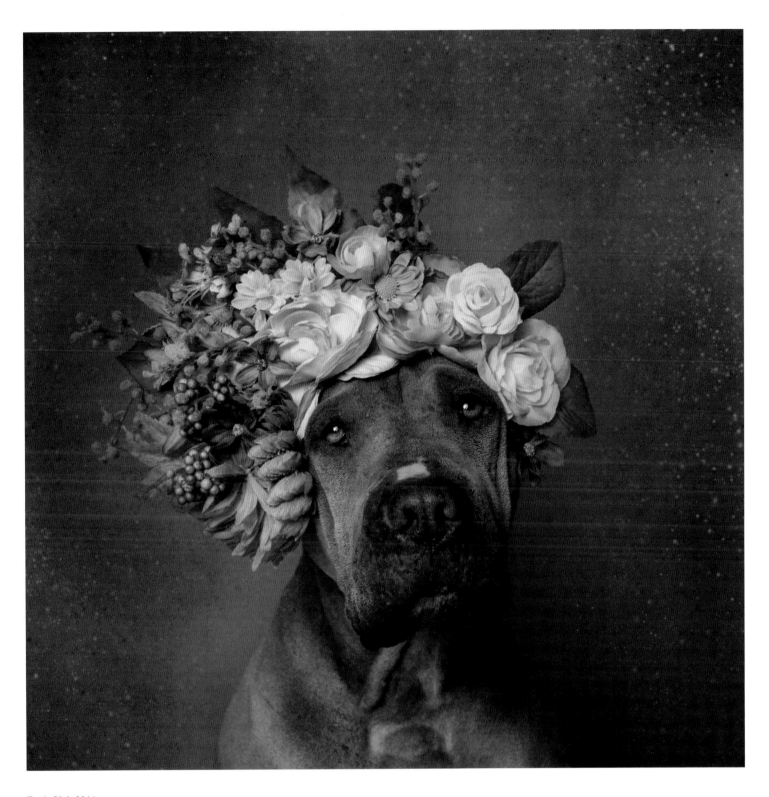

Tank Girl, 2016
Adopted
Austin Pets Alive, Texas

Tank Girl was found with porcupine quills in her face and wounds on her back and she was heartworm-positive. Over the next couple of years, she bounced in and out of homes, which increased her anxiety when left alone. Finally, Tank Girl's last foster adopted her. "On our first night together," Alyson recalls, "she slept with me and snuggled all night. I couldn't believe how lucky I was. The next day was less of a fairy tale. While I was at work, Tank had gotten sick all over herself and the apartment. It was a poop-apocalypse. We gave her a bath and wrapped her up. She was shivering. After a disastrous day of cleaning up her poop, I was still in love with her and I didn't want to ever have to give her up. Now Tank is living the good life, and I'd be lost without her. She is the reason I get out of bed most days. She has given my life a purpose, and I am forever changed by her unconditional love."

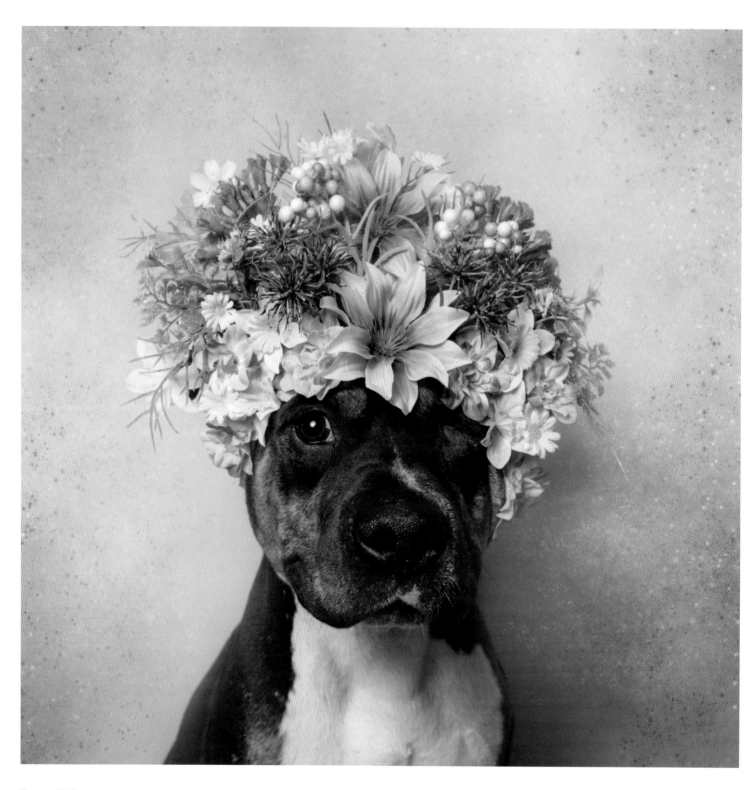

Roose, 2017
Still waiting
Miami Dade Animal Services, Florida
Main Line Animal Rescue, Pennsylvania

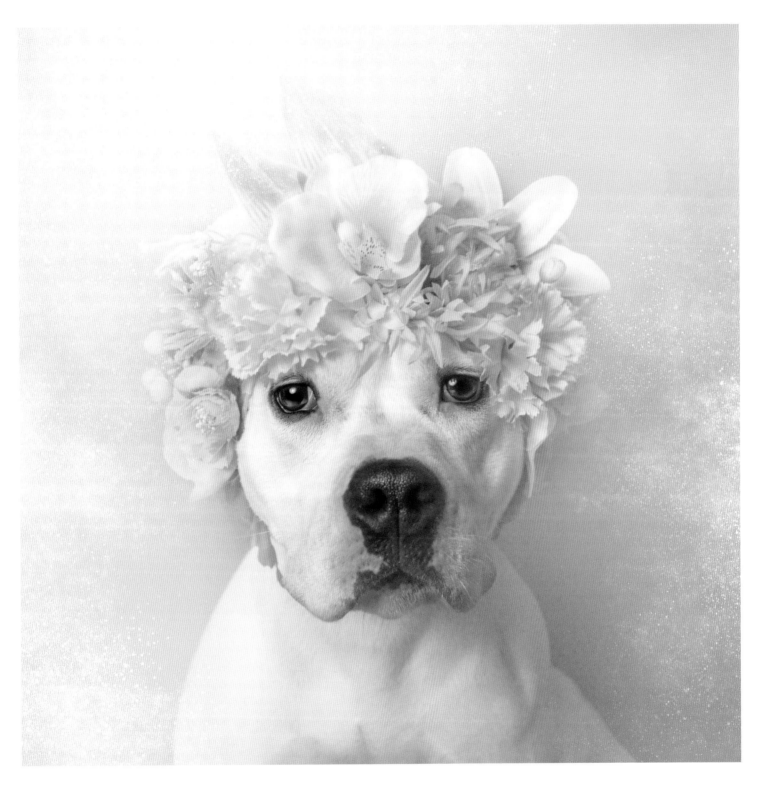

Boss Lady, 2014
Adopted
Town of Brookhaven Animal Shelter, New York

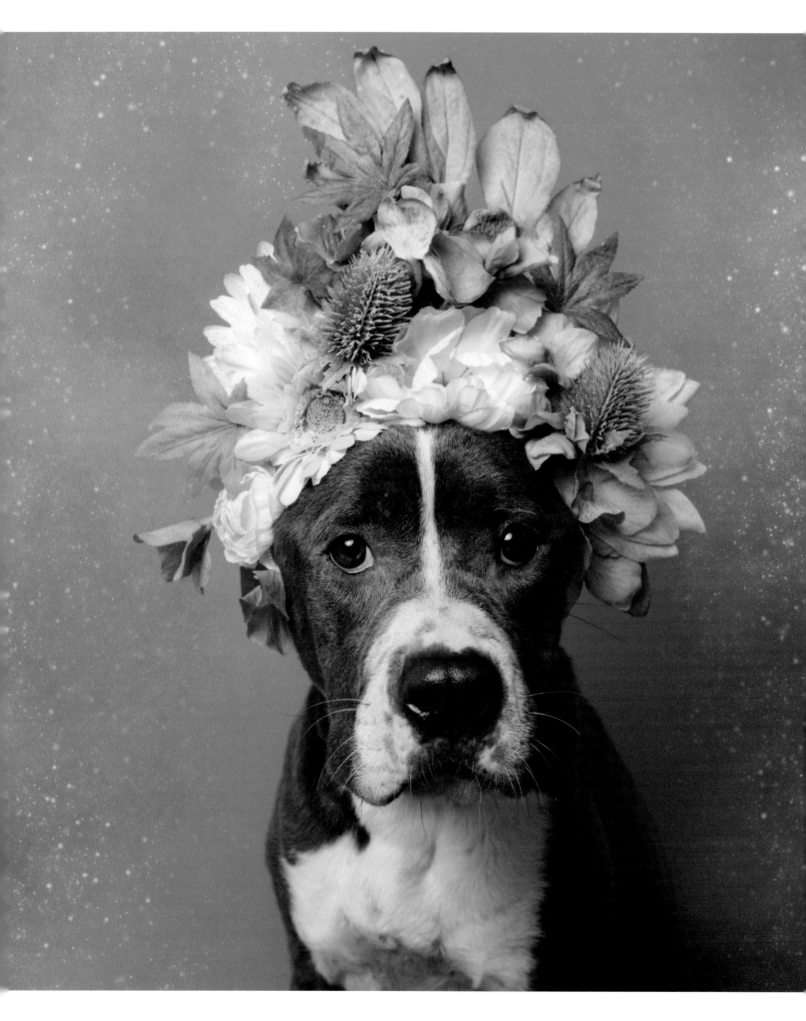

LADY O

2016, *Adopted*
Calhoun County Humane Society, Alabama

At the mercy of the shelter system, Lady O only survived thanks to the many dedicated people who crossed her path. At every step of her journey, these people made decisions on her behalf, sometimes taking chances against their better judgment and pushing forward in hopes of saving her life. Her story should be a reminder that in the imperfect, sometimes unforgiving world of rescue, there's no clear roadmap, and success may very well depend on taking a chance on a dog and on a human being, too.

I met Lady O at the Calhoun County Humane Society in Alabama. I remember her very clearly, despite the fact that we photographed fifty-four dogs that day. I was walking up and down the rows of kennels surrounded by a deafening concert of barks and whines. Lady O seemed particularly aggravated by my presence. She'd bark, throw herself against the fence, and bounce off the walls of her kennel, wide-eyed. *Gosh*, I thought as I walked away. *That's one I'll be sure to keep my distance from during our shoot!*

Later, the staff brought Lady O to our set and she was transformed. She was so terrified to be outside of her kennel that she pancaked immediately, making herself as flat and low to the ground as she possibly could in an attempt to disappear. I realized she'd been furiously defending her kennel because it probably was the only place she felt she had control over.

Lady O had been brought in by animal control a couple of years prior. Despite being loved by the staff, she was constantly overlooked by the very few adopters that would visit the kennels in that isolated shelter in rural Alabama. Her future looked grim unless the shelter managed to transfer her elsewhere. In that regard, my photographs could be instrumental. In her portraits,

Lady O appears as a delicate, shy, broken spirit whose eyes seek to captivate the right person. And that's exactly what happened.

A few weeks after our shoot, a woman named Jennifer fell in love with Quincy, another Calhoun longtimer and one of my models. Jennifer lived in Colorado, and the shelter was a bit hesitant to send any animal to that state because they didn't have a local network to fall back on, should things go awry. Calhoun decided to take a chance on Jennifer, who seemed perfect. Jen was about to make the drive to pick Quincy up when she showed the shelter's website to a friend, Mariel. Later, Mariel told the shelter that Lady O had taken her breath away in the photos, and she'd known right then that she and Lady O were meant to be together. This had been Lady O's only chance at adoption in two years, and the shelter's staff decided it was worth the risk. Jennifer drove Lady O, Quincy, and Arlo the cat, three longtimers, back to Colorado with her. There, Mariel welcomed her new best friend. She introduced Lady O, now named Willow, to the horses next door and sent heartwarming pictures and updates. "Thank you for caring for Lady O for so long until we found each other," Mariel wrote. "She's already turned into a couch potato and is so good with her kitty sisters."

Three weeks later, a shattering email appeared in my inbox: *Emergency! Any rescue contacts in Colorado?* Mariel wanted Willow out. The Alabama shelter was distraught. Willow had unexpectedly started showing a little too much interest in her feline sisters, although at the shelter she ignored cats. Was it just a game of chase, a temporary thing, or was it about to escalate? Regardless, Mariel refused to take a chance and demanded Willow be removed from her home immediately or she'd bring her to a local shelter. The

Alabama staff was at a loss for a solution, especially knowing that local shelters would most probably euthanize a dog like Willow because of her kennel behavior. Jennifer, Quincy's adopter, jumped in and agreed to help coordinate a network of people in Colorado for Willow. After a couple of stressful months and several foster homes, Willow was adopted again. But her journey wasn't over yet.

Aiste and Aurelijus had a rambunctious nine-month-old pit bull named Dozer, who was in serious need of a companion and playmate. They decided to adopt and came across an ad for Willow. The couple were intrigued and reached out to Willow's foster. Soon after, a meet-and-greet was arranged in a park, and the two dogs hit it off immediately. "Dozer was so happy!" his dad remembers. "He was completely mesmerized by Willow. He would not leave her side even for a split second. It was so adorable! He and Willow played for thirty minutes straight. They were a perfect fit. The home visit went even better. It was so funny watching them 'kiss' for two hours! Dozy didn't care about his toys or his food. His attitude was, *Whatever you want, just play with me.*"

After two successful meetings, Willow moved in. For the next few weeks, everything was going great and it seemed Willow was finally home. Then things slowly started deteriorating between her and Dozer. Willow was becoming cranky and possessive with food and toys. One morning, the two dogs were playing downstairs when their humans heard a scream. Dozer came running to them and a piece of his cheek was missing. The incident was, understandably, so upsetting that the couple decided it was best to give Willow back before things got out of control.

"That week, we agreed to keep Willow because everyone was out of town or busy, and we didn't want to bring her to a shelter," said Aiste and Aurelijus. "She had been through enough in life: so many shelters and homes. We decided to keep her for a few more days, until we could find a solution. But a few days later, we had changed our minds and things were back to normal. Time went on, and suddenly Willow started acting up again. But this time, we were smarter. We decided to work with

a trainer, and he asked us, 'Have you considered that maybe Willow is tired of Dozer?' We decided they were probably not a good fit, and we told the rescue people that we wanted to give Willow back. Once again, by the end of the week we had changed our minds.

"We started questioning ourselves instead of blaming Willow, and it became clear to us that Dozer, our eighty-five-pound puppy, was the one in need of training and learning Willow's boundaries. We hired a trainer again and educated ourselves. We should have done that much earlier. Willow became a big sister that took on the huge responsibility to teach her brother a few things about being a dog. Everything is great now! They play, but Dozer also respects when she doesn't want to be bothered anymore. They've become more social with other dogs, too. They cuddle and lay together by the fireplace. After all the worry, twisting our brains, we really didn't want to give her up. Today, we are proud of ourselves for not giving up and for being opened to learning in this process."

The couple sent me adorable photos of the two dogs together: hugging, playing, or just giving the camera a stink eye (the mafia shot, they call it). Two peas in a pod. On a video, both dogs appear playing in the snow, and I can see how Willow would have been frustrated. Dozer has some serious moves! He engages, retreats, hops around, incredibly smart in his moves, dodging her grasp constantly and making her head spin. At six years old, Willow, who is much slower and less enthusiastic about the whole routine, seems a very good sport.

Before talking to Aiste and Aurelijus, I was very concerned about Willow. The thought had crossed my mind that she might have been euthanized or might have ended up in a less fortunate situation. But after our phone conversation, my heart burst with happiness for Willow, and I immediately forwarded a warm update to her people back in Alabama. Lady Willow, as I like to call her now, is home. One of the best parts of the story has been to hear that she's now comfortable being in her own kennel when her parents are away. No more barrier aggression. She actually enjoys having her own woman-cave, and, no doubt, a quiet retreat away from Dozer.

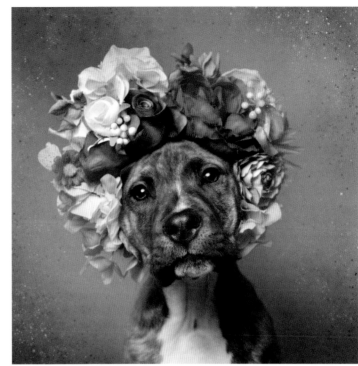
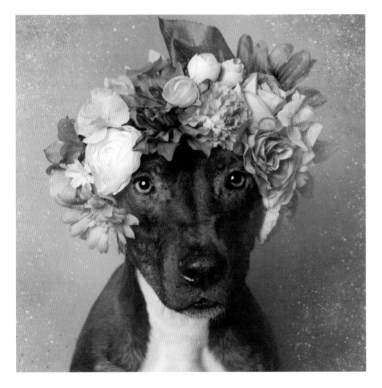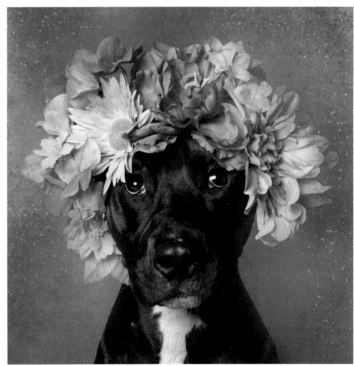

Duncan, 2017
Adopted
Animal Haven, New York

Devon, 2015
Adopted
Animal Haven, New York

Dan, 2016
Adopted
Mr. Bones & Co., New York

Midnight, *2015*
Adopted
Mr. Bones & Co., New York

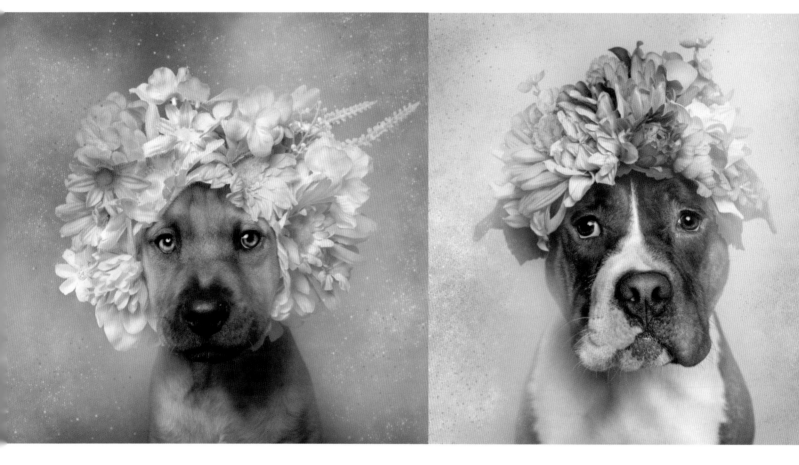

Astro, 2015
Adopted
Mr. Bones & Co., New York

Big Papa, 2014
Adopted
Sean Casey Animal Rescue, New York

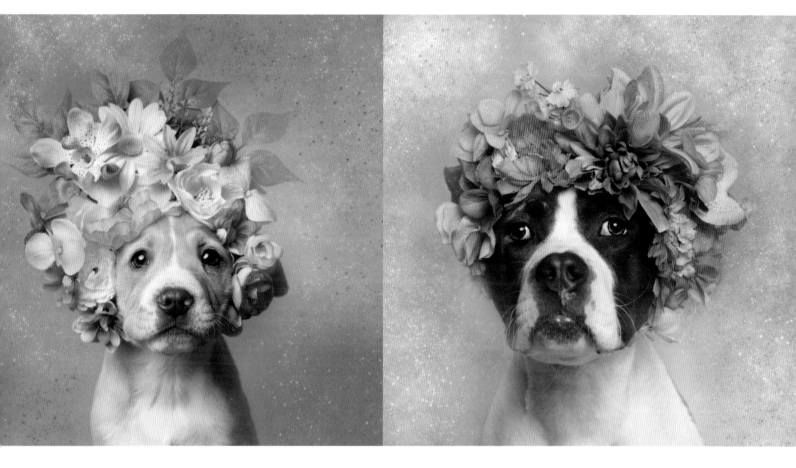

Chandler, 2016
Adopted
Mr. Bones & Co., New York

Minnie, 2015
Adopted
Mr. Bones & Co., New York

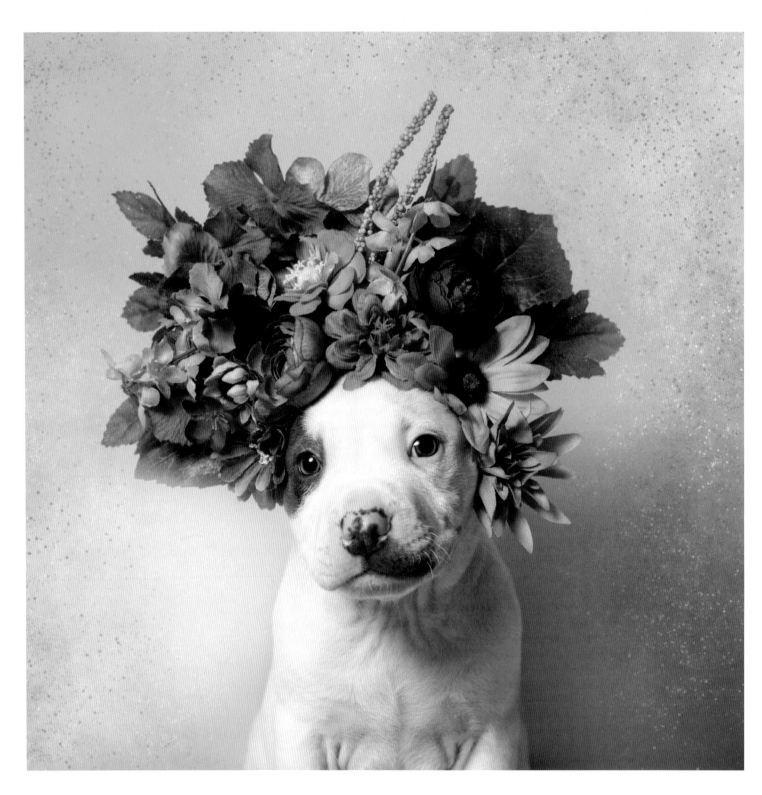

Doritos, 2017
Adopted
Luvable Dog Rescue, Oregon

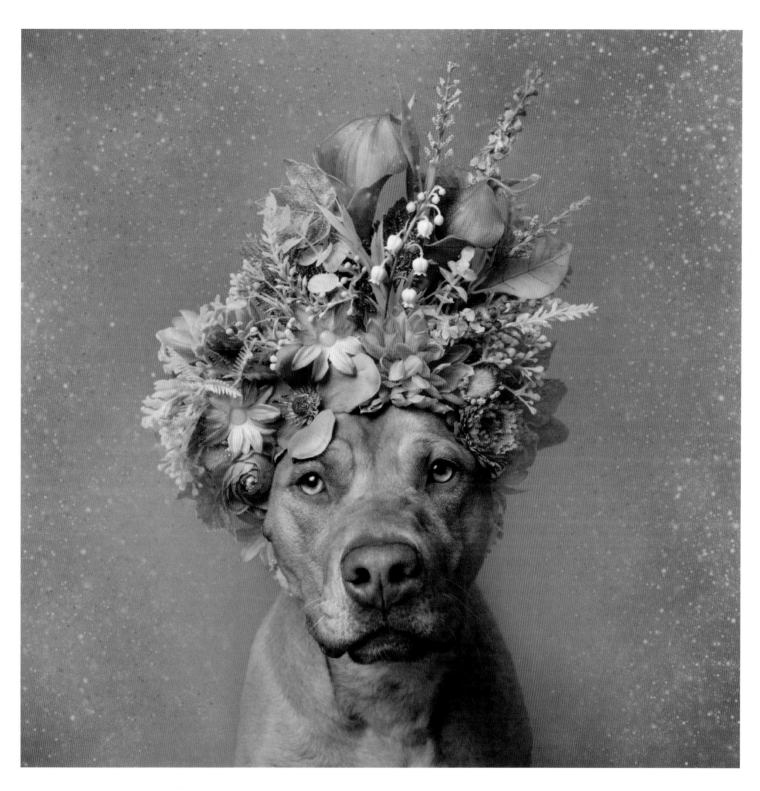

Nancy, 2017
Adopted
Miami Dade Animal Services, Florida

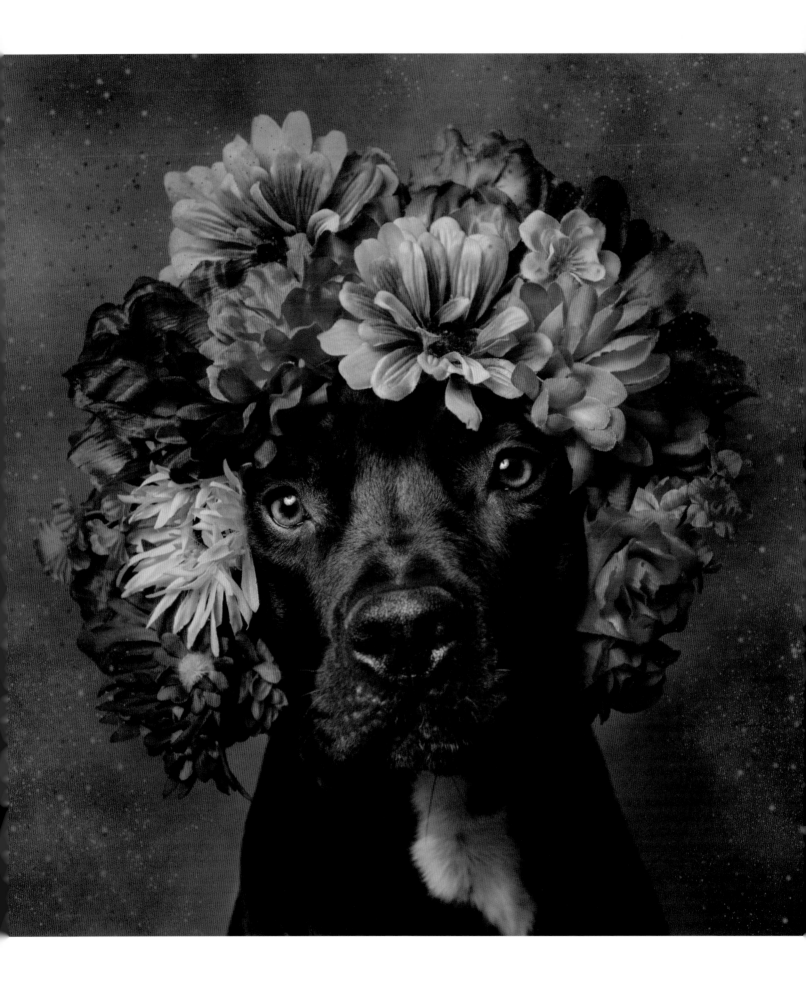

MIDNIGHT

2015, *Adopted*
New York

Out on a walk, Samantha noticed a black pit bull wearing an old muzzle held together by duct tape and tied to a pole. She waited for signs of an owner, and when nobody showed up she took the dog to the vet, who successfully scanned him for a microchip.

Samantha contacted the number registered on the chip and talked to a woman who explained that the dog was her son's and that her building had threatened to evict them after finding out they owned a vicious dog, a pit bull. The woman added, "God bless you for finding him."

Indeed, this was nothing short of a miracle. The family had shown very poor judgment leaving the dog exposed and vulnerable in that part of Brooklyn, where he was at the mercy of all sorts of potentially ill-intentioned people. They had discarded their family pet like an old mattress. Samantha was furious. She asked if there was a particular reason they had left him muzzled, and the woman stated that he was very sweet but that they "didn't want to take a chance." Samantha named the gorgeous black dog with piercing eyes Midnight and decided to foster him until he found a home.

The first night, Midnight growled at Samantha's husband, Josh, who, understandably, asked that they sleep with the lights on. The couple knew nothing of the dog's past and temperament, but it quickly became apparent that Midnight was terrified of men, especially when they reached out to touch him. His first response would be to cower, shake, and pee himself, but if they kept trying he would "muzzle punch" them, telling them to back off. Samantha remembers it was nerveracking walking down busy streets in Brooklyn, because she didn't know who would get too close and cause him to react. He was also dog-selective, which turned out to be because he wasn't socialized and had no idea how to act around other dogs. "He was also allergic to everything under the sun, including human dander," Samantha explained. "Basically, this dog was going to be a lot of work behaviorally and medically expensive."

Samantha and Josh agreed they wouldn't keep Midnight, but after months of inadequate adoption applications, they started wondering if they would ever find an adopter who'd be up to the challenge. Meanwhile, Midnight became Samantha's shadow, following her everywhere. Finally, she found a promising applicant. On the first meeting, Midnight tried to bite the man. But three meet-and-greets later, everyone agreed the adopter was a great fit. As the day approached when Samantha was to bring Midnight over to his new home, she started having cold feet. She couldn't do it. Finally, she called the man and said, "I'm sorry, I can't let Midnight go." The man, to her surprise, answered, "I have been waiting for this phone call. I think it is meant to be."

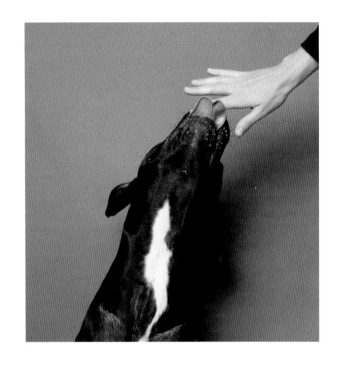

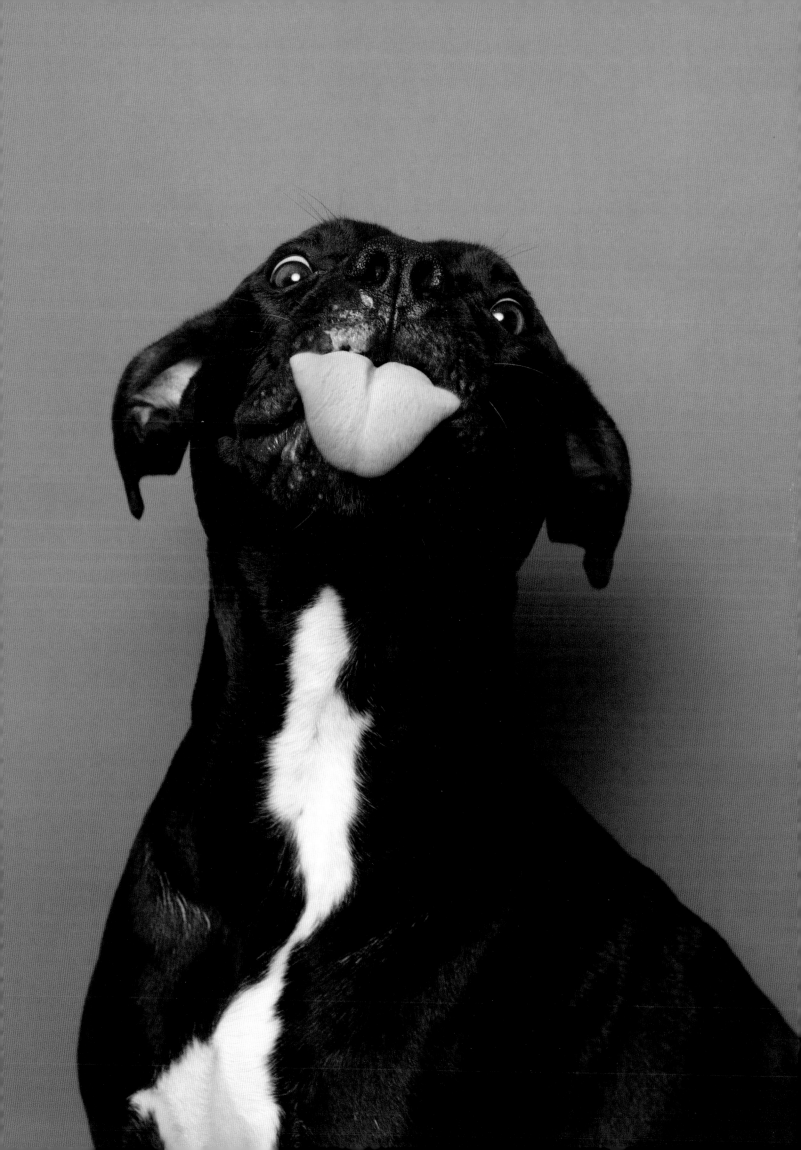

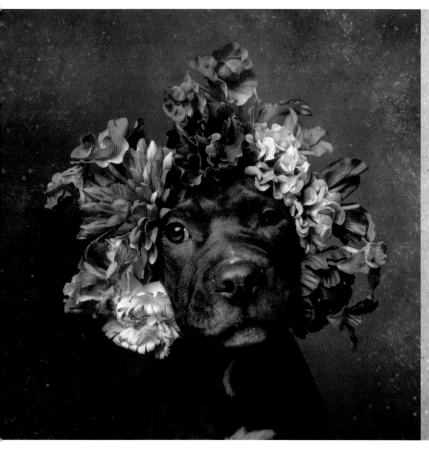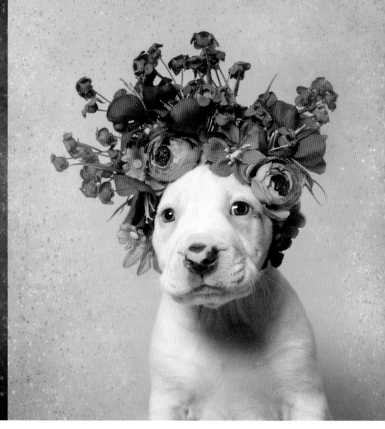

Dax, 2015
Adopted
Mr. Bones & Co., New York

Sunchip, 2017
Adopted
Luvable Dog Rescue, Oregon

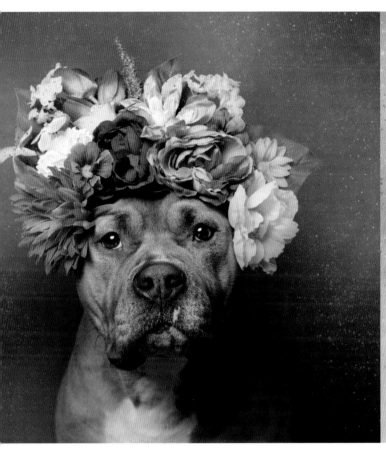

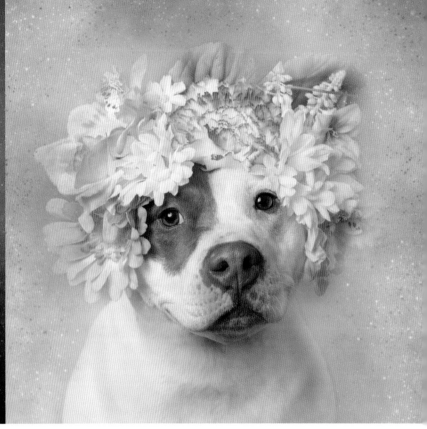

Billy, 2016
Adopted
Beastly Rescue, New York

Parmalee, 2015
Adopted
Town of Hempstead Animal Shelter, New York

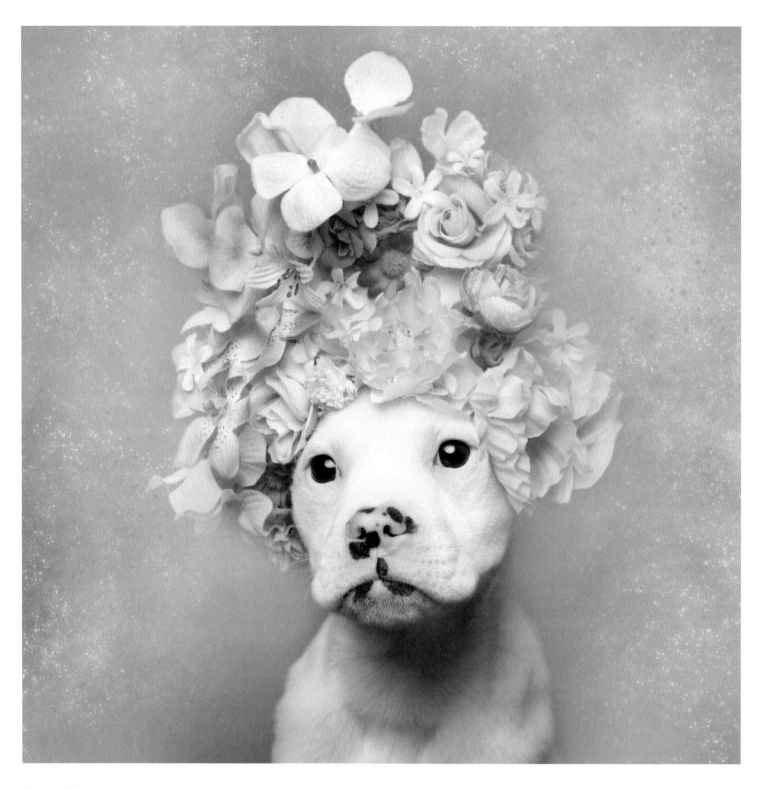

Tucker, 2016
Adopted
Mr. Bones & Co., New York

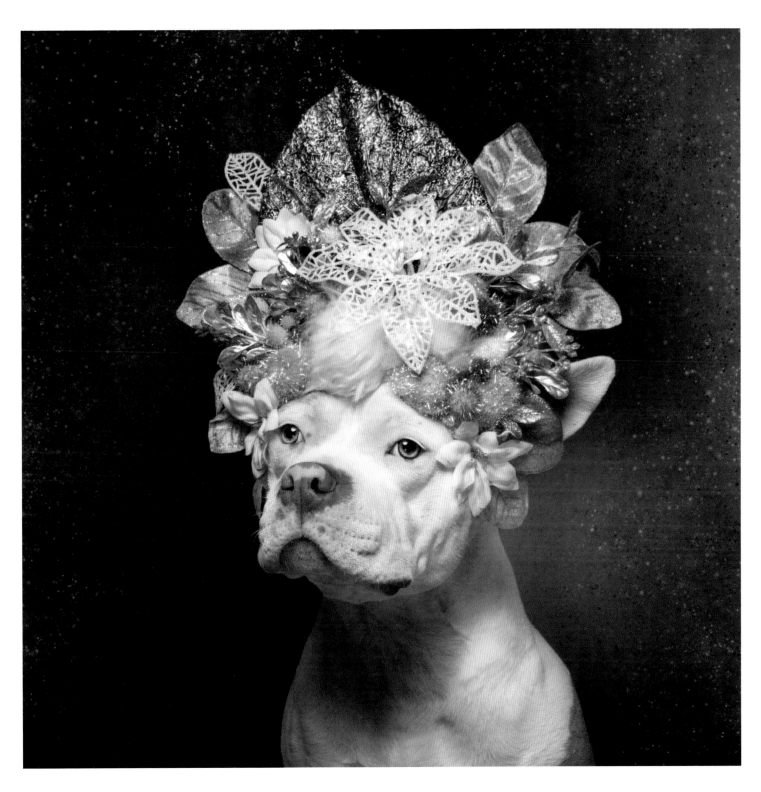

Sunshine, 2017
Adopted
Rebound Hounds, New York

Polar Bear, 2017
Adopted
Central Missouri Humane Society, Missouri

Paula, 2016
Adopted
Mr. Bones & Co., New York

Dodger, 2016
Adopted
Austin Pets Alive, Texas

Hope, 2016
Adopted
Richardson Animal Shelter, Texas

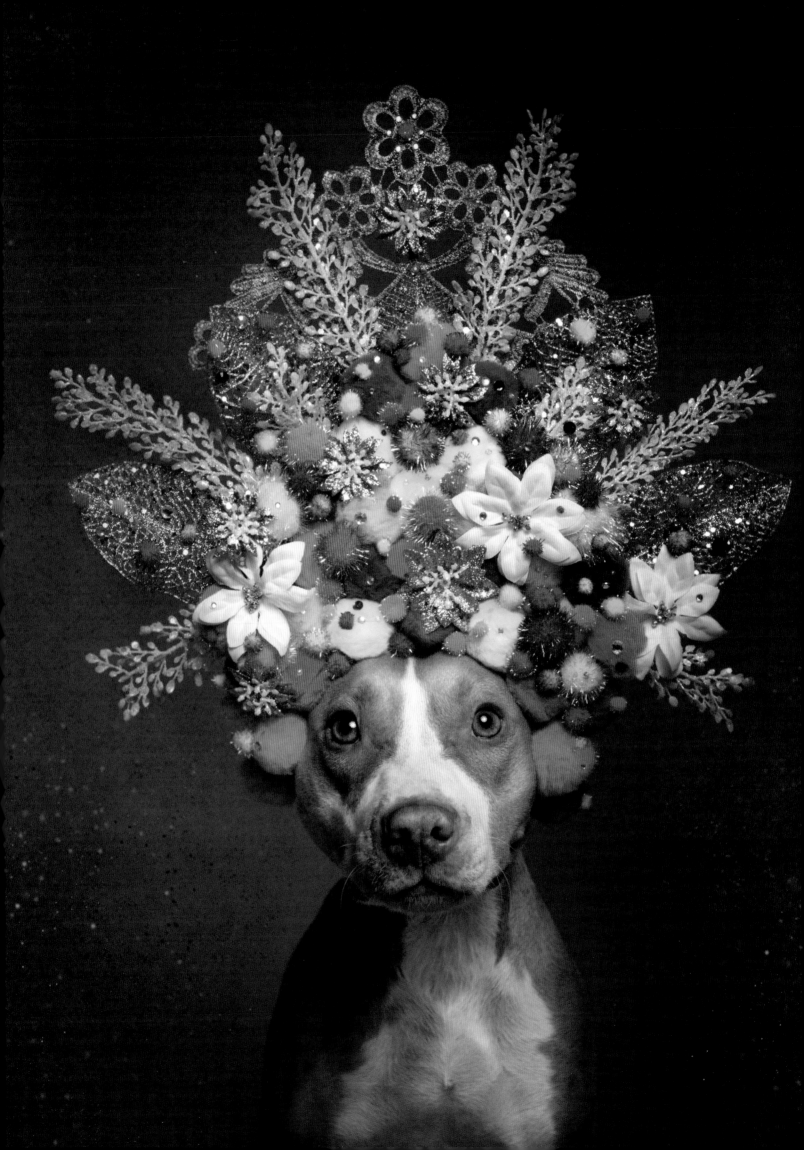

FRIDA

2018, *Adopted*
Riviera Rescue, Mexico
Animal Haven, New York

Frida came from an impoverished neighborhood in Mexico. A volunteer at a local spay-and-neuter initiative found her in front of a house, dragging her back legs. Her owners claimed not to know how she'd become paralyzed but they still had plans to breed her because, the wife explained, Frida was special, and a local vet had assured them she could carry the pregnancy to term, despite her paralysis. The volunteer convinced the owners to let him take Frida in for a medical checkup. Exams revealed that Frida had very bad pyometra, a life-threatening infection of the uterus. She immediately underwent a spay procedure that saved her life.

For the following months, the group continued to tend to Frida, bringing her to physical therapy in the hopes she might walk again. Unfortunately, she didn't improve and her owners decided to surrender her. Soon after, she was transferred to Riviera Rescue.

A wonderful man named Matteo runs Riviera Rescue. Years ago, he fled the violence of his hometown to isolate himself in the jungle. Matteo found his calling when he encountered an injured dog and saved his life. Since then, this gentle soul helps the "unadoptables," as he calls them: animals who are gravely sick or injured; the ones people usually turn away from. Matteo nurtures them back to health and adopts them locally or via his international rescue partners in the United States and Canada. The man also has a dream to create a large rescue-and-rehabilitation center for animals in Mexico. For now, he lives modestly, surrounded by the animals he rescues and surviving thanks to the few private donations he receives and the beautiful pet portraits he paints for clients.

While preparing for what was supposed to be a relaxing family vacation in Mexico, I researched local rescues I might help and found Riviera Rescue. Matteo agreed to meet me. When the day came, he picked up my husband and me and drove us to his compound in the jungle. He had about fifteen dogs in various stages of rehabilitation, most roaming freely and following him around like a happy pack, some hopping on three legs. Matteo also cared for opossums and a raccoon, who was later successfully released into the wild but kept returning to the compound.

We toured the rescue, pursued by mosquitos and the unbearable humidity. Inside one of the enclosures, two rambunctious puppies danced around us, and a gorgeous red pit bull shuffled toward us. "This is Frida," said Matteo. He explained her past. Frida had been waiting for nine months at the rescue. There was little hope of her getting adopted.

Frida dragged her legs over the difficult jungle terrain all the way to a dirty mattress at the back of her enclosure. Matteo had recently found the mattress and was excited to provide a comfortable bed for his Fridita, whom he loved dearly. Above us, monkeys rustled in the trees. My heart fluttered. I sat with Frida, whose tail hadn't stopped wagging. She stretched out her paw to beg me for belly rubs. The two black puppies who shared her enclosure were bouncing off her; she was unfazed, with a huge Buddha-like grin on her face.

There was something incredibly poignant about Frida and her desperate need for human contact. I knew I couldn't leave her behind, and her intense gaze made me want to move mountains for her. Before her, I'd always helped and supported the work of rescuers, but had never taken the lead on a case. For the next couple of days, I reached out to my network, and my rescue friends offered their help. In particular, Animal

Haven in New York agreed to be my backup. Without their support, I don't think I would have dared the undertaking.

A couple of weeks later, Frida, personally escorted by Matteo himself, flew to New York, where I welcomed them. Frida stayed at Animal Haven for a few weeks, started physical therapy again, and moved in with us. MacLovin, my dog, was afraid of larger dogs. Frida eagerly kissed him until he fell in love, and the two became an adorable yet unlikely pair. MacLovin taught Frida how to use toys (or rather, how to not touch his). They played constantly—there was nothing cuter than Frida's play bow, and Mac seemed to understand Frida couldn't chase him. He'd roll next to her and play at her level as she nibbled his neck gently.

The three of us could be seen on the streets of Brooklyn with Frida's stroller, Mac often hitching a ride. I took Frida on the subway to her therapy appointments. Everywhere and with everyone, she shone. Several times, we were stopped by people asking "Is this Frida?!" She'd become a celebrity on social media.

Frida hated being alone. At home, if we moved to the other side of a room, she'd sit on the edge of the rug and cry for us with the strangest voice I'd heard, a mix of Chewbacca and what I imagine a chorus of baby dinosaurs might sound like. I built a "rainbow road" of children's mats to cover our hardwood floors so Frida could navigate the place as she pleased. All she wanted was to be wherever we were. She craved bodily contact. She'd lie at our feet and grab our legs with her paws; then, maintaining deep, loving eye contact, she'd slowly draw our feet in closer, hugging us with all her strength. It was fascinating to see her use her front legs to communicate, like human hands.

One night, I dreamed that Frida had gotten a set of wheels and was running freely and happily toward the horizon, without looking back. I woke up in tears, incredibly happy for my girl and heartbroken to think that she was running toward her real family and our days together were numbered. When we finally received her custom-made pink wheelchair, my heart swelled to see her run for the first time in years.

A couple of months after Frida had arrived in New York, Animal Haven and I decided to accept adoption applications for her. I'd waited until then, wanting some time with her, but she deserved to move on. Almost immediately, I received a lovely note from Chelsea.

Something about Chelsea's message felt right—except for the fact that she lived in Ohio, hundreds of miles away from us, which meant I'd probably never see Frida again. Chelsea seemed equipped to deal with Frida's quirks, such as her reactivity with some people and dogs. I was also hoping for a quieter lifestyle for her, away from a big city, with a house and a garden to frolic in, all of which Chelsea and her boyfriend Daniel would provide. After many conversations and a virtual home visit, we decided to organize a meet-and-greet in New York. Chelsea and Daniel made the nine-hour drive from Ohio. Our rendezvous went so well that they returned home with Frida the next day. I said my goodbyes, drying a couple of tears on Frida's cheeks.

As the family's car drove away, I couldn't help but feel overwhelmed by the feelings I always have when a foster child leaves the nest. Did I betray Frida by giving her away to strangers, or the trust and love she'd placed in me? It took only a few hours for Chelsea, Daniel, and Frida to reassure me. In the photo updates they sent me from their road trip, Frida seemed already treasured and at ease. Soon after the family arrived home, Frida helped Chelsea pop the big question to Daniel, and he said *Yes!* Frida was already part of the family.

"The following weeks were filled with new experiences for Frida," Chelsea writes, "including choosing favorite toys, sleeping in Mom and Dad's king-sized bed, and eating meals out of puzzle feeders, to keep her entertained and stimulated. I adore the way Frida smells. Her attitude and personality embody the best parts of the foster and family dogs I have cared for in my lifetime. Late one night, Frida was feeling anxious, so Daniel took her to his car and drove her around the neighborhood until she fell asleep."

A few months later, Animal Haven took in Fede, another of Matteo's paralyzed rescues. In this way, Frida's legacy continues.

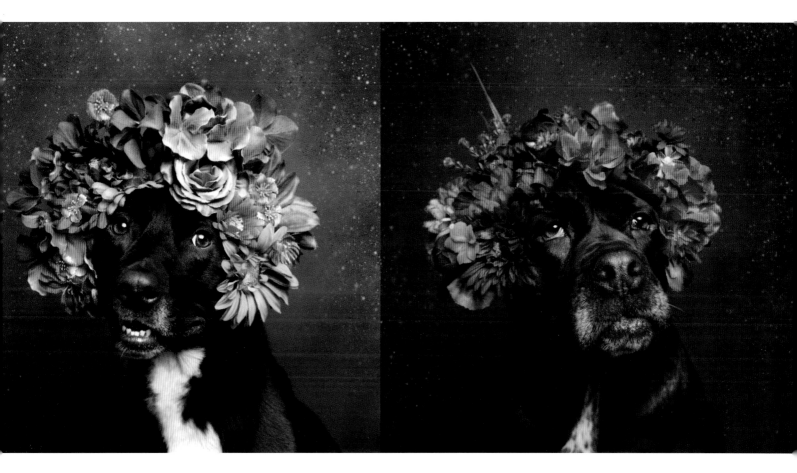

Kaylee, 2016
Adopted
Almost Home Animal Shelter, New Jersey

Baby, 2016
Adopted
Almost Home Animal Shelter, New Jersey

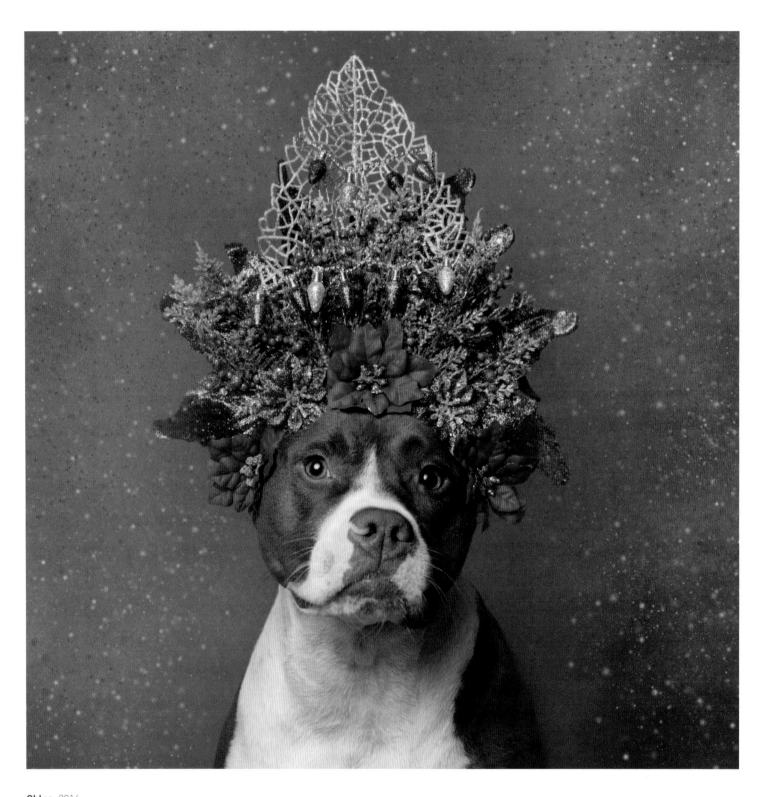

Chloe, 2016
Adopted
Mr. Bones & Co., New York

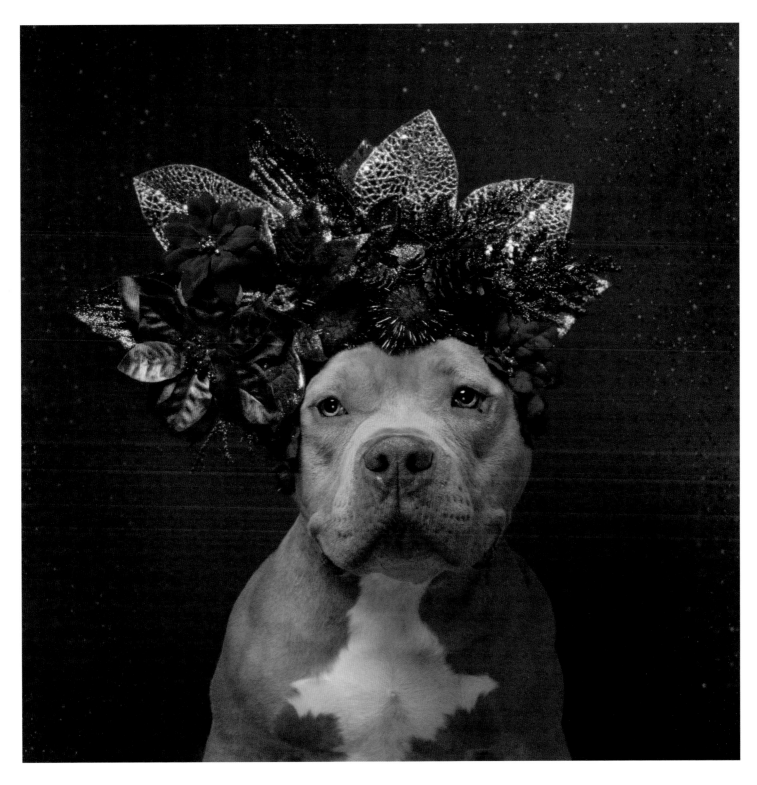

Willie Pep, 2017
Adopted
Hounds in Pounds, New Jersey

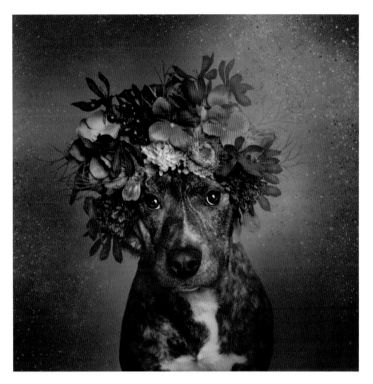
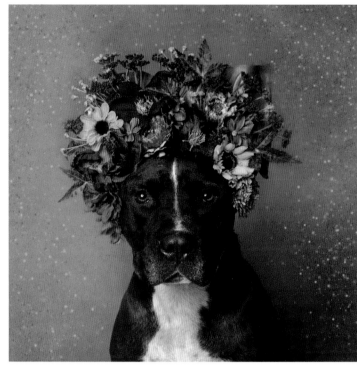
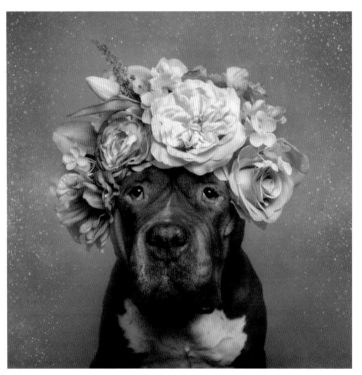

Payton, 2016
Adopted
Animal Haven, New York

Adelaide, 2016
Adopted
Animal Haven, New York

Jester, 2016
Adopted
Austin Pets Alive, Texas

Chopper, 2015
Adopted
Town of Hempstead Animal Shelter, New York

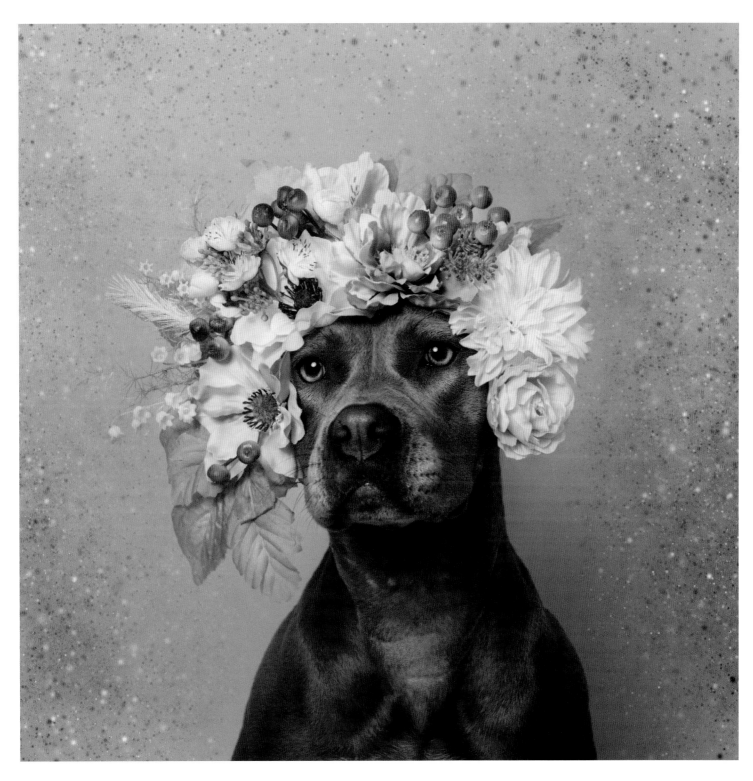

DeeDee, 2018
Adopted
DPFL's National Canine Center, Florida

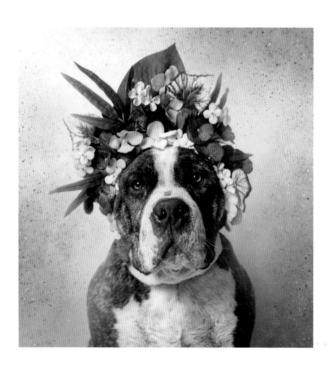

Luther, 2016
Still waiting
Luvable Dog Rescue, Oregon

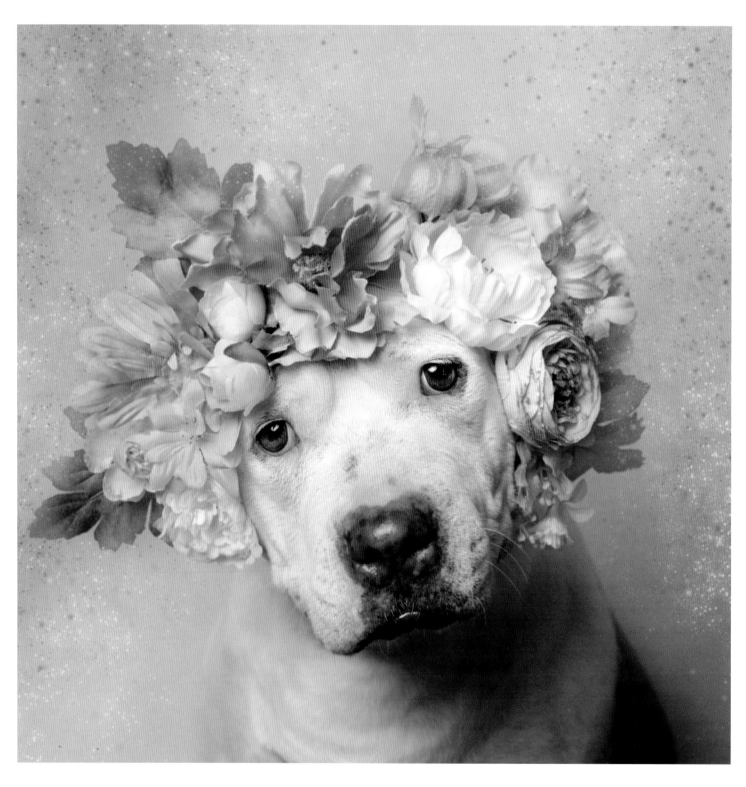

Creasy, 2015
Still waiting
AZK9, Arizona

Creasy and Sula were seized in a cruelty case and impounded for over a year as evidence against their owner. Animals who are held as evidence are usually kept in a state of limbo for extended periods of time. As was the case with Murdock (see page 128), Creasy and Sula couldn't be with the public or other animals, nor could they be adopted out. Evidence animals often spend most, if not all, of their days in their kennels. They are hidden away until their owner's case is resolved, which can take months or years. Meanwhile they become an invisible part of the shelter's population. In overcrowded shelters, evidence animals rarely receive the amount of care, attention, and socialization they need to recover from their past. This is a cruel procedure for these animals who are, in a way, re-victimized. By the time Creasy and Sula were released in 2012 and AZK9 pulled them into their

104

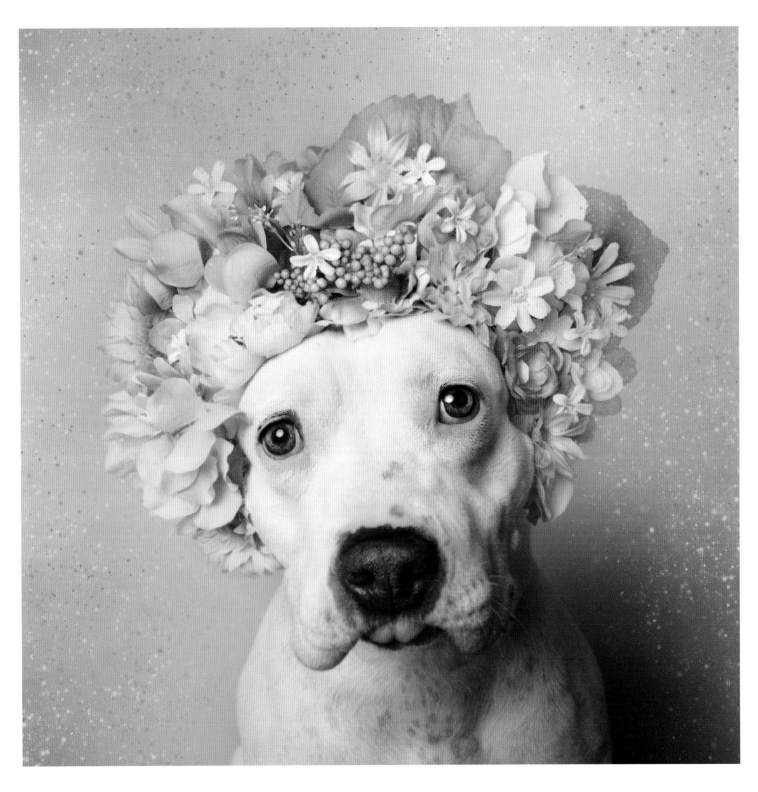

Sula, 2015
Still waiting
AZK9, Arizona

rescue program, they had serious health issues. They'd been kept strictly in an indoor kennel, and after a year in this state of isolation they had both deteriorated. Creasy, a senior, could barely walk, and Sula had developed an obsessive-compulsive type of behavior called shadow chasing. She would obsess over shadows and light. Both dogs had untreated advanced heartworm disease. The rescue nurtured them back to health and, since they were quite bonded, tried to adopt them together, without success. Creasy and Sula have now been waiting for a home for six years, and are available for adoption as a pair or separately.

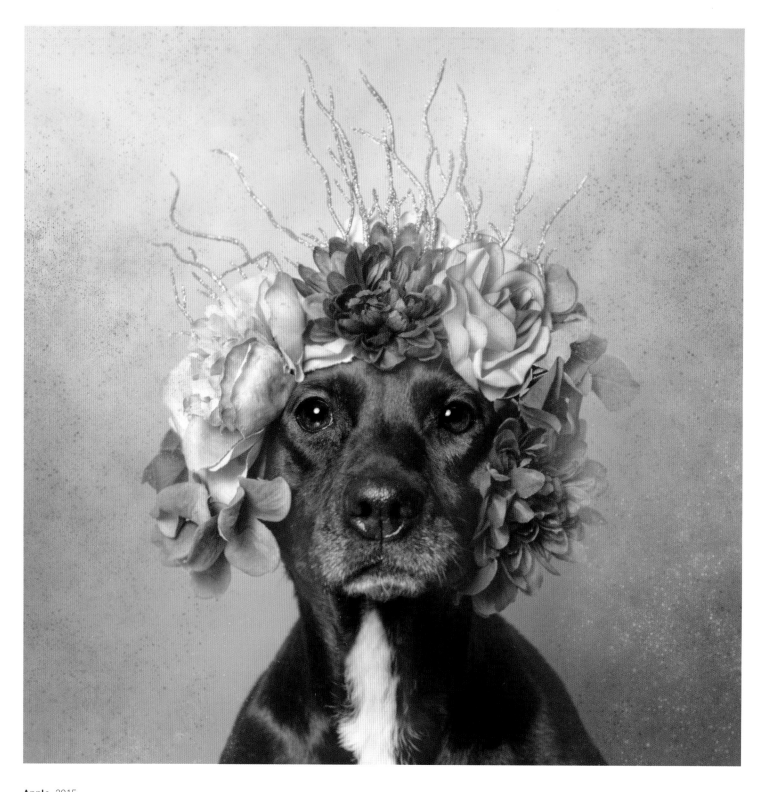

Apple, 2015
Adopted
Mr. Bones & Co., New York

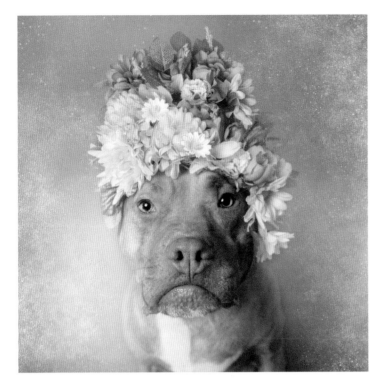
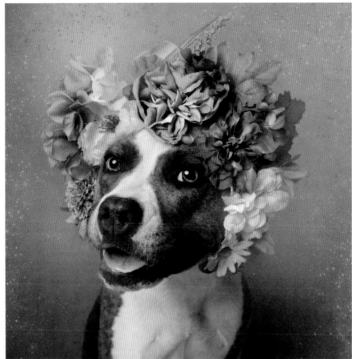
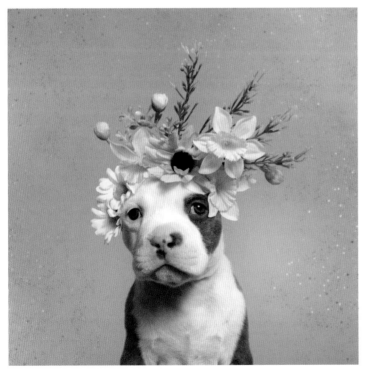
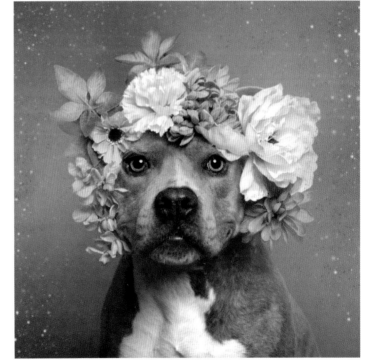

Cash, 2014
Adopted
Town of Brookhaven Animal Shelter, New York

Galveston, 2017
Adopted
Animal Haven, New York

Izzy, 2015
Adopted
MASH Unit, Arizona

Blue, 2015
Adopted
Town of Hempstead Animal Shelter, New York

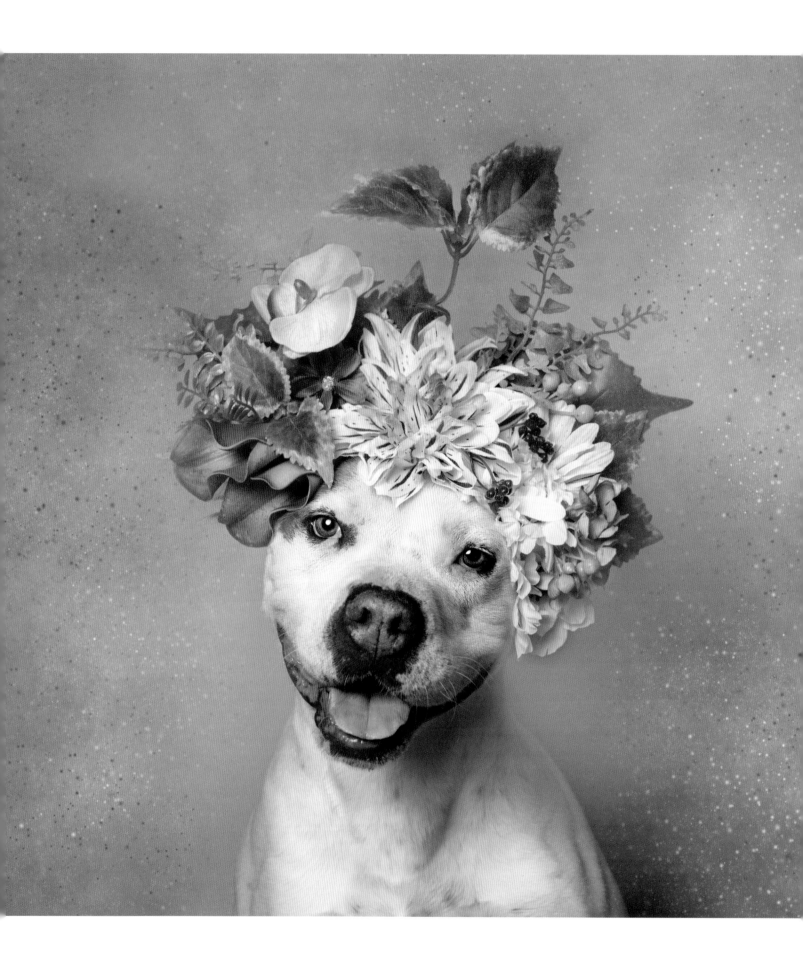

#1199475

2017, *Euthanized*
A municipal shelter, California

"Hi! #1199475 was one of my flower dogs from our shoot last week, but I can't find him on your website. Can you confirm his status please? I'd like to post him right away."

"We are very sorry to report that the dog that you're asking about has been euthanized."

I named him Flower after he died.

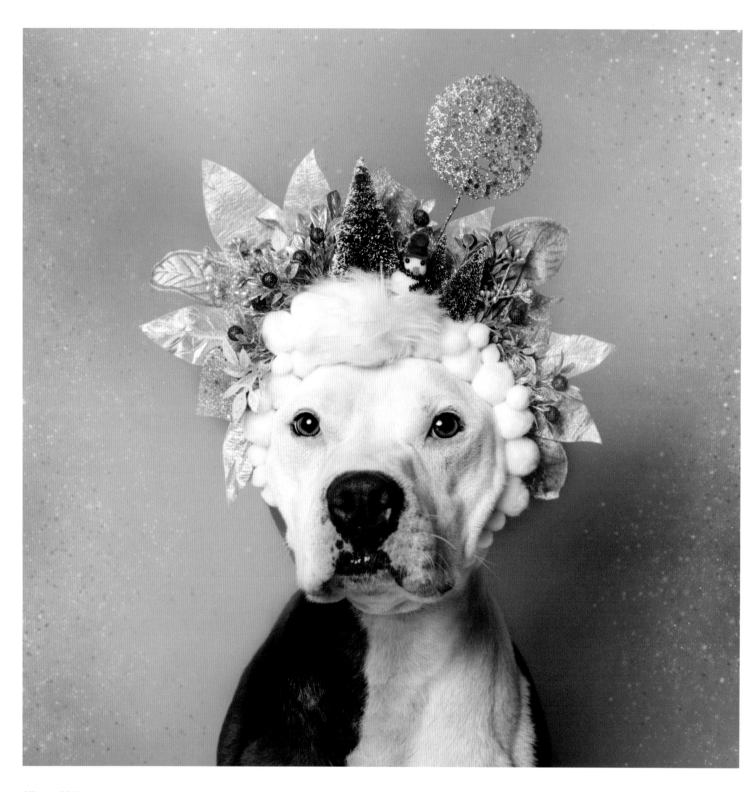

Gibson, 2016
Adopted
Austin Pets Alive, Texas

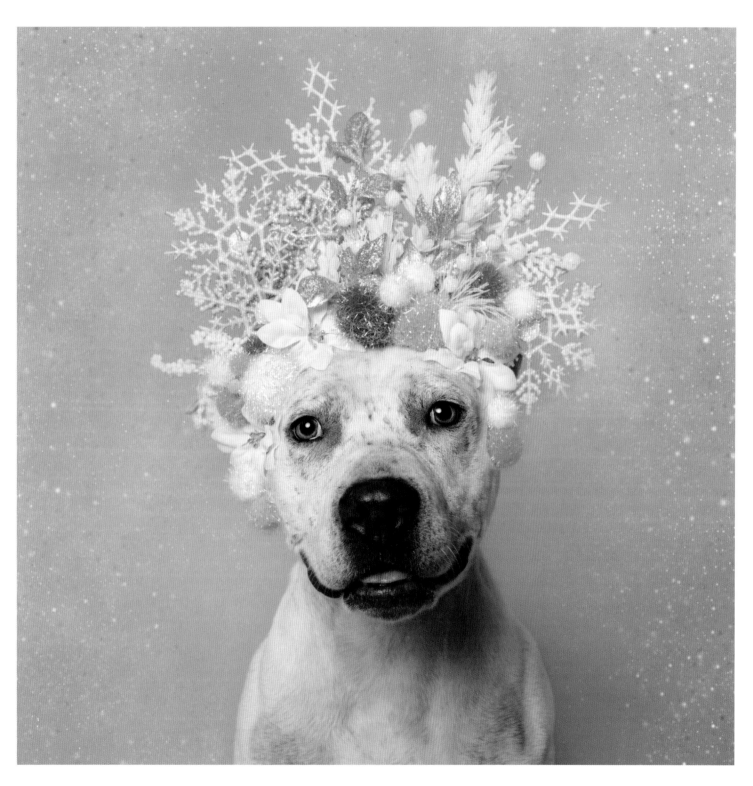

Icicle, 2016
Adopted
Austin Pets Alive, Texas

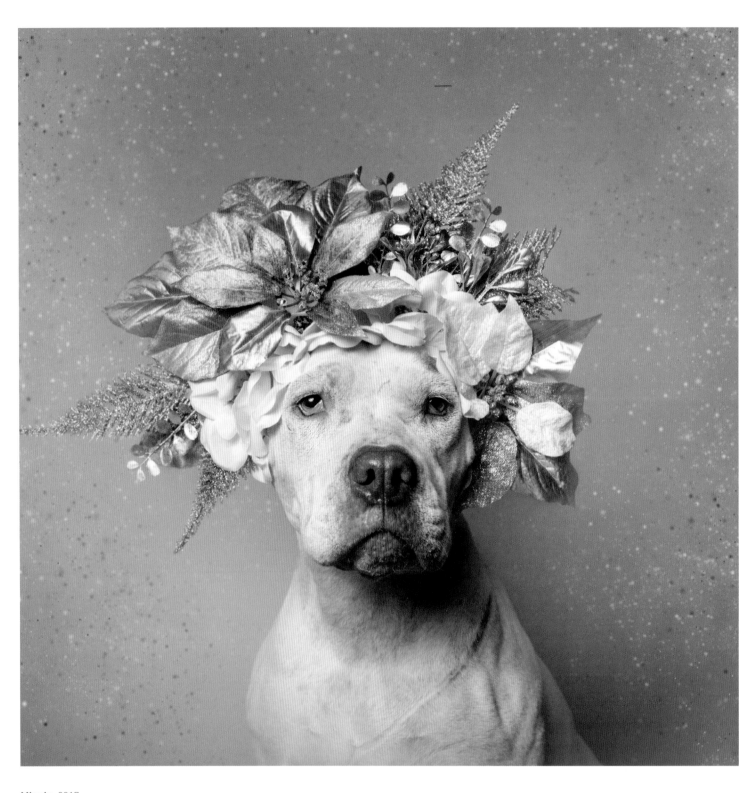

Minnie, 2017
Still Waiting
Hallie Hill Animal Sanctuary, South Carolina

Journey, 2016
Adopted
Luvable Dog Rescue, Oregon

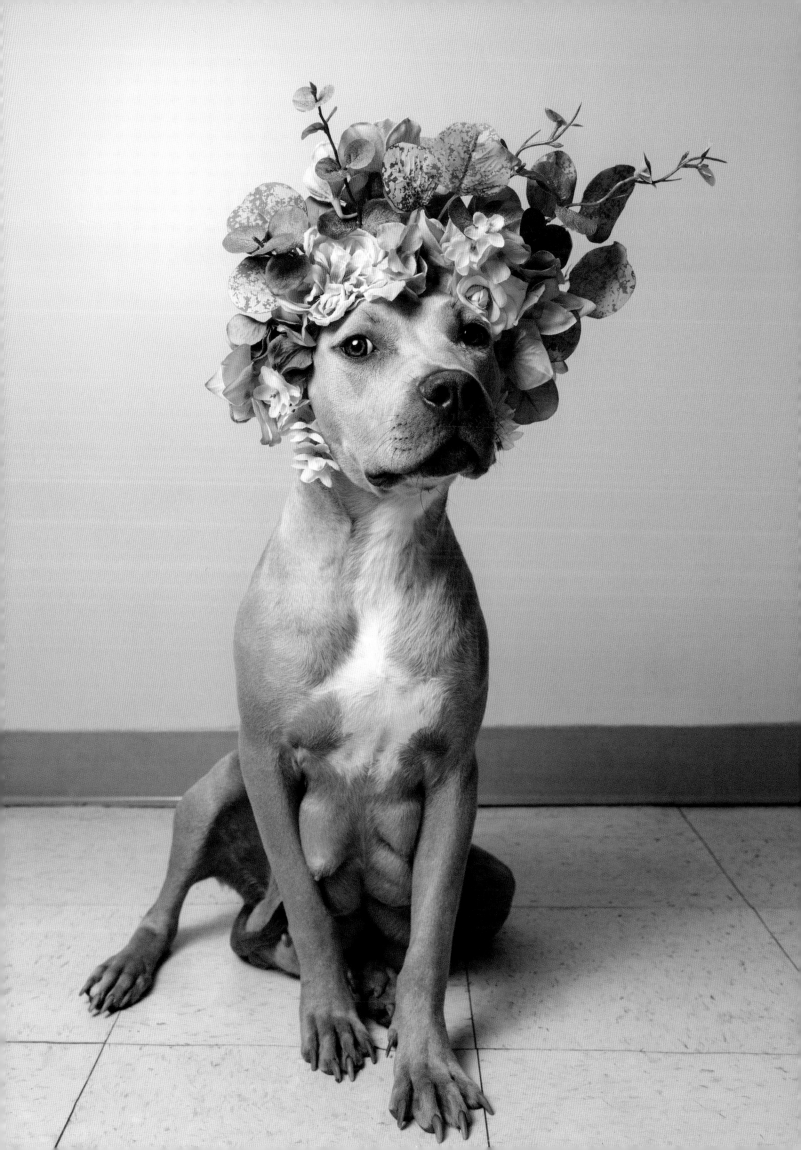

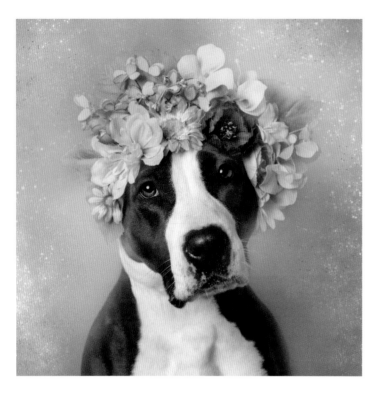
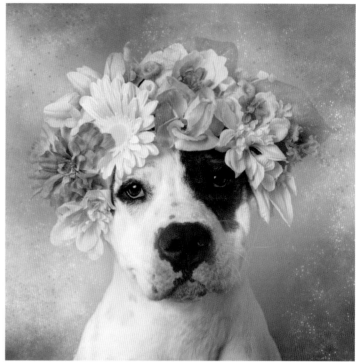
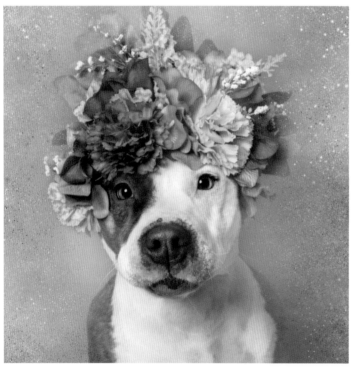
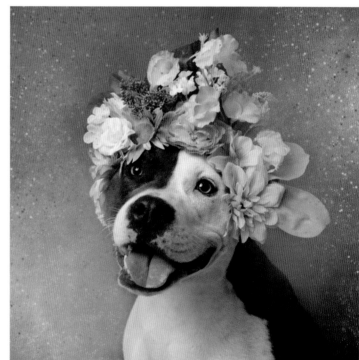

Remi, 2015
Adopted
Town of Hempstead Animal Shelter, New York

Coco, 2014
Adopted
Town of Brookhaven Animal Shelter, New York

Lilly, 2015
Adopted
Town of Hempstead Animal Shelter, New York

Giraffe, 2016
Adopted
Monmouth County SPCA, New Jersey

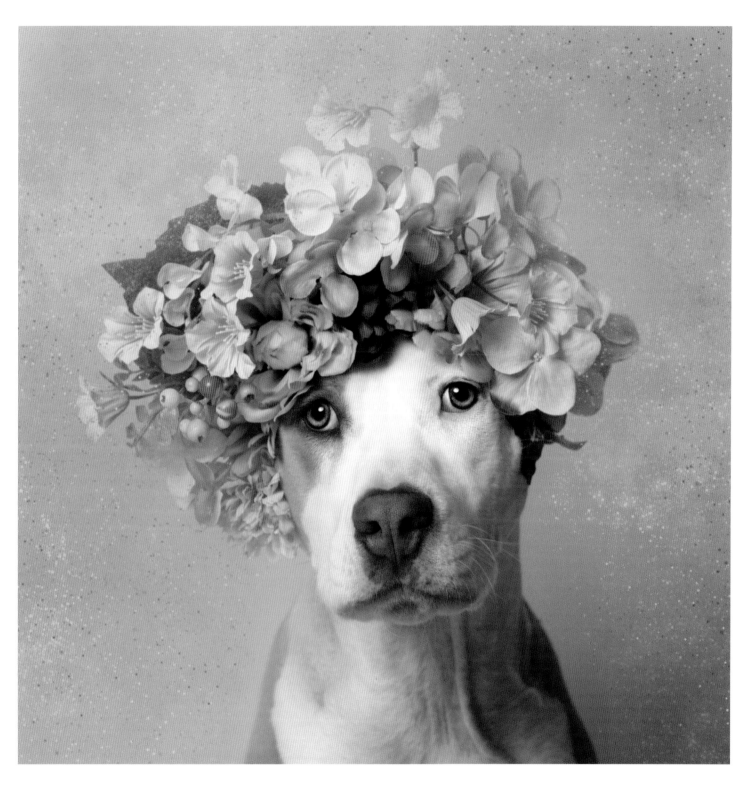

Stardust, 2016
Adopted
Luvable Dog Rescue, Oregon

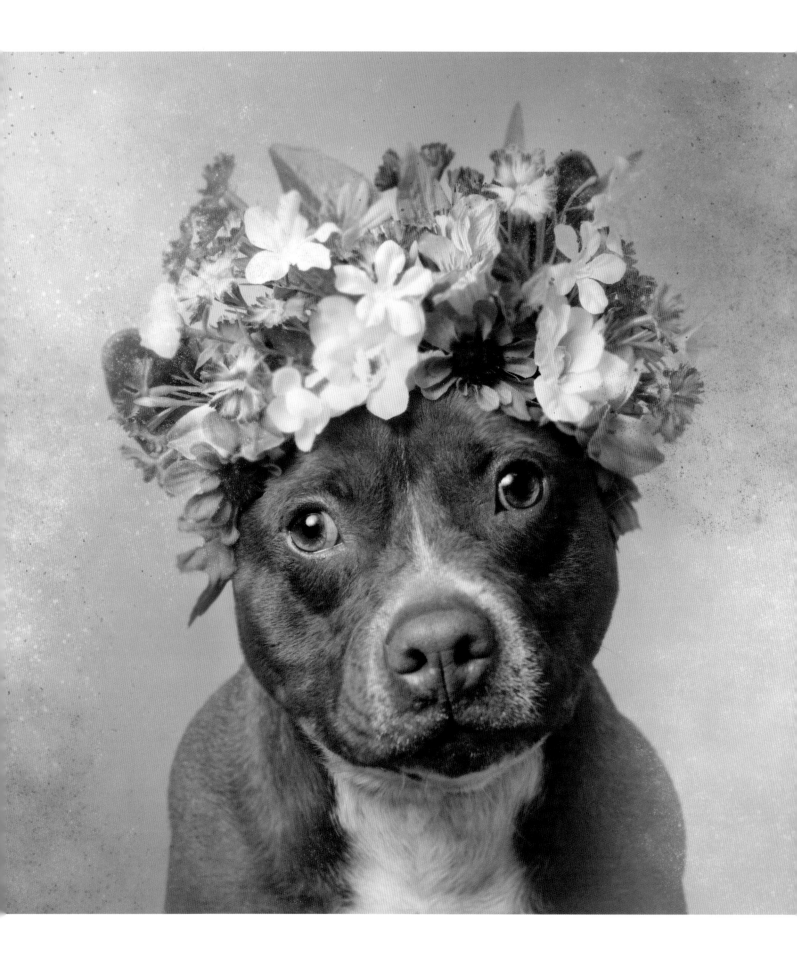

BROWNIE

2014, *Adopted*
Town of Hempstead Animal Shelter, New York

Shortly after my first *Pit Bull Flower Power* portraits came out, I received a plea for help from the Town of Hempstead Animal Shelter. A municipal shelter operating in an area plagued with cases of animal cruelty and dogfighting, Hempstead is always at full capacity, with mostly pit bull–type dogs.

Brownie was Hempstead's longest resident, having waited two years. The longer a dog waits in a high-intake shelter, the more invisible he or she tends to become. Despite the best efforts of the shelter staff, it's incredibly difficult to give each dog the exposure he or she needs to find a home. When you see Brownie's sweet face, it's hard to imagine how this petite chocolate princess waited so long. But had you seen Brownie in her kennel, you would have discovered another side of her. She had barrier aggression, which is when dogs guard their kennel. It often stems from the stress shelter dogs experience—exposed daily to the constant barks, the sea of smells, and the intense activity surrounding them. If you've visited a shelter before, you know exactly which dogs I'm referring to: loud ones, who bark threateningly at you and throw themselves against the bars, all teeth out. It's frightening. Some say it's the number-one reason dogs are euthanized in shelters.

Unfortunately, when a dog shows barrier aggression most adopters will pass over them quickly. Ironically, by rapidly moving on to the next dog, would-be adopters participate in reinforcing the behavior of these dogs,

because their barks chased the scary humans away. Often, as soon as you take these dogs out of their kennels, they are either extremely sweet and wanting nothing more than human contact and reassurance, or, like Lady O (see page 74), they're so terrified that they pancake (flattening themselves on the floor and making themselves as small as possible). Brownie was no exception to that rule. As soon as she stepped on set, she sat quietly and looked at me with soul-piercing eyes. For a girl who showed so poorly at the shelter, I knew Brownie's photos could be life-saving.

Brownie's *Pit Bull Flower Power* portrait became very popular. It's hard to resist that kissable face. It kept being shared again and again on social media. A couple of months after I photographed her, I received an email from John, who'd adopted her: "Your photograph of Brownie and her story did the trick. I've had Brownie living in my house for a little over three weeks now and she is a joy and so affectionate."

Over the following months John sent me the occasional update, and it was beautiful to see the love continue to blossom between the two of them. When BB, as Brownie was renamed, went blind a few weeks after moving in with John, he was devastated. However, BB continued navigating the world perfectly, as if nothing had changed. "I've discovered, with time, that BB is only part dog," John says. "She is also part frog, part reptile, part pig, part deer, and part human. She is the love of my life."

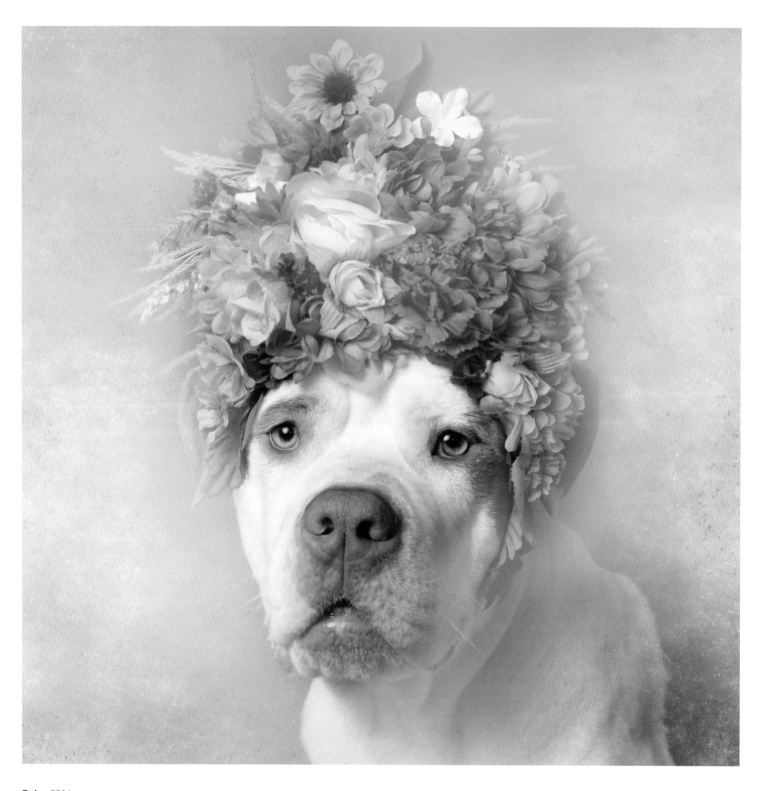

Baby, 2014
Adopted
Second Chance Rescue, New York

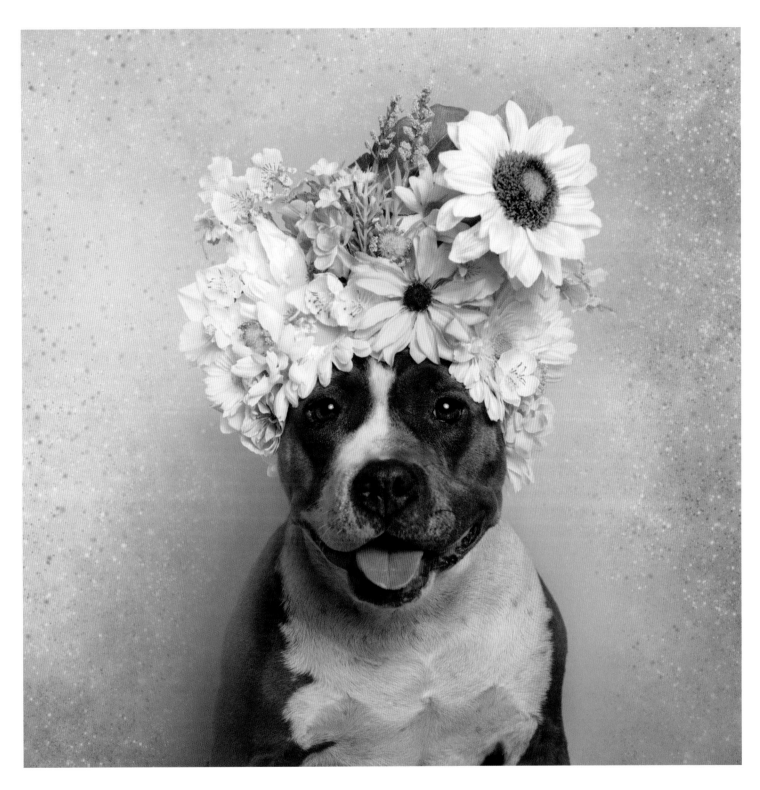

Wren, 2017
Adopted
Luvable Dog Rescue, Oregon

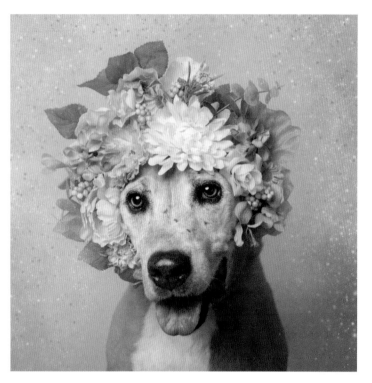

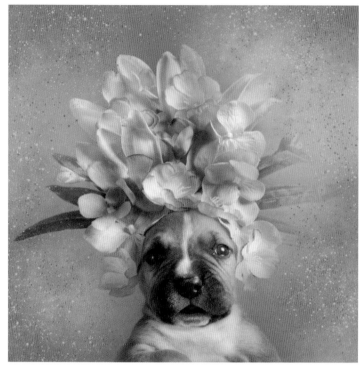

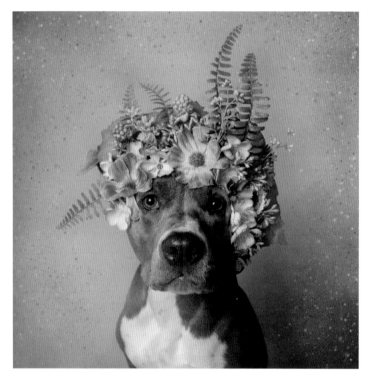

Penelope, 2015
Adopted
AZK9, Arizona

Patsy, 2016
Adopted
Austin Pets Alive, Texas

Ramble, 2016
Adopted
Luvable Dog Rescue, Oregon

Rocky, 2015
Still waiting
AZK9, Arizona

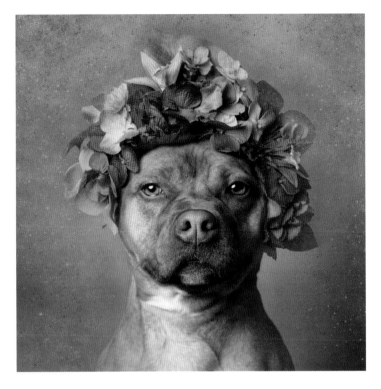

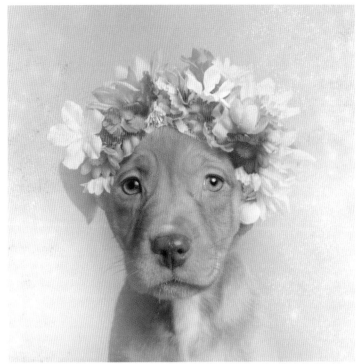

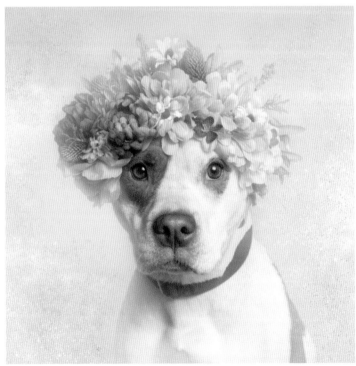

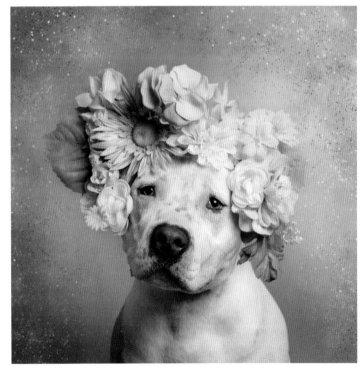

Apple, 2015
Adopted
Town of Hempstead Animal Shelter, New York

Styles, 2014
Adopted
Sean Casey Animal Rescue, New York

Rome, 2014
Adopted
Animal Haven, New York

Prada, 2015
Adopted
Town of Hempstead Animal Shelter, New York

ASHLEY

2017, *Adopted*
Miami Dade Animal Services, Florida

Things looked grim for Ashley after she'd been returned twice to the overcrowded Miami shelter. She was afraid of men and had run away from her adopters. She probably had post-traumatic stress from her past. She'd been seized, all skin and bones, during a cruelty investigation. Now, she needed someone who'd be patient and establish trust, someone like Elaine: "I saw Ashley's *Pit Bull Flower Power* portrait and I couldn't stop thinking about her. Ashley was challenging in the beginning. She was fearful and reactive on the leash. We worked on building a routine, acclimating her to her new life, and socializing her. We found a wonderful, kind dog trainer who really helped us. The first couple of days I had Ashley, I worried about her running away, but after the second day, she wouldn't let me out of her sight. Ashley loves the park and the woods. Although her pictures are glamorous, she loves the mud most. If there is mud, you can't keep her out of it. I did a DNA test for fun. Ashley is a cocktail! She is an American Staffordshire Terrier, American Bulldog, Shar-Pei, German Shepherd, Chow, and hound mix. She still has reservations about men, although we work every day to help her. This winter, she made friends with a neighbor who was here for the season. Once he cooked her steak, the deal was sealed. After the man went back to New York, she continued looking for him and salivating in his driveway."

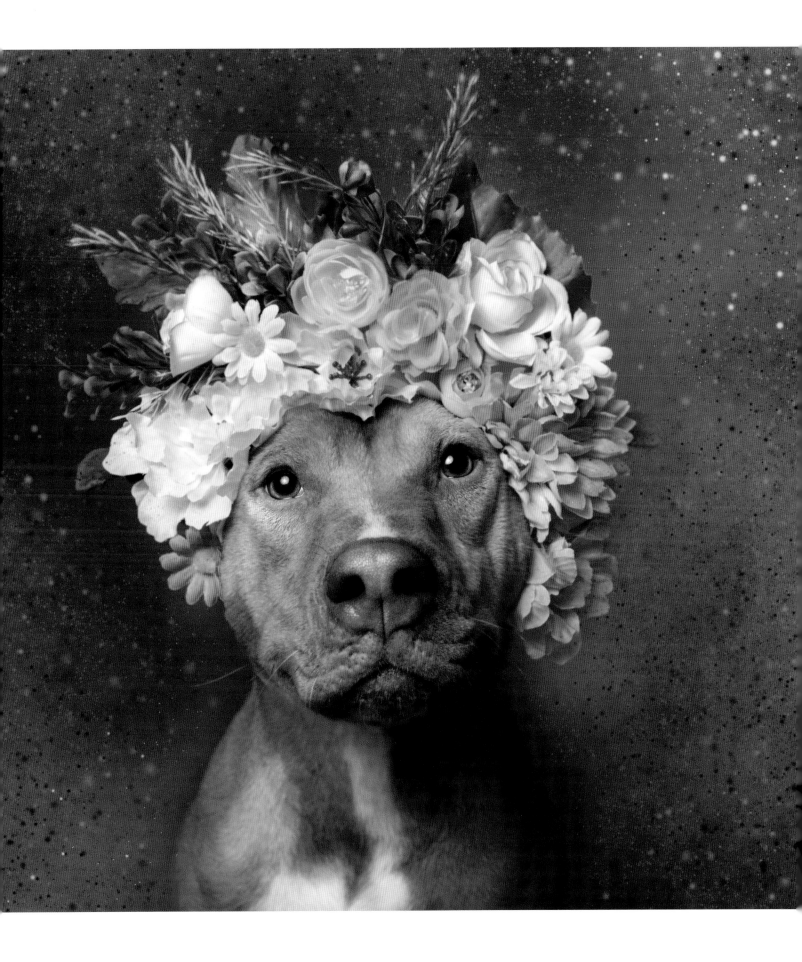

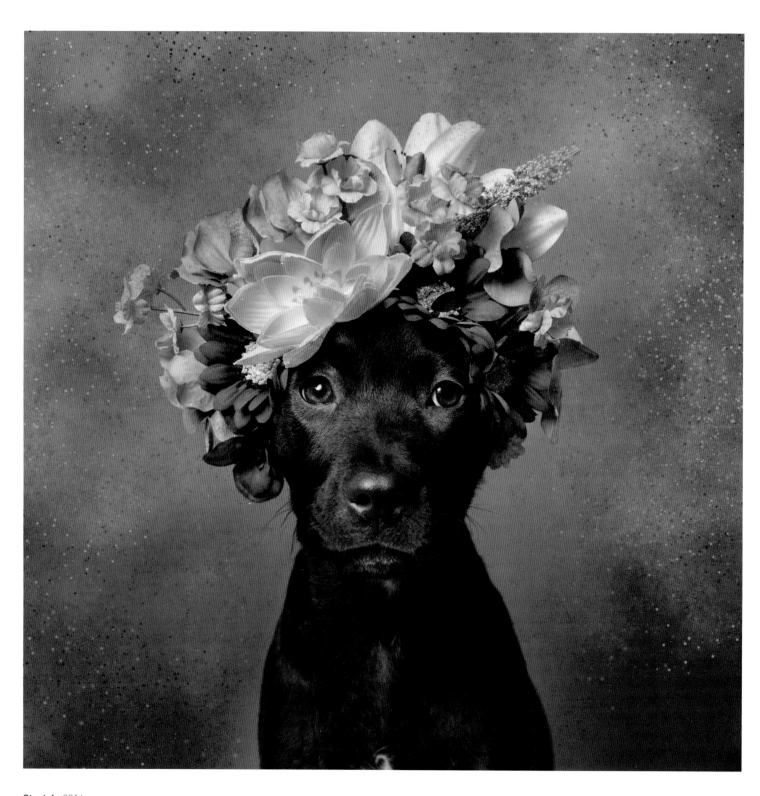

Stretch, 2016
Adopted
Stray Rescue of Saint Louis, Missouri

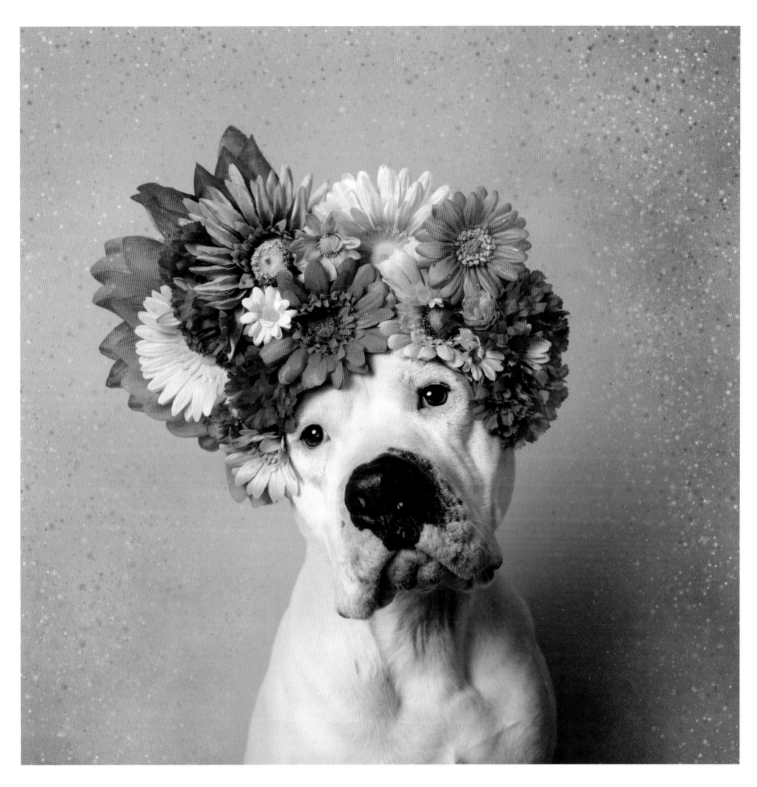

Hercules, 2017
Adopted
Miami Dade Animal Services, Florida

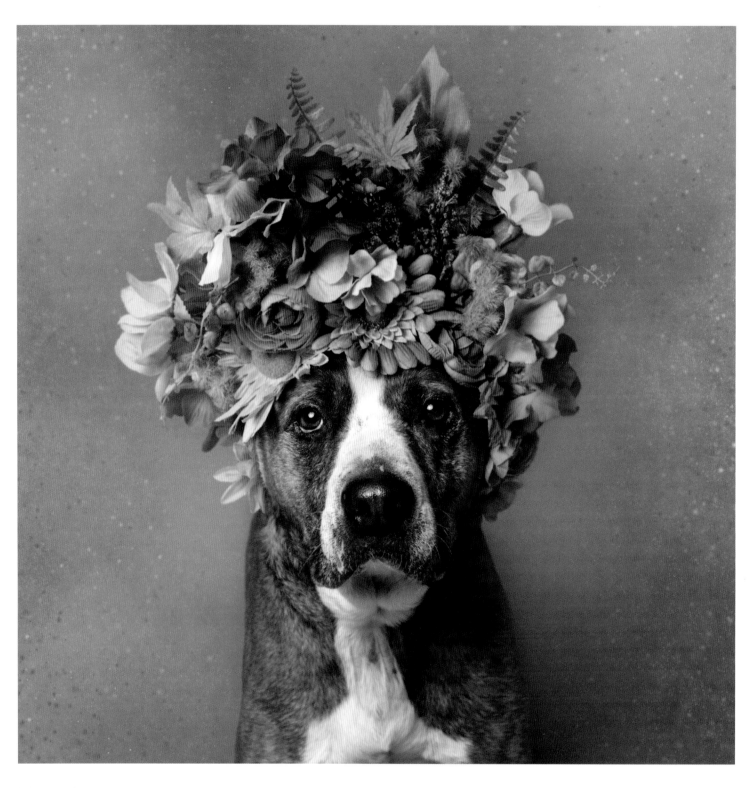

Sylvester, 2016
Adopted
Austin Pets Alive, Texas

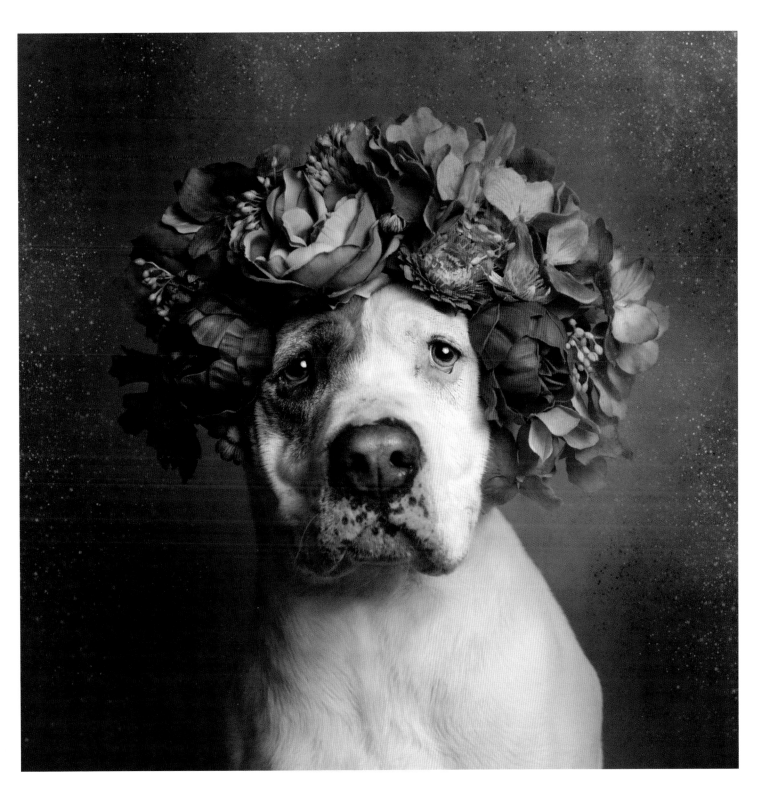

Cooper, 2016
Adopted, deceased
Warwick Valley Humane Society, New York

MURDOCK

2015, *Adopted*
Town of Hempstead Animal Shelter, New York

In July 2014, authorities brought Murdock to the Town of Hempstead Animal Shelter with fresh wounds, filed teeth, a torn ear, and a variety of old scars on his face and legs. One of his eyes was severely injured and he ended up losing it. Murdock's owner had just been arrested on dogfighting charges, and Murdock was placed on legal hold as live evidence against his owner. We'll never know Murdock's true story before he was seized from his owner, but what is painfully clear is that his injuries were the result of human cruelty.

Murdock was hidden away at the shelter while the case against his owner followed its course. As with Creasy and Sula (see page 104), as a general rule, evidence animals aren't allowed contact with the public or other animals, nor can they be placed up for adoption until the case is resolved. It took about eight months before Murdock's owner pled guilty to animal fighting (an unclassified misdemeanor) and was given a sentence of not being allowed to own animals for five years and a $200 fine. Murdock himself was finally released and made available for adoption in the spring of 2015, which is when I met him.

Murdock was my first dogfighting-survivor model, and I was apprehensive about working with him. I had started *Pit Bull Flower Power* only a few months prior and was still uncomfortable around pit bulls. The thought of rolling around on the floor with a pit bull wasn't exactly thrilling (yet).

One sunny May morning, I took the train to the Town of Hempstead Animal Shelter with all my equipment. Given the number of pit bulls at the shelter, I was prepared for a long and hard workday. We ended up photographing over forty dogs, a personal record that left me sore for an entire week. The staff had cleared a corner of their kitchen/office space, and I had just enough room to tape a piece of backdrop paper on the wall and plug my light over the kitchen sink. Murdock was the eighteenth dog of the day. Members of staff had filled me in on his case because they were excited to finally introduce him to the world.

I expected Murdock to be a large, energetic, scary-looking pit bull. I could picture the flames coming out of his nostrils, the glaring eyes, and the muscular body. Those you'd see on the cover of vintage magazines or T-shirts from the 1990s. *Beware. Hell Hound. Born to kill.* And although the staff had assured me Murdock was an absolute sweetheart, he had, after all, been through unspeakable abuse at the hands of humans. I wouldn't be surprised if he'd be the kind to easily snap. The staff announced that Murdock was next. My throat tightened in the mixture of excitement and anxiety that I was now familiar with. A couple of minutes later, the door opened and Murdock entered.

A sweet, short, round-potato dog with a huge smile on his face, Murdock waddled toward me and shoved his head in my chest, wiggling his entire body and covering me with kisses. There he was, the beast, the dogfight survivor. Murdock's face told a story you could have never imagined from his demeanor, and it was soon outshone by his loving, adorable personality. Our photo shoot went very well (except we had to constantly bring him back to his mark because he was more interested in snuggling and kissing everyone).

Murdock's story and portraits got a lot of media attention, yet nobody came for him. Later, he was transferred to another rescue, Last Hope in Wantagh, a place where he could continue to blossom, and get more personal attention, socialization opportunities,

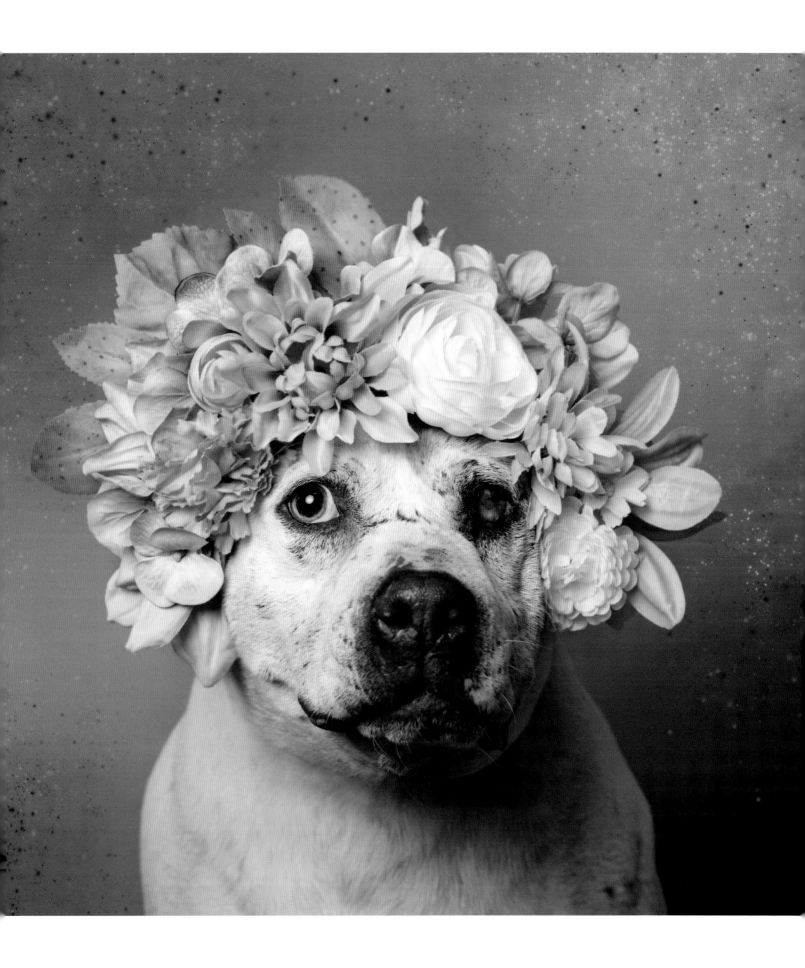

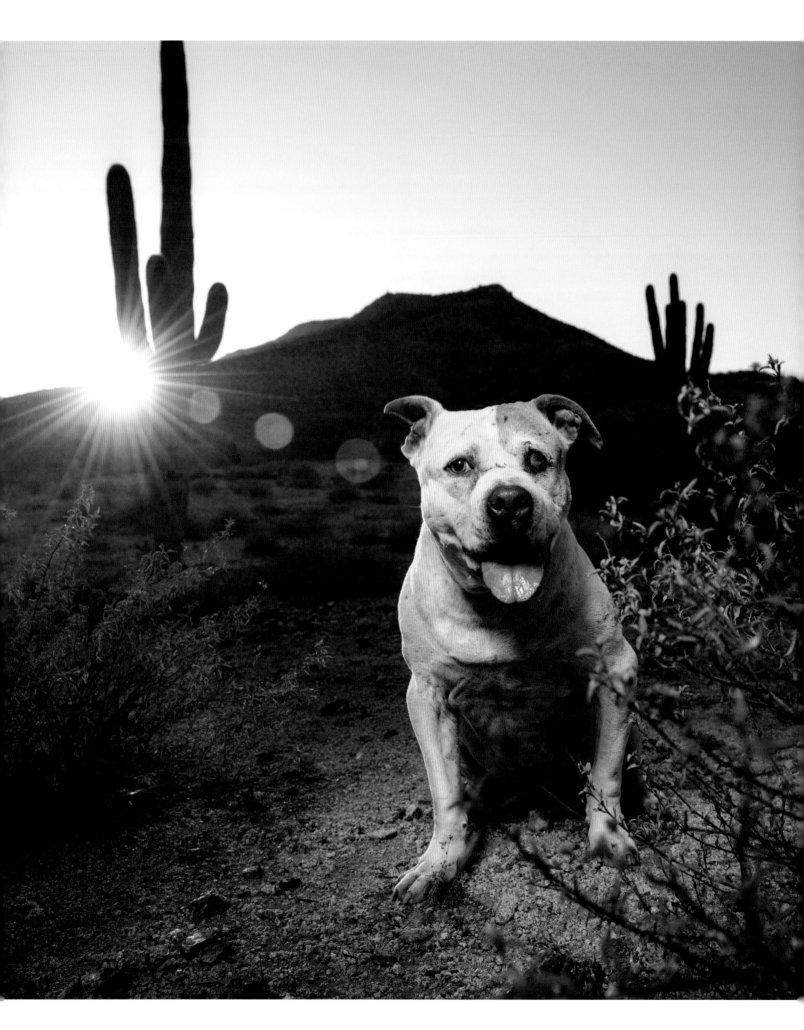

and a new audience. There, he captured the hearts of staff and volunteers, just as he did at Hempstead. He enjoyed rolling and wriggling in the grass, playing with toys, and being a normal dog at last.

Finally, Murdock's story and face caught the attention of Ed and Cheryl. They lived in Arizona but were willing to make the trip for Murdock. They had experience with dogs who had quirks, just like their recently departed dog Lexi, who'd been adopted and returned to her shelter five times before they'd adopted her. Ed and Cheryl were determined to provide a safe home to a dog that had little chance at being adopted. Both the rescue and the couple agreed a meet-and-greet was in order. As soon as the car driving Murdock pulled over in their hotel parking lot, Cheryl and Ed were struck by how adorable Murdock was in person.

After spending the day with the Last Hope volunteers, all agreed that Murdock had found a home. Well, almost. The newly completed family still had to drive three days back to Arizona, a journey they completed without any issues. Twenty-five hundred miles after Murdock had first arrived at the shelter, he was finally home, where his new parents would show him a world of love, comfort, safety, and compassion. Murdock entered his new house as if he'd lived there forever, grabbed a toy, and went directly onto one of the dog pillows Cheryl and Ed had on the floor. He quickly claimed the couch, too.

A couple of months later, one of my shelter trips took me to Arizona, and I jumped at the chance to catch up with Murdock. We met in the rough and unforgiving Arizona desert, surrounded by splendid saguaro cacti reaching to the sky with all their might. At sundown, when the earth cools off and all desert life starts to breathe again, I captured Murdock in all his glory.

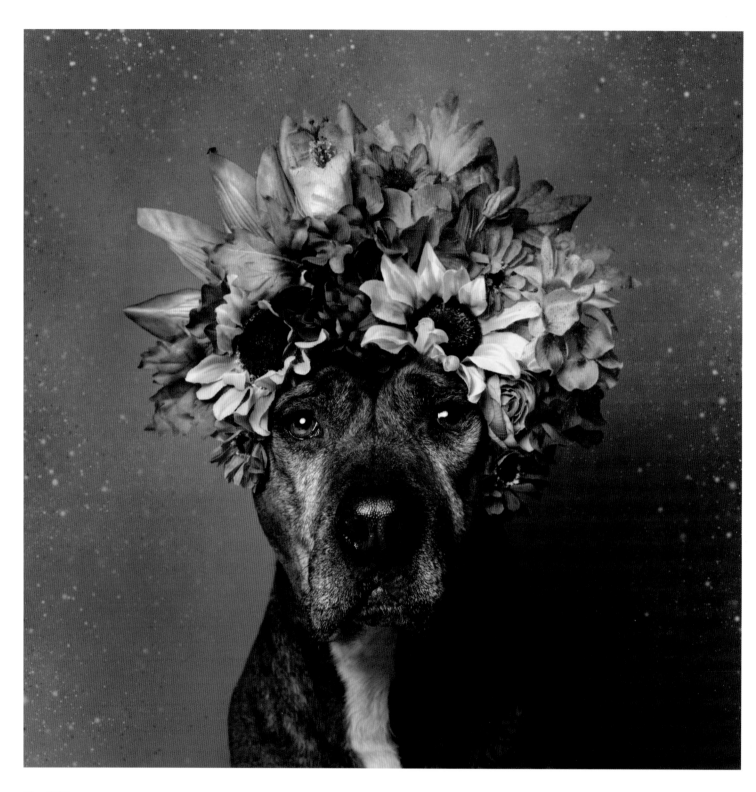

Mac, 2016
Adopted
Austin Pets Alive, Texas

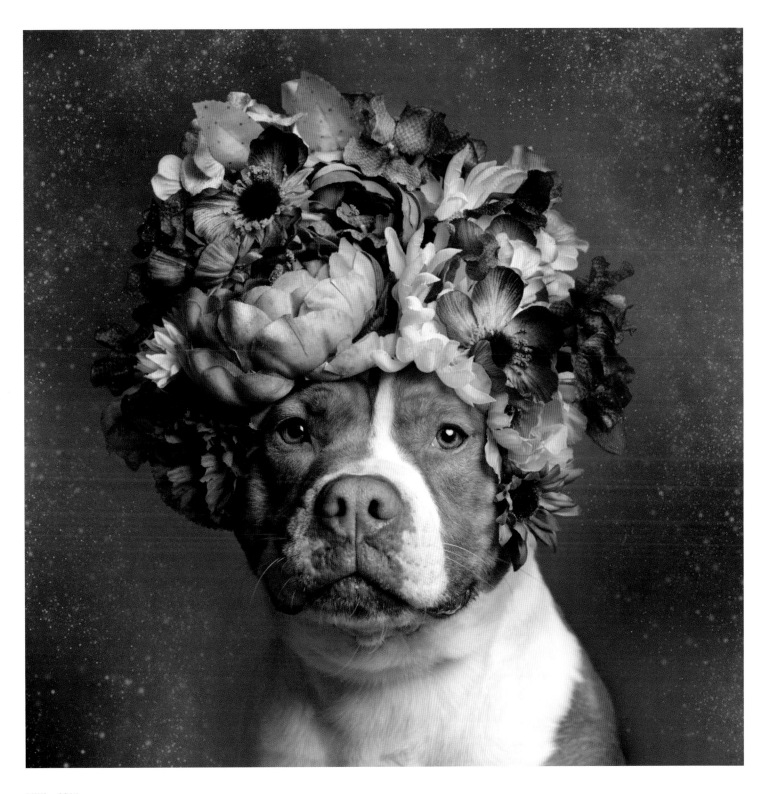

Millie, 2016
Adopted
Warwick Valley Humane Society, New York

Millie waited over two years for a family. Her adopter, Louise, wrote: "A week after our senior Rocco passed, my mom said she wanted a girl dog and to name her Millie. I said, 'Whatever,' as I headed out. That day I met someone from the Warwick shelter who had known Rocco. They said when we were ready they had a girl dog who'd be perfect for us, named . . . Millie. I was shocked! This doesn't happen. For a year, I begged my family to go meet her. Finally, I won and we adopted her. At the shelter, they told us she was high-energy and would get overstimulated around other dogs. But once at home, she was completely different. She actually loves dogs and has a best friend living next door. She is mostly sleeping on the couch, or jumping in people's laps, or licking someone's face. She loves to be dressed up and is the happiest dog we've ever had."

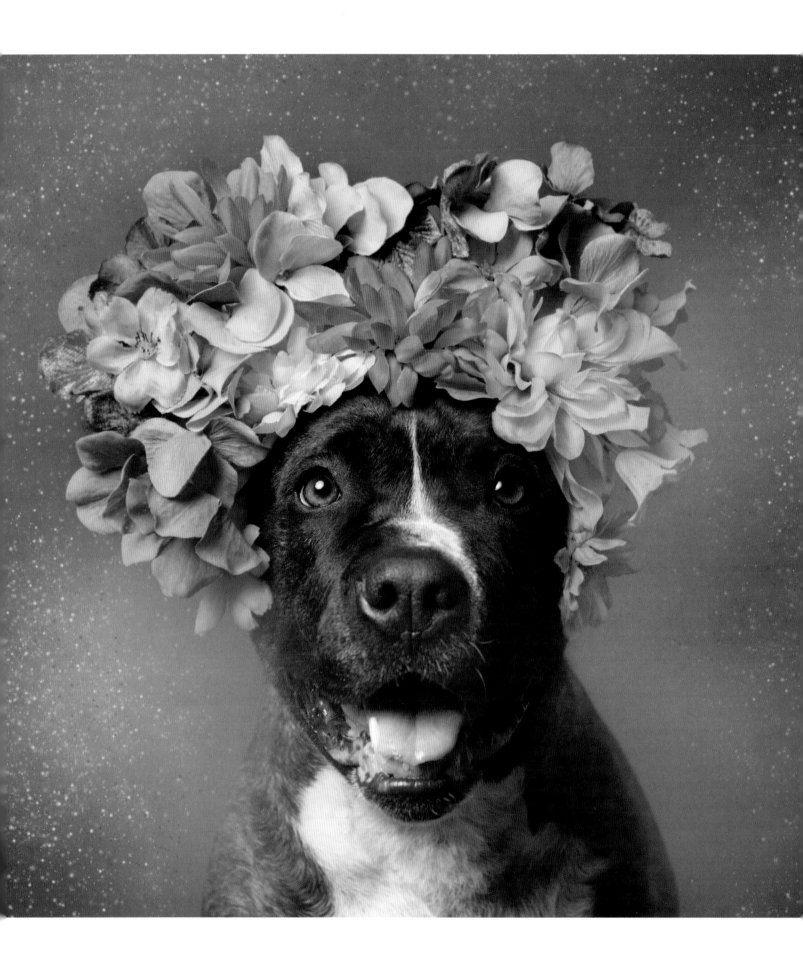

ANGEL

2016, *Adopted*
Danbury Animal Welfare Society, Connecticut

Angel was found in an abandoned house. Presumably, her owner had moved out and had left her behind. Immediately upon intake at the Danbury Animal Welfare Society, Angel stole everyone's hearts and became an ambassador, joyfully participating in all the shelter's community outreach events. On a field trip to New York City, she navigated the bustling streets of Chinatown so well that a stranger yelled at her handler, "What a good dog!" At a hockey game Angel connected with a woman in a wheelchair and happily sat next to her while the woman petted her. At an after-school art club, one little girl was so scared of dogs that the teacher had to prepare her for Angel's arrival. The girl stayed far back at first, but after about an hour she had made her way closer and closer, keenly watching how Angel interacted with all the other kids. Right before Angel left, she asked if she could pet her, and to her teacher's surprise, the little girl smiled and said, "I like her!"

Angel was perfect in all situations. Yet it took her over a year to find a home. The only thing standing in her way was her looks. A dark pit bull, people automatically assumed she was dangerous. The few adoption applications that had come through for her all had to be pulled due to local landlord restrictions on pit bulls—a legal yet discriminatory practice.

Sarah and Kristen asked me for help getting Angel more exposure. The two women were volunteers at the shelter and had taken her to all the events, where she shone. Over the course of a year, they'd developed an undeniable bond with Angel, and I was so touched by their dedication I agreed to squeeze them into my busy schedule. The women drove nearly three hours for our photo shoot. Angel was wonderful. What we

didn't know was that my photos wouldn't make a big difference, because Angel's adopter had been around all this time.

After he retired, Bob started volunteering at the shelter. He knew he'd eventually adopt one of the longtimer dogs there. He always stayed a bit past his shift to spend time in the play yard with the dogs who might need it the most, and this is how he got to know Angel. A year after he started volunteering, Bob took her home for a trial foster. It went so well that he never brought Angel back to the shelter and officially adopted her. At first, some of his neighbors were frightened, but Angel and Bob were more than happy to prove them wrong. Now, neighbors run up to them to catch up with the pair.

A few weeks after the adoption, Kristen paid them a visit. "They were waiting outside for me, and when Angel recognized me she went nuts in the best way possible!" she wrote. "I got lots of kisses all evening. I swear, every once in a while she'd look at Bob as if to say, *I can't believe it.* I brought her two toys and she'd play with them for a few minutes, then run over to kiss me. I cried the whole carride home, just so happy for my old friend who now has the life she deserves. Bob and her live a fairly quiet life and are very content together. Angel follows him everywhere, keeps him 'burning hot' at night in bed, watches TV, and enjoys greeting children in the neighborhood and eating carrots from Bob's grandson's hand when he visits. Bob has to give her a big cookie or bone to distract her when he leaves the house, because she cries when he does. She is always excited to give him a bath of kisses when he returns."

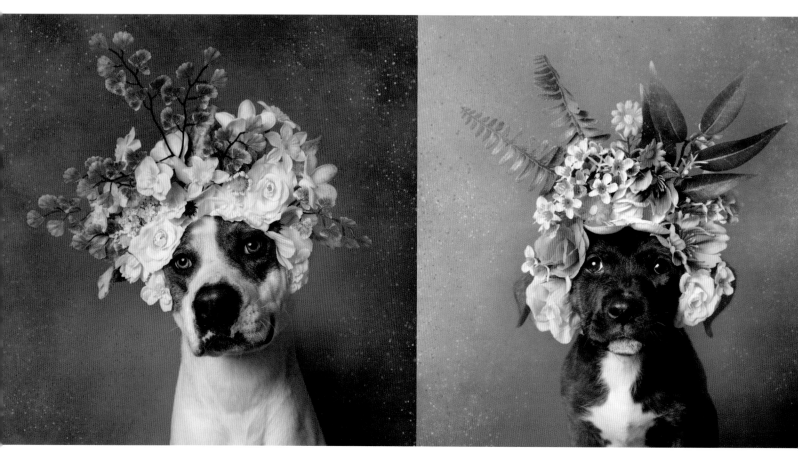

Zeus, 2017
Adopted
Miami Dade Animal Services, Florida

Buddy Love, 2016
Adopted
Mr. Bones & Co., New York

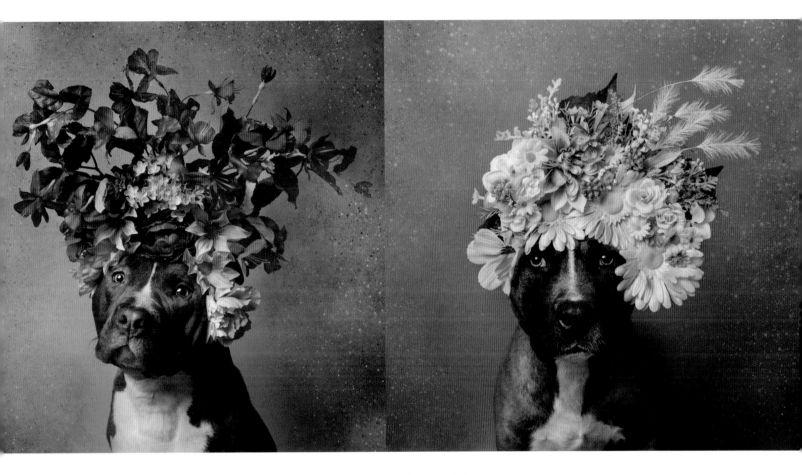

Maybach, 2017
Adopted
Mr. Bones & Co., New York

Valentino, 2017
Adopted
Miami Dade Animal Services, Florida

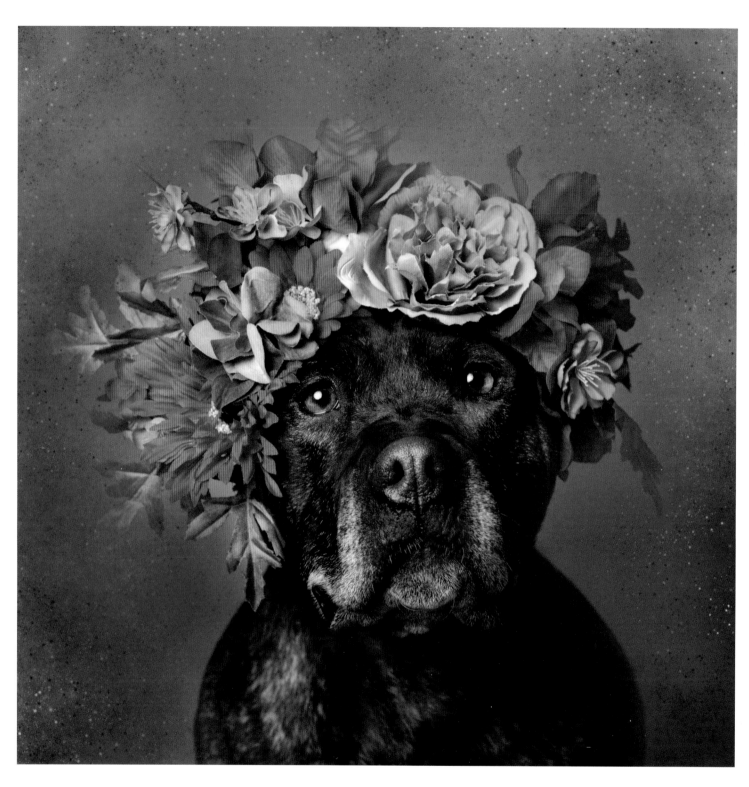

Remy, 2015
Adopted
Town of Hempstead Animal Shelter, New York

Monica, 2016
Adopted
Mr. Bones & Co., New York

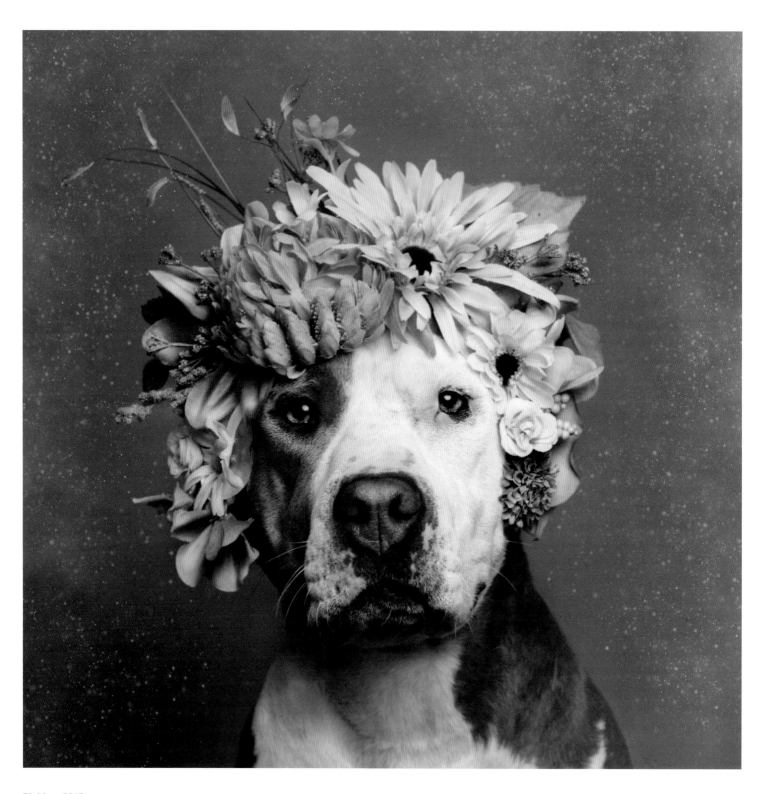

Pickles, 2015
Adopted
Town of Hempstead Animal Shelter, New York

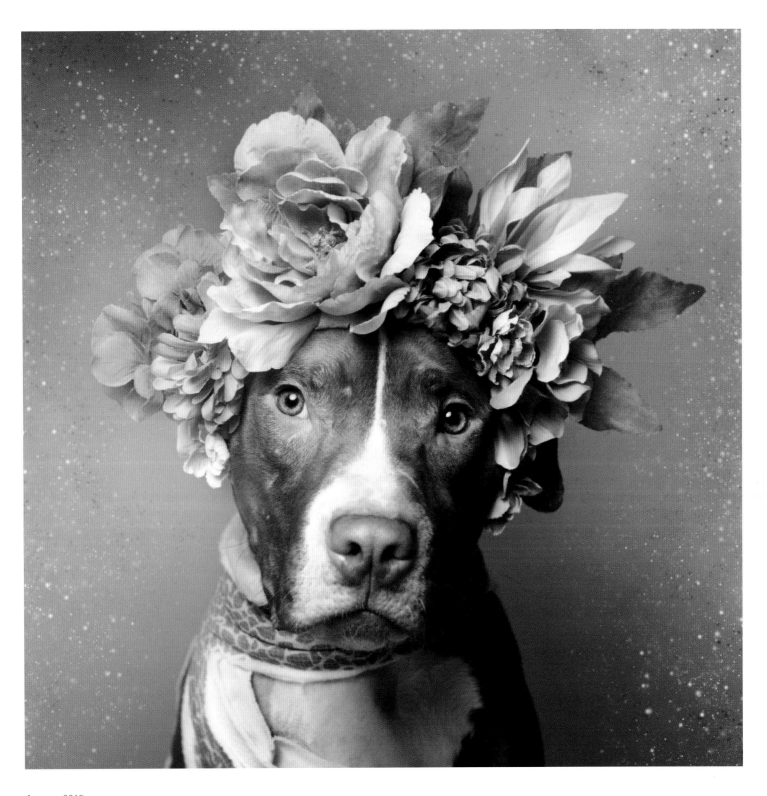

Jasper, 2015
Adopted
Mr. Bones & Co., New York

Shortly before Christmas, a Brooklyn neighborhood was disturbed by loud and desperate cries. A couple sought to find the source of this agony. There was Jasper, tied to a fence with a scarf, and suffering a severely broken leg. He was soon transferred into the custody of Mr. Bones & Co., and his leg had to be amputated. I photographed him right after his surgery, and he was already adjusting to having only three legs. His photos led him to his adopter, Melissa. "I was going through a difficult time then and Jasper's resiliency really helped me. After we applied for him, I looked at his photographs every day and hoped it would work out." The adoption went through and Jasper moved in. Since then, he's been doing great and loves nothing more than being outside, going for jogs every day, hiking in the woods, or climbing big, rocky hills.

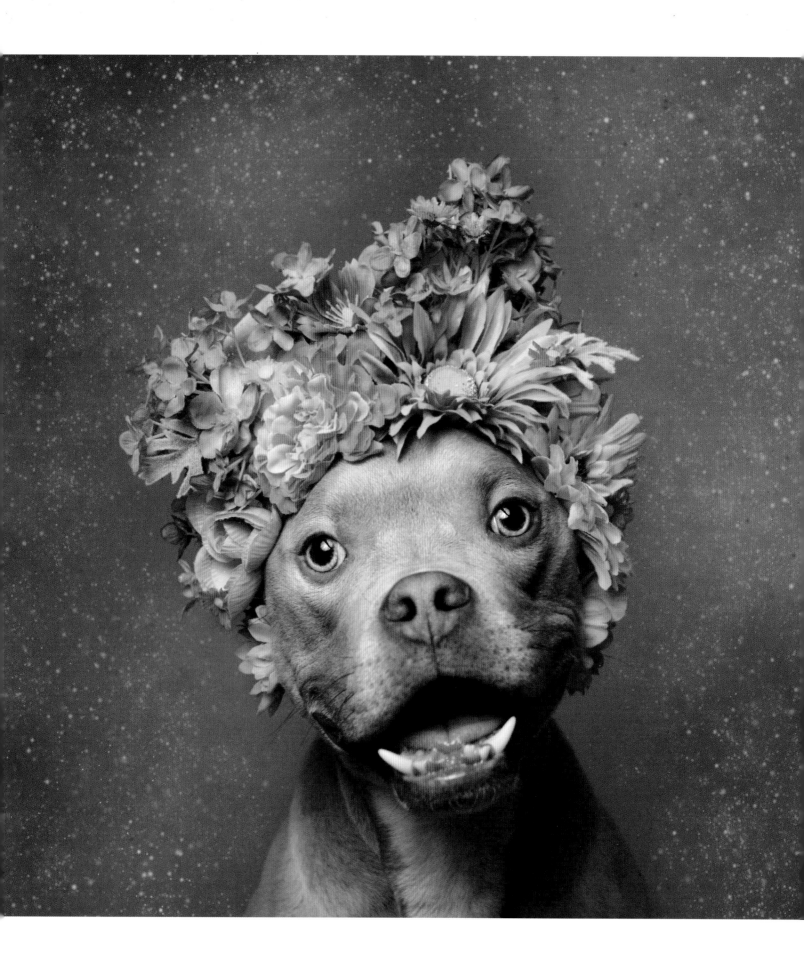

BEAUREGARD

2016, *Adopted*
Redemption Rescues, New York

"Will die at noon today, urgent."

"Will die at noon today, urgent." Attached to these words was a picture of an adorable Bailey with only a few hours to live and dreadful intake notes. The police had picked him up as a stray. He had terribly overgrown nails and rotted teeth, and his ribs and spine were showing through his skin. He was estimated to be about six years old, maybe more, and not particularly happy to be at the shelter.

Between his bad overall condition and his intake notes, Bailey couldn't be adopted directly by the public, and rescue groups themselves were hesitant to pull him— leery of costly health and behavioral issues. Thankfully, shelter volunteers had noticed his sweet, loving nature, and were advocating for him. Tiffany of Redemption Rescues decided to take a chance on him.

It was easy to see why Bailey had captured Tiffany's attention, with his big, human eyes and unforgettable smile. From the moment they met, Tiffany realized what a sweet boy Bailey was and that he'd simply been very scared during his intake at the shelter. She pulled him, and Bailey became Beauregard, and Tiffany's foster. After costly but much-needed dental surgery, Beau was ready for a new home. It wouldn't be easy for Tiffany to let him go. We had a fabulous photo shoot and I myself was smitten with Beau. He was a very gentle, happy, sweet boy, whose teeth—what was left of them—prickled your hand when he delicately took a treat from you.

"Beau got me through some very trying times that year, and I'm not sure what I would have done without him," Tiffany wrote. "When his soon-to-be dad walked into our lives, I witnessed the bond that I had with Beau being trumped immediately by the instant bond the two developed. Everything fell into place, and I knew it was right. It made it easier to let him go." Attached to Tiffany's note was an adoption picture: Beau relaxing on a boat with his adopter. "Just a guy and his dog doing what they love most, being side by side enjoying a beautiful day out without a care in the world."

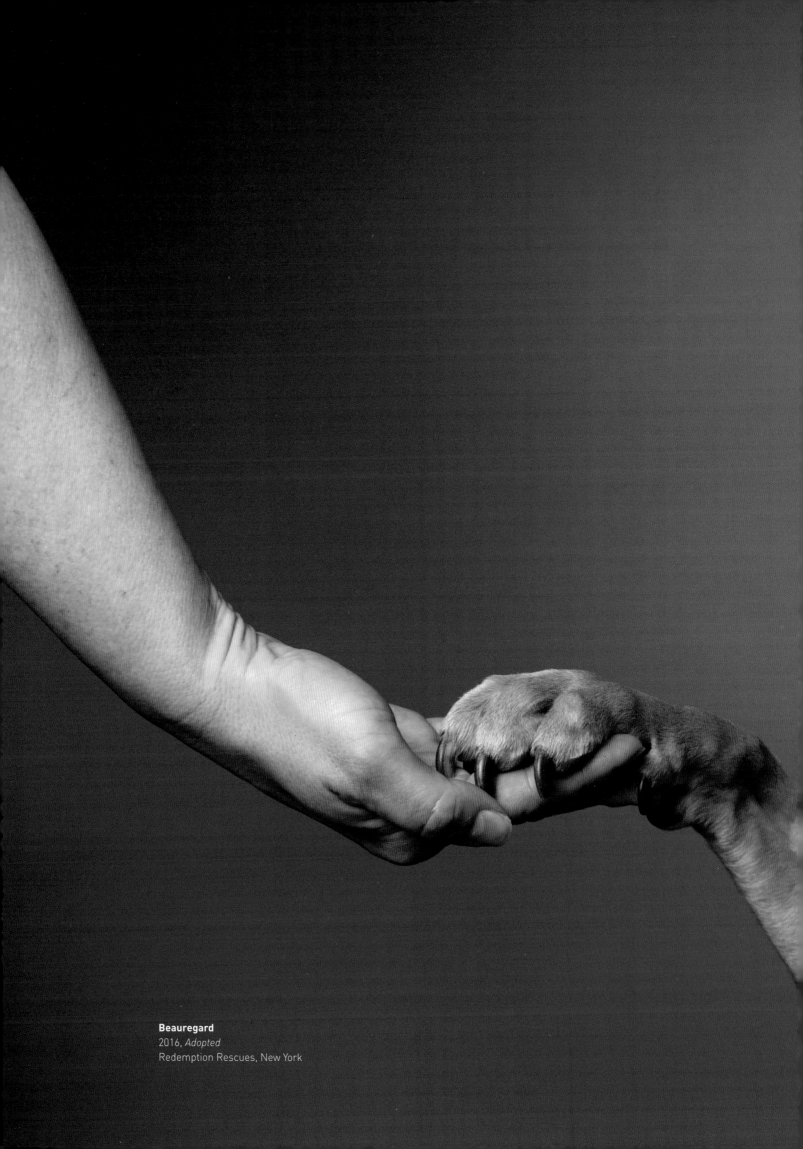

Beauregard
2016, *Adopted*
Redemption Rescues, New York

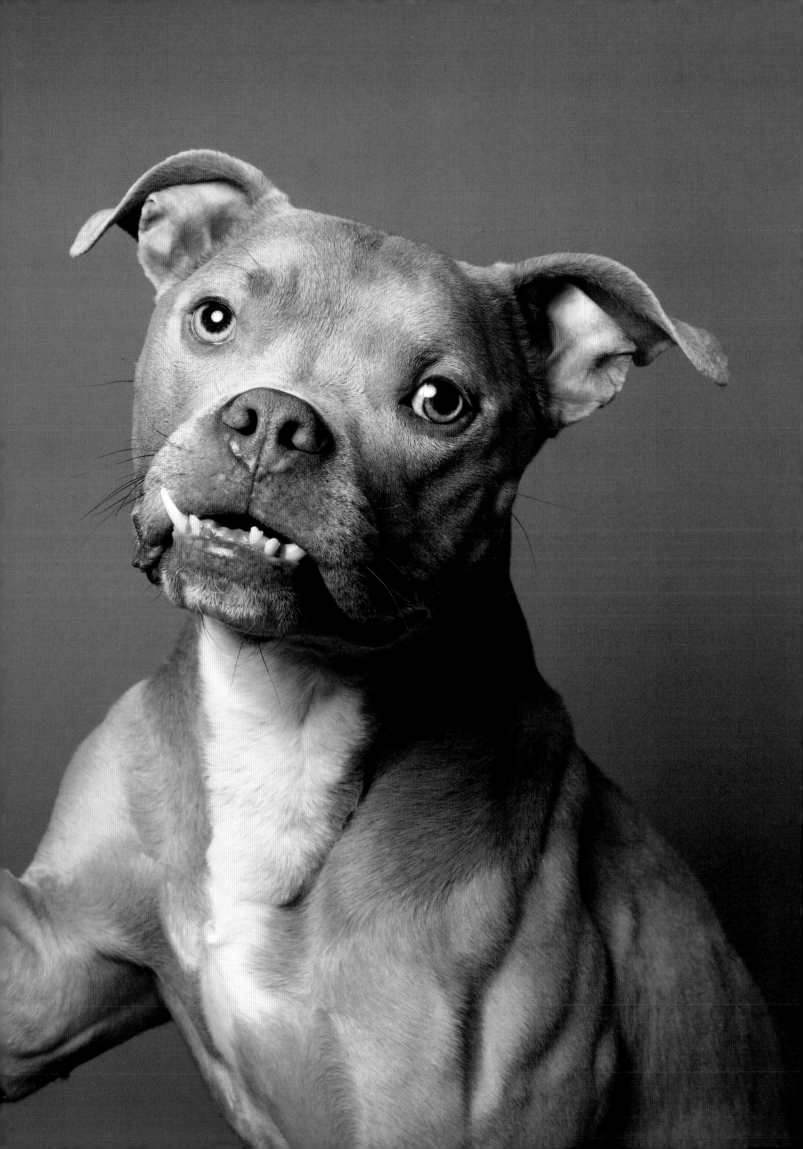

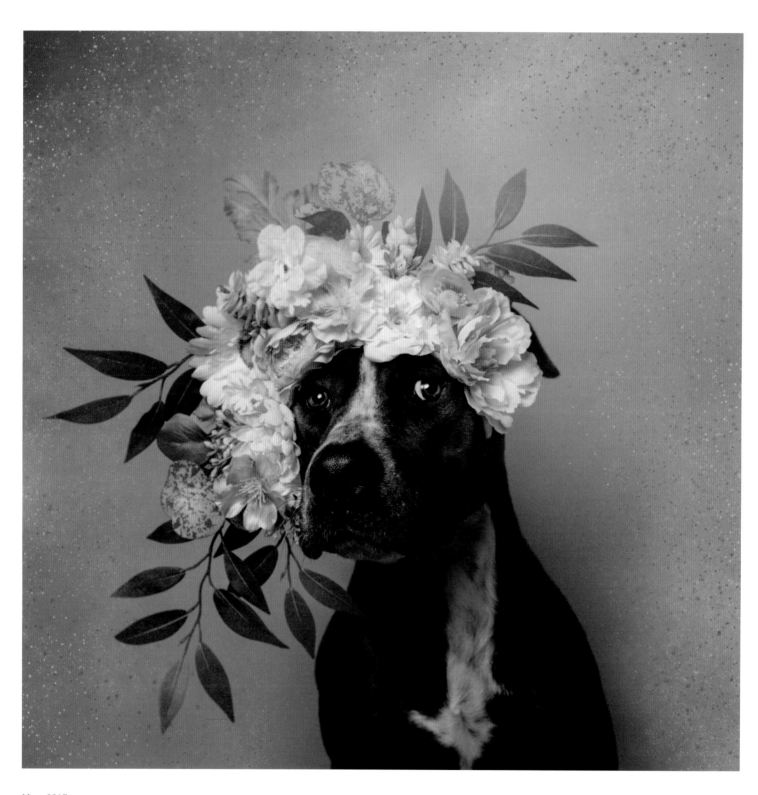

Max, 2017
Adopted
Miami Dade Animal Services, Florida
Main Line Animal Rescue, Pennsylvania

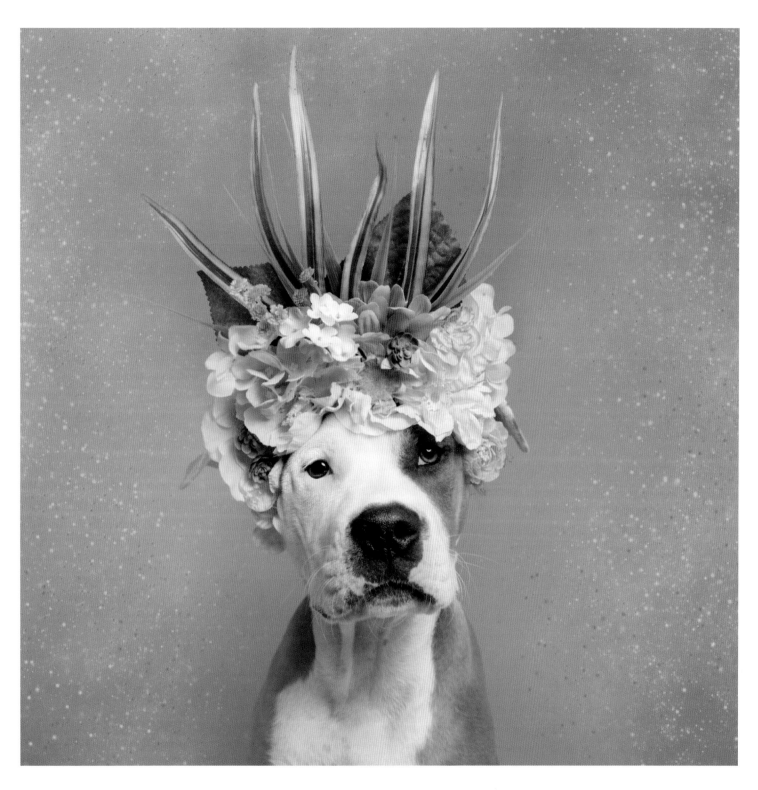

Daphne, 2016
Adopted
Operation Education Animal Rescue, Tennessee

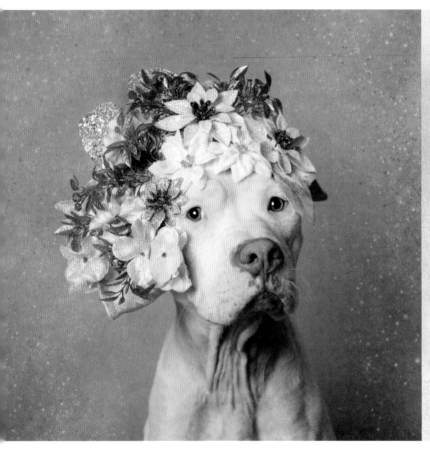

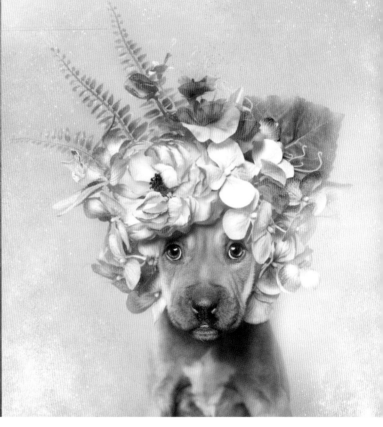

Maria, 2016
Adopted
BARC Houston, Texas

Kahula, 2014
Adopted
Animal Haven, New York

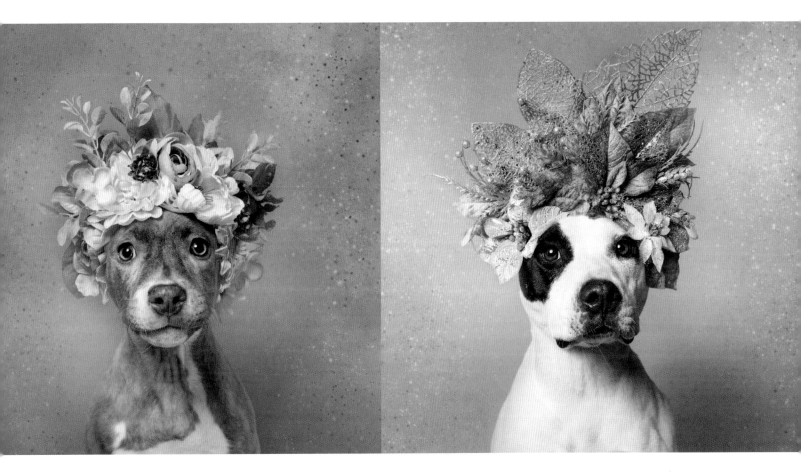

Precious, 2015
Adopted
ASPCA, New York

Goku, 2017
Still waiting
Hallie Hill Animal Sanctuary, South Carolina

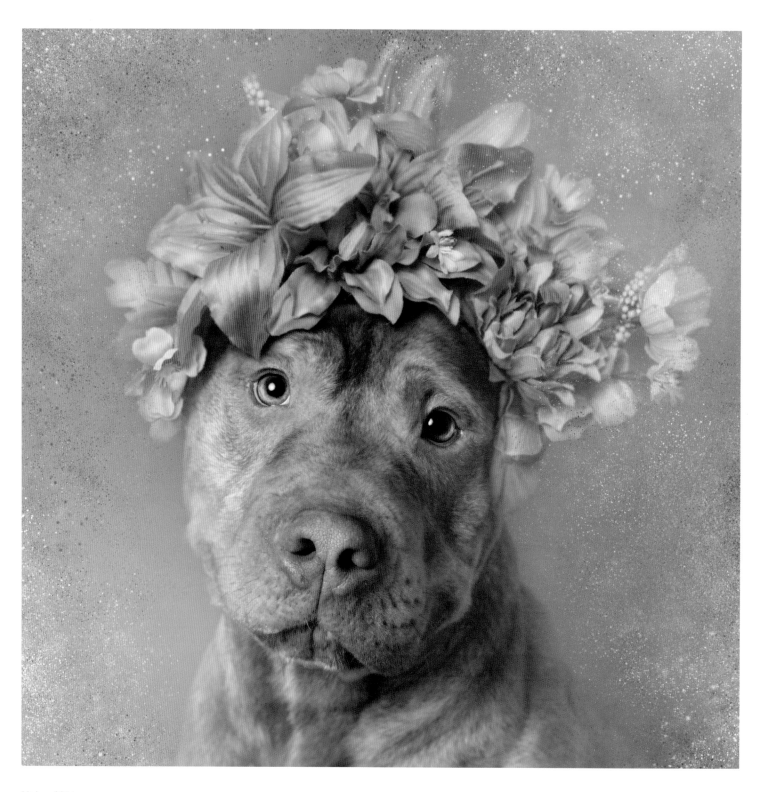

Major, 2014
Adopted
Town of Brookhaven Animal Shelter, New York

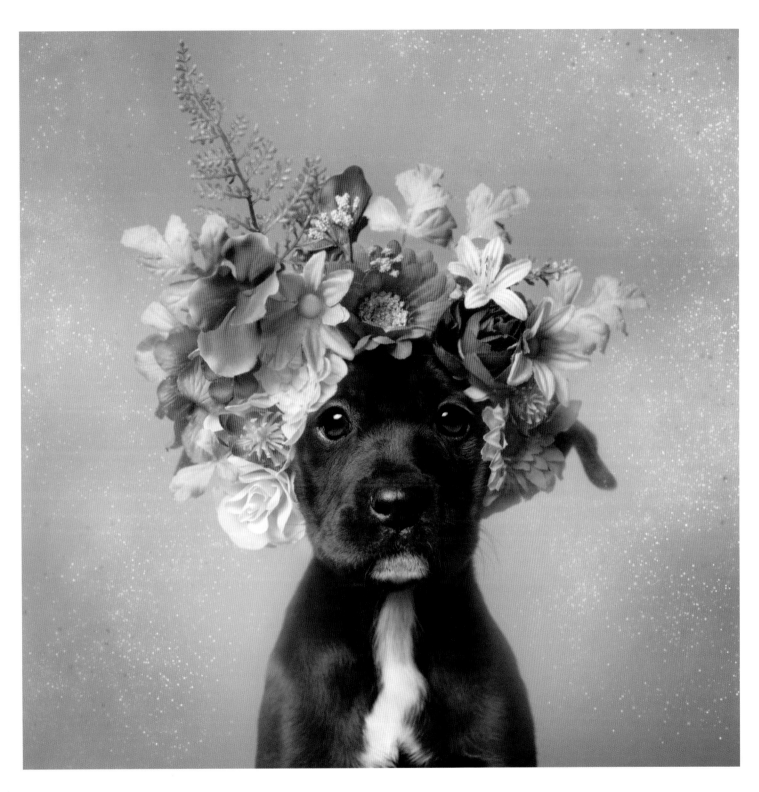

Joey, 2016
Adopted
Mr. Bones & Co., New York

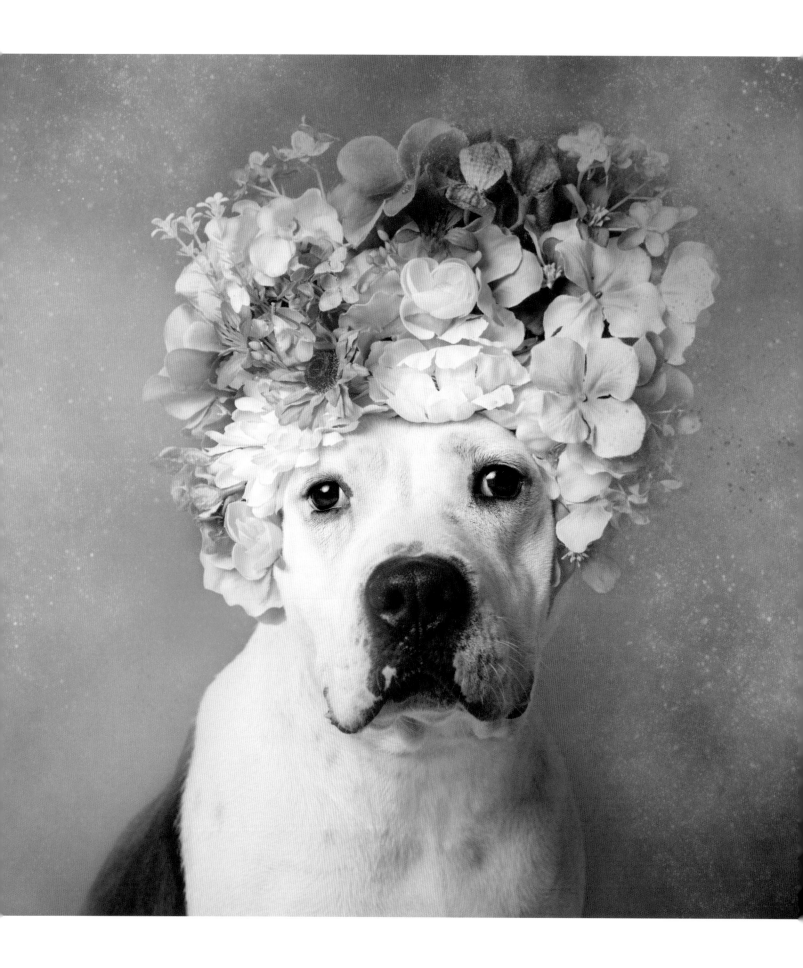

HUBERT

2016, *Adopted*
Fulton County Animal Services, Georgia

"How would I know? I gave him away a long time ago."

"Hi, this is Fulton Animal Services. You adopted Hubert from us. We just found him emaciated, covered in cuts, and in rough shape. Can you tell us what happened?"

"How would I know? I gave him away a long time ago."

This conversation occurred between staff at Fulton County Animal Services and Hubert's first adopter. Hubert's second stay there was short and he was adopted again a few weeks later. Volunteer Danielle witnessed the whole event. She wrote: "[Hubert's] new adopters were told that they must move very slowly with him to gain his trust. When Hubert got scared and growled at Dad, he laid himself on the breakroom trailer floor and allowed Hubert to come to him in his own time. Once Hubert met his two fur sisters, his confidence soared and the deal was sealed."

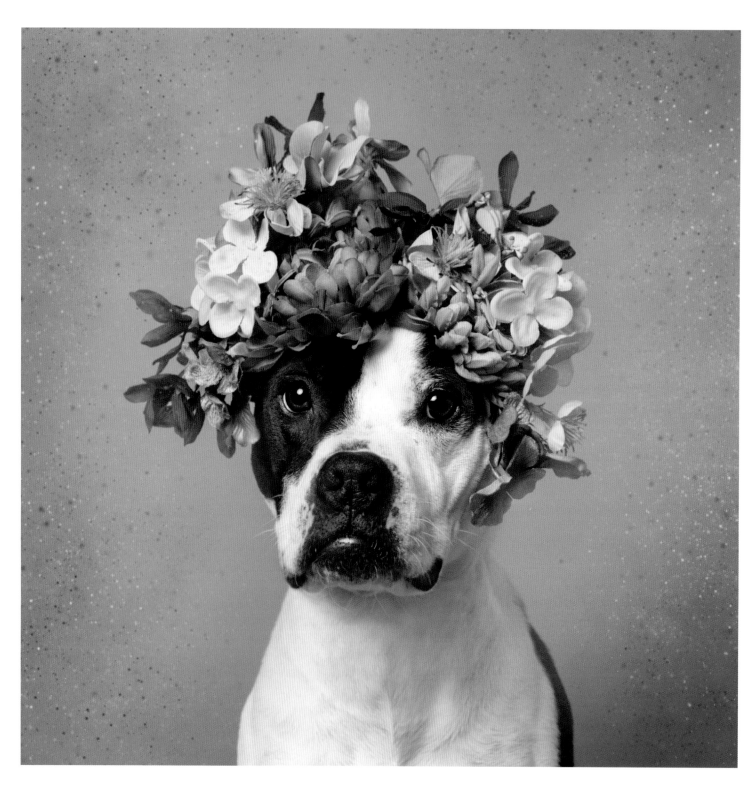

Nikki, 2016
Adopted
Warwick Valley Humane Society, New York

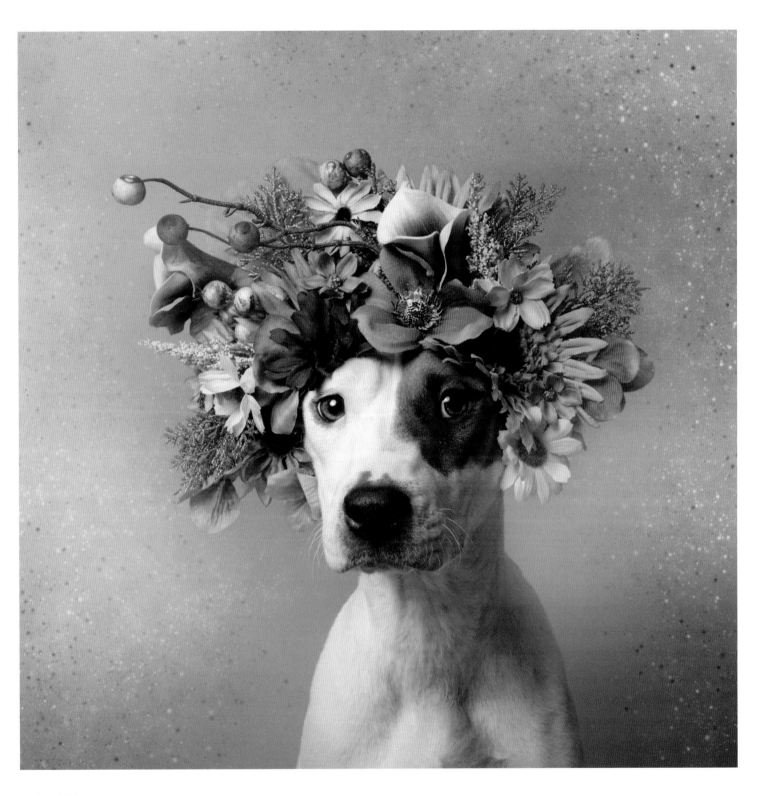

Lucille, 2016
Adopted
Animal Haven, New York

HOLIDAY

2017, *Adopted*
Mr. Bones & Co., New York

Holiday was found as a stray in North Carolina. She seemed to have been bred repeatedly. Suspecting she'd escaped an infamous local backyard breeder, someone brought her to a shelter. My friend Elli from Mr. Bones & Co. met her during a Southern outreach trip and brought her back to New York City, where she knew her chances at adoption were greater.

Eight months later, after a lengthy and difficult treatment for advanced heartworm disease, Holiday was still waiting for a home. Elli asked for my help: "We need some Sophie magic, please!" I wasn't entirely sure my photos would make a difference, but I was willing to try. In the summer of 2017, I was marking the third-year anniversary of *Pit Bull Flower Power*. To celebrate the milestone, Elli, who knows me well, had brought over a bottle of rosé, cupcakes, and an adorable, wiggly Holiday ready for her glamor shot.

Holiday was mesmerizing. Gorgeous, she was painfully sweet. It's always heartbreaking to see dogs still crave human affection when you know where they come from.

I had a large, over-the-top crown I'd created a few months prior with a big sunflower in the middle, a flower I'd never used before. The crown seemed outrageous, unwearable, and I thought I might have reached the limit of *Pit Bull Flower Power* with it. I showed it to Elli and explained to her that she was the only "crown assistant" I would entrust with it. Elli has always been very supportive of my outside-the-box ideas. Was it the rosé or was it Holiday's perfect nature? We decided to give it a try. The photo shoot went incredibly well, and I knew that portrait was special.

It was as if that crown had been created for Holiday specifically. The stars were aligning, although I hadn't realized how much yet. Holiday and I shared a cupcake, and as my nose and hers touched, I realized how far I'd come since I had started *Pit Bull Flower Power*. She was a pit bull, and I wasn't afraid of her.

Over the following days, Elli shared Holiday's portraits, as well as an adorable succession of photos and videos from her foster home: Holiday snuggling, wearing pajamas, and eating ice cream. Time was running out. Her foster couldn't keep her any longer and Holiday needed a new place to stay—or better, an adopter.

Sherry had recently lost her dogs. She felt ready for a new companion, but was waiting for a sign. "One day I was on social media scrolling and my heart just stopped," she explained. "There she was, Holiday, all smiles and wearing a big fat sunflower on top of her head. My grandfather used to grow them in his garden, and they've always been my favorites. Seeing her with that sunflower crown was fate."

Holiday moved in shortly after and was renamed Luna. "What's special about her?" Sherry wrote. "It's simple: everything."

I sometimes wonder if my portraits really help, and how much they help. Holiday's story is a constant reminder for me not to worry. I don't know why I chose a sunflower for her crown or why I kept that crown for so long, unused. I simply knew it was meant for a special dog, and I suppose the universe worked in its mysterious ways.

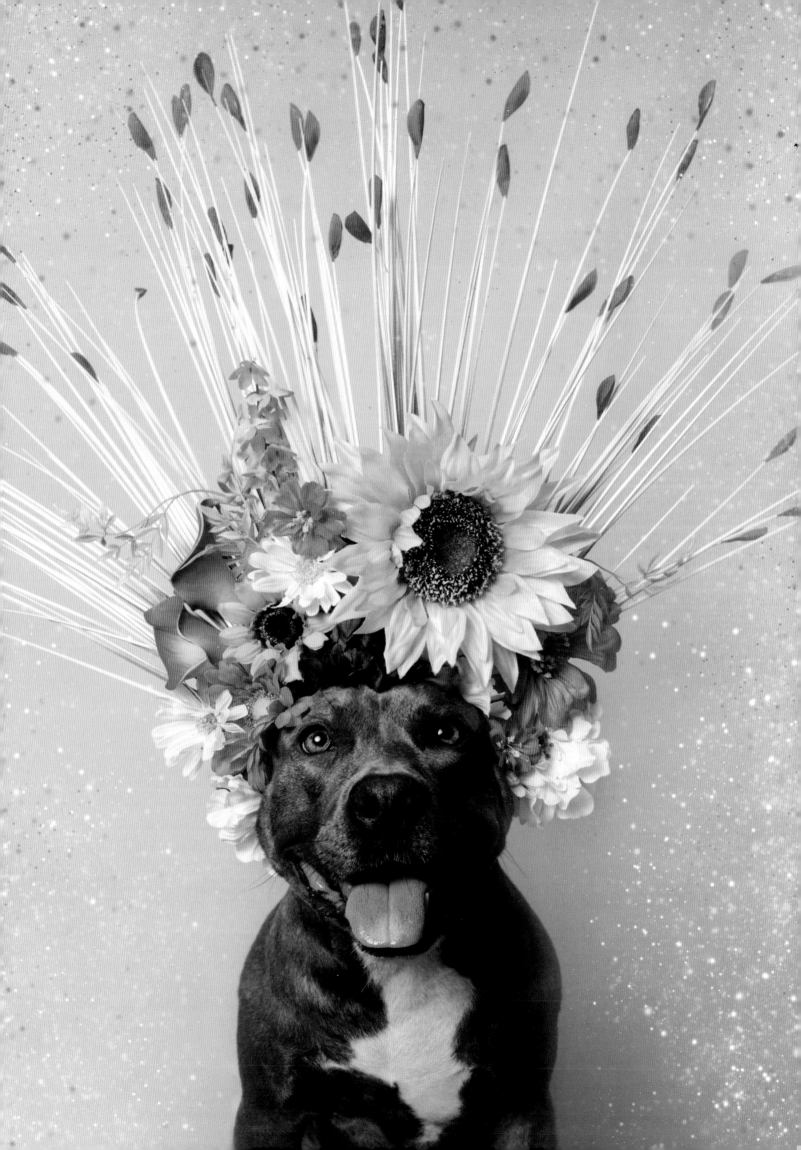

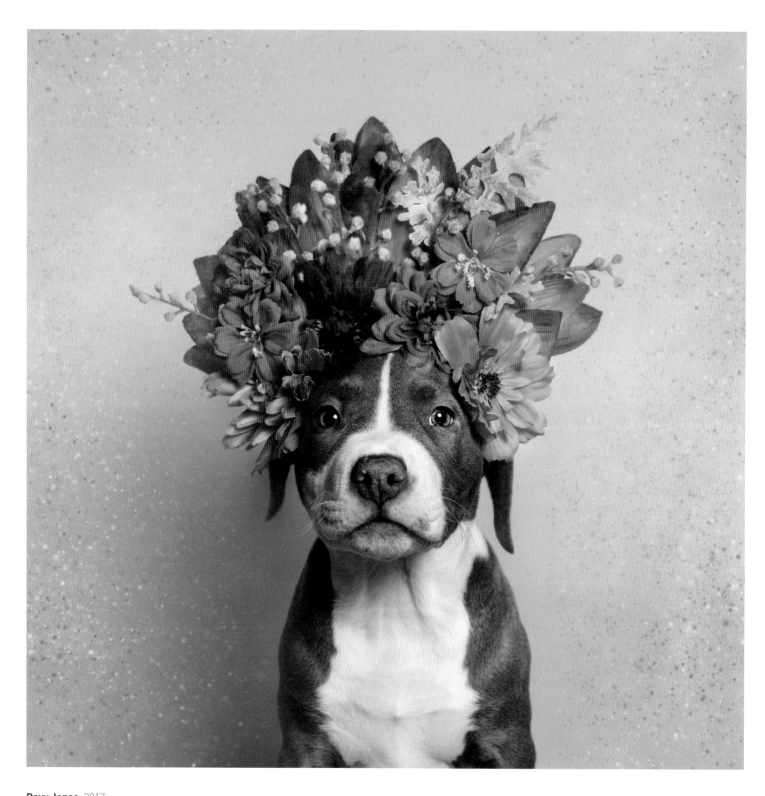

Davy Jones, 2017
Adopted
Luvable Dog Rescue, Oregon

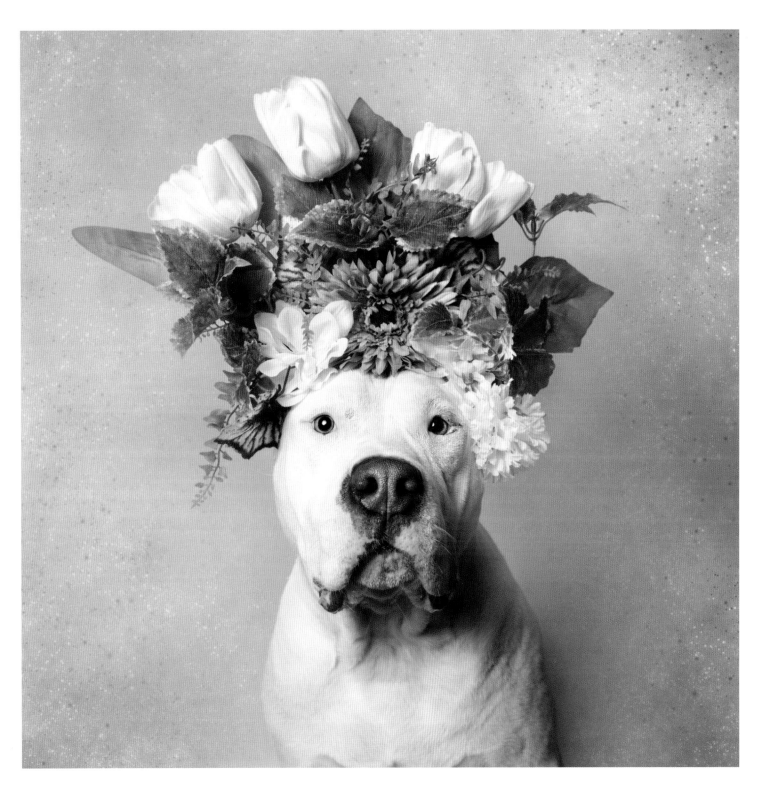

Blinx, 2017
Adopted
Mr. Bones & Co., New York

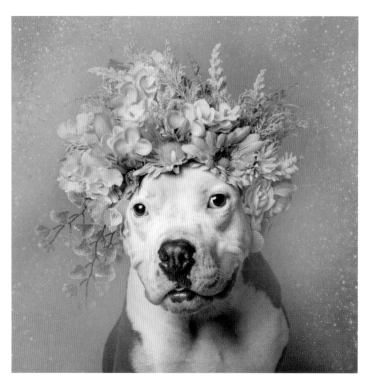
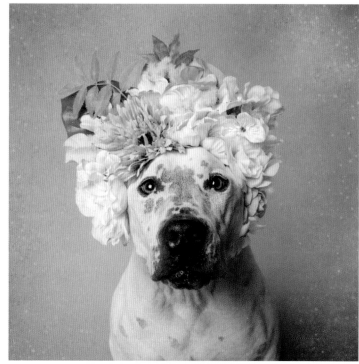
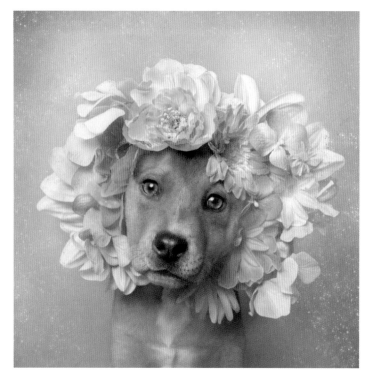
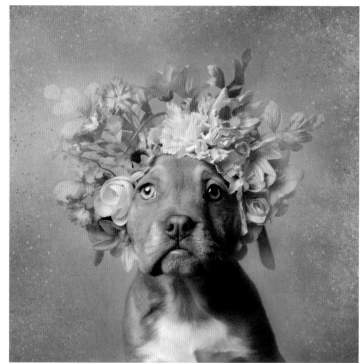

Lucy, 2016
Adopted
Austin Pets Alive, Texas

Cyclone, 2015
Adopted
Mr. Bones & Co., New York

Marzipan, 2016
Adopted
Austin Pets Alive, Texas

Rachel, 2016
Adopted
Mr. Bones & Co., New York

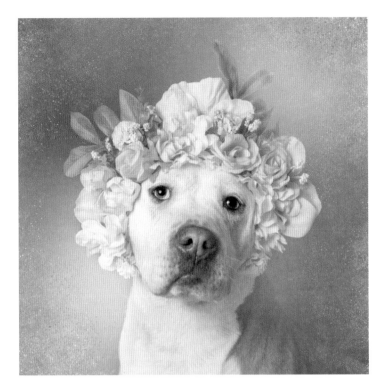
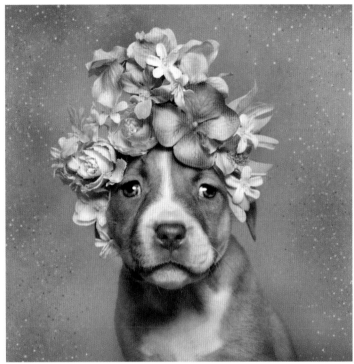
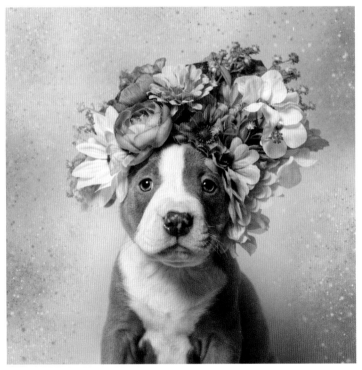
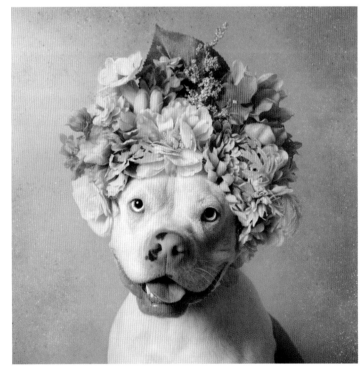

Erin, 2014
Adopted
Town of Brookhaven Animal Shelter, New York

Frito, 2017
Adopted
Luvable Dog Rescue, Oregon

Peanelopea, 2015
Adopted
Animal Haven, New York

Rain, 2016
Adopted
Luvable Dog Rescue, Oregon

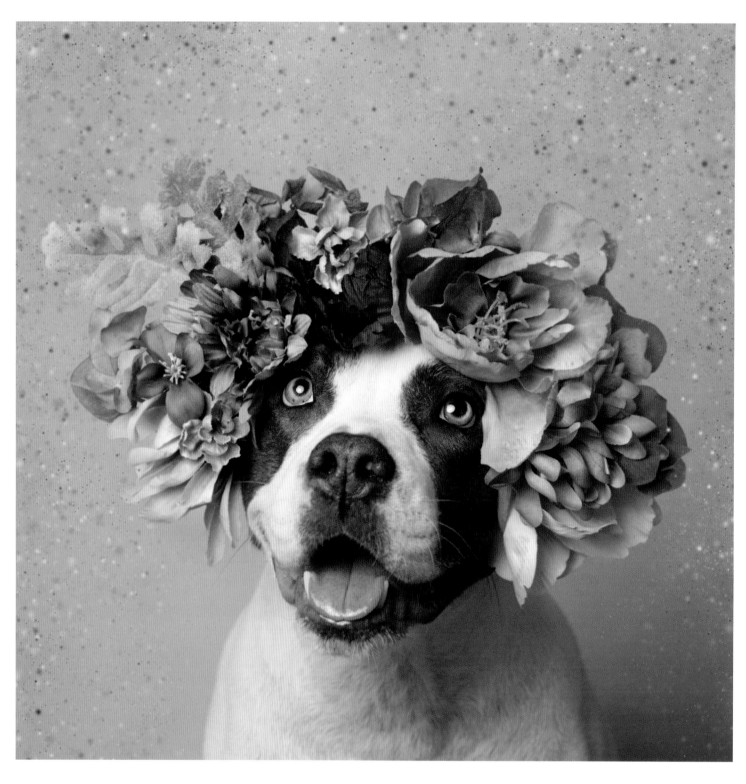

Nakita, 2015
Adopted
AZK9, Arizona

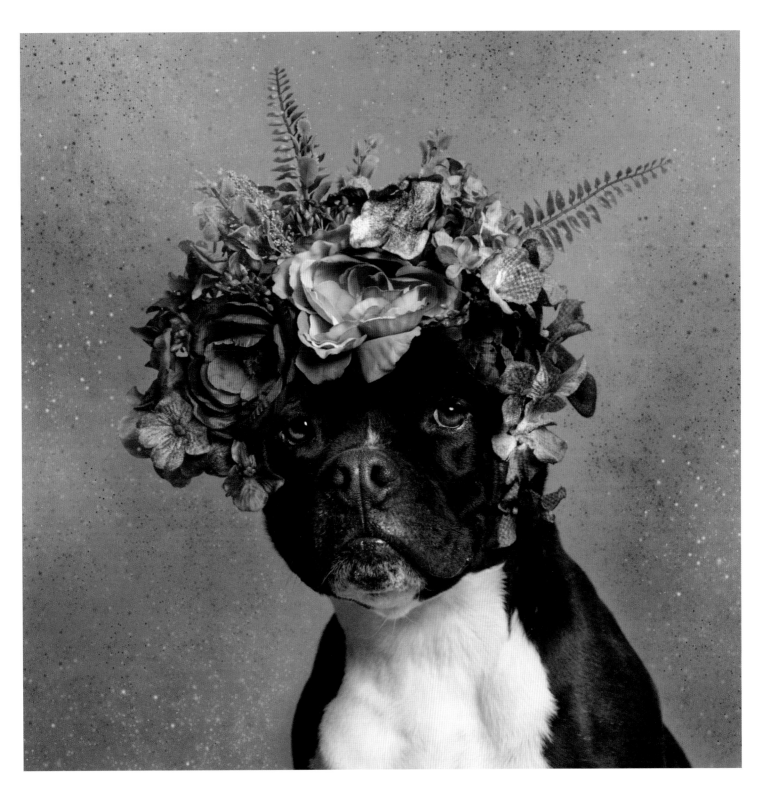

Prince, 2016
Adopted
Warwick Valley Humane Society, New York

SUSIE

2016, *Adopted*
Philadelphia Animal Welfare Society, Pennsylvania

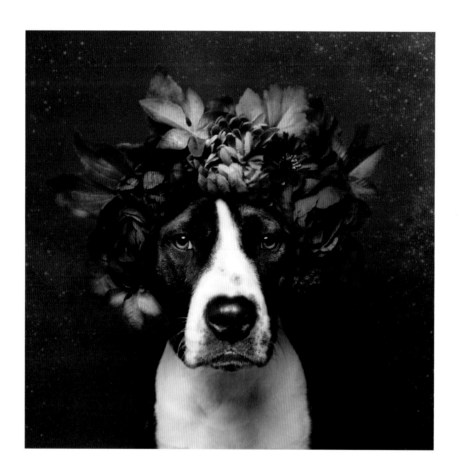

When Ashley fell in love with Susie, she realized she might one day have to choose between her and her hometown. "I was devastated," Ashley wrote. "We'd moved to Philadelphia from Toronto, Ontario, which is home to a strict breed-ban on pit bulls. It felt cruel that Canadian authorities might seize my dog if we were to move back. But in the end, we chose to keep Susie. Maybe we'd never move back to Toronto or the law could get repealed by then, and it seemed crazy to say *goodbye* to an amazing dog without knowing what the future would hold. Whatever happens, we will make our decisions based on what is best for Susie. We love her so much. And it is my hope that down the road, when people think of pit bulls, they think of *Pit Bull Flower Power* rather than the harsh images the media conjure up on a regular basis."

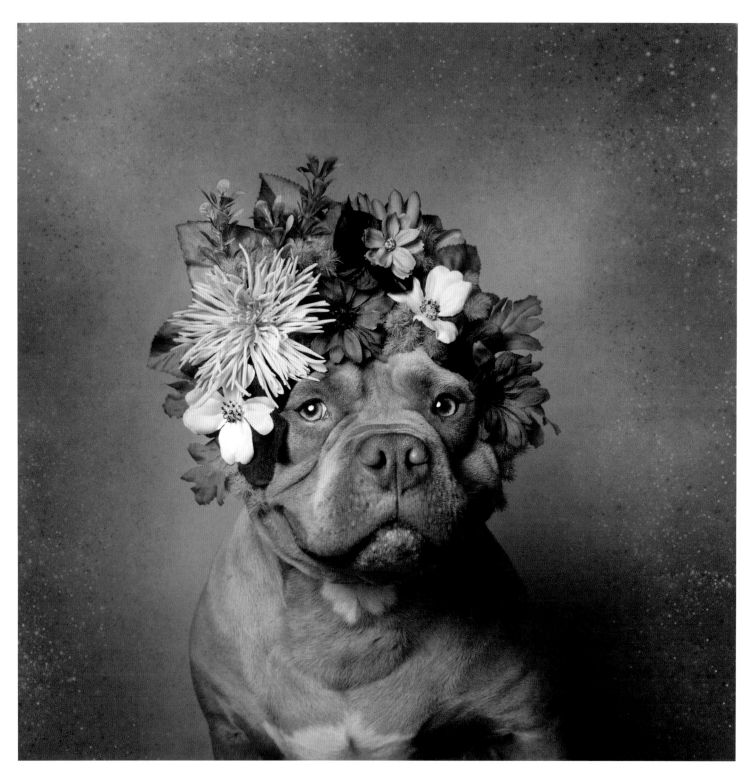

#1342920, 2017
Adopted
Riverside Animal Services, California

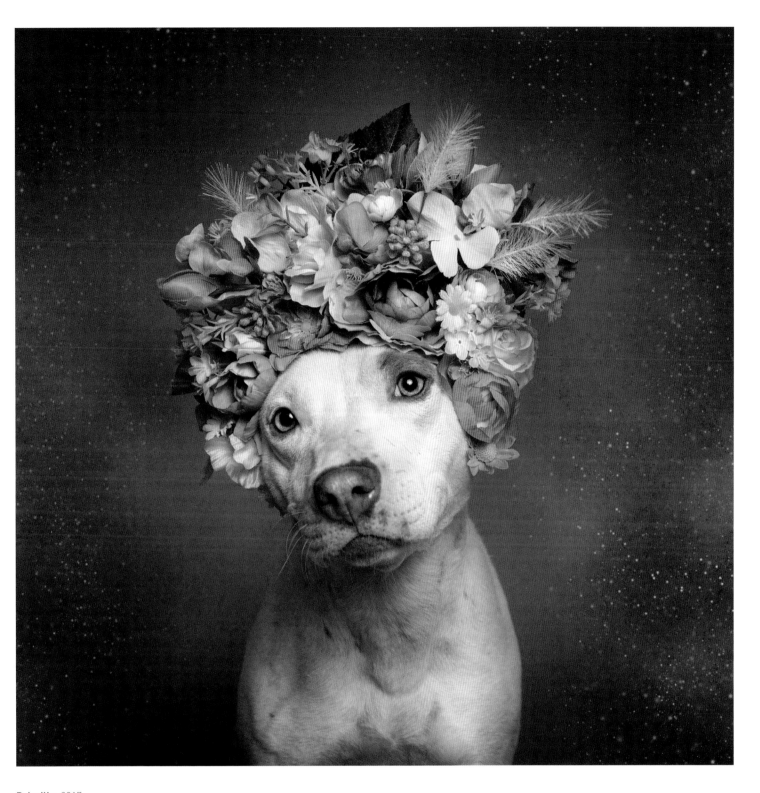

Priscilla, 2017
Adopted
Animal Haven, New York

Priscilla was rescued from a breeder who kept her isolated in conditions so bad that her last litter didn't survive. Upon rescue, Priscilla was very shy, covered in scars, but loving. She was soon adopted and made herself comfortable at home. Priscilla, renamed Pearl, is learning life in a big city. She is reactive on the leash, something that has proven challenging, but the family is working on it. "At home," her adopter says, "she is a cream puff.

When I tickle and play with my son, Pearl wants to get in on it, too. She stays in his bed while I read bedtime books and will fall asleep there. She looks like an elegant little lady, but snores sometimes like a man." A few months after she was adopted, I had a surprise reunion with Pearl. I recognized her at a local dog park. She seemed so much more confident. She stopped by to give me a kiss and hopped away like a graceful gazelle.

RUCKUS

2014, *Adopted*
Town of Hempstead Animal Shelter, New York

When Carrie and her family adopted Ruckus, they were excited to give a new home to a dog in need. A year later, however, they were forced to give Ruckus up. "Our landlord knocked on our door one day," Carrie told me, "and when I answered, Ruckus blew past me, leapt up, and latched onto our landlord's arm. He had never shown any sign of aggression in the year that we had him. Our landlord informed us that we had to euthanize Ruckus, give him up for adoption, or be evicted. We had nowhere to go. We were heartbroken. But loving a dog and being able to meet his specific needs are two very different things. Ruckus, although we loved him dearly, was a high-energy dog who wasn't fit for an apartment."

Carrie brought Ruckus back to the shelter but worried about his fate there. A few months later, she checked his status online. Ruckus was still waiting for adoption, but in his adoption portrait he was wearing a flower crown. "I had never seen anything like it, and it made me see that people cared about finding him a home." Shortly after, Ruckus was adopted. This time, the family was better equipped for his high energy; Ruckus on a five-plus-acre property had all the space he needed.

Jill and her family drove over three hours to meet Ruckus at Forgotten Friends of Long Island, a rescue that had pulled him from the municipal shelter he'd been in. There, they met Mike, a man who'd developed a friendship with Ruckus while he was at the shelter and now visited him regularly at the rescue. "Ruckus met our dogs and it went well, although they didn't hit it off," Jill wrote. "We had been informed that he had been surrendered for biting a human, so we knew that we would need to be careful with him. I had made up my mind that he was coming home, but what sealed the deal was to see Mike through a window with his fingers crossed, almost praying, hoping we would say yes to the 'Ruckstar.' We decided to give it a shot."

With slow introductions to their dogs and constant supervision, the family integrated Ruckus into their home. Those were a long few months, and there were times when the family wanted to give up, but they loved Ruckus and were determined to make it work. Eventually, all the dogs got along fine and now only need to be separated when the humans are not home.

Ruckus is now known as the "Kissing Bandit" and can wash a whole face with just one lick. He's become a wonderful emotional support for Jill's son, who suffers from anxiety. Says Jill: "Ruckus still goes ninety miles an hour and he twirls a bunch of times on his way to the door, but when he is calm, he is the sweetest, most loving dog ever."

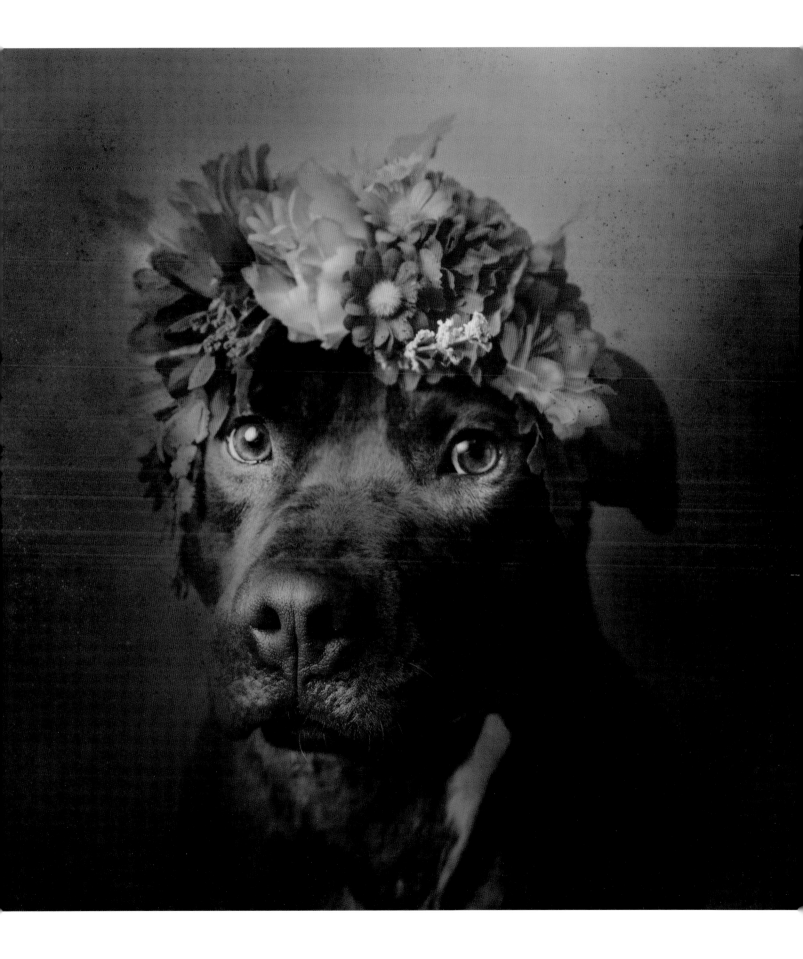

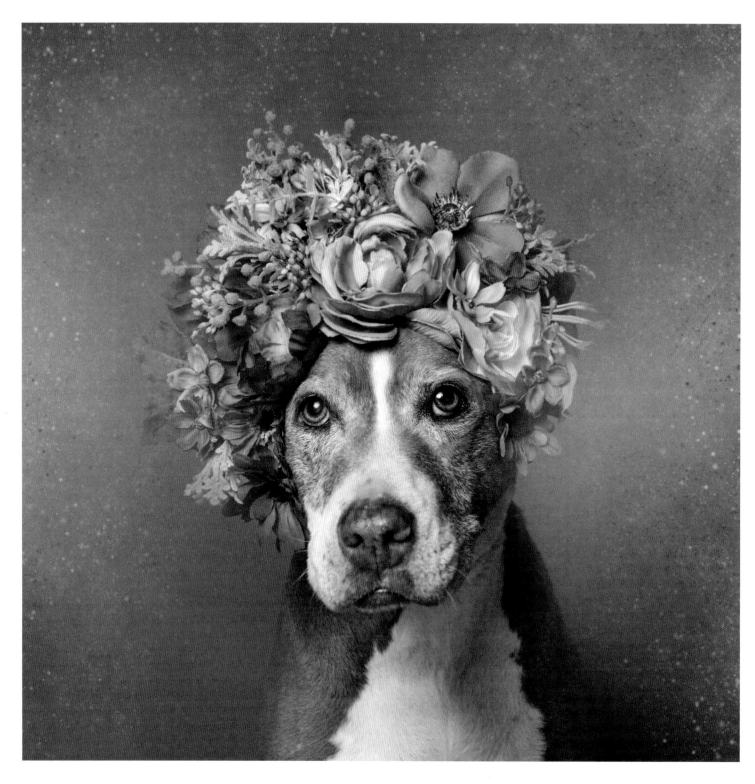

Shelley, 2016
Adopted
Austin Pets Alive, Texas

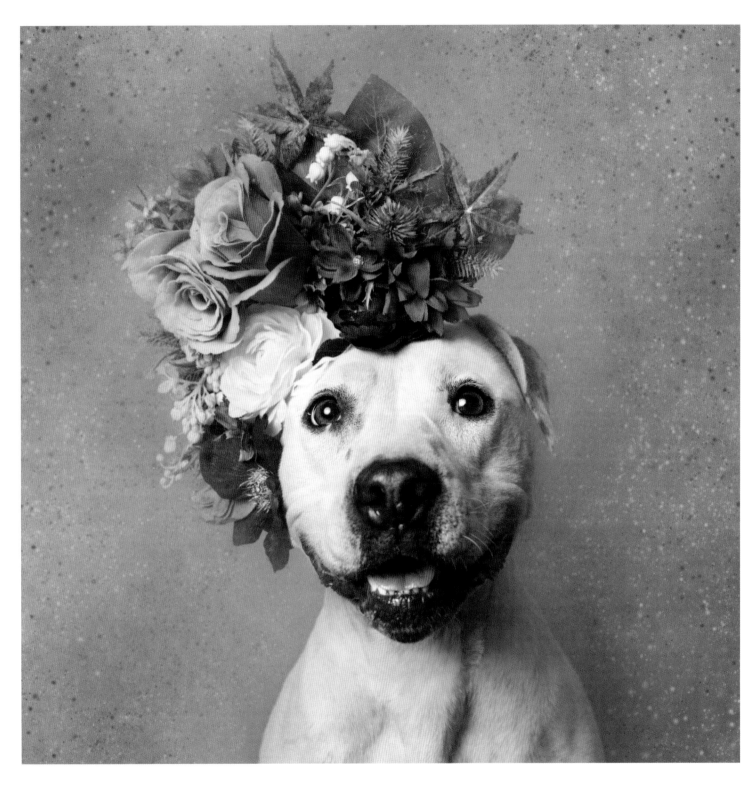

Venus, 2016
Adopted
BARC Houston, Texas

CHAMPION

2017, *Adopted*
The Sato Project, Puerto Rico / New York

Champion was rescued in Puerto Rico and later brought to New York for adoption. Nobody applied for him despite his great temperament. His pit bull looks deterred people. When Laura decided to adopt a children-friendly sato, the adoption coordinator encouraged her to consider Champ. It was a perfect match. Champ grew particularly close to his new best friend, an eight-year-old boy he could play video games with and pick up after school. Laura writes: "He is the best dog I could ever wish for. He loves everyone, dogs and humans alike, but especially my kids. He spoons, cuddles, and kisses everyone. He has completely decompressed since he moved in. He has a very human-like demeanor, like a wise old man, and the looks he gives us are beyond words. It's eerie. We can't even remember how it was before we got him. He totally belongs with us."

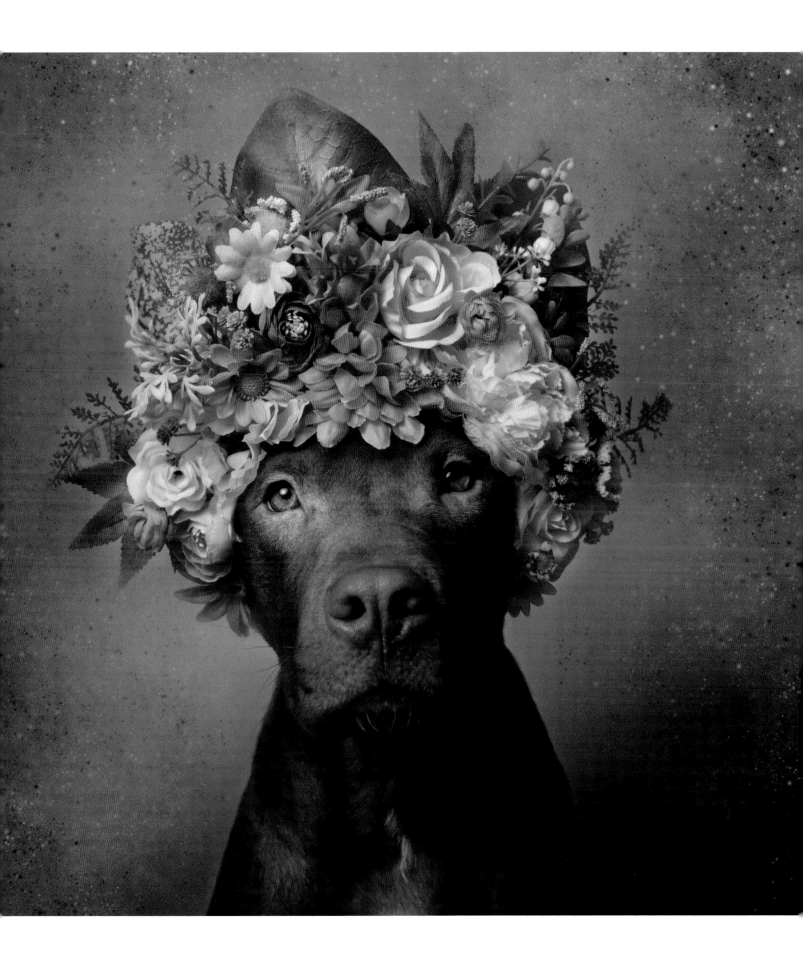

IVY

2015, *Adopted*
Redemption Rescues, New York

Ivy gave birth to nine puppies in a scorching, filthy backyard of the Rockaways, a New York neighborhood riddled with animal abuse and dogfighting. There, she lived day in and day out, tethered, and the prospect for the young mom and her litter looked grim, until Redemption Rescues received a call for help from a neighbor.

Ivy's owner claimed to have no idea how she'd gotten pregnant, and suspected someone had brought a male into his backyard while Ivy was in heat. The man agreed he needed help with the litter but refused to let the rescuers enter his home, and was hoping to keep Ivy and one puppy. He finally reluctantly agreed to surrender the whole family.

The next day, Ivy's owner handed over to the rescuers a greasy cardboard box containing eight tiny puppies and asked them to return the box when they were done. He declared that one of the puppies had been stolen overnight. Ivy herself was barely a year old and was malnourished. Dirty, covered in scars, she would cower at the slightest movement. She was particularly sweet and clearly relieved to be on her freedom ride.

Later, the family settled into the comfort of a foster home. Ivy proved to be caring and patient with her eight hungry mouths. Sadly, one of the puppies passed away due to a congenital defect. The seven remaining puppies all got adopted quickly, but not Ivy. She needed to be an only dog and was still quite shy; otherwise, she was easy, loving to all people, and affectionate.

For the following months, and despite Ivy's flower portrait going viral and getting published by major media outlets, I kept seeing the rescue's posts pop into my feed. *Adopt Ivy!* they all begged. As months went by, Ivy's puppies grew into healthy, gorgeous adults, and Ivy still waited.

Almost a year after her rescue from the Rockaway backyard, Ivy was finally adopted. Tears immediately sprang to my eyes. All this time I'd thought *Pit Bull Flower Power* had failed her, but Ivy's release was finally here. After seeing Ivy's pictures online, Donna was so moved she'd contacted the rescue. On the first meet-and-greet, Donna recalls, "It wasn't love at first sight. Ivy was very standoffish. But I had this feeling that I was meant to take care of her."

As I caught up with her, Donna shared some of the challenges they face, and it seemed the journey with Ivy wasn't an easy one. Ivy still has a lot of anxiety, and she has to be kept strictly separate from other animals. She's made some progress and doesn't crouch and cry anymore when Donna makes a sudden motion, and even ignores the dogs who live nearby, but life with Ivy is a commitment not many people are willing to make.

Donna is one in a million. She's had to adapt her lifestyle to Ivy's needs and has made peace with the fact that she'll probably never enjoy leisurely strolls in public parks with her best friend. "I don't have this fantasy of a perfect dog," she says. "That's okay. I understand her limitations; I have plenty of my own. Fortunately, I have a gigantic backyard and she has plenty of room to play. I don't have small children or other animals and I'm retired, so we have all the time we want together and I can accommodate her needs. Aside from her anxiety, she is very mellow. She loves to lie in the sun and to cuddle. She sleeps in my bed and rests her head on my stomach. If I let her, we would spend thirty hours straight in that position. I am her person and she is my girl."

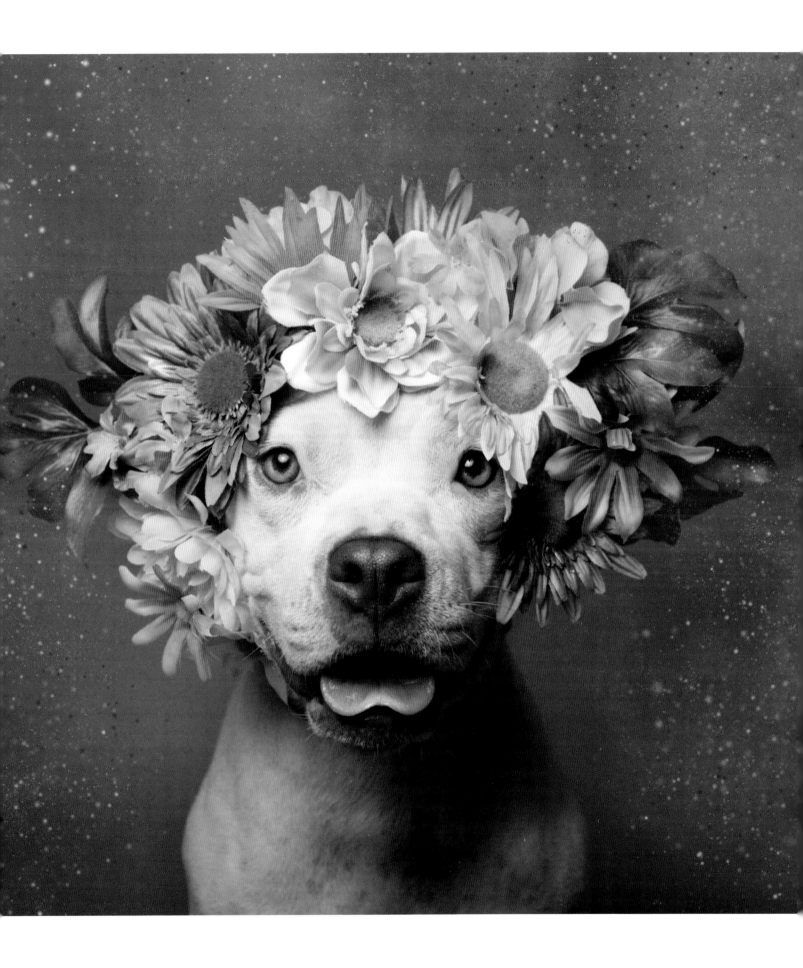

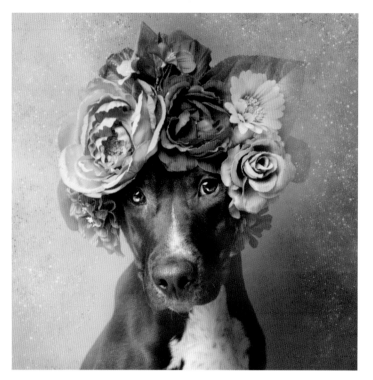

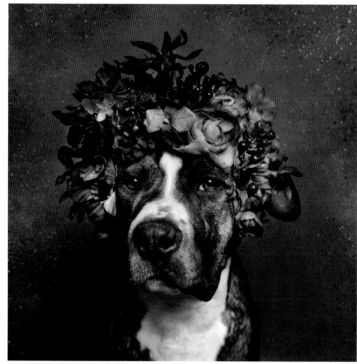

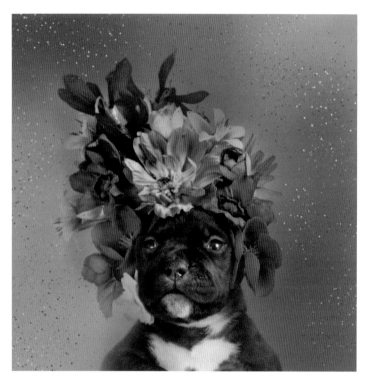

Bane, 2015
Adopted
MASH Unit, Arizona

Gypsy, 2016
Adopted
Luvable Dog Rescue, Oregon

Cam, 2016
Adopted
Animal Haven, New York

Destiny, 2016
Adopted
Almost Home Animal Shelter, New Jersey

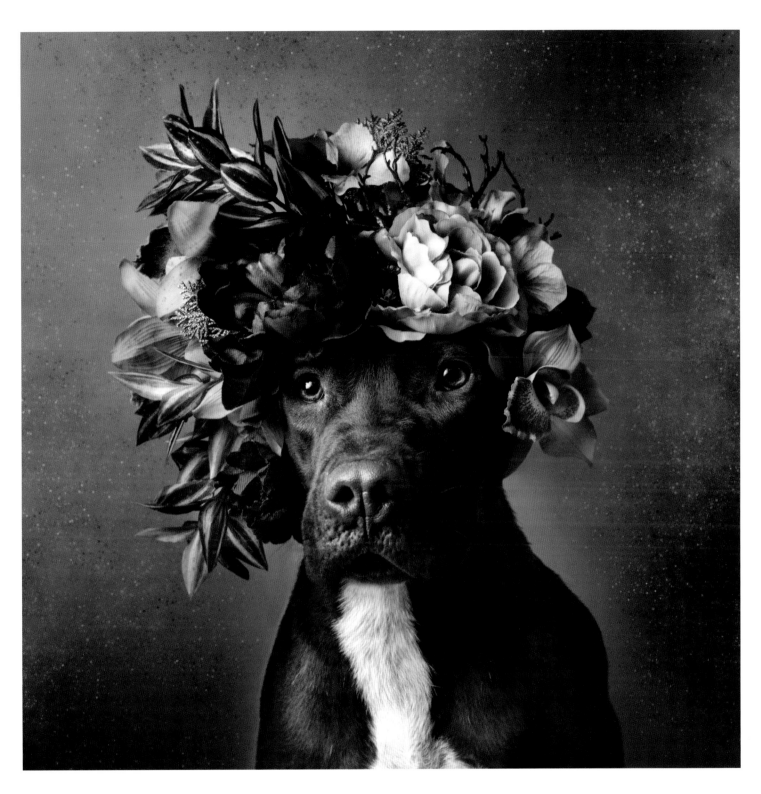

Aden, 2016
Still waiting
Calhoun County Humane Society, Alabama

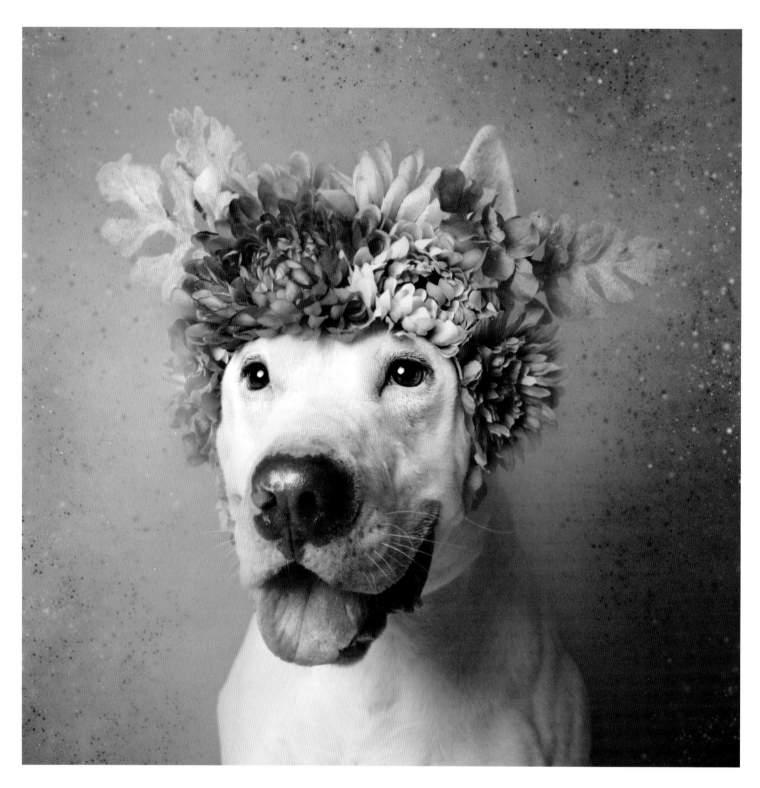

Kane, 2015
Adopted
MASH Unit, Arizona

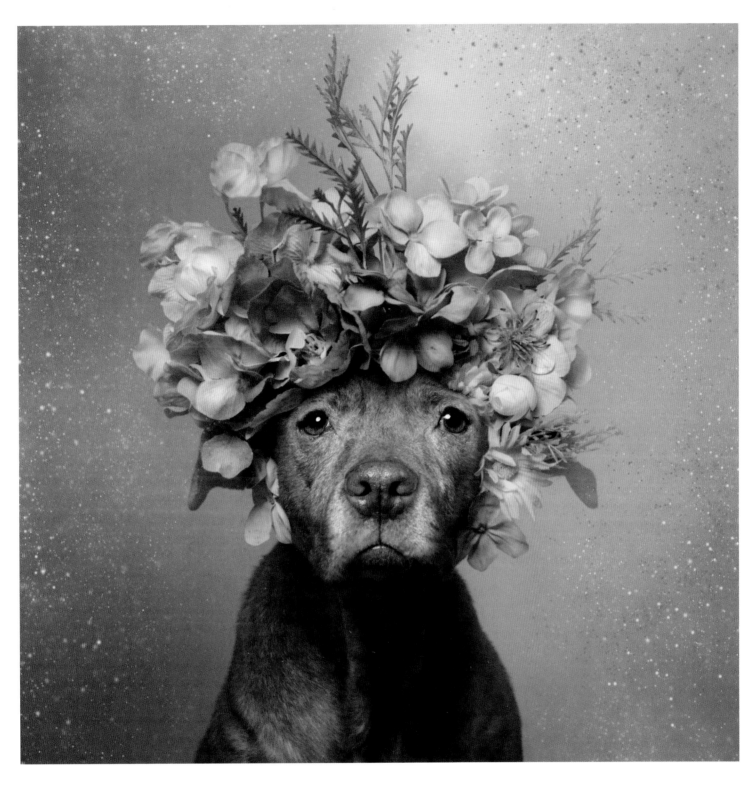

Miranda, 2016
Not adopted, deceased
Warwick Valley Humane Society, New York

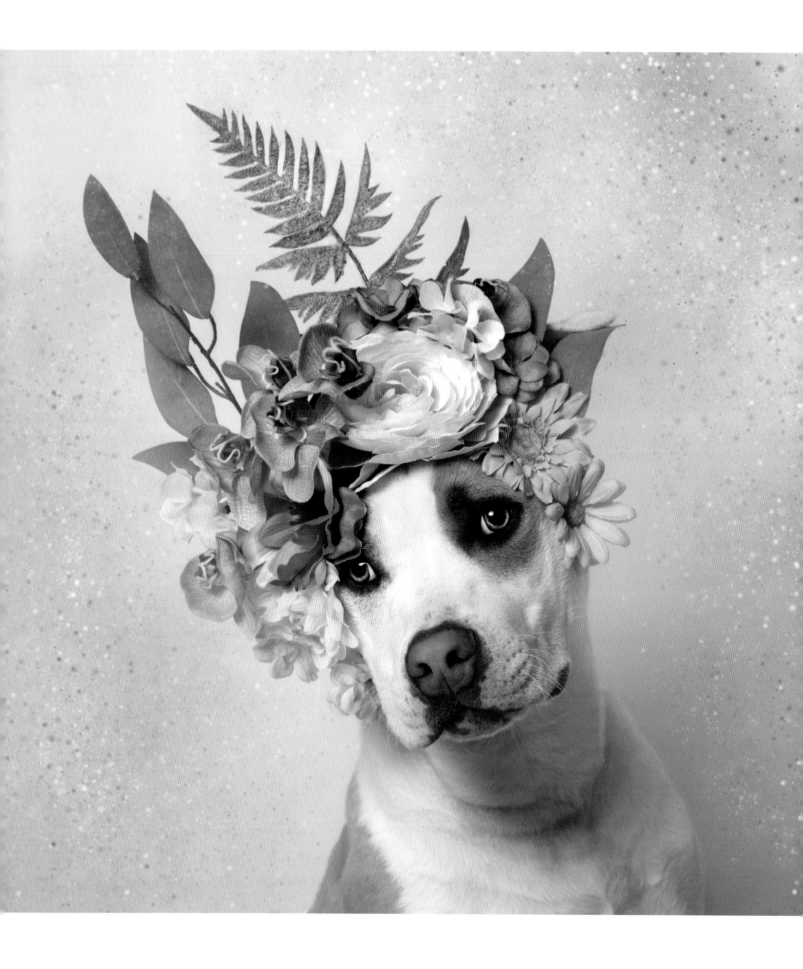

CONNOR

2016, *Euthanized*
Luvable Dog Rescue, Oregon

Connor's story is beautiful and tragic. It can teach us about mental illness in dogs, a subject that is only starting to get the attention it deserves.

Connor's mom was rescued in California. She was so skinny that nobody had noticed she was pregnant until she delivered seven puppies. Malnourished and weak, she could not produce milk. The seven puppies were initially left on their own at a loud and busy boarding facility; later, they were sent to Luvable Dog Rescue in Oregon. From what Ashley, director of adoptions at Luvable understood, the litter had been bottle-fed by staff and hadn't gotten the interaction and socialization they needed from their mom, who'd been adopted.

"From the moment we got them, something seemed off about the whole litter," Ashley remembers. "We had had many litters before them, but this one was different." Luvable nursed the puppies back to health (they were malnourished and full of worms), and within a few weeks all of them had been adopted into loving Oregonian families.

Three months later, Ashley received a frantic call from Connor's adopters, who wanted to return him. Connor had become difficult to manage, had meltdowns, and would chase his adopters around. It was clear his adopters were overwhelmed and not equipped to handle the puppy, so Ashley removed Connor from the home. From their first outing at a nearby dog park, Ashley quickly realized there was something more complicated going on than just a lack of training. There was a jackhammer, dogs barking, and cars driving by. Connor had a complete meltdown. He started mouthing Ashley's legs and then his own legs; he pulled hair out of his tail, and desperately tried to mouth anything he could find. This was a serious case of overstimulation.

Back at the rescue center, Ashley started a long journey with Connor, spending months training him, working with him every day. One thing made the work difficult: Connor had the memory of an elephant. If he heard something that set him off as he was passing through a door or across any type of threshold, he'd always remember that moment and have a fit crossing that same threshold again, even if nothing was happening at the time. This was something Ashley, an animal trainer with many years of experience with all sorts of domestic animals (as well as tigers, cheetahs, cougars, and even exotic birds), had never encountered. Other dog experts couldn't help either, as no one had ever experienced such behavior. People started advising Ashley that perhaps Connor should be euthanized.

Ashley wasn't ready to give up, though. By then, she and Connor had an undeniable bond. After several more months without much progress, however, she started wondering if Connor had some sort of mental illness. The training alone wasn't enough to help him. The rescue booked an appointment with the Animal Behavior Clinic in Portland. After a lengthy assessment, Dr. Pachel diagnosed Connor as having a sensory processing disorder.

Similar to autism in humans, the condition meant that Connor would have dramatic responses to sensory stimuli (visual, touch, sound). It was extremely difficult for him to process most situations and stimuli, and once triggered, he'd become less and less functional. "As long as his physical and social environment is calm and predictable, he is able to focus, learn, and respond correctly to direction and commands," the doctor explained. "However, when anything stimulating happens—you arrive home from work, a dog passes by on a walk, the presence of food or treats, etcetera—the

emotional part of his brain essentially overrides the thinking part of his brain in a way that is very similar to the fight-or-flight response that animals use as part of their survival instinct. This may be due to genetics, developmental abnormalities, or early socialization and training experiences. Unfortunately, this condition is not very widely recognized in dogs and has not been studied enough to know the specific causes or factors."

The doctor's report gave hope to the rescue team, stating that significant improvement was possible through dedicated training, management techniques, and careful environmental control. Dr. Pachel listed highly specific dosages of medication to be administered in a particular order. The cocktail included medicine used for anxiety-based behavior disorders, anti-depressants, and nerve blockers traditionally used as anti-seizure treatment and as mood stabilizers. The list would have made most people's head spin. But Ashley was ready for the challenge and committed to Connor. They were in this together.

From then on, the team worked to fine-tune the cocktail and find the perfect dosages for Connor. By December 2016, they seemed to have found the right combination, and Connor was doing much better. He had a normal quality of life at last. He was good with other dogs, great with people, and calmer overall, while still maintaining his personality. He was hiking in the forest every day, being playful, getting tons of cuddle time with visitors, and being himself, minus the meltdowns. As she recalled that part of their story together, Ashley's voice lightened, and I could hear this had been the happiest time they'd had. Connor had also moved to a more isolated building of the compound, where he was less exposed to loud noises, barking, and the excitement of a shelter life. He was doing so well, in fact, that when approached by a foster, Luvable decided it was time to trust Connor on the next step of his journey. He was scheduled to head to his first foster home the following weekend.

But Mother Nature had other plans for Connor and Ashley. That Wednesday, freezing rain began to fall heavily on the little rescue nestled in a giant forest. The rain would turn into a major ice storm that would

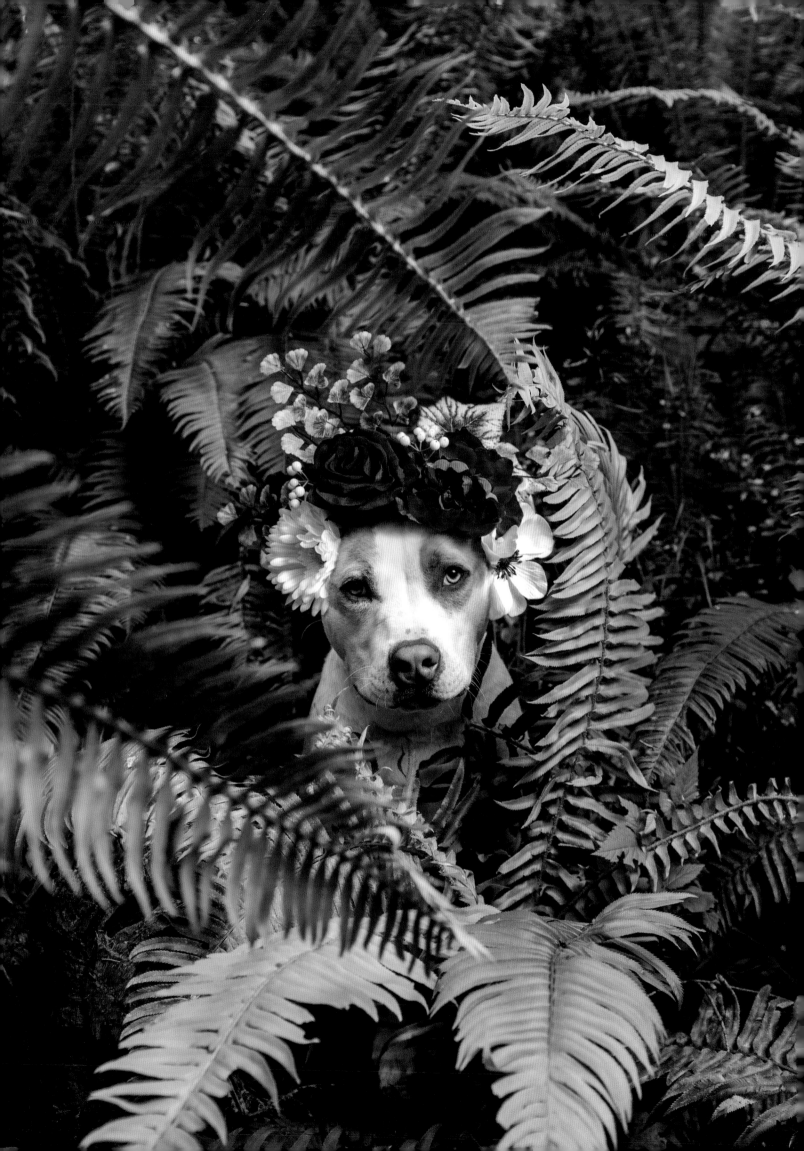

ravage the region, leaving over ten thousand households without power for days. The ice storm brought devastation. As Ashley recounted these days, trying to put words to the unimaginable, I shivered. Liesl (the founder and owner of the rescue), Ashley, and Christine, alone on the rescue compound, were not only stranded on the property, they also had about fifty dogs to take care of, including moms and their litters. With only one generator for the whole rescue, the women kept puppies in their car with the engine running for warmth. Each dog wore as many sweaters as possible.

The worst part of the storm was the multitude of ice-glazed trees and branches that broke and fell. "They sounded like bombs," Ashley recalls. It was traumatic for everybody. But imagine what that did to Connor, a dog who had a sound-processing disorder and was in the middle of the woods with giant trees falling around him! His medication was off-schedule because it was impossible for the team to reach his building after sunset since they couldn't see if a tree was about to fall. After a few days, Ashley decided to move him back to the main building.

She was getting Connor situated in his room when he had a serious case of explosive diarrhea. She took him outside so she could clean everything, and suddenly Connor had one of his meltdowns. "I opened the door and he was screaming and running. I was wearing ice shoes at the time because everything was covered in thick ice, and they made that awful screeching sound on the concrete floor each time I took a step. I walked up to him and I went to grab his collar and he just. . . ." Ashley's voice broke as she relived the scene, tearful. "He was. . . . He wasn't Connor anymore, you know? He was completely checked out and . . . he turned around and got a hold of my arm and started shaking me with all of his strength."

Fortunately, Ashley was wearing multiple layers of clothing, and that probably saved her arm. She also has extensive experience in dealing with dangerous animals and knew what to do. But she was alone fending for herself against one of her dearest companions. "I finally got him off me and pressed him against a wall and he was still jumping and trying to get to my throat. I was his favorite person. I had spent the most time with him. We had a really, really special bond. So I knew that if he was doing this to me he was completely gone. He was in complete survival mode. I managed to push him into the bathroom and closed the door behind him. He was still throwing himself against the door. My adrenaline stopped and I collapsed onto the floor. Blood was pouring down through my sleeves. I called Liesl and Christine and they came running down, and when they peeled off the layers of clothing I was wearing, I had all this tissue and muscles hanging from my arm. Christine drove me to the hospital. I spent the night there and Connor spent the night in that bathroom."

The next morning, the team made the decision to euthanize Connor. Yes, it was a series of really unfortunate circumstances—how many historical ice storms would Connor experience in his life?—but if it could happen once they couldn't take a chance on it happening again. "I wanted to be there for him, but I was still at the hospital," Ashley said. "So one of the other girls from Luvable who really cared about him sedated him and brought him to the vet to put him to sleep. That's my biggest regret, that I wasn't there with him in that last moment."

For several days after the storm and the horrific turn of events, Liesl herself had to run the entire shelter without power. Although the rest of the staff remained with her during the day, at night Liesl was alone, a prisoner of her frozen, ravaged rescue compound, a place she'd built lovingly over the years. These were trying times.

As for Ashley, after months of treatments to soften the scar tissue on her arm, she got a new tattoo, crowned with a moon crescent shaped like the letter C, for Connor. "I want to carry a piece of him with me always. He was a special boy and I wanted to help him so much." Connor's flower portrait now hangs in Ashley's home, looking over her recently adopted special-needs dog, Lumen.

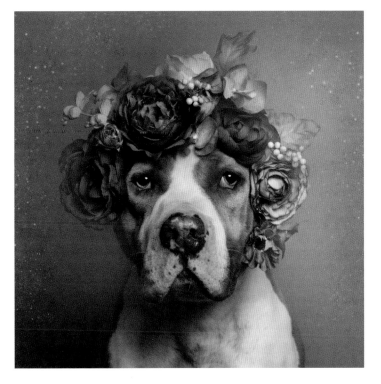
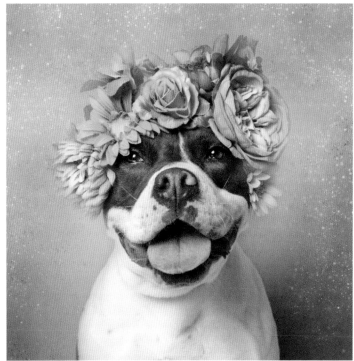
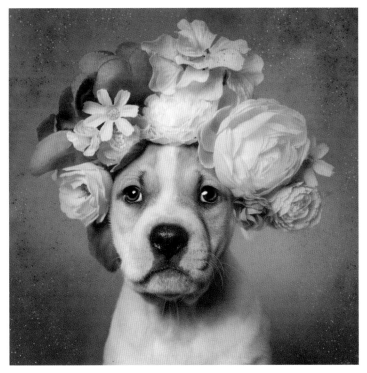
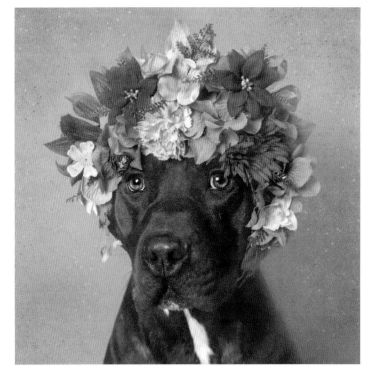

Pongo, 2015
Adopted
Town of Hempstead Animal Shelter, New York

Jacob, 2015
Adopted
Redemption Rescues, New York

Roxie, 2015
Adopted
MASH Unit, Arizona

Fin, 2014
Adopted
Town of Brookhaven Animal Shelter, New York

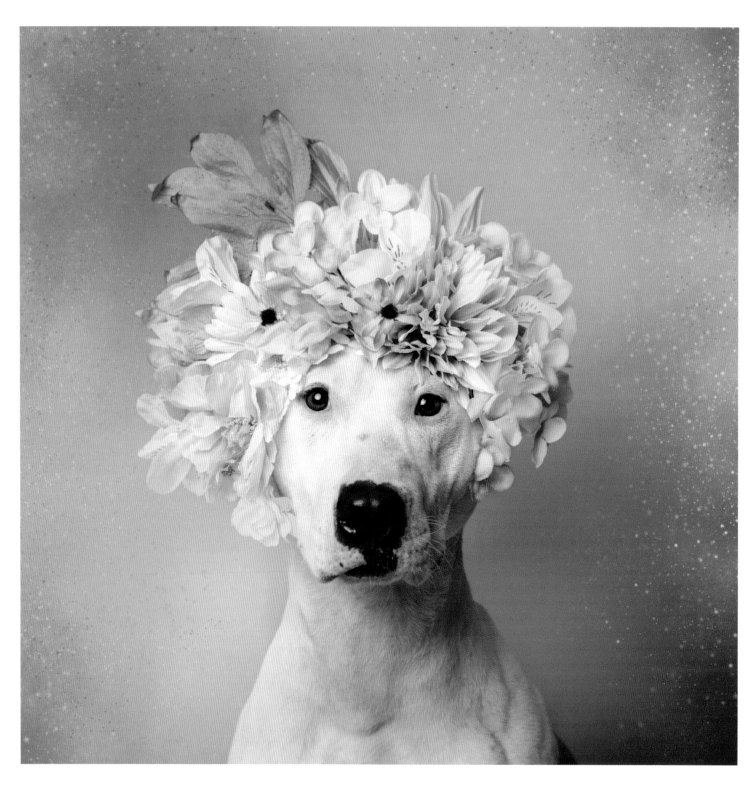

Ebert, 2016
Adopted
Austin Pets Alive, Texas

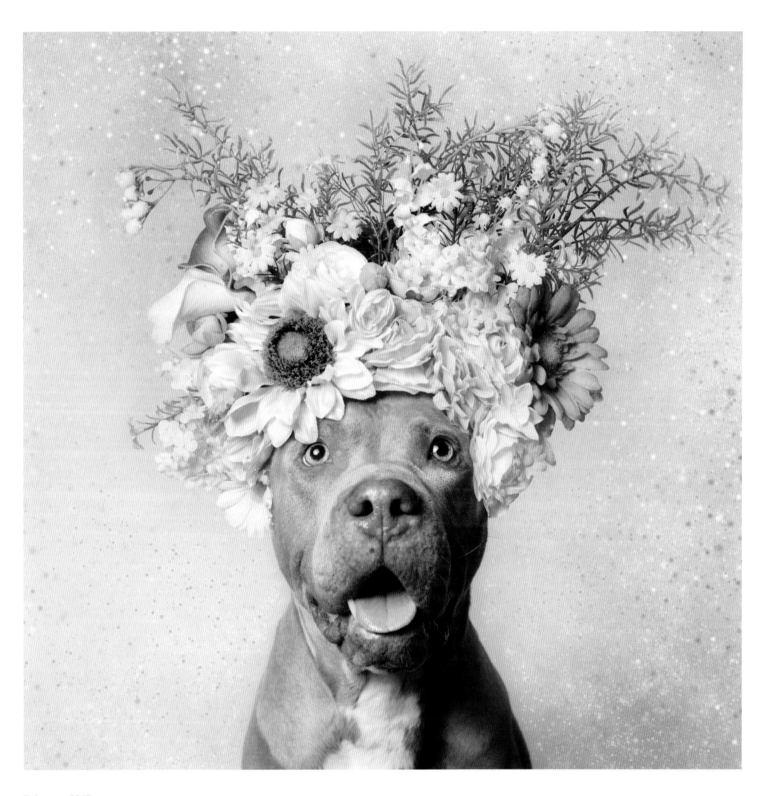

Princess, 2017
Adopted
Rebound Hounds, New York

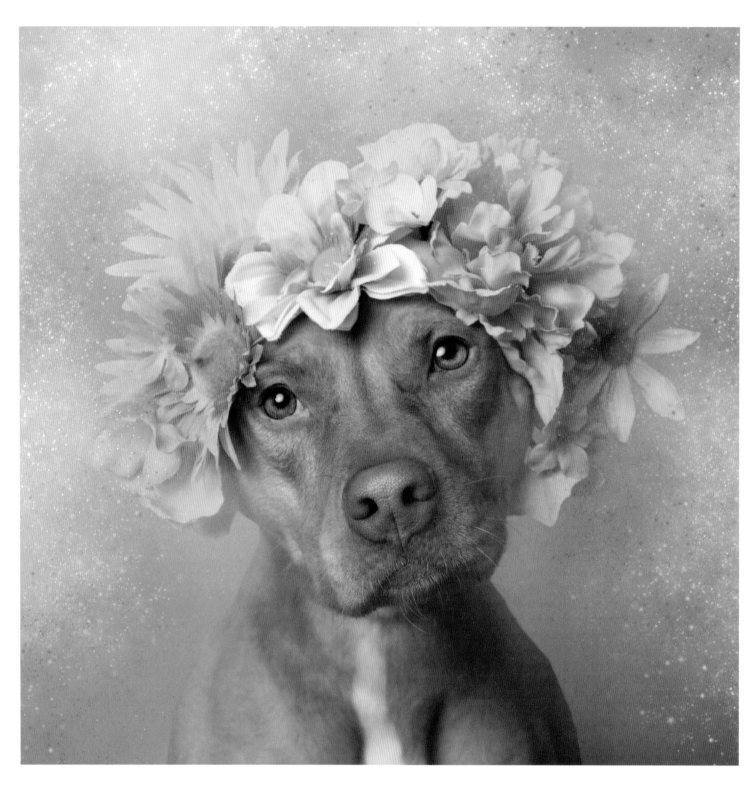

Una, 2015
Adopted
Town of Hempstead Animal Shelter, New York

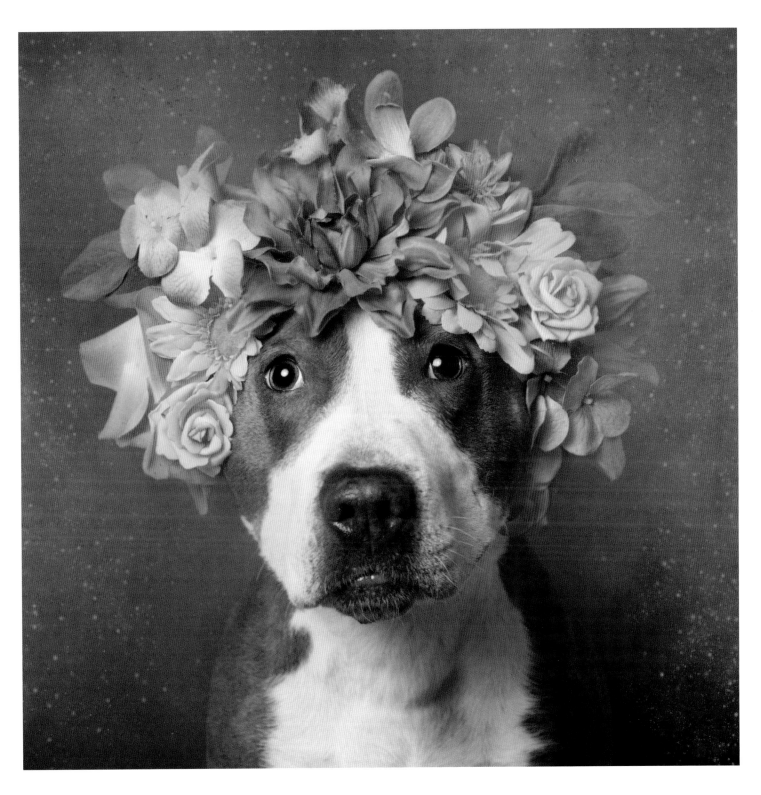

Sasha, 2015
Adopted, deceased
Redemption Rescues, New York

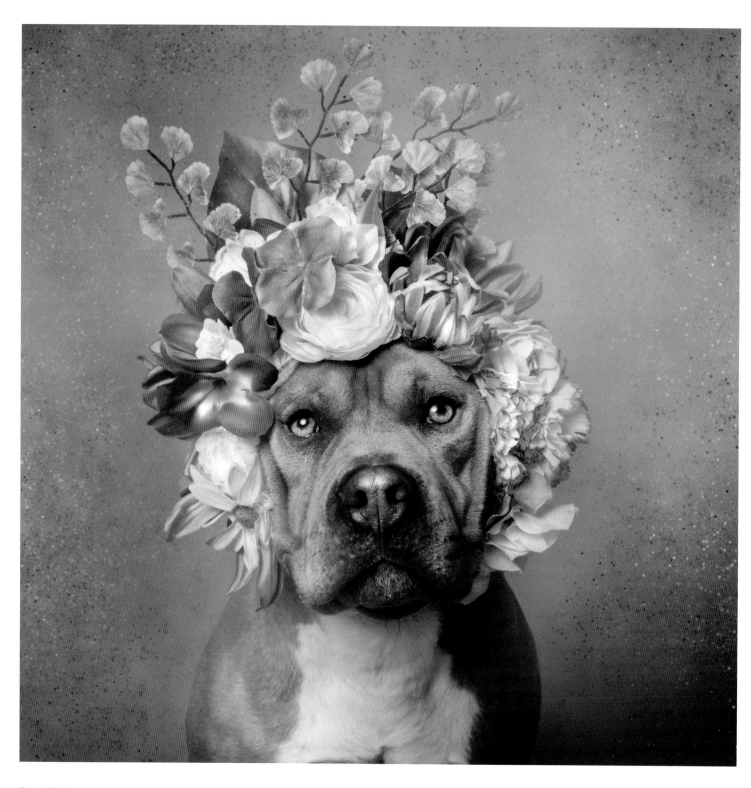

Bane, 2016
Adopted
Animal Haven, New York

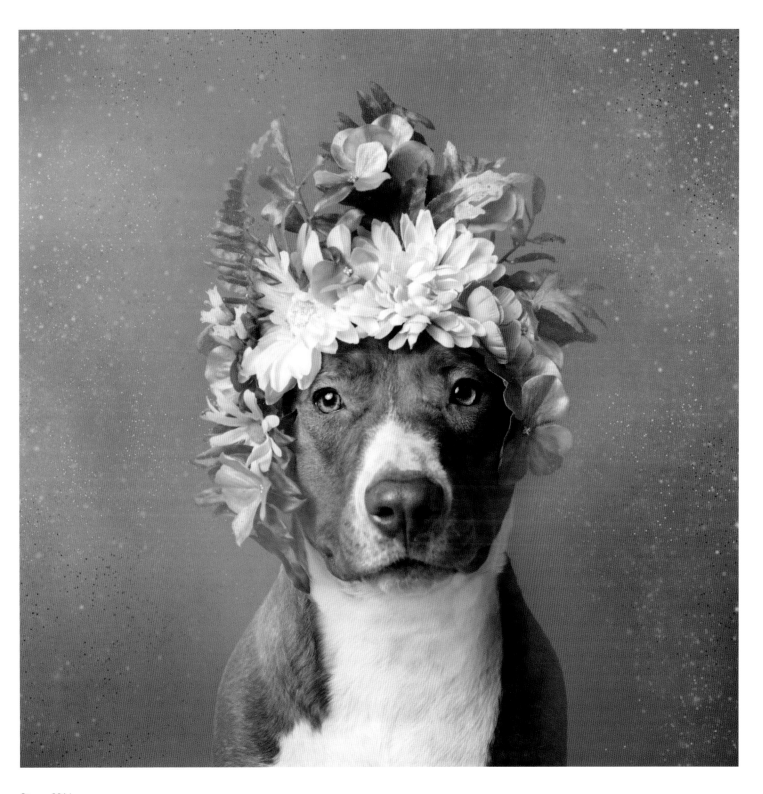

Stacy, 2016
Adopted
Fulton County Animal Services, Georgia

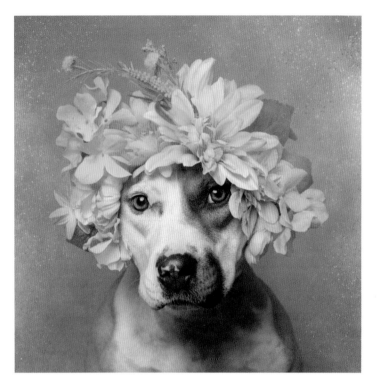

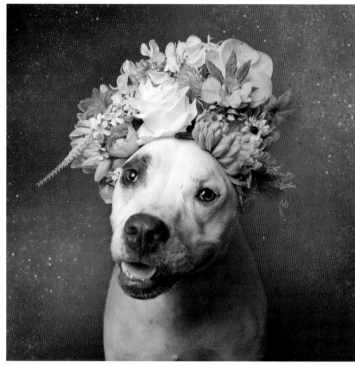

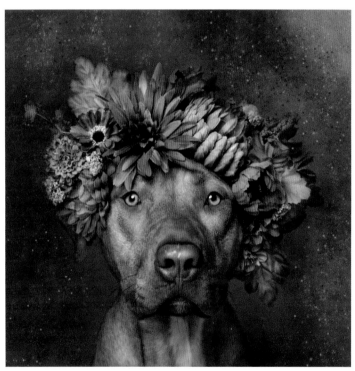

Marina, 2015
Adopted
Town of Hempstead Animal Shelter, New York

Finn, 2015
Adopted
Sav-a-Bull, New York

Casey, 2016
Adopted, deceased
Redemption Rescues, New York

Coney, 2015
Adopted
Mr. Bones & Co., New York

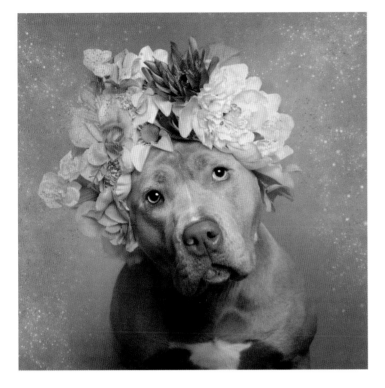
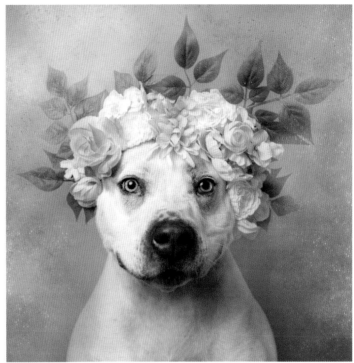
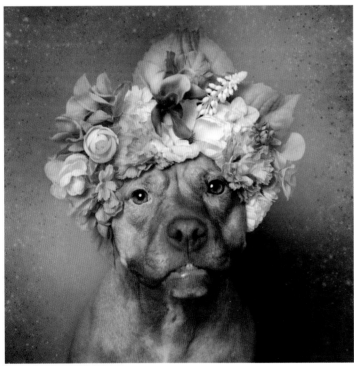
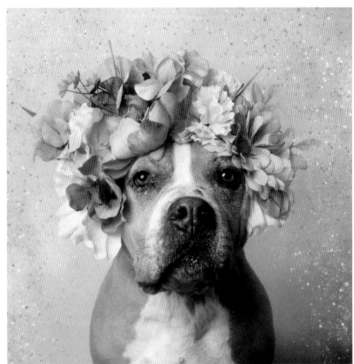

Carly, 2015
Adopted
Town of Hempstead Animal Shelter, New York

Cali, 2015
Adopted
Town of Hempstead Animal Shelter, New York

Melody, 2016
Adopted
Philadelphia Animal Welfare Society, Pennsylvania

Desi, 2015
Adopted
AZK9, Arizona

AMY

2015, *Adopted*
Animal Haven, New York

Amy was found chained to a fence with part of her face missing. As she settled into shelter life, she got more and more anxious and restless. Her condition escalated to a point where she became difficult to walk, lunging at random things and even snapping at people. Animal Haven has a great enrichment team and the staff tried the usual techniques, providing Amy with healthy stimulation and toys, and giving her extra playtime in their spacious training room.

When all failed, the staff chose a more unconventional approach. Instead of trying to tire Amy out, the members gave her a quiet area where she'd feel safe and comfortable. Using donated items—a couch, water fountain, and TV—they created a Real-Life Room (a makeshift living room) and assigned an intern to hang out with Amy.

A few hours of watching soap operas and silly TV court shows transformed Amy. No more whining or excessive drooling, no random snapping. By the time she was adopted, her crippling anxiety was drastically reduced, although she remained challenging for the first months.

Today, she does much better. One of Amy's—now Blair's—favorite things to do is to run to her heart's content with her mom, Serena. "When we lived in Manhattan, we would run down Madison Avenue and through Central Park," says Serena. "We once went to Philadelphia and ran up the *Rocky* steps. In our new apartment complex there is an off-leash area, which allows her to run at Mach 5 speed."

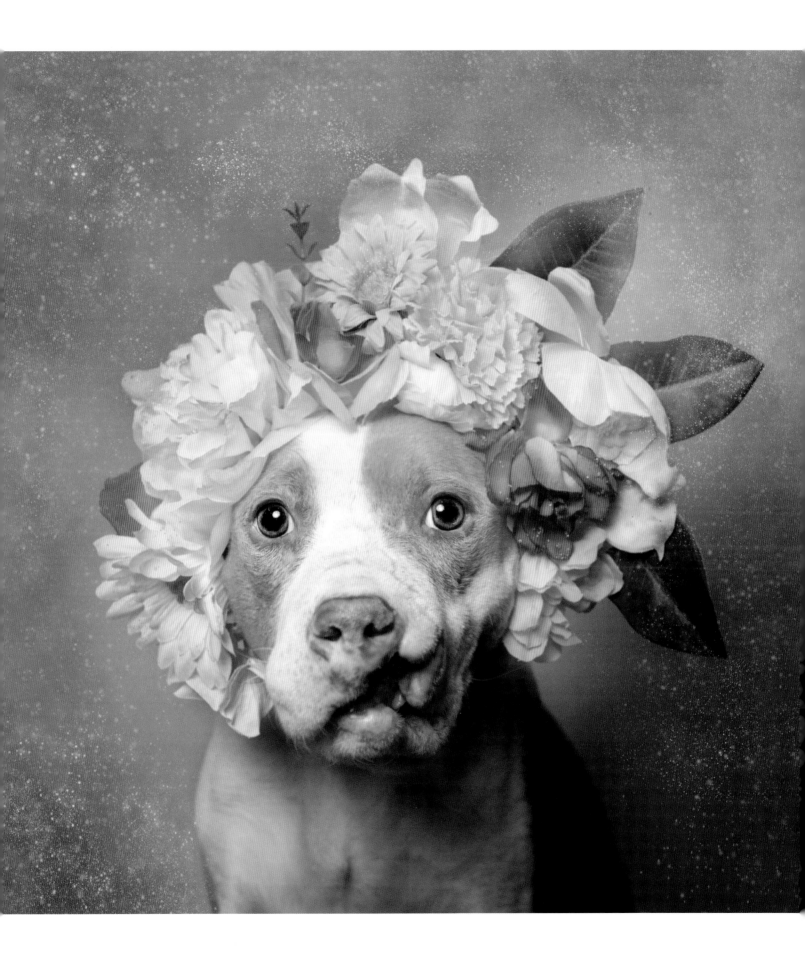

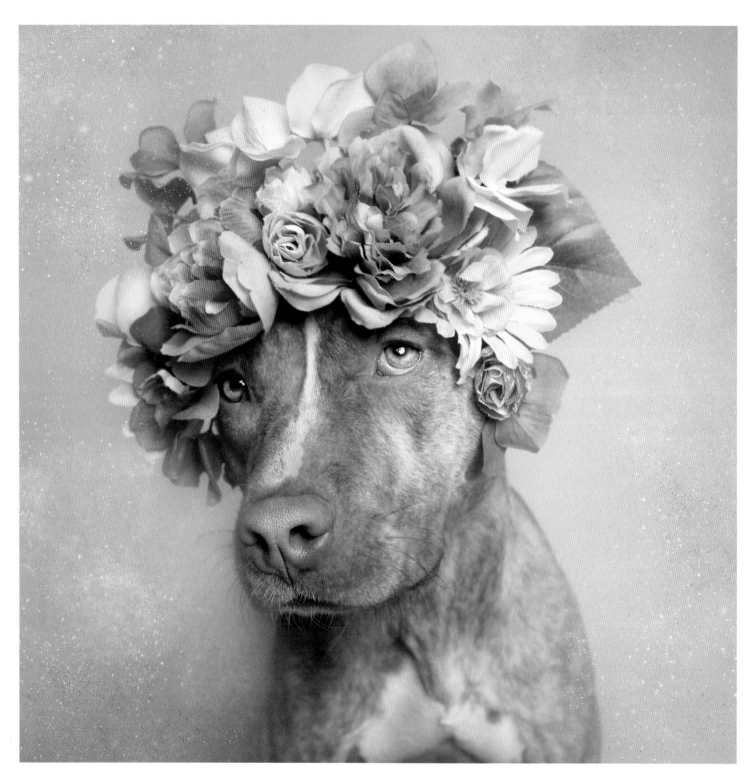

Lux, 2014
Adopted
Sean Casey Animal Rescue, New York

"I moved in with my brother after a painful divorce. One day, I came home and found a surprise waiting for me. It was Casper. My brother had seen your photograph of him and went to adopt him. He was perfect. Casper was a big teddy bear who couldn't get enough of the cuddles. He became one of my six-year-old nephew's best friends. Even people in my building who initially were worried or scared of him because of his size and type came to love him. One is highly considering adoption now. Casper would know when you were in need of comfort and provided just that, either by being "little spoon," sleeping on your chest, or just laying next to you as you slept. Unfortunately, he was diagnosed with intestinal cancer. He stayed with us for another six months

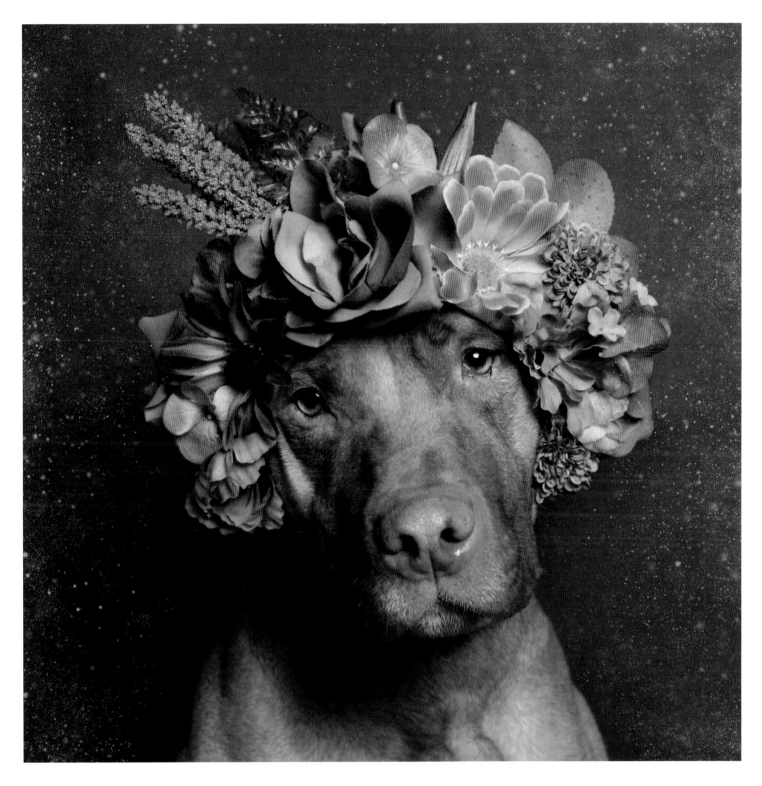

Casper, 2015
Adopted, deceased
Sean Casey Animal Rescue, New York

until he knew his work was done. Despite his difficult past, and having waited two years at the shelter, he was able to trust people again, love wholeheartedly, and be strong and fight no matter how hard things got. And at a time when I needed it the most, this is exactly what he taught me, and I will forever be grateful to him. We also adopted Lux, another *Pit Bull Flower Power* model.

Even though she has a strong and independent spirit, she idolized Casper and followed his every move. He would be proud to know that she is holding down the fort well." —Kethonia

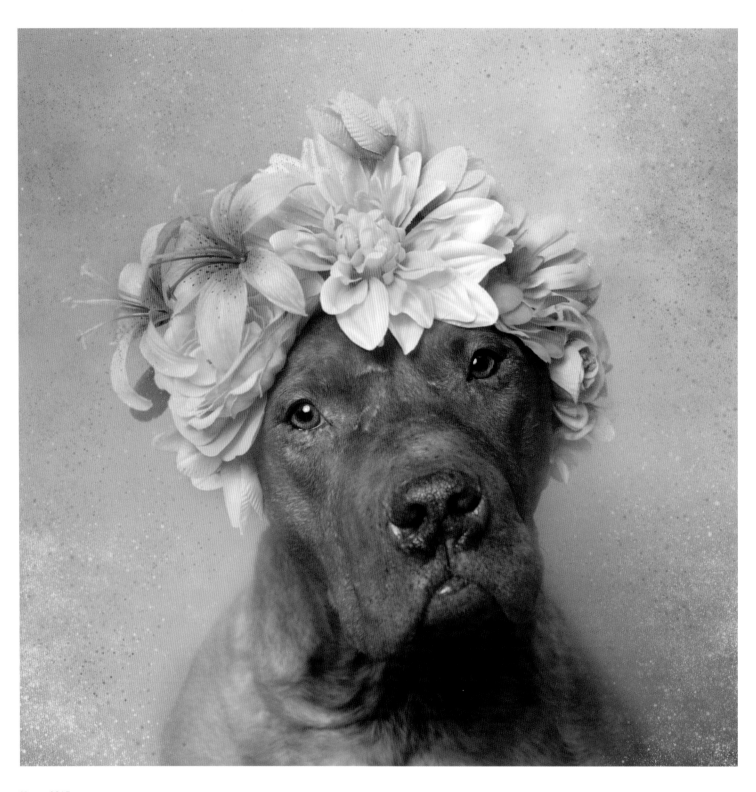

Kona, 2015
Adopted, deceased
Mr. Bones & Co., New York

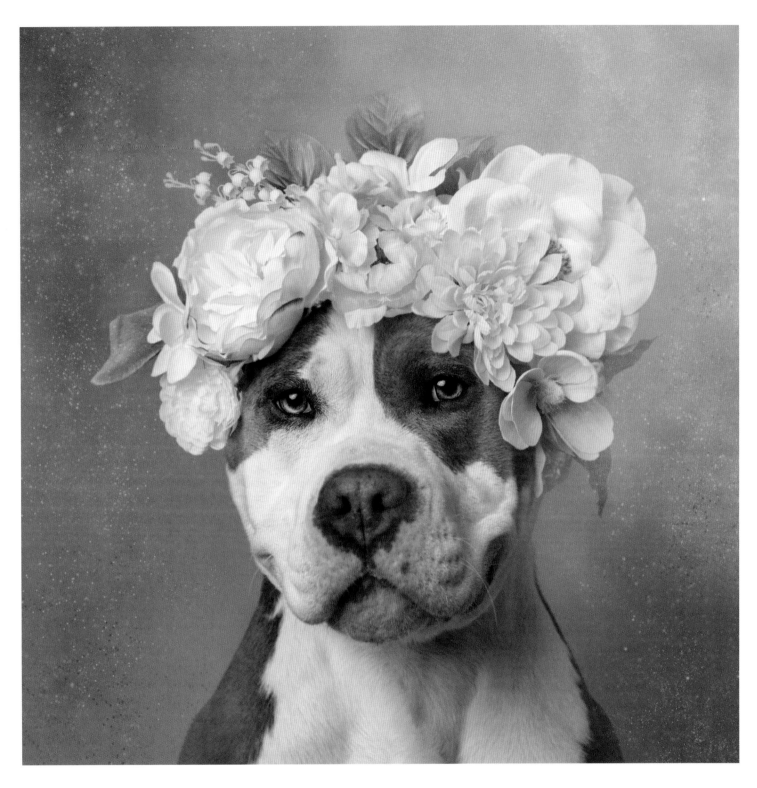

Bertha Bean, 2015
Adopted
Town of Hempstead Animal Shelter, New York

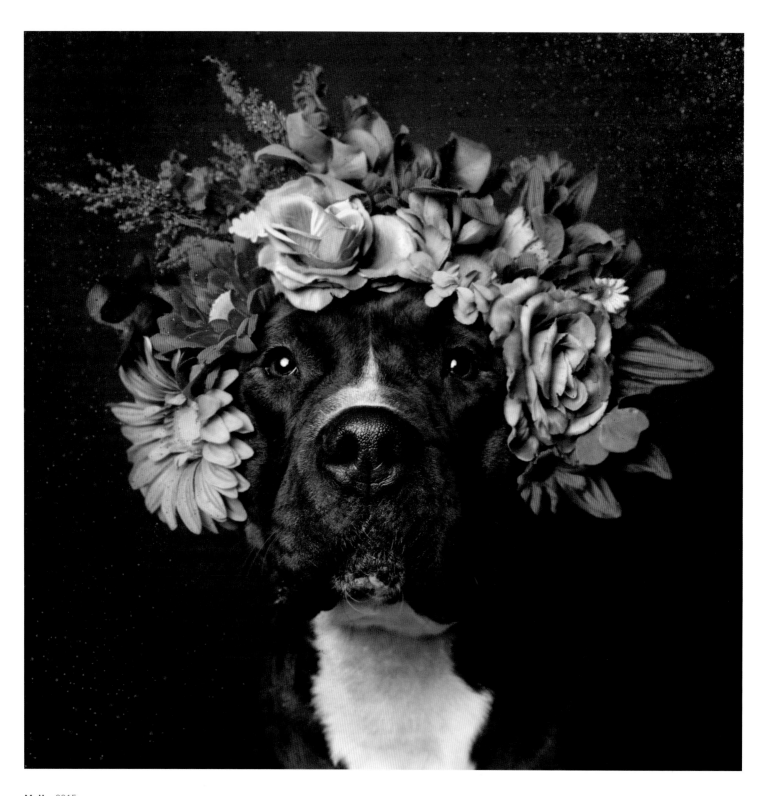

Molly, 2015
Adopted
Hudson Valley Animal Rescue Sanctuary, New York

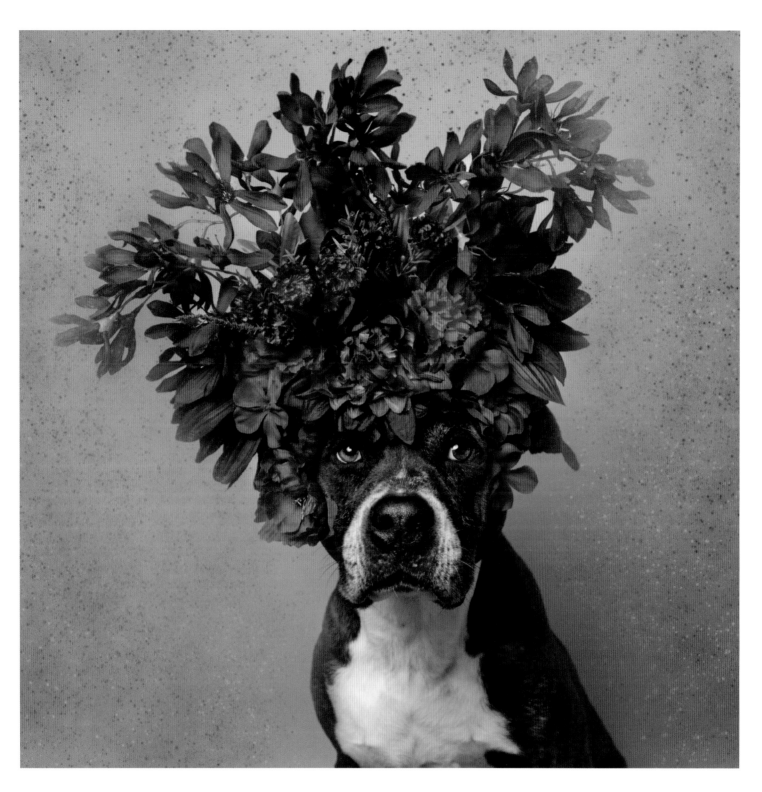

Suzie, 2017
Adopted
Miami Dade Animal Services, Florida
Main Line Animal Rescue, Pennsylvania

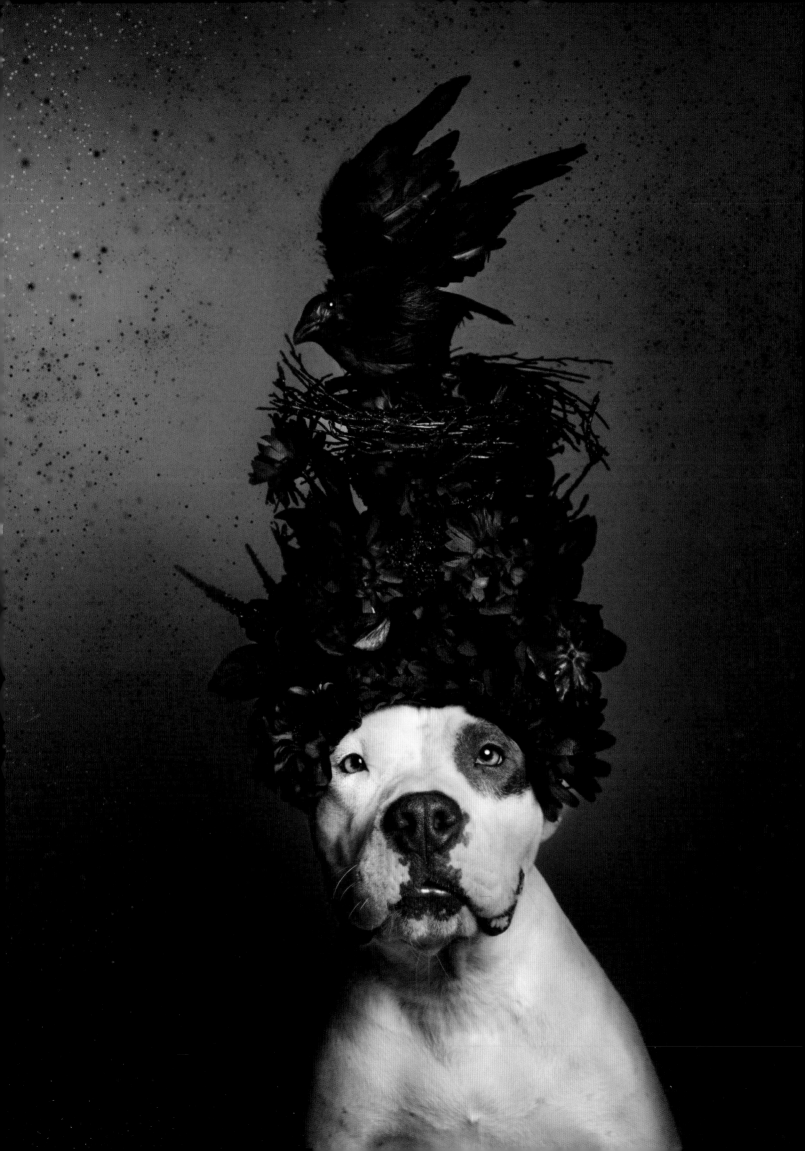

It was a race against time to save them.

Captain Kidd and her twelve puppies (see eight of them on the following pages) were abandoned at an overcrowded shelter in California. There, they couldn't be quarantined properly and were at risk of catching dangerous, contagious diseases. It was a race against time to save the Pirate family. Thankfully, they were pulled by Luvable Dog Rescue and traveled all the way to Oregon, where they all found homes a few weeks later, even the mom.

Captain Kidd, 2017
Adopted
Luvable Dog Rescue, Oregon

CAPTAIN KIDD | PIT BULL FLOWER POWER

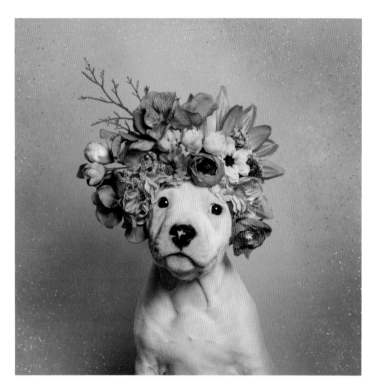
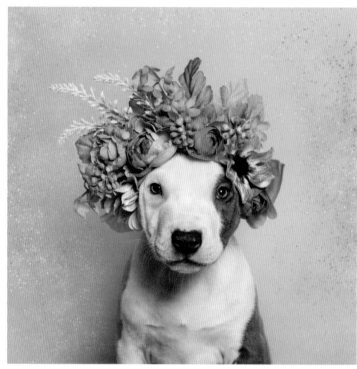
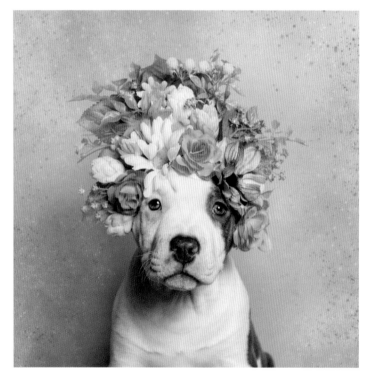
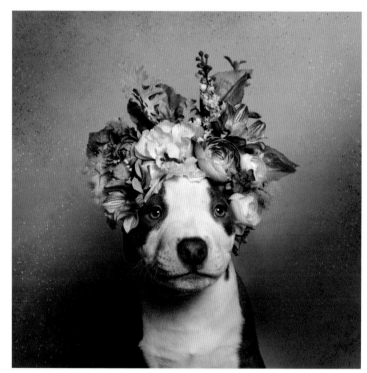

Salty, 2017
Adopted
Luvable Dog Rescue, Oregon

Pegleg, 2017
Adopted
Luvable Dog Rescue, Oregon

Treasure, 2017
Adopted
Luvable Dog Rescue, Oregon

Jolly Ranger, 2017
Adopted
Luvable Dog Rescue, Oregon

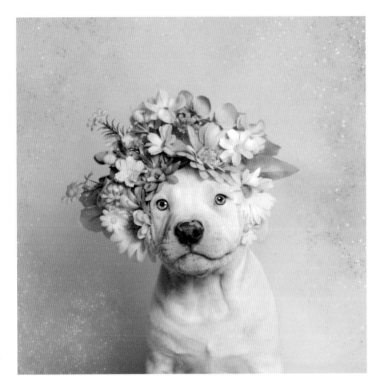

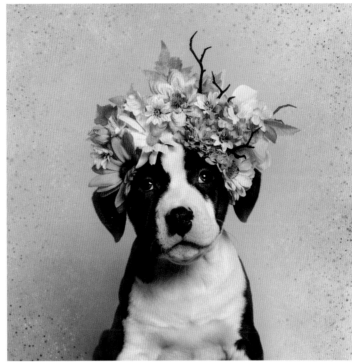

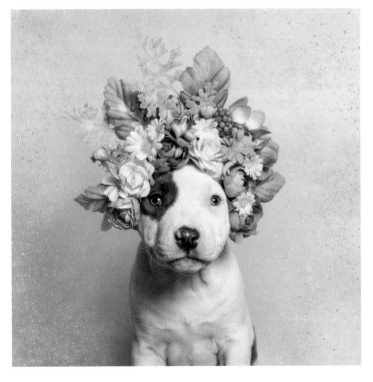

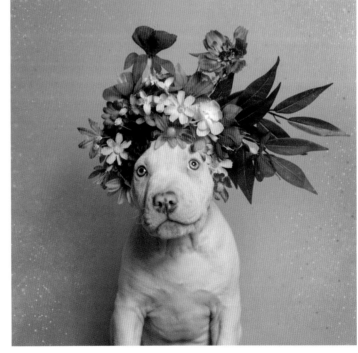

Parlay, 2017
Adopted
Luvable Dog Rescue, Oregon

Ahoy, 2017
Adopted
Luvable Dog Rescue, Oregon

Black Pearl, 2017
Adopted
Luvable Dog Rescue, Oregon

Matey, 2017
Adopted
Luvable Dog Rescue, Oregon

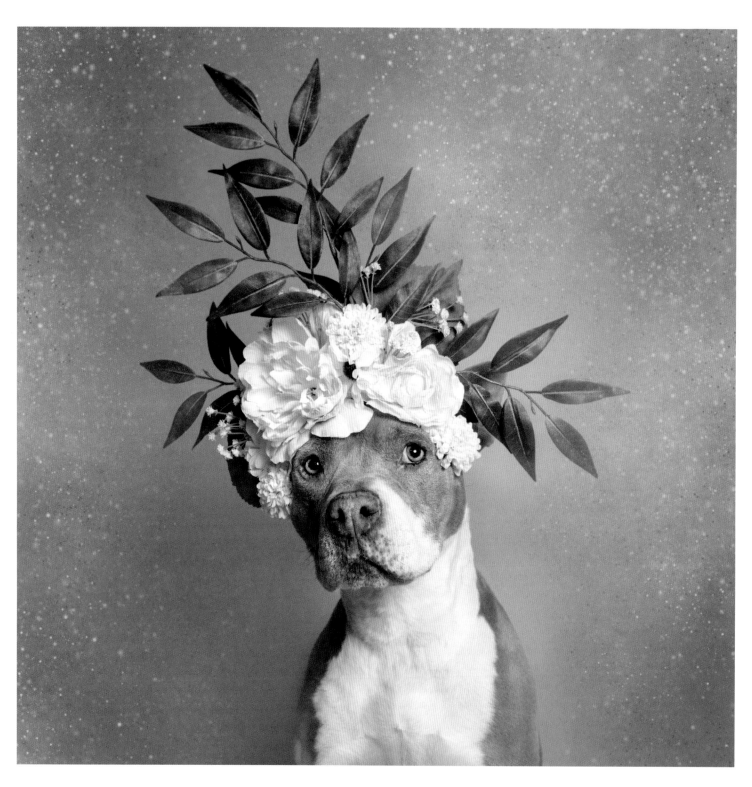

Amanda, 2017
Adopted
Animal Haven, New York

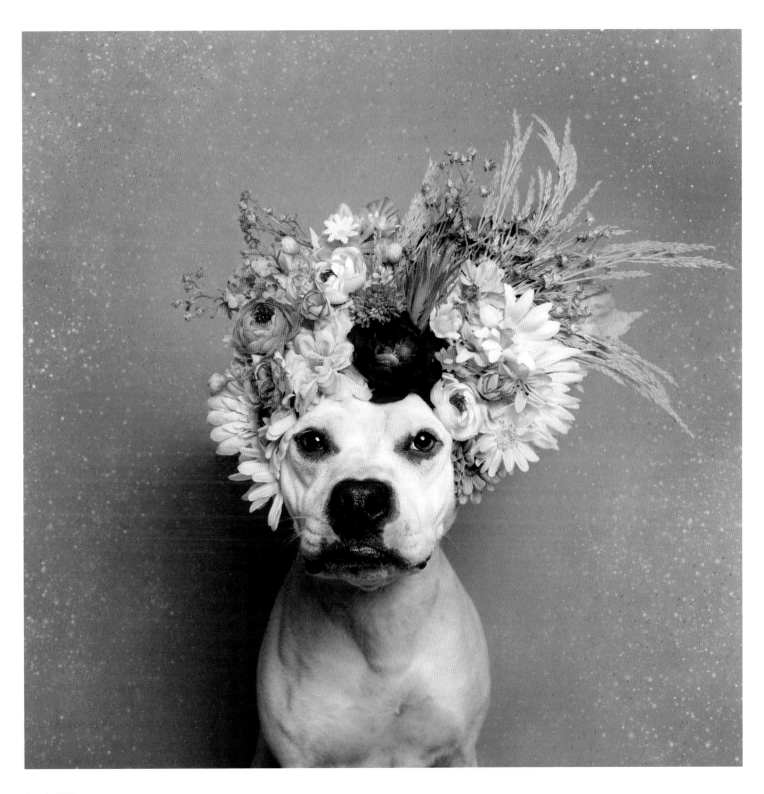

Pearl, 2017
Adopted
Central Missouri Humane Society, Missouri

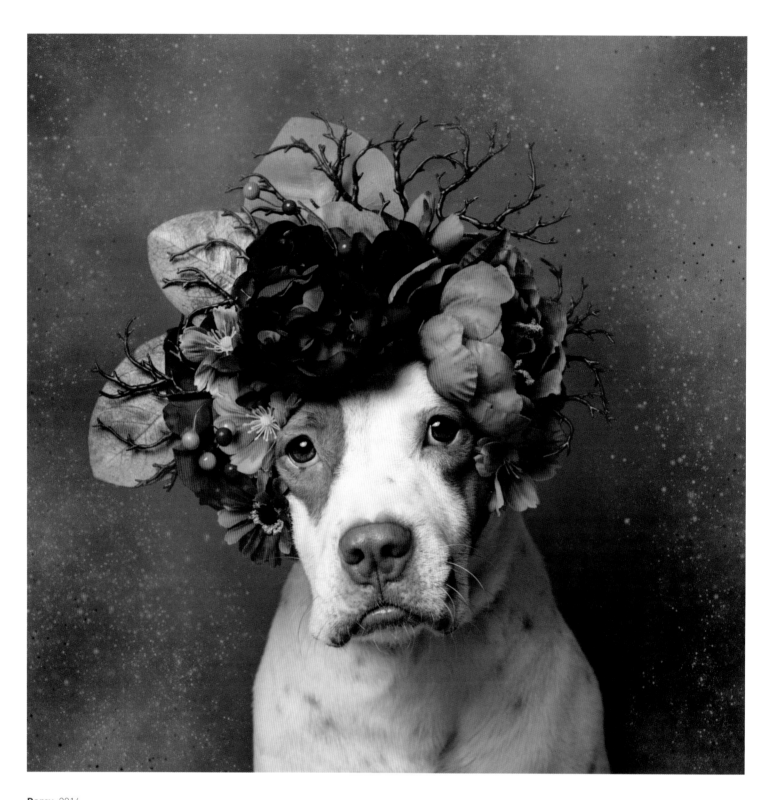

Darcy, 2016
Still waiting
Calhoun County Humane Society, Alabama

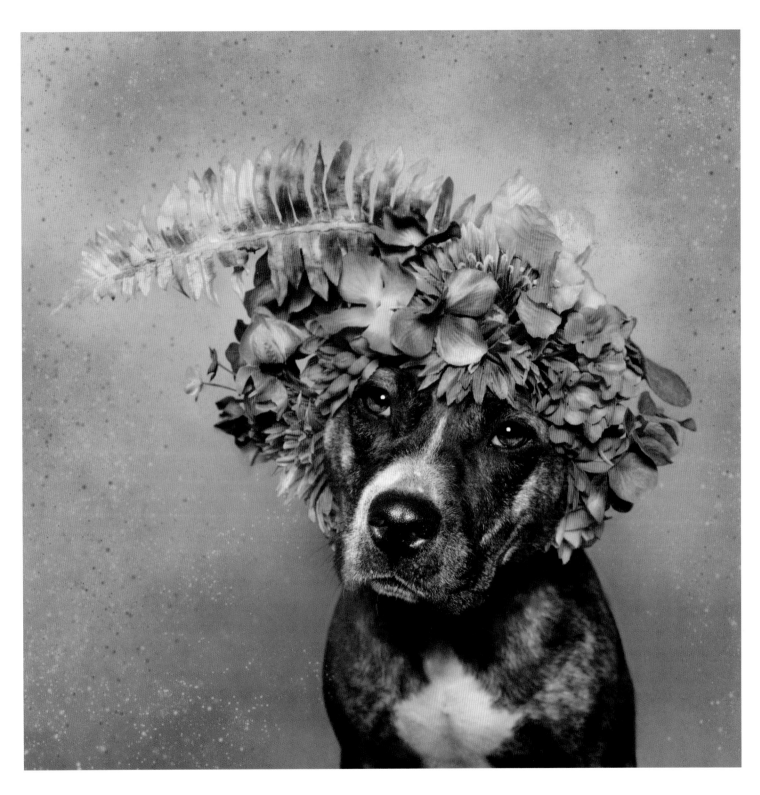

Peapod, 2015
Still waiting
Animal Haven, New York

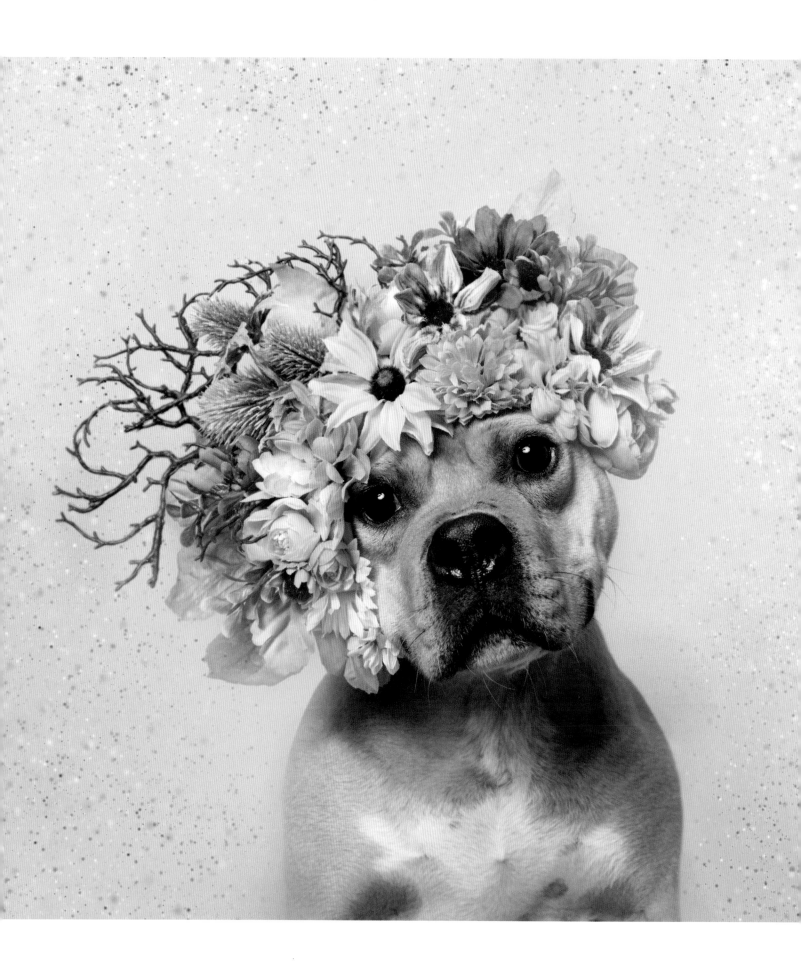

THE 21

Bubba, 2018
Still waiting
DPFL's National Canine Center, Florida

In 2015, the Ontario Society for the Prevention of Cruelty to Animals (OSPCA) in Canada participated in the largest dogfighting investigation in its history. Thirty-one pit bulls and a mountain of dogfighting paraphernalia were seized from Dirty White Boy Kennels in Tilbury. After a brief behavioral evaluation by an expert from the American SPCA, twenty-one of these dogs were deemed a menace to society and the OSPCA asked the court for permission to destroy them. It's worth noting that during their assessments, these dogs hadn't shown aggression toward their human handlers, only various degrees of reactivity or aggression toward the plush dog and lifelike human doll—disputed assessment techniques that the ASPCA has since questioned in a position statement.

This situation was legally intricate because it was taking place in Ontario, a Canadian province with some of the world's strictest Breed Specific Legislation (BSL) against pit bulls. The OSPCA couldn't easily transfer these dogs since their kind is outlawed where it operates.

As did Michael Vick's victims years earlier—the Vicktory dogs confiscated from his dogfighting operation—The 21, as they became known, would challenge the animal welfare community. In the end, Vick's dogs had taught us that dogfighting victims could be rehabilitated and retrained. Many of them were adopted out to loving families, some even becoming therapy dogs or service dogs. Could The 21 be given a chance, too? Could dogs who'd been "bred to fight" be retrained, and at what cost?

As the dogs sat at the shelter waiting for the court order that would seal their death sentence, animal advocates and organizations rallied and protested. In particular, Rob and Danielle, owners of Dog Tales, a rescue and

sanctuary located a few minutes from the OSPCA shelter, decided to take on the legal battle for The 21. *These dogs didn't deserve to die just yet*, they thought, *at the hands of an organization created to protect animals.*

For the next year, Dog Tales tried to convince the OSPCA and the court to consider an alternative to euthanasia and to give these dogs a chance. Such a decision would have been a first for Ontario pit bulls, and the authorities needed a bit of encouragement. It took a trending social media campaign (#SaveThe21) and an international public outcry—the OSPCA received tens of thousands of emails—for Dog Tales to be heard. Their request for a second, independent behavioral assessment of the dogs was granted, and later the court ordered the owners to surrender ownership of the dogs. The 21 were legally transferred to Dog Tales on the condition they be sent to Florida for retraining, in-depth assessment, and, potentially, adoption.

In the summer of 2017, nearly two years after The 21 had been seized and placed in isolation, where they were given twice-daily doses of mood stabilizers, the dogs arrived in Florida. The group included the surviving dogs from the original confiscation (three had since died), puppies who'd been born at the OSPCA, and dogs who'd been seized later in connection with the case. The most adoptable dogs were transferred to a rescue called Pit Sisters in Jacksonville, Florida. Some of the OSPCA team traveled there to visit the dogs' new residence. They were introduced to various programs for the dogs, including a fantastic one in which the dogs are trained by inmates from local prisons. Seeing these pit bulls being treated like any other dog, and given a real chance, must have been inspiring for the Canadian team. The dogs who needed further assessment and training went to Dogs Playing For Life in Wellborn, Florida.

Dogs Playing for Life (DPFL) is a wonderful, groundbreaking training program rooted in the notion that a dog's natural instinct is to play. Founded in 2015 by world-renowned expert Aimee Sadler, the program teaches shelters how to use playgroups safely and successfully. Not only do these playgroups provide incredible emotional and behavioral benefits for the animals, they also change the way shelter staff and volunteers interact with and assess their dogs, ultimately leading to more adoptions. Aimee agreed to take The 21 into her brand-new facility, the National Canine Center (NCC): "I wanted to participate in these dogs not going from cruelty, to incarceration for two years, to the euthanasia table. Whatever the outcome for these dogs, they deserved to get out and run in grass and have positive experiences outside of their kennels."

But these dogs were not regular shelter dogs. DPFL called in Jay Jack, a dogfighting expert and trainer extraordinaire, for some insight. Jay noted that these dogs were the one percent people never see—dogs who usually stay underground and suffer cruel deaths at the hands of criminals, unless the authorities seize them in time. When The 21 arrived at the NCC, it seemed they hadn't received much positive human contact. This came as a surprise, as dogs subjected to intense conditioning before fighting are usually very easy to handle. Treated like professional athletes by their handlers, they go through strict training regimens, are massaged, and receive regular veterinary care. As for The 21, however, it became apparent that they'd been inbred for their level of drive, meaning their enthusiasm for and dedication to a task, with the sole purpose of throwing some of them into fights. Clearly, the owners had been trying to make money off the dogs without even properly preparing them for the gruesome experience.

In January 2018, the case against The 21's owners was stayed after the prosecution failed to bring them to trial within thirty months, the legal ceiling. There would be no trial at all. The men were released and are allowed to own animals. A couple of months after this devastating news, I traveled to Florida to meet and photograph the dogs at the NCC. It had been a year since DPFL had taken the group in. Huge amounts of resources had been invested to save these dogs and retrain them. But was all this enough? Could these dogs really be considered adoptable?

Retraining The 21 proved challenging, but not impossible, and most of them became perfectly manageable and obedient. While one dog had to be euthanized for a redirected attack on his handler, most of the Florida dogs are now cleared for adoption and a handful have been adopted already. Some of them can even be trusted around other dogs and have playmates. A few remain too intense around other dogs or in certain situations for their trainers to be comfortable recommending adoption by the general public, but they could make great competition or working dogs. As a matter of fact, right after our shoot, world-level competition trainers in dock-diving and disc dogs adopted two of The 21, and another one is in the process of becoming a Virginia police dog.

The most important lesson The 21 teaches us is that every dog is an individual. Despite their shared genetics and upbringing, and later a strict retraining regimen by the best experts in the field, each of these dogs has different needs, and reacts and has adapted differently. This fact seems to support the idea that nurture and environment play a major role in overall personality development. Some of The 21 are outgoing, others are still scared of the world. Some cannot be around other dogs, others have playmates. Some love to snuggle on the couch with their person, others would rather play with a spring pole.

The biggest part of the journey still lies ahead for all involved in The 21's story. They must find the right adopters. Each dog must be matched with a person who will understand the dog's past, his or her limitations, and the responsibility involved. It's always paramount, of course, to match dogs and adopters carefully and responsibly, regardless of their past. But in the case of The 21, there is potentially something more at stake— the fate of all pit bull types in Ontario.

For the first time since the ban was installed in 2005, the province took a chance on saving pit bulls, and the eyes of the animal welfare community are on The 21. Their caretakers are aware of that and worry any incident could set pit bull advocacy back. Pit Sisters' executive director Jen confessed: "It's quite a burden and a liability to find the right place for these dogs, but if I had to, I would do it all again in a heartbeat."

At the DPFL's National Canine Center, Aimee and I reflected on what it means to save a life and at what cost. Before I left to head back to New York, she asked me, "So, what did you think about our dogs?" I struggled to find the right words. The truth was, I told her, I'd seen nothing different in these dogs than in many dogs I had met before. They face challenges and will need experienced adopters—but so do many other dogs, and they still find responsible homes. Aimee smiled, and I noticed a sparkle in her eye: "Wow. That's actually amazing to hear. You should have seen them when they first arrived. That means we achieved something."

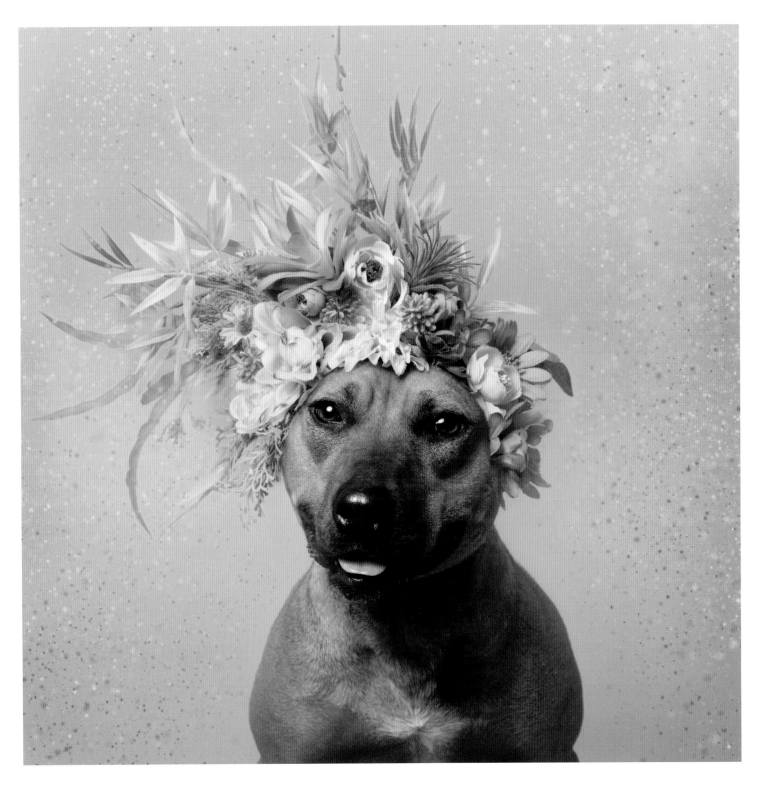

Velvet, 2018
Adopted
DPFL's National Canine Center, Florida
Brandywine Valley SPCA, Pennsylvania

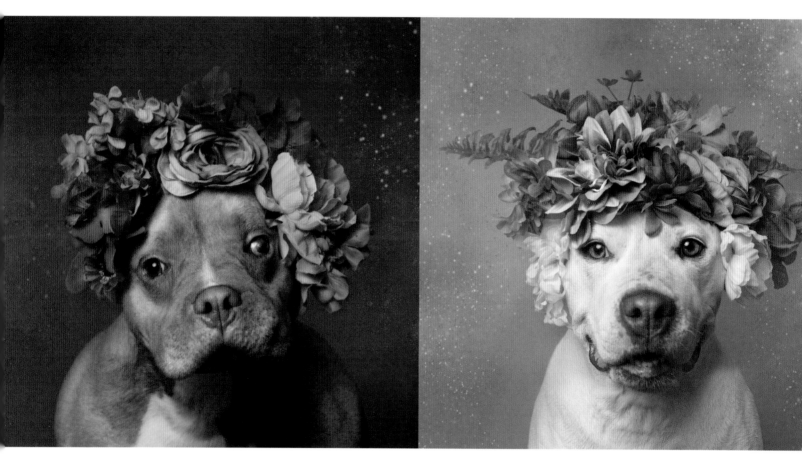

Garlic, 2015
Adopted
Mr. Bones and Co., New York

Jonas, 2015
Adopted
Ready for Rescue, New York

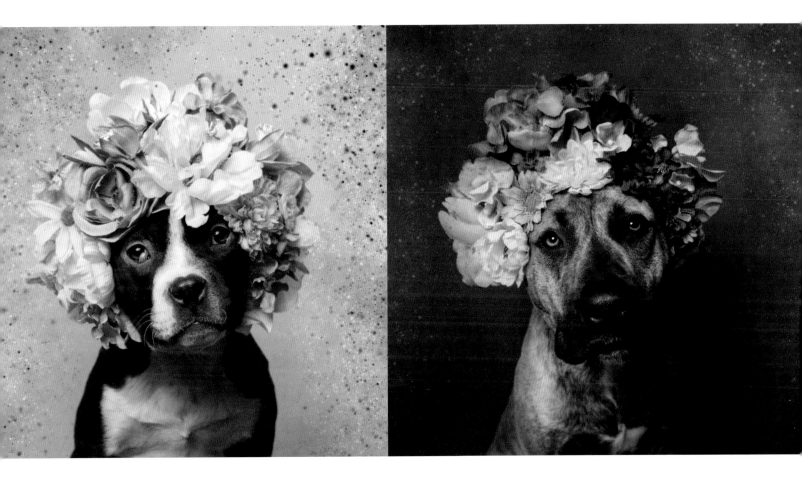

Beans, 2016
Adopted
Mr. Bones & Co., New York

Avon, 2016
Adopted
Philadelphia Animal Welfare Society, Pennsylvania

Roam, 2016
Adopted
Luvable Dog Rescue, Oregon

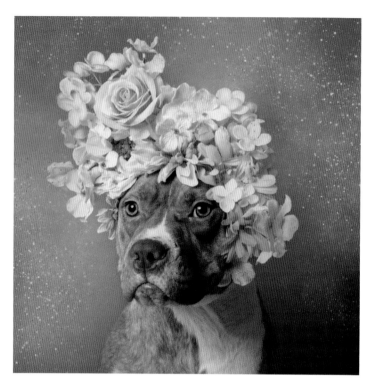
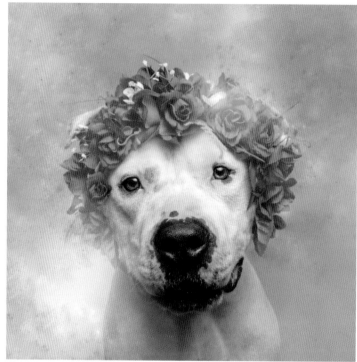
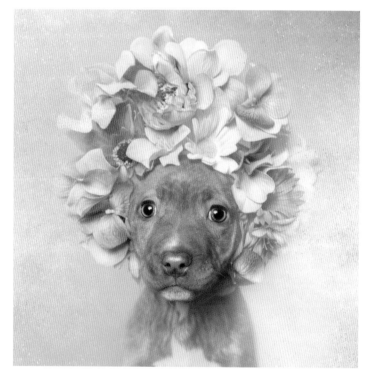
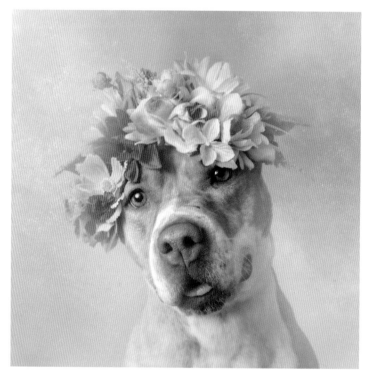

Scotch, 2016
Adopted
Fulton County Animal Services, Georgia

Akoni, 2014
Adopted
Animal Haven, New York

Rex, 2014
Adopted
Sean Casey Animal Rescue, New York

Bridie, 2015
Adopted
Town of Hempstead Animal Shelter, New York

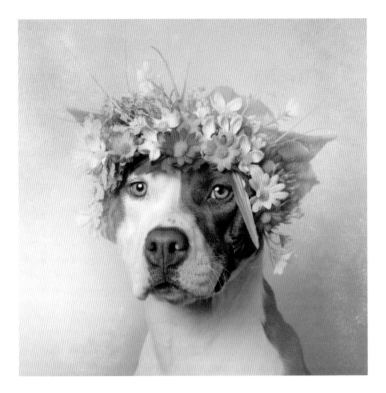
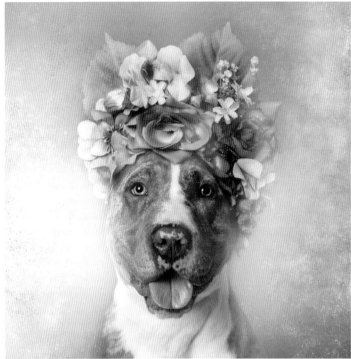
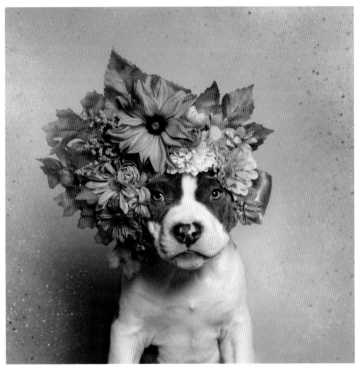
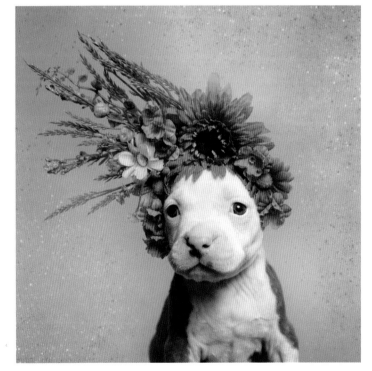

Shelbie, 2014
Adopted
Town of Hempstead Animal Shelter, New York

Doubloon, 2017
Adopted
Luvable Dog Rescue, Oregon

Dice, 2014
Adopted
Town of Brookhaven Animal Shelter, New York

Sugarland, 2017
Adopted
Animal Haven, New York

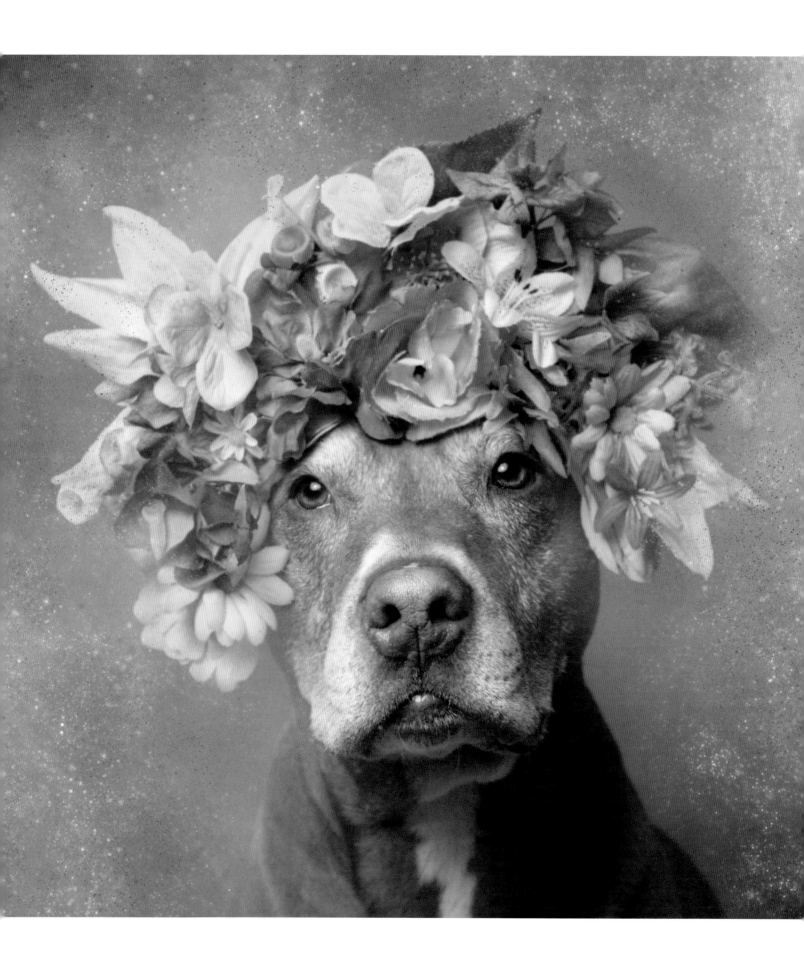

JOEY

2015, *Adopted*
New York

The world of animal rescue is built on good intentions, but unfortunately that doesn't always guarantee the best outcome for the animals. Some people believe lives must be saved at all costs, and sometimes they fail to consider quality of life.

An older dog, Joey arrived at an open-admission shelter and started deteriorating. He was reactive to other dogs, and when he caught kennel cough he was put in isolation, which meant almost certain euthanasia. Seeing his at-risk status, Becky offered to help any rescue that would pull him. A local group answered and took Joey to a vet clinic to be neutered. Becky offered to visit and to walk Joey for the few days he was to stay there. While Joey was recovering, the foster home lined up for him fell through and there was nowhere for him to go except remain boarded at the clinic.

Things became extremely stressful for both Joey and Becky. The rescue stopped actively looking for a home for Joey, probably busy with all the other dogs they continued pulling from the shelter. At the boarding facility, Joey wasn't a priority either, and wouldn't be let out of his cage unless Becky took him out. During that time, Joey somehow injured his paw and developed a couple of health issues. Becky remembers: "Joey was in pain, stressed, and desperate for human companionship. I worried about him every day. I couldn't take him home because my own dog was also dog-reactive. I knew that Joey trusted me to show up, and I kept thinking, *Is tomorrow the day he expects me to show up and I don't?* So, I visited him every single day, which was not easy. I'd walk into his kennel to see a puddle of slobber from him compulsively licking at the bars of his cage for hours."

Finally, Becky asked the rescue to transfer ownership of Joey to her. If anything, she thought, she would

then have the legal right to put an end to his suffering, should it come to that. The rescue agreed. Month after month, Becky continued visiting and doing everything she could to find Joey a home. She created a social media page for him, engaged the support of another local rescue to cross-post his information, and hung posters in cafes and stores. *He only needs one adopter,* she kept reminding herself. But Joey had no takers. By the time she reached out to me for help, Becky had done more than most people would have and was at the end of her rope.

After our *Pit Bull Flower Power* photo shoot, my friend Erin from Susie's Senior Dogs shared Joey's picture on her page dedicated to finding homes for senior shelter dogs. April and Chad fell in love and decided to adopt him. Joey needed surgery on his wrist, and while he recovered, Becky took a chance and fostered him with her own reactive dog. "After a couple weeks of rest at my house," she remembers, "I would come home to find him snoring and I would have to wake him up. It was a huge difference from what I had witnessed in the kennel—and such a relief."

Finally, three hundred days after Joey had first arrived at the shelter, Becky drove him to his new home. His family did a lot of training with him. It was a challenge dealing with his reactivity, but they were committed and they loved him. Later, they moved to a house where Joey had his own backyard.

Becky sent me a lovely locket with a piece of Joey's tennis ball in it—his favorite thing in the entire world. Unfortunately, only months later, Joey passed. When I wear my locket and I reflect on Joey and Becky, I see a formidable woman who took a chance on a dog nobody else truly saw.

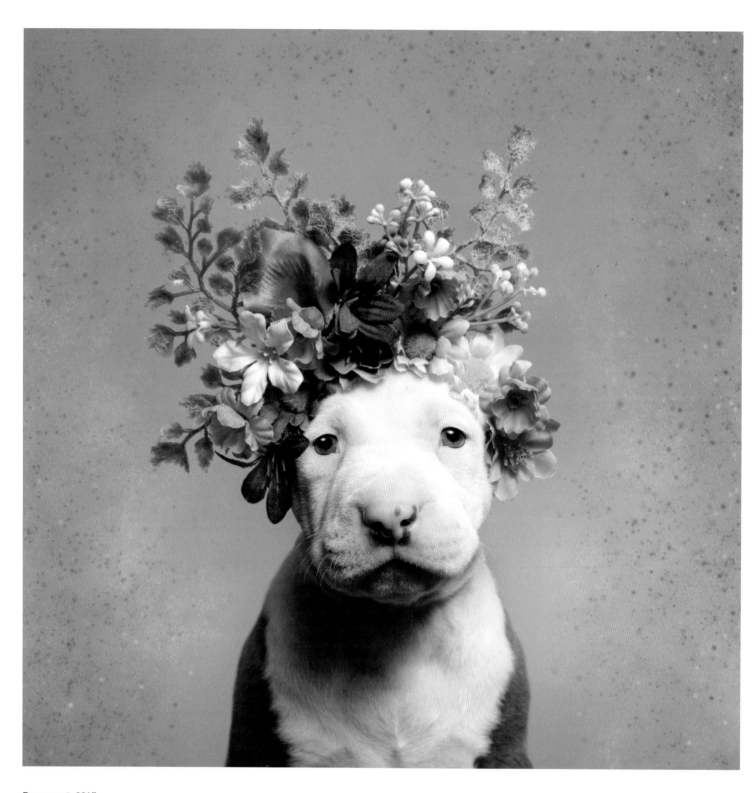

Beaumont, 2017
Adopted
Animal Haven, New York

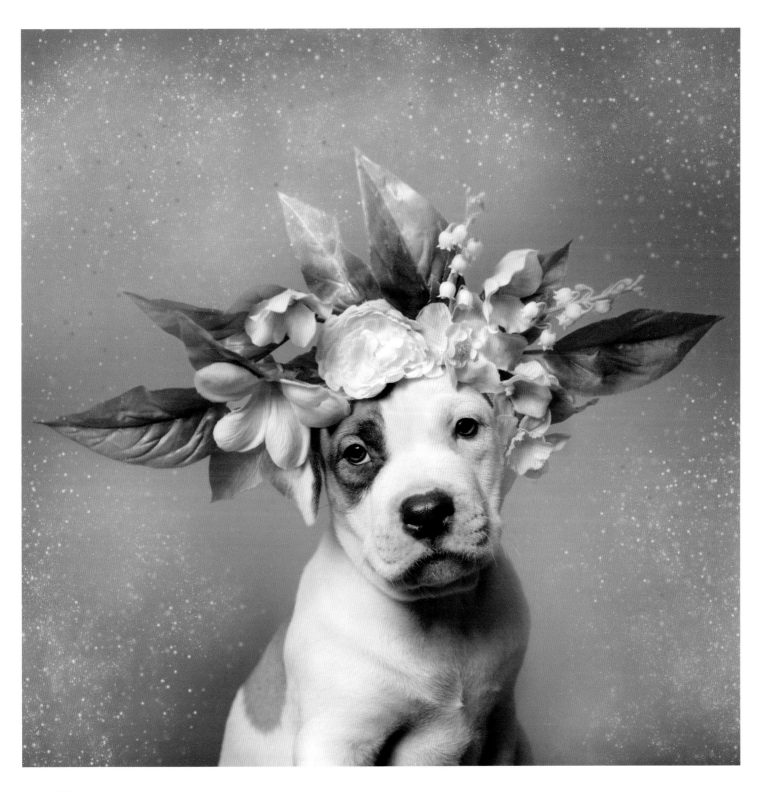

Adam, 2015
Adopted
Redemption Rescues, New York

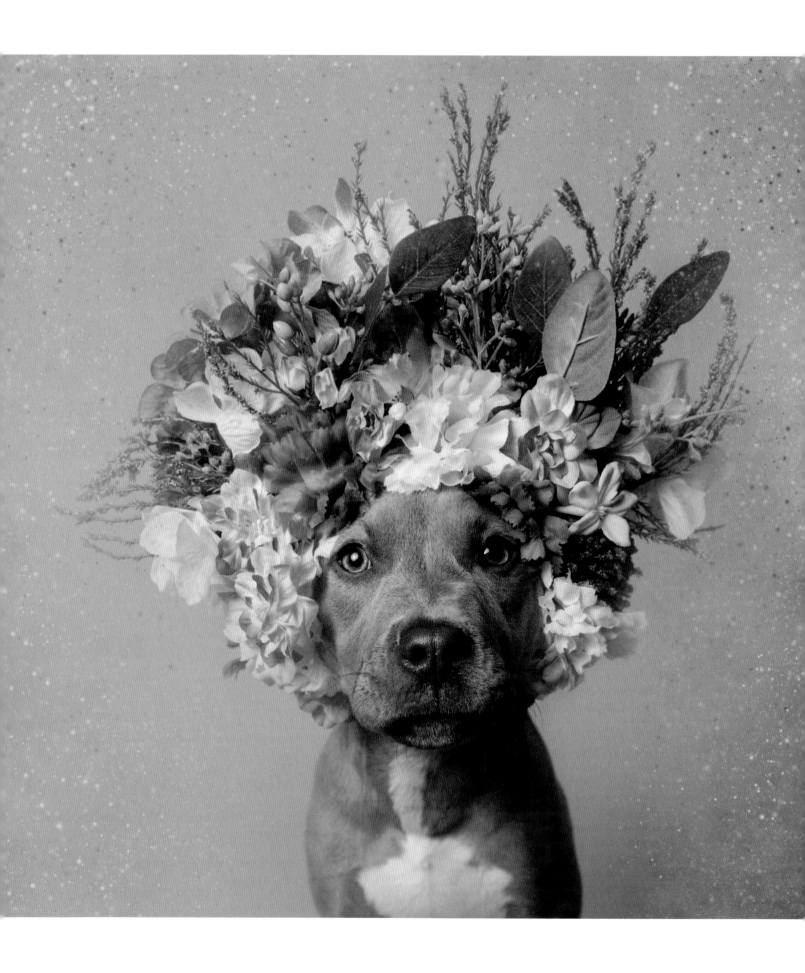

KYLA

2017, *Adopted*
Rebound Hounds, New York

At just three months old, Kyla couldn't keep food down and wasn't gaining any weight. Presented with large vet bill estimates that she couldn't afford, Kyla's owner decided to surrender her to Rebound Hounds. The puppy was diagnosed with a malformation that had led to an enlarged esophagus, which couldn't push food down to the stomach. For the best chance at a normal life, Kyla needed very costly surgery as soon as possible. For now though, she had to be fed when she was sitting up and had to remain in that position for thirty minutes afterward.

When I shared Kyla's story on social media, people were angry at her owner: *How could she give up on Kyla so easily? She should have sacrificed everything for her dog.* As the opinions filled the comment section of my post, I received a message from Kyla's owner.

"Lexi [her previous name] was supposed to be my emotional support dog," she wrote. "Her brother, whom I have from the first litter, is amazing, and I registered him for my autistic four-year-old. I wanted to register Lexi for myself, as I suffer from anxiety and thought she would help me. But when she started throwing up I didn't know what to do. I took her to the vet, but I would have been homeless paying for just a diagnosis, let alone the care Kyla needed. My children were watching her throw up, and it was hard to see her like that. I work at a nursing home and I believe in quality of life. I called places to see who could take her. I wanted her to get better. I just couldn't afford it."

Even after Kyla's $8,000 surgery, which was made possible by private donations, it was unknown whether Kyla would ever be able to eat normally, or need more surgeries. Her foster parents were in love and felt equipped to handle her recovery, so they decided to officially adopt Kyla.

A few months later, when a healthy Kyla turned one, I received this sweet update from her new mom, Janaina. "Kyla is doing great and is the troublemaker of our squad—always counter-surfing and dropping her prize so her brother Bruno can tear apart the packaging. Her big sister Nahla stays out of their shenanigans and comes to let us know what's going on. Kyla is still on a semi-liquefied diet, but she doesn't need assistance eating anymore. No chair, no holding her up to eat or keeping her upright for thirty minutes after. We put her food in the bowl and that's it. This means that the stricture in her esophagus has loosened a lot since the surgery. We can give her regular treats as well, since she chews them up pretty good. She loves her siblings and every person and child she meets. She's very happy-go-lucky, with a mischievous side. She loves to nuzzle her people and has to have her head resting on us at all times. She blossomed into her personality after her health issues started melting away."

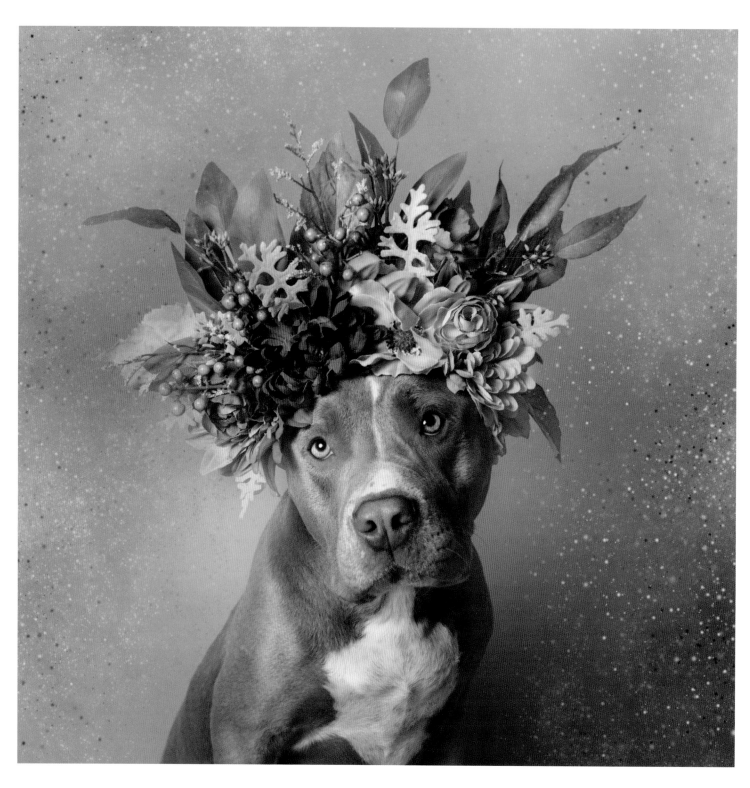

Pringles, 2017
Adopted
Luvable Dog Rescue, Oregon

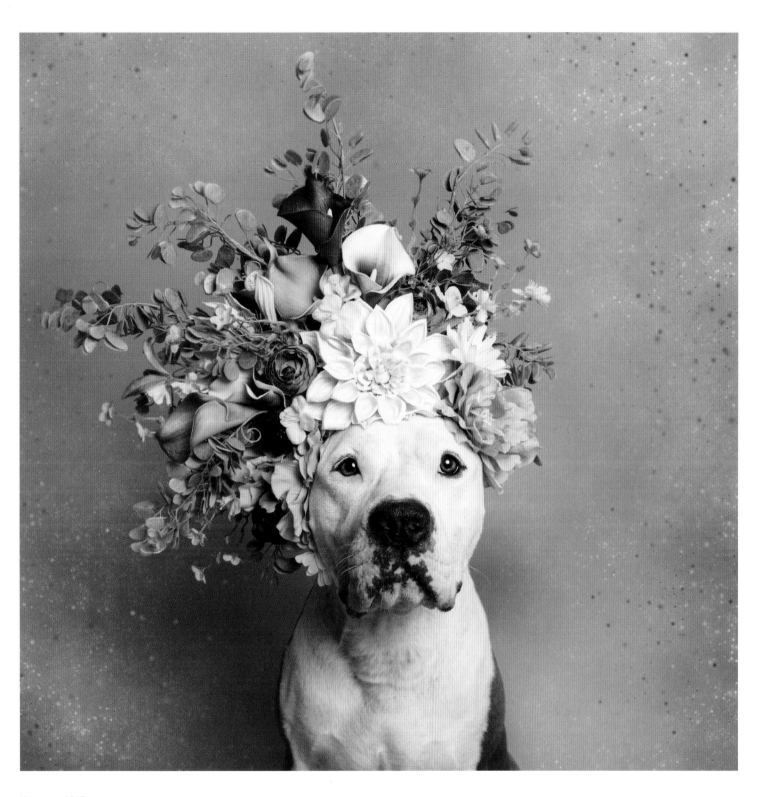

Houston, 2017
Adopted
Animal Haven, New York

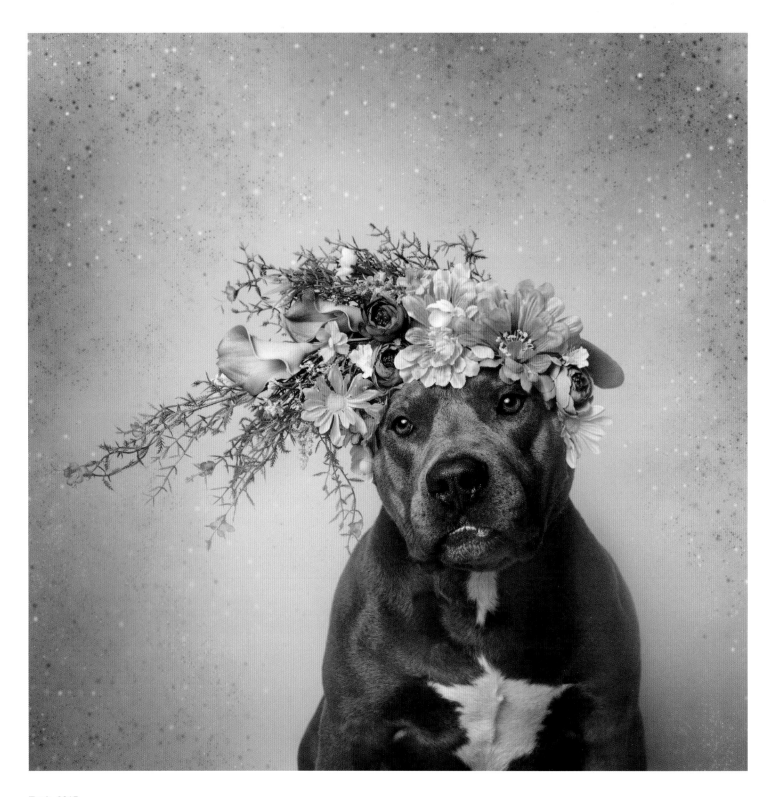

Tank, 2017
Adopted
Luvable Dog Rescue, Oregon

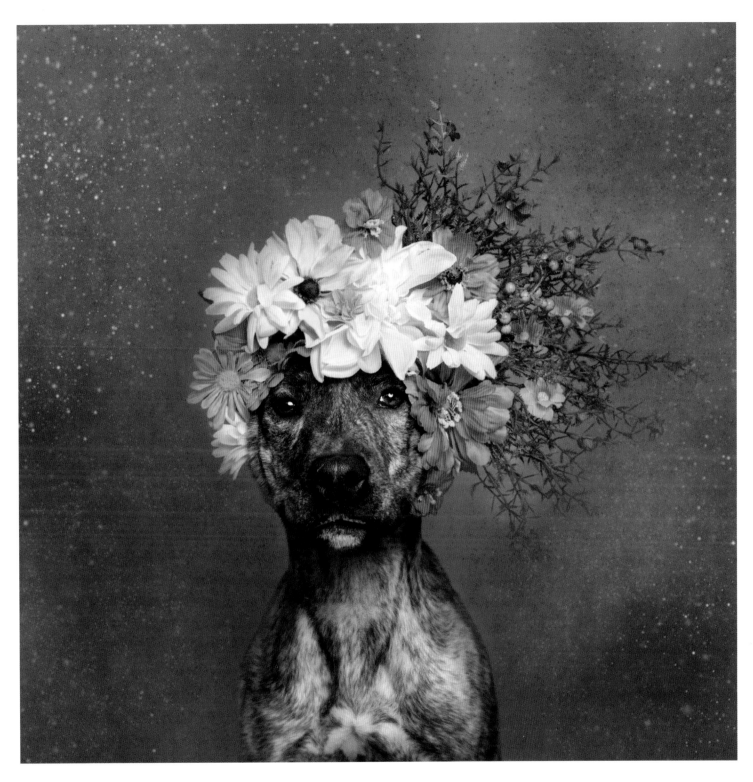

Sasha, 2017
Still waiting
Animal Haven, New York

TYSON

2016, Adopted
Fulton County Animal Services, Georgia

Tyson's appetite for life almost cost him his own at the overcrowded Fulton County shelter, which welcomes about forty new animals every day. In recent years, the shelter has achieved much higher live-release rates, but given those intake numbers, euthanasia always hangs over their residents' lives like the Sword of Damocles. The staff does its very best, though. During my visit, for example, I was shocked to see five or six dogs—many of them pit bulls—housed together in the same kennel. I'd never seen that before. It was a bold way to make room, and it saved lives.

Tyson was dumped from a car. He sat in shock as the car drove away. Once at the shelter, his high-spirited personality emerged and he became a favorite. He was adopted twice and returned both times within twenty-four hours because the resident dogs didn't approve of his boisterous nature.

Months after our photo shoot, Tyson had become the longest-staying resident at the shelter and showed signs of stress. My contact feared he might be on the shelter's next euthanasia list. With four days to save his life, I begged my social media followers to help Tyson.

On the other side of the screen, Claudia gasped. In his *Pit Bull Flower Power* portrait Tyson looked exactly like her dear Daisy. Daisy was a well-known, skinny junkyard dog near a campus in Milledgeville, Georgia. Claudia's sister lived across the street from the junkyard and started feeding Daisy. One day, rumor spread among students that a car had hit the dog. Daisy was nowhere to be found, until she showed up on Claudia's sister's porch a couple of days later, beat up and limping. The sisters decided to take Daisy to the vet. "Both of us were nervous about touching her because

she had been so skittish and we didn't have the best perception of pit bulls," Claudia told me. "We took her to the vet and worked for an hour to get her collar off, which was embedded into her skin, leaving it raw. Daisy had a broken pelvis. We left her at the vet overnight. When we picked her up the next day, she was a whole new dog. She limped/ran towards us with a big smile on her face and we knew we were keeping this dog."

Daisy moved in with Claudia's family and became a "constant source of joy and love." She enjoyed cuddling and hiking. Claudia being a *Pit Bull Flower Power* fan, she and her sister created a flower portrait of Daisy. Unfortunately, a few months later, the family noticed a lump on Daisy's neck, which turned out to be cancerous. Daisy lived for a few more months, cherished, until it was time to let her go.

While she was preparing herself for Daisy's departure, Claudia noticed my urgent post about Tyson and headed to the shelter that same day to meet him. "He was a little unsure of me," she recalls, "but he put both his paws on my shoulders and gave me a big hug. I realized that if I couldn't save Daisy I could save another misunderstood pup just like her. No matter what his tendencies, this was my dog." A staff member at the shelter personally fostered Tyson so he could get some home experience before moving in with Claudia. Just two weeks after saying goodbye to Daisy, Claudia's family welcomed Tyson. Tyson, now Toby, is treasured and enjoying life with his big sister, Cleo. And at last, his exuberant personality is celebrated. "Toby is silly, very intelligent, and gentle. He talks back like a teenager, but is a good listener, too. He loves to cuddle and snores like a man. I cannot wait for our summer hikes together."

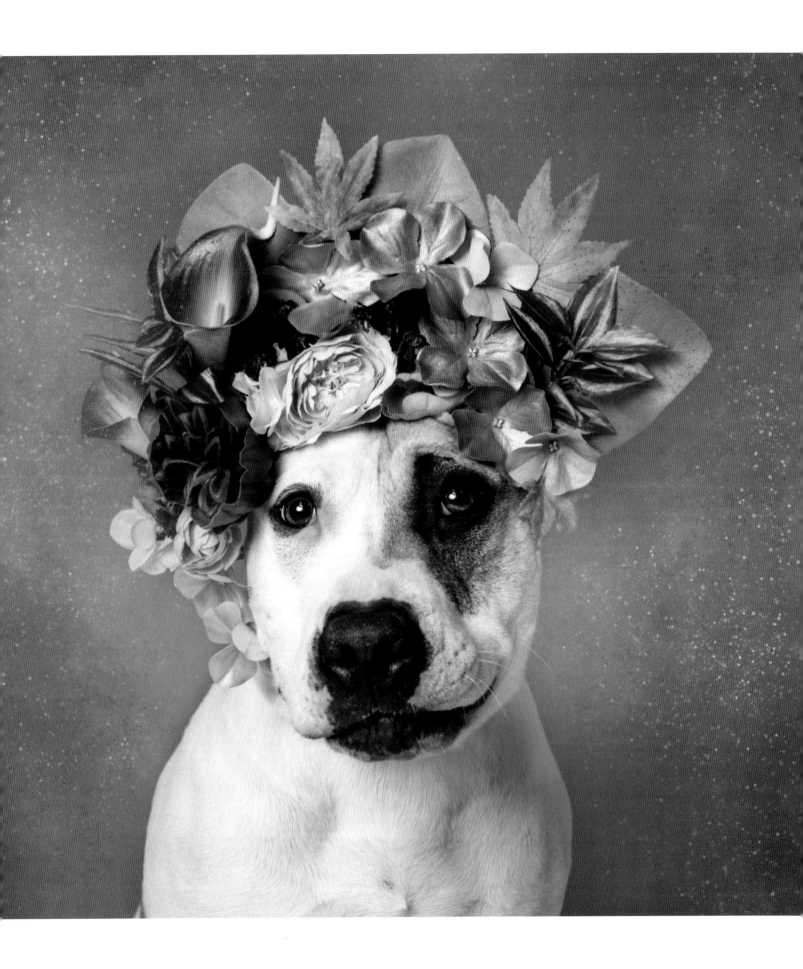

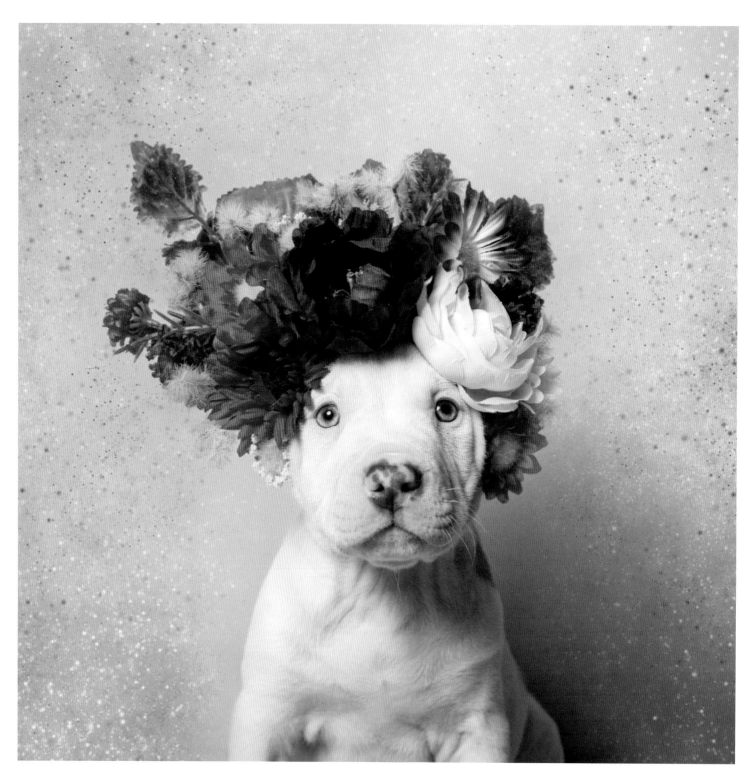

Ruffles, 2017
Adopted
Luvable Dog Rescue, Oregon

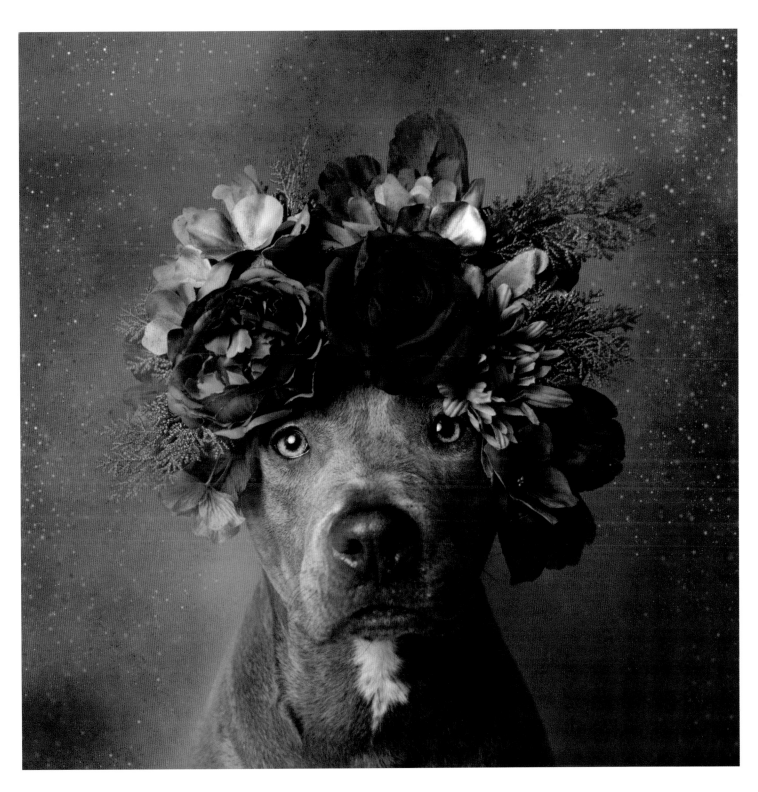

Xena, 2016
Adopted
Fulton County Animal Services, Georgia

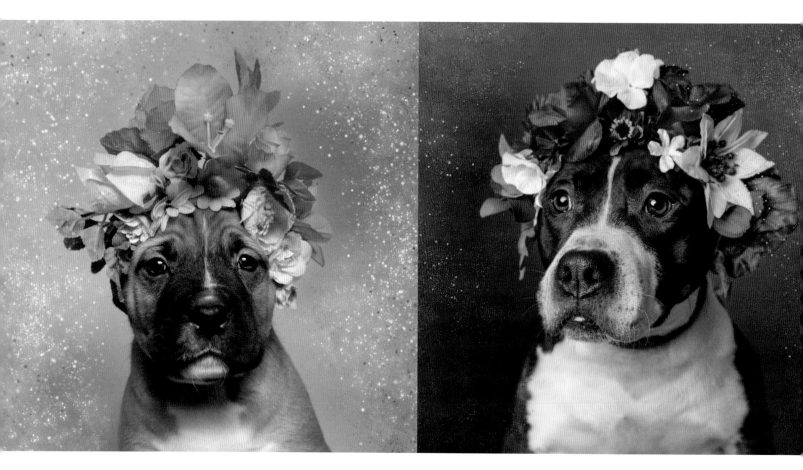

Teapea, 2015
Adopted
Animal Haven, New York

Truffles, 2014
Adopted
Town of Brookhaven Animal Shelter, New York

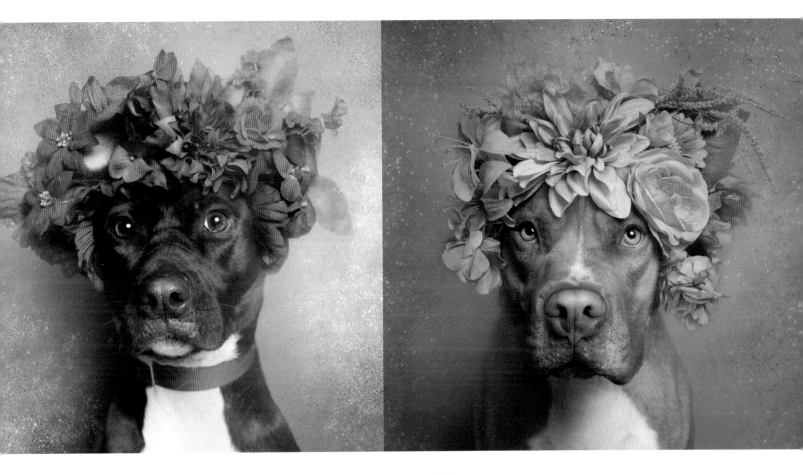

Shirley, 2014
Adopted
Sean Casey Animal Rescue, New York

Dexter, 2015
Adopted
Town of Hempstead Animal Shelter, New York

APPENDIX

SPECIAL ACKNOWLEDGEMENTS

I wish to thank those who, with their exceptional generosity, made this first edition possible. In honor of:

Alicia Tyler and Gabby Grace
Alison Jackson
Barb Shadomy and Karen Meyer / Stonehurst Place
Bonita, Rio, and Fiona
Boom Boom Beckles
Bowinkle T.
Carol Stamm Howell
Charlie
Chie Smith
Christine McWilliams in honor of Cassie
Colette Skurdal / Lexie Skurdal
Creekside Pet Center
Cynthia Nixon-Aly and Ahmed Aly
Daisy and Chumley
Dana Ross
Danielle and Rocky Darowz Grek
Danielle Doscher and Jon Mefford
David Glicksman
Duke, Gracie and Trey
Ed Jamison / Anita Jamison
Erin Frederickson
Erin, Nathan, and Ollie Louer
For Ace (aka Acers, aka Bubbas), our sweet boy
For my heart, my pittie Pearl
For Rusty, Beau, Pebbles, Smokey and Honey
For the love of my rescue, Tigger
Harley
Harper Lee Beaton
Heather A. Robertson
In honor of Animal Haven
In loving memory, Buffy Grossman
In loving memory, Pnut "Boog" Brening / In loving
 memory, Kenya Brening
Jack and Nicola
Jada Rose
Jamie Wilcox, with your undying strength,
 I'll fight forever. Love, Sara Kula

Jane Holley
Justice Friedenberg
Kat
Kim Meneely and Hailey
Koozie "Cougar" Hoenig
Lamar, my bug and angel
Liesl Wilhardt and Luvable Dog Rescue
Lisa A. Clifton
Lisa and Peter Jakobson
Liz Ferayorni and Jasper
Liz Ferayorni. Animal advocate, teacher, mother, friend
Lottie / Kerstin
Lucy and Banana Niedermair
Mairi Nicol
Makenna Moore
Mary and Rusty Tally
Mary Margaret Crocker
Mayor
Merci Sophie, talent, amour des chiens blessés
Millie and Stefany Strah
My beloved Whisper M.
Nancy and Mark Pollard
Nicki (Browns) / Hexx
Pamela Keld
Rich Frembes and Linda Seid Frembes
Robyn Benensohn
Sara
Scottie Zimmerman
Shannon Donohue
Stephanie Oreo and Kara Schafer
The Foster pack from NorCal
Widget, for being my BFF / Fitzhugh,
 for helping to heal my heart
Zenaida Tapawan-Conway

ACKNOWLEDGEMENTS

In four years of working on *Pit Bull Flower Power* I have received the support of countless people who all deserve my grateful thanks. In particular:

My wonderful husband, Sten, for his undying support and for letting me take over our apartment with flowers more than once. His only fault is to be a cat person, which we are working on. My family back in France and away in Australia—far but always near.

All the incredibly generous people who preordered this book, making it possible, and those who purchase my work or have donated to support *Pit Bull Flower Power* throughout the years. Pamela Keld for her friendship and generosity; Tony Low-Beer and the American Bully Breed Rescue Foundation; Kat Knott for all the work she does for New York dogs and for being an incredible champion of my work; Amy Grossman for being so supportive; and all my collectors.

The team that brought this book to life and made it everything I could have dreamed of. In particular, Carolyn Mullin for introducing me to Lantern Books; Martin Rowe of Lantern Books for his publishing acumen and reassuring stewardship; Mary Bahr for her editorial insights; Stefan Killen for designing this book so beautifully; Emily Lavieri-Scull for her careful work; and the team at Versa Press, in particular Joe Medvesky, Diane Morris, and Jeff Harmison, for guiding us so patiently.

All the rescuers, shelter staff, and their volunteers I have worked with: for believing in my vision and helping me materialize it, welcoming photo shoots, and handling the dogs and the crowns. In particular, Ally Andriolas at the Sean Casey Animal Rescue and my friend Samantha Gurrie, who both helped me with the very first *Pit Bull Flower Power* shoot; Animal Haven, my second home, where Tiffany Lacey and Mantat Wong as well as the entire team have always been fantastic to work with and so supportive; my hilarious friend Elli Frank of Mr. Bones & Co. who has been a rock and, when all else failed, knew when to bring a bottle of wine over; my friend Erin Stanton of Susie's Senior Dogs who is so dedicated to the dogs and traveled with me occasionally, making our trips memorable and very efficient; my friends at Luvable Dog Rescue who have been so generous and supportive—in particular, the wonderful Liesl Wilhardt and the witty and beautiful Ashley Olson and Christine Lagos.

All the friends I made through this project, near and far, who have offered a shoulder to cry on and lent their skills and knowledge; Lucien Zayan and the team at The Invisible Dog Art Center, for inviting me into their space and allowing me to grow as an artist, and for hosting the launch party for this book; Melanie MacIntyre from Afloral; and so many more.

All my social media followers, who are by my side day after day—a group of mostly anonymous people brought together by the idea that we must make the world a more compassionate place. For their kindness when things are tough, and for rooting for all my models, even from the other side of the world.

All the bloggers and journalists who have written about the project, helping further its reach.

And last but certainly not least, all my models and their adopters.

THE ORGANIZATIONS

Almost Home Animal Shelter
Pennsauken, NJ
www.ahasnj.com

Animal Care Centers of NYC
New York, NY
www.nycacc.org

Animal Haven
New York, NY
www.animalhavenshelter.org

ASPCA
New York, NY
www.aspca.org/nyc

Austin Pets Alive
Austin, TX
www.austinpetsalive.org

AZK9
Peoria, AZ
www.azk9.org

BARC Houston
Houston, TX
www.houstontx.gov/barc

Beastly Rescue
New York, NY
www.beastlyrescue.org

Brandywine Valley SPCA
West Chester, PA
www.bvspca.org

Calhoun County Humane Society
Anniston, AL
calhouncountyhs.blogspot.com

Central Missouri Humane Society
Columbia, MO
www.cmhspets.org

Centro de Control y Albergue Capitán Correa
Arecibo, PR
albergueyclinicacapitancorrea.org

Danbury Animal Welfare Society
Danbury, CT
www.daws.org

DPFL's National Canine Center
Wellborn, FL
www.dogsplayingforlife.com

Hallie Hill Animal Sanctuary
Hollywood, SC
www.halliehill.com

Hounds in Pounds
Allendale, NJ
www.houndsinpounds.com

Hudson Valley Animal Rescue and Sanctuary
Poughkeepsie, NY
www.hvars.org

Fulton County Animal Services
Atlanta, GA
www.fultonanimalservices.com

Luvable Dog Rescue
Eugene, OR
www.luvabledogrescue.org

Main Line Animal Rescue
Phoenixville, PA
www.mlar.org

MCSO Animal Safe Haven (MASH) Unit
Phoenix, AZ
www.mcso.org/Mash

Miami Dade Animal Services
Doral, FL
www8.miamidade.gov/departments/
animals/home.page

Monmouth County SPCA
Eatontown, NJ
www.monmouthcountyspca.org

Motley Mutts Pet Rescue
New York, NY
www.motleymuttspetrescue.org

Mr. Bones & Co.
New York, NY
www.mrbonesandco.org

Operation Education Animal Rescue
Christiana, TN
www.opedanimalrescue.com

Philadelphia Animal Welfare Society (PAWS)
Philadelphia, PA
www.phillypaws.org

Ready for Rescue
New York, NY
www.readyforrescue.org

Rebound Hounds
New York, NY
www.reboundhounds.org

Redemption Rescues
New York, NY
www.redemptionrescues.org

Richardson Animal Shelter
Richardson, TX
www.cor.net/departments/animal-services

Riviera Rescue
Riviera Maya, Mexico
www.rivierarescueac.com

Riverside County Department of Animal Services
Riverside County, CA
www.rcdas.org

Sav-a-Bull
New York, NY
www.sav-a-bull-ny.org

Sean Casey Animal Rescue
Brooklyn, NY
www.nyanimalrescue.org

Second Chance Rescue
New York, NY
www.nycsecondchancerescue.org

Stray Rescue of Saint Louis
St. Louis, MO
www.strayrescue.org

Susie's Senior Dogs
New York, NY
www.susiesseniordogs.com

The Sato Project
Yabucoa, PR and Brooklyn, NY
www.thesatoproject.org

Town of Brookhaven Animal Shelter
Brookhaven, NY
www.brookhavenny.gov/animalshelter

Town of Hempstead Animal Shelter
Long Island, NY
www.toh.li/animal-shelter

Warwick Valley Humane Society
Warwick, NY
www.wvhumane.org/animalshelter

THE DOGS

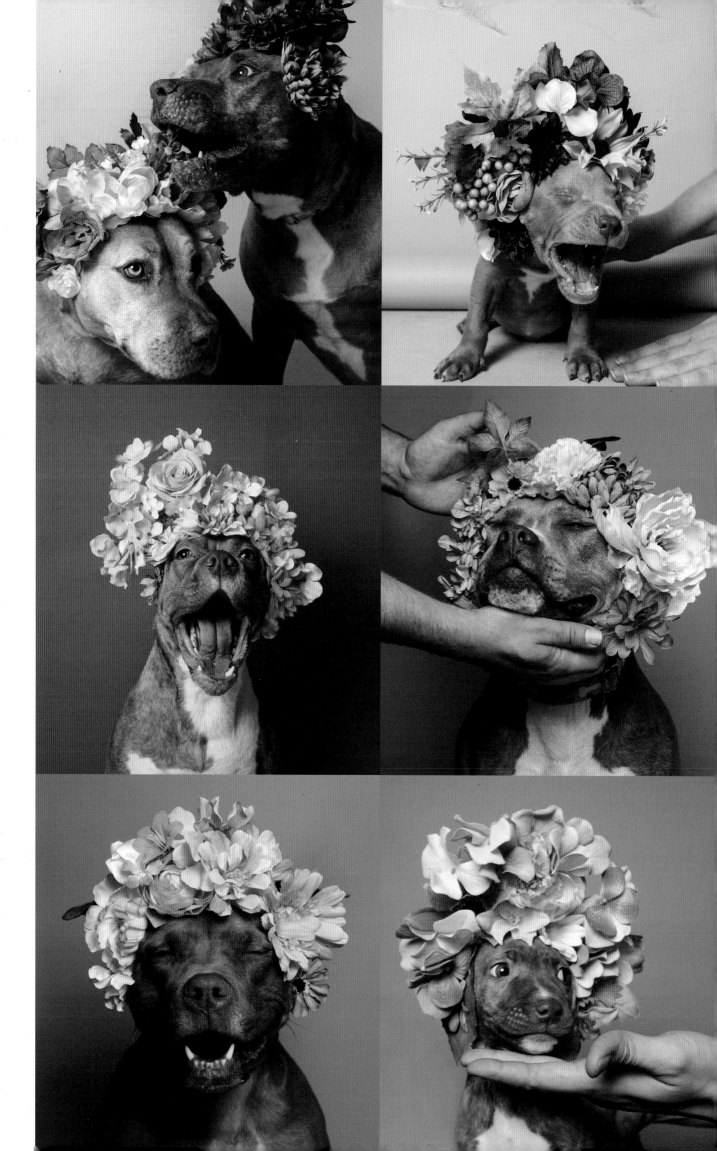

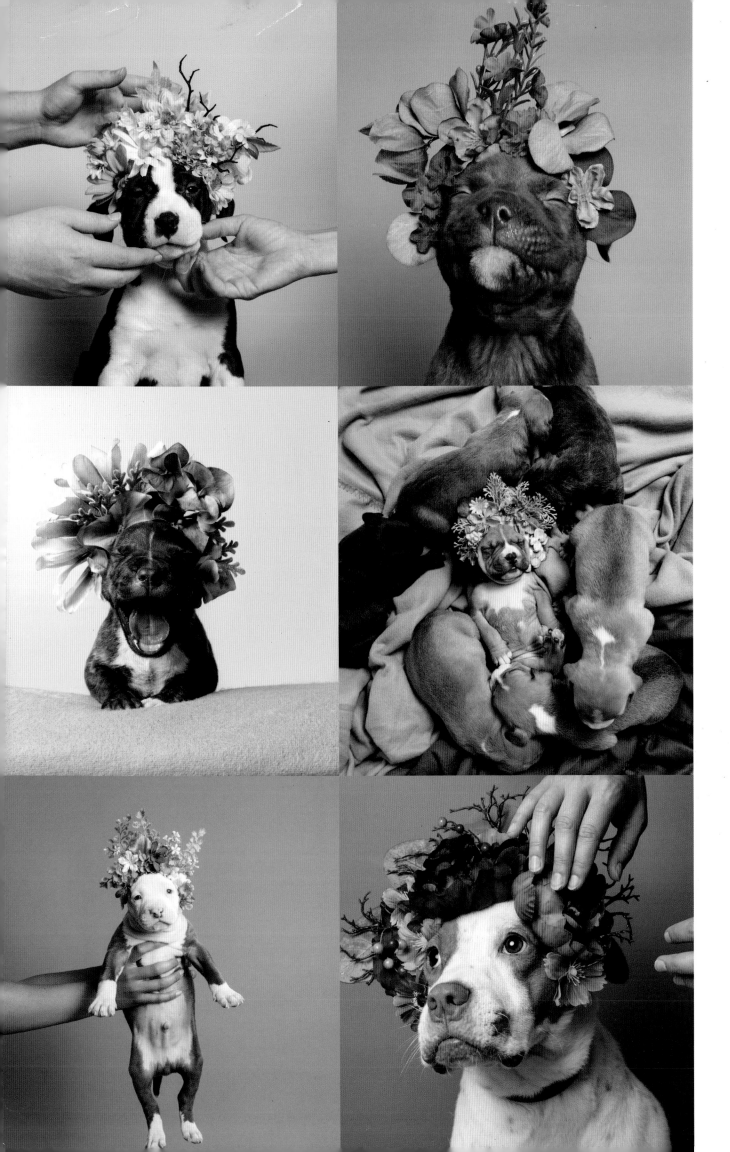

ABOUT THE AUTHOR

Born and raised in Lyon, France, Sophie Gamand holds a master's degree in law. Before becoming a full-time artist and animal advocate, Sophie worked for an intergovernmental organization in Geneva, studied opera singing, and created and directed *AZART Photographie*, a French magazine dedicated to contemporary photography.

After she moved to New York in 2010, Sophie discovered the huge number of pets waiting for homes all over the United States. She decided to donate her time and skills to help them.

In 2013, Sophie's career in photography took off when her series *Wet Dog* went viral. She won multiple awards for the series, including a prestigious Sony World Photography Award in 2014, and published her first book, *Wet Dog* (Grand Central, 2015). By the summer 2014, when the *Pit Bull Flower Power* series first came out, Sophie's work had been recognized for having revolutionized the way shelter dogs are photographed. She became a sought-after shelter-dog photographer, and a respected pit bull advocate.

Since then, Sophie has traveled the country photographing shelter dogs for free and telling their stories. Her social media accounts inspire people around the world to adopt and volunteer, and promote compassion. Her work is directly and indirectly responsible for finding homes for hundreds, if not thousands, of dogs worldwide.

Sophie lives with her husband, Sten, and their canine companion, a multi-mutt named MacLovin, in Brooklyn, New York. She continues to explore the world of dogs, in the hopes it will help her better understand human beings.

Photo by Elli Frank

www.sophiegamand.com
www.instagram.com/sophiegamand
www.facebook.com/sophiegamand